Garden
Structures

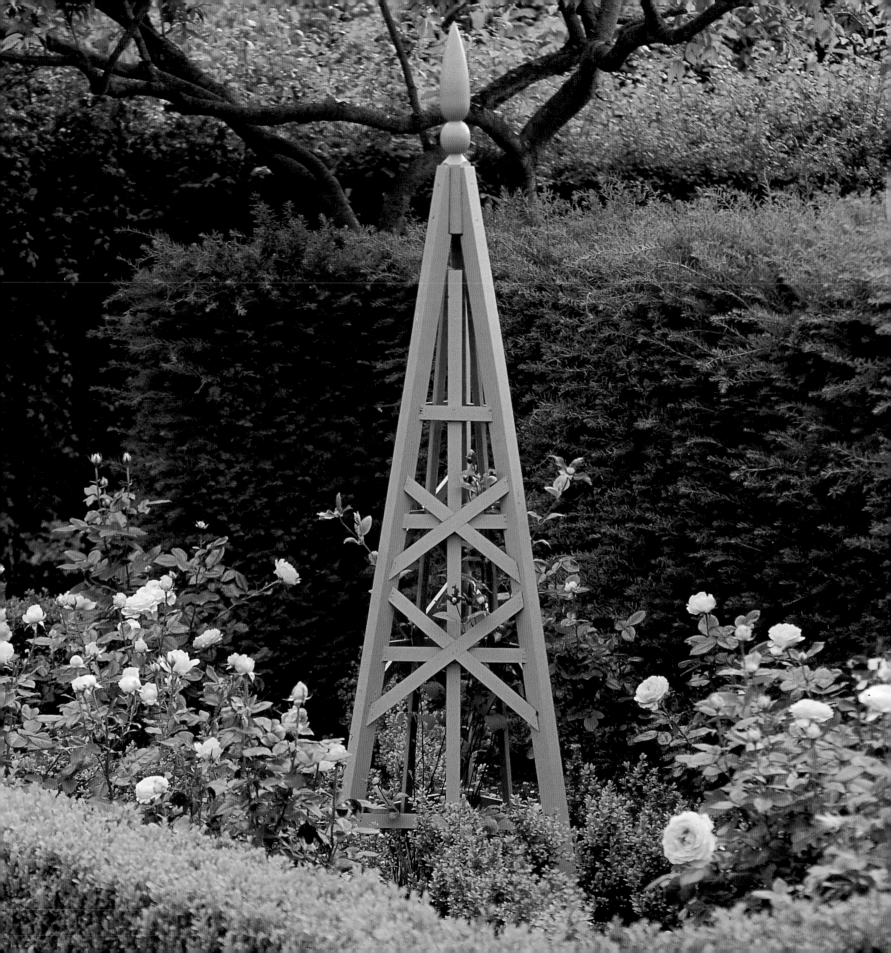

SMITH & HAWKEN

Garden Structures

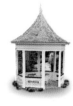

by Linda Joan Smith

WORKMAN PUBLISHING · NEW YORK

To all those who, through the centuries, have left their stamp
upon the earth by growing—and building—a garden.

Text copyright © 2000 by Linda Joan Smith

All rights reserved. No portion of this book may be reproduced—
mechanically, electronically, or by any other means, including photocopying—
without written permission of the publisher. Published simultaneously in
Canada by Thomas Allen & Son Limited.

Design by Paul Hanson and Elizabeth Johnsboen

Library of Congress Cataloging-in-Publication Data

Smith, Linda Joan.

Smith & Hawken Garden Structures / by Linda Joan Smith.

p. cm.

Includes index.

ISBN 0-7611-1406-8

1. Garden Structures. I. Smith & Hawken. II. Title.

TH4961 .S55.2000

624--dc621 99-053342 CIP

Workman Publishing Company, Inc.
708 Broadway
New York, NY 10003-9555
www.workman.com

Printed through Dai Nippon Printing Co., Ltd. in Korea

First printing May 2000

10 9 8 7 6

ACKNOWLEDGMENTS

I'm deeply grateful to the dozens of photographers whose work appears on these pages, and to the gardeners, designers, masons, carpenters, landscape architects, and manufacturers whose structures the photos depict. Without their talent and ingenuity, this book would not exist. Additional thanks must go to Barbara Pitschel of The Helen Crocker Russell Library of Horticulture at the Strybing Arboretum; Mike Shoup of The Antique Rose Emporium of Brenham, Texas, for the wire rose trellis inspiration; Jerry Taylor, civil engineer; Mrs. Scot Butler of the American Boxwood Society; Erna Morris for introducing me to hypertufa; Mary Kristen Smith for her detailed research; and the staff at the McLean Library of the Pennsylvania Horticultural Society. All of their help has been invaluable.

My special thanks to Deborah Bishop and the crew at Smith & Hawken, and to Peter Workman and the creative and diligent team at Workman Publishing Company, particularly copy editor Lynn Strong and art director Paul Hanson. In addition, my heartfelt gratitude to Jim Anderson for his adept illustrations; to Alexandra Truitt, who tracked down photos from around the globe to come up with this extensive array; to designer Elizabeth Johnsboen, who worked magic in fitting the pieces together; and especially to editor Sally Kovalchick, who steered our course with skill and tact.

Lastly, profound thanks to my parents, family, and friends for their unfailing support and encouragement, and to my husband, Mike Bailey, who so enriches the structure of my life.

—LJS

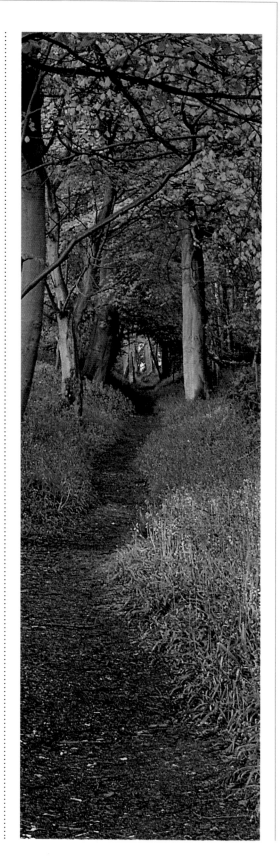

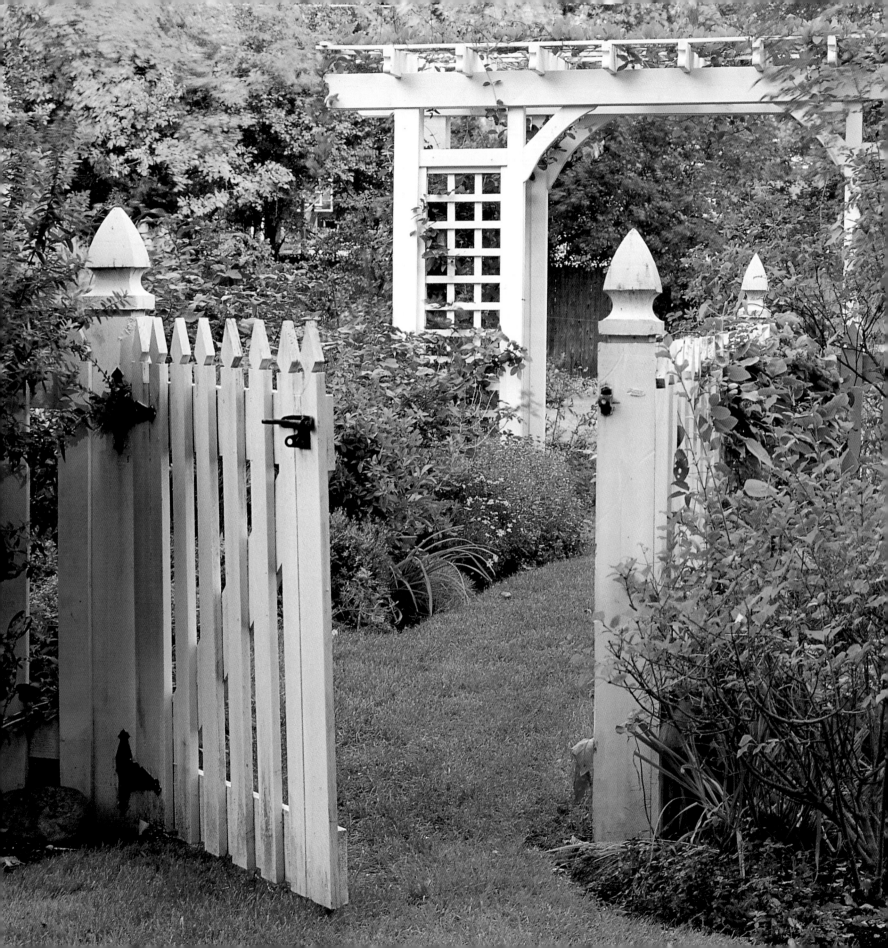

CONTENTS

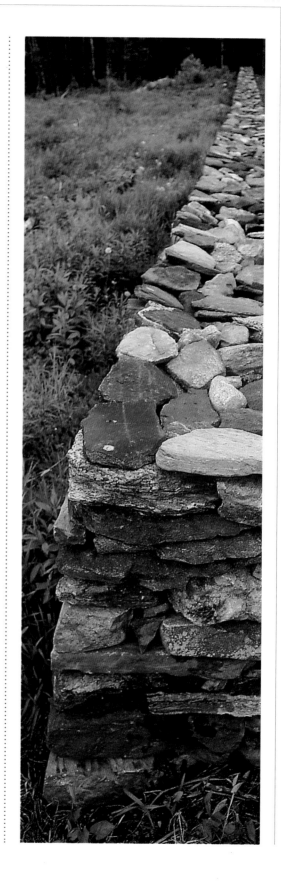

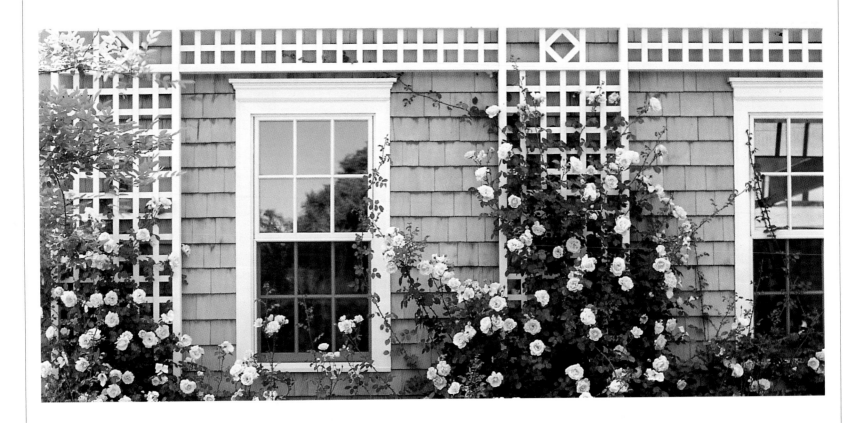

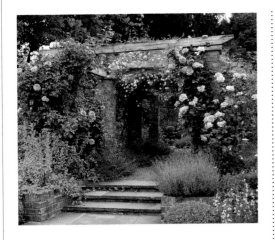

PART II: *The Garden Above*

*G*ardens are rooted in the earth, but the sky beckons. To send plants climbing is to lift up the garden, to elevate it above the sprawl and damp. There, the sun can coax forth the berry and beckon the rose to flower. In the process, we benefit: from an arbor's shade, from a pergola's shelter, from an increase in the garden's bounty.

CHAPTER FIVE

TRELLISES: *Climbing Lessons · 101*

CHAPTER SIX

ARBORS, PERGOLAS, AND ARCHES:
Seeking Shelter · 123

PART III: *The Garden Underfoot*

We connect with the garden through our feet. Toes in the new-clipped grass. Clogs crunching on gravel. Soles on brick pavers. To set our feet upon any one of these is to savor the garden's pleasures, lured by a well-mown path or lulled by a sun-blessed patio. These form the floor of our outdoor home, the foundations on which the garden—and the gardener—rests.

PART IV: *The Living Garden*

The growth of the garden follows our lead. To plant and nurture and prune and tie is to bend the garden to our own designs, to shape it to our bidding. It rewards us for our protection and guidance with an extended season of growth and living architecture rooted deep within the earth. We use the tools that nature lends us, and our gardens flourish.

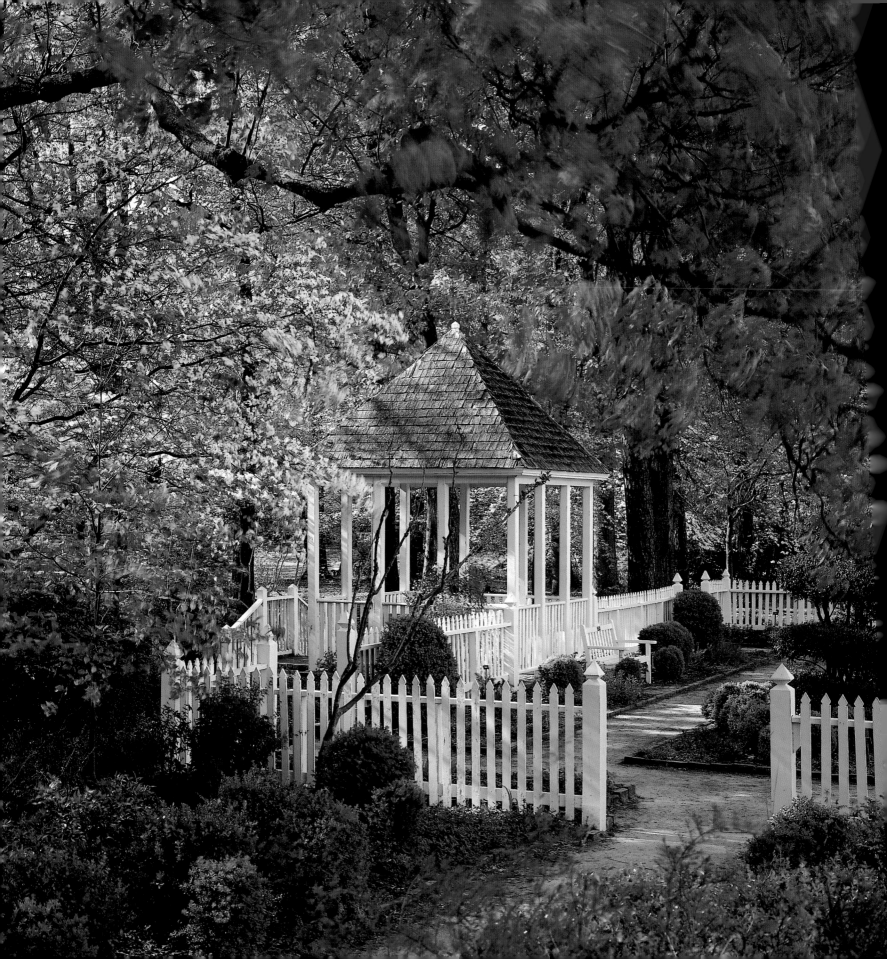

the power of garden structure

W<small>E ARE BUILDING A HOME IN THE WILDERNESS.</small> Hammer in one hand and trowel in the other, we are carving a niche in the world's vastness, a protected garden spot that we can call our own. We clear away woods, or weeds. We bound the land with walls or fences, then we lay out beds and delineate their edges with woven willow, river stones, or terra-cotta tiles. We mark off pathways and line them with brick or gravel or rough-edged flagstones. We pave patios, construct arbors, and erect arches, building floors and rooms and doorways under a sheltering roof of sky.

It's an ancient and honorable pastime. Ever since the first cultivated crop was raided by hungry wild beasts, building and gardening have been joined together, as inseparable as lake and shore. The very roots of the word *garden* mean "enclosure," and rare is the garden throughout time that hasn't included an enclosing fence or wall for protection or privacy, as well as paths for access, edgings for definition and control, and trellises and arbors for supporting vining plants and providing shelter from the sun. Without structures of some sort, in fact, there *is* no garden, only unmarked field, meadow, or unbroken lawn.

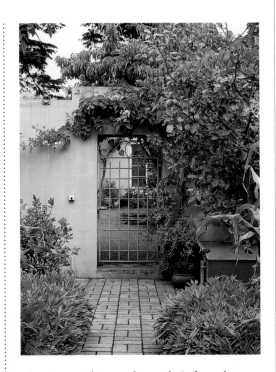

An airy pavilion at the garden's formal border (opposite) provides both a haven and a focal point. The rigid gridwork of a metal gate is the perfect counterpoint for nature's lush curves (above).

GARDEN STRUCTURE, DEFINED

Squash vines become high fliers when trained on a tunnel-trellis in the kitchen garden (below). Concrete pads transform from stepping-stones to a bridge (center). Tepees laddered with string (right) lend a hand up to pole beans and give the garden height.

Garden structure can be as simple as a bamboo tepee for your 'Blue Lake' beans, a string trellis for your 'Painted Lady' sweet peas, or a path of concrete paving stones embedded in the dirt. It can be as commonplace as a picket fence or a rickrack edging of brick that peeks from beneath the petunias. But it can also be as grand as a gazebo, shingled in weathered cedar and smothered in jasmine, or as rare as a hip-high fence of espaliered pears.

Such structural elements most often come to the garden to fill a specific, practical need. We need to keep the grass from spreading onto the gravel of the walkway. We need to travel from the house to the potting shed without stepping on the squash vines. We need to train up the sprawling canes of a 'Fortuniana' rose, provide a stage for the dangling wisteria, or lock out the deer that are devouring

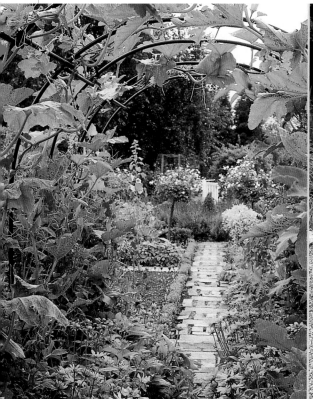
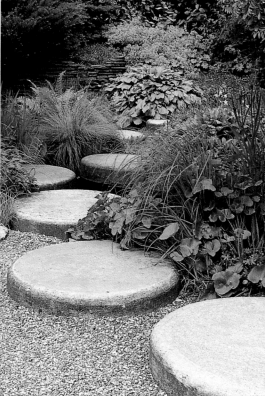
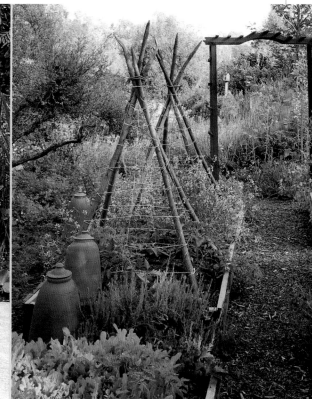

the agapanthus. All such needs generally require us to search out, buy, build, or otherwise concoct structures that are up to the chore at hand.

These helpmates, well chosen, well constructed, and well placed, will do their specific jobs without complaint. A sturdy arbor or pergola will support the weight of a 'Rêve d'Or' rose that bears a thousand blooms; a suitable wire trellis for an espalier will stand fast until the apple's supple branches have matured into their chosen shape. A perfect privacy fence will thwart prying eyes, a stalwart stone retaining wall will hold back tons of earth, and a carefully crafted pavilion will shelter us from the searing sun or a sudden storm and enhance a hundred summer fêtes. Through the heat of summer and winter's winds and frost, such structures will work alongside us in the garden, holding back, bearing up, keeping in, keeping out, roofing over, and generally making the garden a better place to be. We are grateful for their company.

"*O*rder is Heaven's first law."
—ALEXANDER POPE

Ways to coax roses skyward vary from an elaborate pavilion made from recycled gingerbread and trelliswork (left) to a simple double arch, purchased from a catalog or garden center (below). Both emphasize garden pathways.

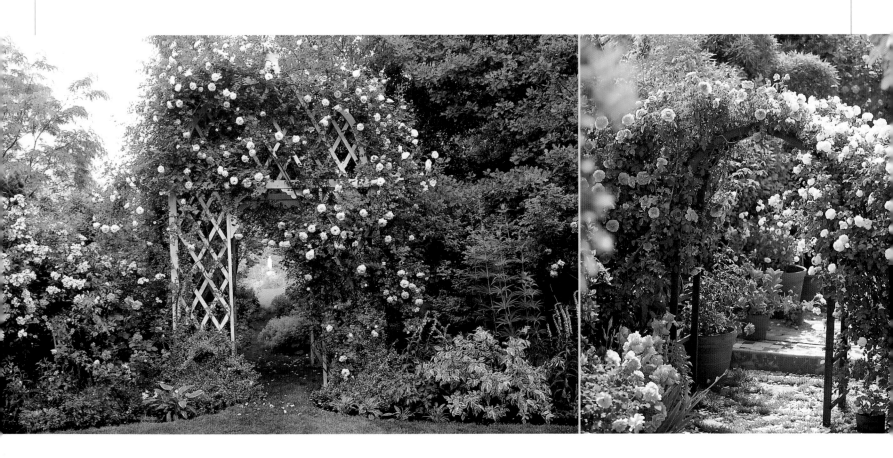

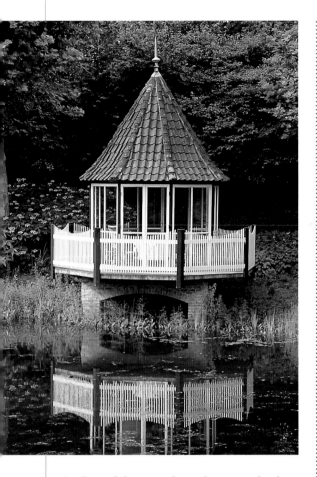

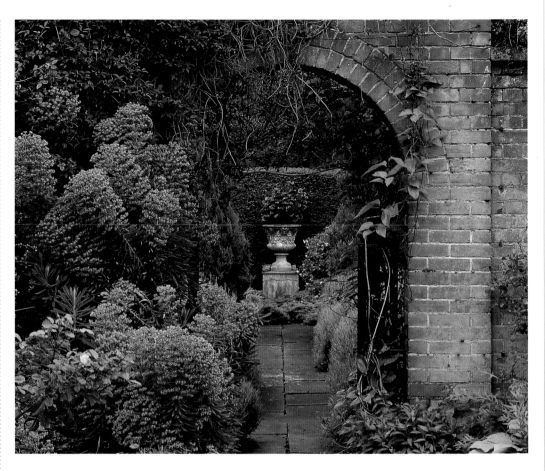

A tile-roofed summerhouse has a pond-side view (above), but is screened to fend off insects. A brick arch lends a formal air to its surroundings, and is tailor-made for framing views or ornament (right).

But they also do more. From a mossy stone wall built before the Revolution to a hedge of escallonia planted five years ago and shorn neatly as a lamb, structural elements have the power to alter a garden's mood, to guide its uses, to anchor it in time, and to deepen its meaning.

Building a mood. A garden's formality, informality, sense of place, cultural leanings, and general atmosphere arise as much from its structural elements as from its plants or ornament. A picket fence sets a different mood than a palisade of heavy timbers or a 10-foot screen of bamboo. A pebbled path imparts a different tone from that of a straightaway of mortared slate. A trellis in an elaborate chinoiserie pattern says different things about the garden—and the gardener—than a simple plant ladder of branches pruned from the orchard and cobbled together

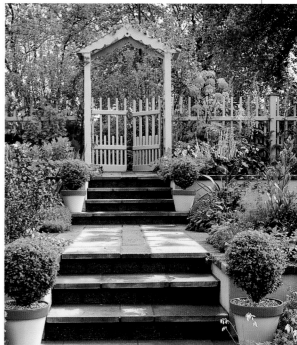

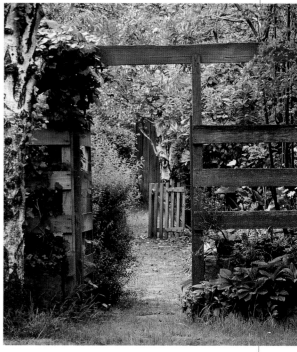

with nails and twine. All communicate a message about who we are, what we like, where we come from, and in what realm our passions lie.

Guideposts. When thoughtfully placed, structure acts as a guide to the garden, telling us where to go and what to look at. A well-placed gate beckons us to enter; an artful hedge tells us where to stop. A sinuous path through the shrubberies lures us to the garden's hidden corners, while a central arch, dripping with honeysuckle, calls us to duck beneath and explore what lies beyond. Even artful misdirection is possible: a carefully sited cedar tripod, drowning in sweet autumn clematis, draws our glance and keeps us from noticing the ragged remnants of the summer's growth. Thanks to structure, there is movement, direction, and intention in the garden: a sense of being gently guided by the gardener through a private world.

A hammock beckons, shaded by a custom-made arbor that stands in for sturdy trees (left). Intriguing gateways, simple or ornate, call to garden wanderers (top and above).

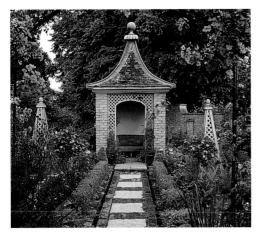

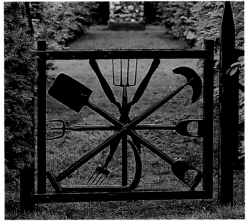

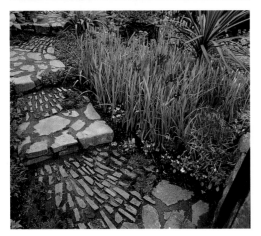

A Colonial-style summerhouse matches a formal garden (top). What other gate (center) could make a gardener feel more at home? This path of salvaged stone (above) flows downhill like a mountain brook.

History lessons. Like letters delivered from another time, some structural elements—if we're aware of their history—connect us to the gardens and gardeners of the past. Border a bed with a trim row of box, and you've collaborated with the gardeners of ancient Rome. Weave a wattle fence around a bed of herbs, and you've shared in the labors of medieval monks. Order up a wall of intricate treillage, and you've followed in the footsteps of William and Mary or the Sun King at Versailles. Erect a pillar for a 'Gloire de Dijon' rose, or build an arched green bridge over a placid pond, and you've communed with the spirit of Englishwoman Gertrude Jekyll or Frenchman Claude Monet. These inherited forms deepen the garden's story and anchor it in time. The continuity they provide gives our gardening the resonance of ritual.

Memory makers. More potent still are structures in the garden that spring from our own memories. One gardener might build a white lattice arbor like the one he recalls from his great-aunt's garden. Seated under its canopy, he'll remember the Hardy Boys mysteries he used to read, the way the old paint peeled off the gray wood in long, narrow flakes, and the cool shade from the scarlet runner beans that twined overhead.

Another gardener might lay out a dirt path, bordered with river rocks, just like the path that intersected her grandfather's circle of prized hybrid tea roses. Walking there on summer days, she'll remember the powdery feel of hot dust on bare feet, the cottontails that nibbled at the garden, and the 'Royal' apricots that dangled temptingly from a nearby tree.

Still another gardener might concoct a wood-and-wire trellis that duplicates the one his long-ago neighbor made and tended, from which he and his boyhood cohorts stole plump boysenberries, warm from the sun of June. He'll remember their sweet-tart taste, the stained fingertips that gave away the thieves, and other daring childhood adventures.

Such nostalgic structures are keys to pleasure and memory as well as fitting memorials: lyrical paeans to the gardeners of our past.

All these things structure can do with ease. But it is in its ability to give shape to the garden—to organize its parts and make a powerful composition out of the chaos nature gives us—that structure's ultimate power lies.

As a fence, arbor, pathway, or other structural element performs its primary practical task, it also creates a vital order within the garden itself. Carve a path through a garden, for instance, and what once was static and inaccessible, without form or order, now stands divided, with two parts that relate to each other in a dynamic way.

Put a fence or wall around a garden and there's now an inside and an outside. You've set off private from public and defined the garden's limits. There's a sense of belonging and of ownership, of stewardship over the land that the walls encompass. You've also defined the scope of your work and delineated the size of your canvas.

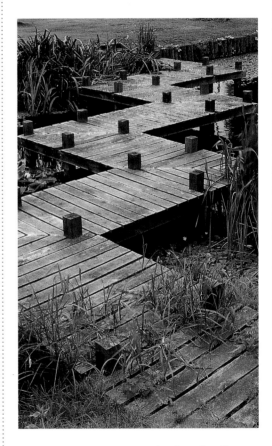

Lay a patio or build a summerhouse, and you've outlined a space within a space—a room within the garden's outer walls. You've created a focal point, a center, a heart, from which the garden can be enjoyed and to which the visitor is drawn. There's now space for living in the garden as well as for hoeing, weeding, planting, and pruning: a home for people as well as plants.

Such organizational structure is essential to the garden's functional and aesthetic success. The paths, arbors, hedges, and other elements that create it are the garden's bones. They hold the garden up, define its form, expand its possibilities, and bring it to life.

They are the framework on which the garden grows.

One can't cut corners on this boardwalk without getting dunked. The right angles serve to slow the speed of passage and lure eyes downward to the water's surface. Such zigzags are used in traditional Chinese gardens to confuse evil spirits.

CHAPTER ONE

GATES AND DOORWAYS:
on the threshold

At THE GARDEN GATE, we stand on the threshold of a new world. This is where outside becomes inside, public becomes private, and wilderness or city street gives way to the glories of the garden. Gates are the transition point, the portal through which we must pass to cross from one realm to the other. Depending on their location, they may be our ticket to familiar territory or our passage to unknown pleasures.

At our own gates, we rarely hesitate. We swing them wide and the garden opens out before us, golden in the slanting sun. The perfume of the nicotiana and heliotrope is a soothing balm, and our workday woes evaporate. We step in, nudge the gate closed, and are home.

If a friend's gate beckons, we pause, then gently lift the latch or pull the string, and enter. We may have been to the garden a dozen times before, but still, the thrill of discovery remains. The philadelphus has exploded in a cloud of fragrant blooms since last we came, and the 'American' pillar rose is more brilliant

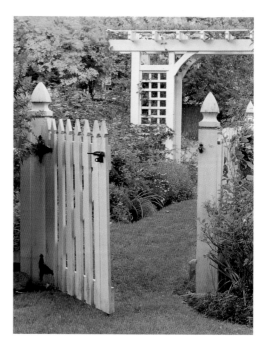

Gates are the garden's welcoming gesture, whether decked in nature's finery (opposite) or painted pristine white (above).

HEAVEN'S GATE

Lych-gates, which are sheltered by sturdy roofs, have their roots in early churchyards. *Lych-gate* literally means corpse-gate; the coffin or corpse was set down beneath the gate's peaked roof before being taken into the church or during the first part of the burial ceremony. Lych-gates in English churchyards are often made of heavy timbers with roofs worthy of a church or cottage. Garden gates roofed in a lych-gate manner have a welcoming, protective feel and provide a resting spot between one world and the next.

than remembered. There is a new fountain, splashing in a sunny corner, and the blossoms of the sugar snaps have metamorphosed into crisp, fat peas.

If a stranger's garden lies beyond the gate, we try to peek—over, under, through the bamboo lattice or the knotholes in the boards—to see what we are missing. Even a low gate, or a framed opening in a hedge or fence that *has* no gate or door, heightens our curiosity. We can easily see over, through, and beyond such gateways, and they provide no physical barrier to our entry. Yet all awaken our desire to explore.

Little of this magic graces the garden that spills onto the street or road and readily displays its charms for all to see. Such a garden lacks the symbolic portal a gate provides. There is beauty in its wide open spaces, but no promises or sweet anticipation.

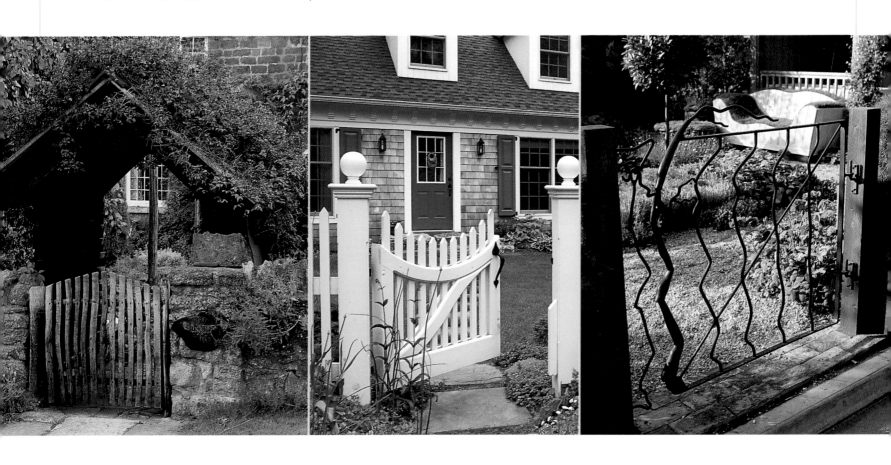

THE WAY IN AND THE WAY OUT

Just as we need doors to our houses, we need gates to our gardens. We need a way to enter and to exit: to get from the front yard to the back, to get from the garden to the alley, to get from one section of the garden to the next. We also want a way to welcome visitors, and a way to discourage uninvited guests. Before any other consideration, the gates we choose must satisfy these wants and needs.

Front gates. Just as a ship's crew searches for the charted entry to an unfamiliar harbor, passersby or visitors unconsciously look for the sanctioned way into a garden. A front gate is like a sign on a gameboard that says *Start Here,* whether it's a commanding timber construction between imposing stone piers or simply a gap between neatly shorn shrubs.

(Left to right) A traditional lych-gate provides a sheltered middle ground between garden and street. A curved brace adds cottage charm to classic white pickets. This sculptural metal gate is a harbinger of quirky things to come. Latticework and roses provide a passage to the past. Potted topiaries and a terra-cotta garden ornament echo the ball finials of an entry gate.

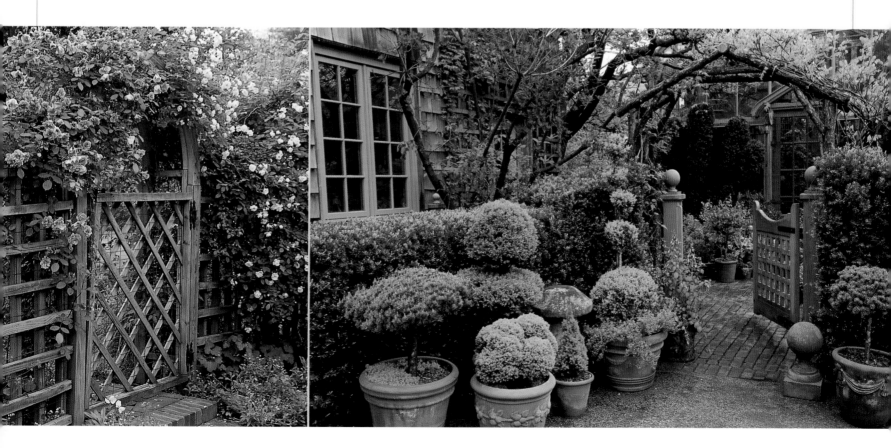

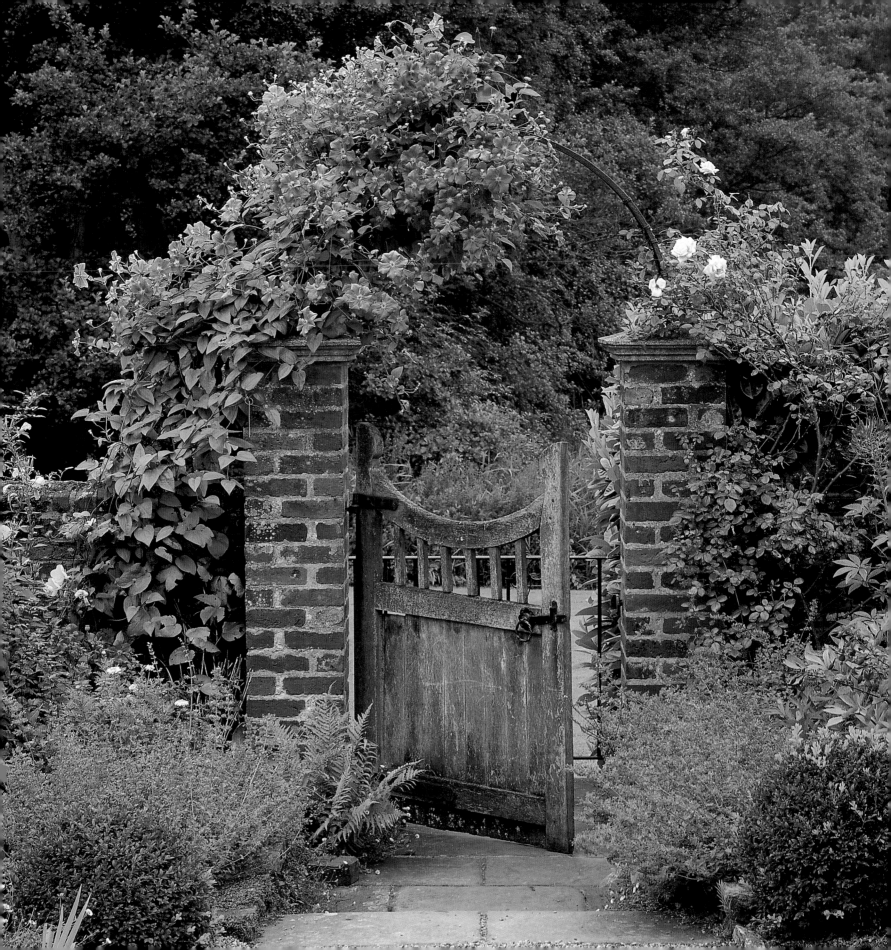

The lower the gate, and the airier its construction, the more inviting it will seem from the street. Low gates set in low walls or fences communicate the message *Come in, you're welcome here.* So do mid-height gates that don't block the view of the garden beyond, such as gates of widely spaced pickets, Victorian wire, rustic twig construction, or lacy wrought iron. They're symbolic, not significant or forbidding, set in place primarily to guide us to the gardener's preferred point of entry.

Visitors can't miss gates that are dressed up with rose-clad arches or peaked roofs; both lend a gracious, old-fashioned note to the garden and amplify our sense of crossing a threshold into a special world. Such structures should be at least seven feet high, so no one feels compelled to stoop.

If you prefer the perks of privacy, consider a garden entry guarded by a solid plank door or head-high solid wood gate that leads to a walled or fenced front courtyard. Few visitors will turn the door's knob or work the gate's latch without an explicit invitation; to do so feels too much like trespassing. But perhaps your garden is walled primarily to block out the rumble of the bus that roars by once an hour, or a less-than-pleasant view. If so, plan ahead for visitors or deliveries. Install a bell by the front gate—whether an antique of cast brass or an electric buzzer—or mount a plaque that invites visitors in.

Side gates.

Gates that lead from front yard to back are the doors to the inner sanctum. Weeding in the front yard, we chat with neighbors or passersby, but ensconced in the back garden we generally expect privacy. A high, solid wood gate ensures our peace and quiet, and also keeps the kids and family dog within safe bounds.

If, however, you relish having your neighbor drop by every summer Saturday, or the kids next door are always trooping in to play with yours, then make sure all comers can see over or through the gate that leads to the back garden. Likewise, it's comforting if you can see who's arriving while you're thinning the beets or weeding the perennial beds. So you're not surprised while you're work-

Solid gates, whether waist-high (opposite) or six feet tall (above), have all the substance of a door. Both gates help establish private garden rooms, yet allow a peek into the garden beyond.

ing in the garden's farthest corners, attach a small bell to the gate. That way you'll know when the meter reader's on his rounds or the kids have strayed.

When choosing or designing a side gate, consider how often it's used and for what. If you're regularly dragging tarps full of hedge clippings from the front yard to the compost pile, or wheeling a garden cart of compost from back to front, be certain the gateway is wide enough for easy passage.

Back gates. Back or side gates that lead onto an alley or street are the garage doors of the garden. Welcome is rarely a concern here; utility is the guiding factor. At the minimum, choose a sturdy, easy-opening gate that allows you to drag the trash bins in and out with ease, or to cart in that 12 cubic yards of mulch you rashly had delivered and dumped in the street. If you do a lot of soil amending or mulching with purchased materials, consider installing a double gate that leads

A double wood gate depends on weighty brick piers and sturdy strap hinges for its fine performance (below). As this artful gate attests (center), the double doors needed for utility needn't be bland. A solid blue door completely fills an arch in a back garden wall (right), but has a wood grill for identifying visitors.

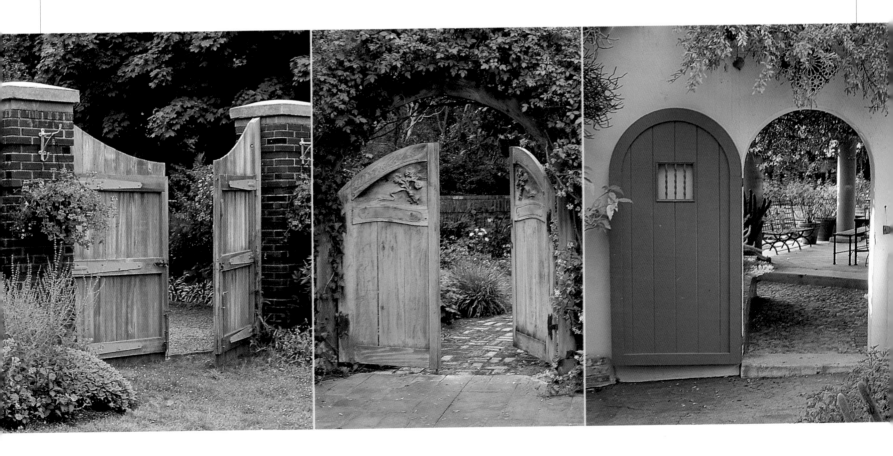

GATEWAY TO THE ORIENT

In the 18th and 19th centuries, Europeans and Americans were captivated first by Chinese motifs, then by Japanese ornament and forms, many of which remain part of our design vocabulary today. No matter where you live, you can transport your garden to the Far East by including one of the following:

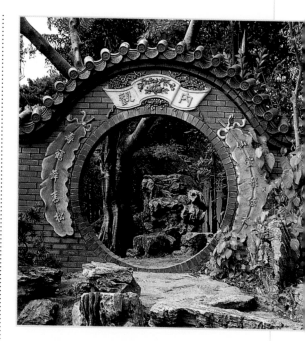

SHINTO GATE. The Japanese Shinto gate, or *torii,* has roots that reach deep into the past; Japan's indigenous Shinto religion predates the introduction of Buddhism to the Japanese isles in the sixth century. Shinto centers on the worship of revered spirits known as *kami,* many of which are found in nature. Shinto gates, and the shrines they guard, are built in spots of special natural significance and beauty where kami are thought to dwell. Like a moon gate, a torii marks the boundary between two worlds, in this case the secular and the spiritual. Traditionally, Shinto gates are constructed from wood and often are painted red and black.

In Western culture, reproductions of Shinto gates have been incorporated into stylized public gardens, where they pay homage to the serenity of the Japanese landscape and the natural beauty around them. In the home garden, a simple torii can be placed in the same way as a garden arch, over a path that leads to some particularly evocative or peaceful spot in the garden where nature's wonders can be appreciated.

MOON GATE. The simple elegance and grace of the Chinese moon gate suits many a garden, imparting a sense of mystery and exoticism without excessive ornament. Moon gates can be round (a completely circular opening in a wall or fence), oval, or may have a cutout section at their base to accommodate a pathway that gives them the shape of an old-fashioned keyhole. Moon gates symbolize the passage into a different reality and are most powerful when they frame a vista or special element in the garden. Round moon gates with a raised threshold that one must step over particularly evoke the sense of entering a different world, and cause walkers to slow their pace and enter the garden single file.

GUARDIANS OF THE GATE. Fo dogs, fu dogs, or foo dogs are mythological creatures that are half dog and half lion, and pairs of them have guarded Chinese temples and images of Buddha for centuries. It's fitting, then, that they should guard the garden, as they symbolize protection and loyalty and are thought to bring good fortune and happiness.

into a garden work area and can be opened to admit a well-laden pickup or even a dump truck.

Back gates generally are solid, for privacy, and high, for security. They should open only from the inside, unless you or your guests or kids regularly come into the garden from the back. It's handy if they can be latched open with a hook-and-eye or cane bolt, so you don't get locked out while you're taking out the recyclables in your bathrobe and slippers.

Tall back gates, side gates, and front gates all may benefit from a cutout or decorative grillwork that allows you to see who's waiting on the other side.

Interior gates. If your garden is divided into discrete sections by fences, shrubs, trellis screens, or hedges, interior gates will emphasize the transition between one garden room and the next. This is where gates of old wrought iron,

A wooden gate in a greenery-clad brick wall (below) adds mystery to the garden beyond. Rustic gates were a favored Victorian form (center). An old iron gate stands fenceless in the garden's midst, but bestows a sense of passage just the same (right).

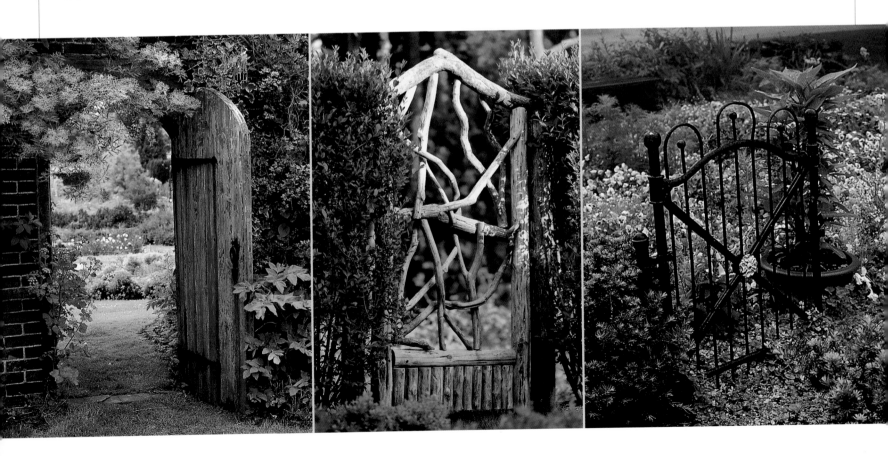

restored wood gates from the Victorian era, or rustic gates of bent willow have the most decorative impact, being part garden structure and part garden ornament. Interior garden gates, in general, should allow a filtered view into the area beyond, but often they are a focal point themselves, particularly if they're painted with bright enamel, have a rich patina, or exhibit unusual craftsmanship.

A heavy plank door, hinged with hand-forged iron and built into an arched frame in a dividing wall or hedge, will also magnify the sense of passage between garden rooms, but with a greater aura of mystery than a low openwork gate. (Think Mary Lennox and *The Secret Garden*.) Leave the door slightly ajar; there's nothing more alluring than glimpsing a sunlit section of the garden through a mere sliver of an opening. Ancient-looking doors also tantalize when set in the boundary hedge or wall of a small garden, giving the illusion that there's more of the garden's glory to be discovered and explored, if only we could find the key.

> "*H*ow shall I ever get into that beautiful garden?"
> —LEWIS CARROLL, *Alice in Wonderland*

Wood grillwork along the base of this gate gives it a Moorish feel (left). Iron tracery mimics the garden's greenery (center), and suits the dreamy spirit of this outlying garden spot. Venerable iron pickets defend a garden pathway, even without a companion fence (below).

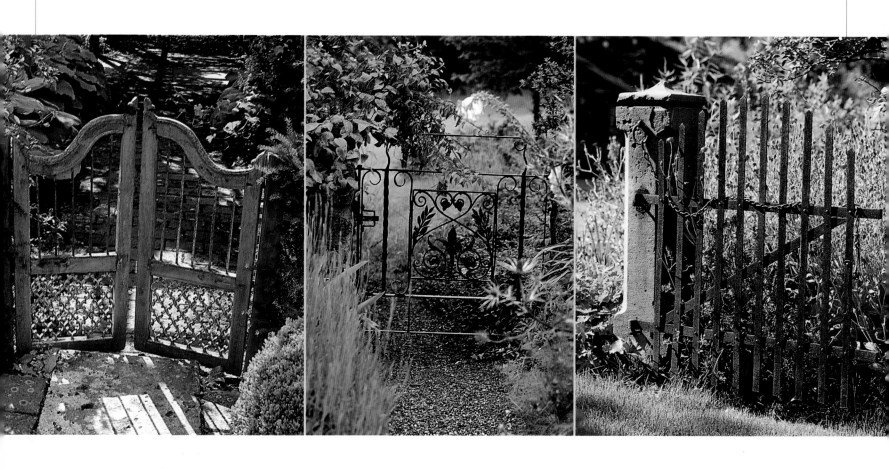

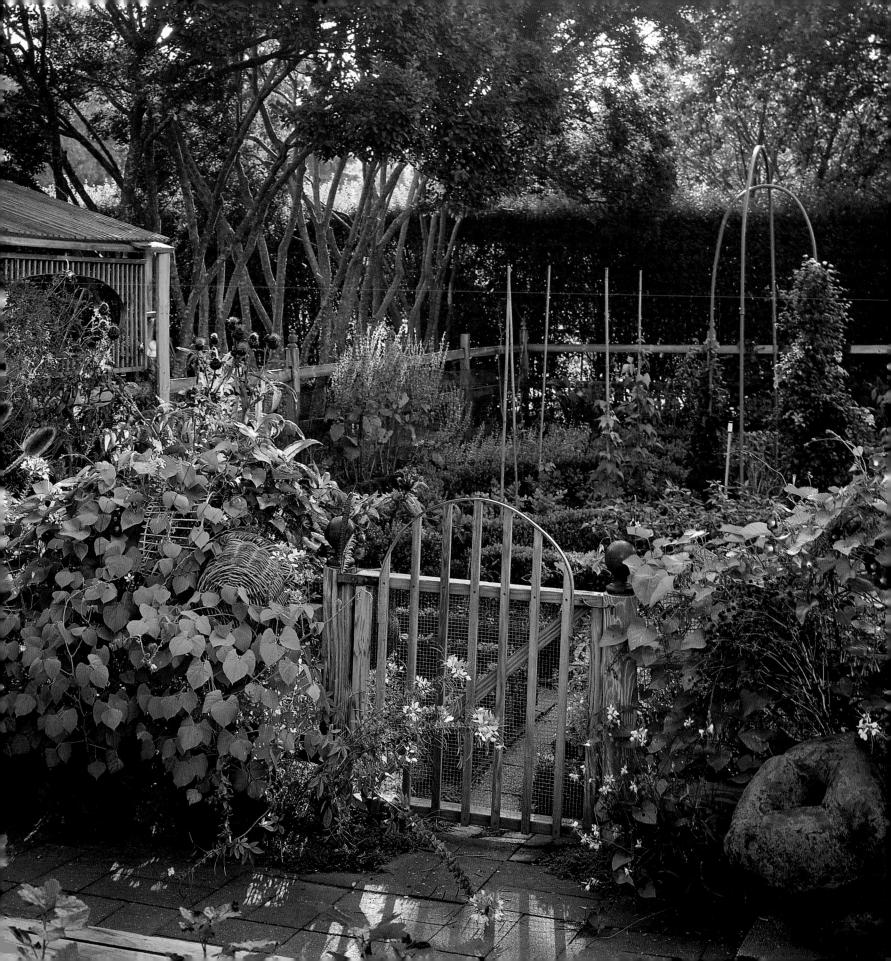

SETTING THE STYLE: CONTEXT COUNTS

Gates do not stand alone, but are part of a whole that's completed by your garden, house, and adjoining hedge, fence, or wall. The formality or informality of these elements, their scale and design, their cultural history, and the materials used to build them should all play a role in determining what gate style you choose. In addition, keep in mind the neighboring structures, the surrounding landscape, the cultural history of your region, your own personality (and its quirks or conventions), even what country you live in. Each can inspire appropriate design directions.

In starting your quest for the perfect gate, seek out examples that attract you in surrounding neighborhoods, at historic restorations, or from catalogs, home and garden magazines, or books (new or old). Then take additional design cues from the elements around you.

The garden. Since a gate is the first taste of the garden, make sure it sets the proper tone for the feast that follows. Match a gate of freshly painted pickets, for instance, to a garden of simple charms and old-fashioned flowers, where pansies and pinks tumble from their beds onto flagstone pathways. Match a gate of framed bamboo to a serene garden where breezes rustle in the pines and moss clothes the ground in velvet. Match a gate of iron pickets to a garden of satisfying order and formality: of box-edged beds, clipped hedges, rose standards, and paved brick pathways.

The house. Gates are architectural by nature, and gain visual power when they echo the dominant architectural style of a house. A gate of weathered grape stakes or white pickets, for instance, takes on added appeal when it fronts a simple

"We are strictly in the fashion now in giving thoughtful consideration to our gateways; for some sort of barrier that will keep the public from making common property of our lawns and gardens has become very sensibly 'fashionable'—with a wider range in the desireable types."

—PHEBE WESTCOTT HUMPHREYS, 1914

Tomato-red finials equip a gate to guard the vegetables (opposite), while contorted sticks form a gridwork gate of blue (above).

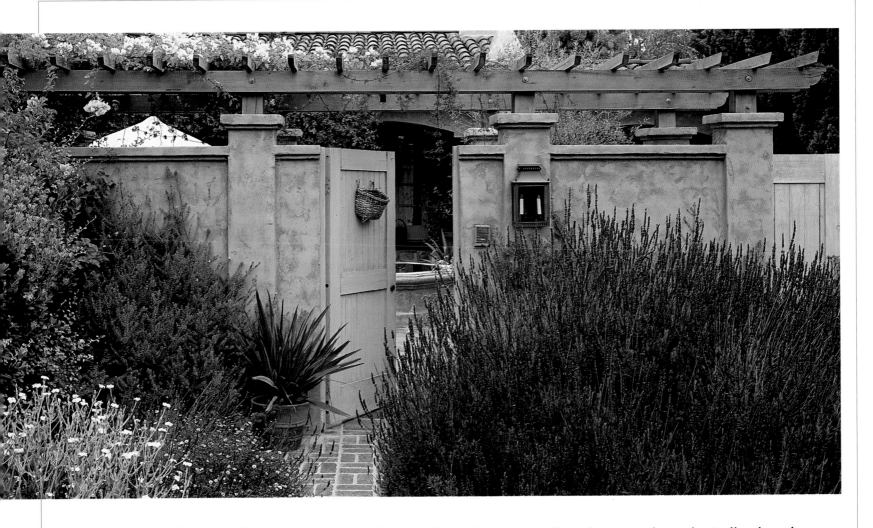

Simple lines and muted tones tie this gate to its surroundings. The tall gate and wall provide complete privacy for the front garden, but the basket keeps the structure from appearing inhospitable or forbidding.

1920s clapboard bungalow; a gate of cased posts and wood spindles does the same when backed by a grand Colonial Revival house; and a simple iron gate stars with a brick-and-stucco Tudor in the background. A simple wood gate suits a low-slung 1950s ranch house best, while a painted picket gate surmounted by an ogee arch seems most at home welcoming visitors to a cottage of Gothic Revival style. Scale matters, too. Grand houses need grand gates, while modest dwellings look out of their league behind double iron gates flanked by stone lions or concrete greyhounds that dolefully dangle flower baskets from their jaws.

Fences or walls. Because of their proximity, gates and the fences or walls in which they are set work best when related in design. That doesn't mean they

THE CROWNING TOUCH

Caps and finials transform workaday gates and fences into elegant bits of architecture. They emphasize a fence's style. They highlight the fence's rhythmic structure, or emphasize the position and importance of a gateway. Fence or gate posts topped by caps and finials seem complete, grounded, lacking nothing. But to achieve that effect, the cap or finial must fit the fence in scale, material, and style.

THE CAP. The quickest way to finish off a fence post is with a simple cap: a square section of board that's slightly larger than the post. Such elementary cap designs will elevate even a plain post-

and-board fence above the ordinary, but they also have an important function: they keep water from soaking into the exposed end-grain of the post, thereby prolonging the post's life. The edges of a cap can be straight or chamfered (cut at an angle).

You can also construct caps by stacking wood squares of varying sizes, or by nailing mitered moldings around the top two inches of fence post, then placing a double cap on top of them. Such caps star on the posts for formal picket fences.

Ready-made decorative caps, often topped with copper, also are available at some hardware stores, lumberyards, and home centers.

THE FINIAL. A finial adds a purely ornamental touch that draws the eye up and away from the ground and into the garden. Turned wood finials are available in a variety of styles, from simple balls to urns or acorns. For a finished look, finials always should sit on top of a post cap rather than directly on the top of the post. You can buy ready-made finials at home centers, at some lumberyards and hardware stores, and at drapery supply outlets. Opt for larger finials rather than smaller ones; undersized finials look stingy and will appear to be an afterthought. The base of the finial should be the same size as or slightly smaller than the post.

The top ends of fence or gateposts also can be shaped into cap or finial form before they're installed, either by

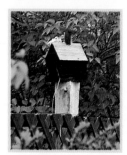

saw or lathe or by hand carving. The simplest ways to finish the top of a post are to chamfer its edges or trim it so that it comes to a point, with a pyramidal shape. Such posts have a rustic air well suited to grapestake or paling fences, particularly if they're left to weather.

OFFBEAT CAPS AND FINIALS. Some gardeners elevate their fence or gateposts into the realm of folk art by choosing out-of-the-ordinary caps and finials. Flat field-stones make eye-catching caps, topped by finials of rounded river rocks. So do bird-houses, stoneware saucers topped by blue glass bottles, or upside-down terra-cotta saucers topped by molded terra-cotta roosters or rabbits.

BEYOND THE FENCE. Finials suit masonry walls as well as fences. Because walls or balustrades will bear more weight than fences, their finials may range from cast-stone spheres or cast-iron urns to well-planted pots or full-scale statuary. Logical placement is important for architectural impact; locate finials at the ends or corners of a wall, at even intervals along its length, or on the tops of pilasters or piers.

Decorative finials also lend their finishing touch when perched on the top of a gazebo, pavilion, obelisk, rose pillar, birdhouse, or dovecote, or at the apex of your greenhouse or potting shed. All will call attention to your garden's finer points.

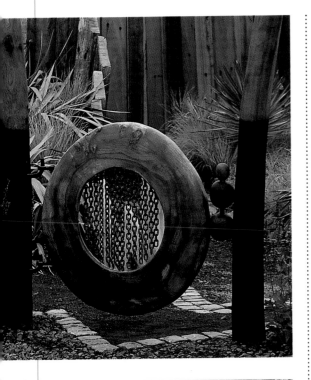

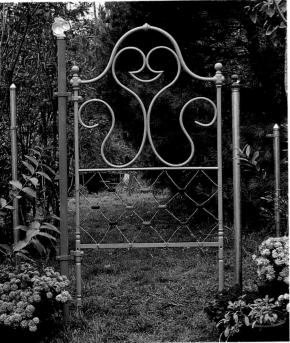

The central screen of chains in a drum-shaped gate (top) makes its own music when the gate is opened. Yellow and periwinkle paint dress a gate in brilliance (above).

should be identical; front gates, in particular, are most effective as entry markers when they stand out from their surroundings in some way. Make the gateposts larger than the fence posts and top them with decorative caps or finials. Jog the fence inward just before it reaches the gate to create an alcove that emphasizes the gate's position. Or make the gate with different but complementary materials, extra framing, or more elaborate woodwork than the fence.

Again, keep in mind the dominant architectural style of the gate's immediate surroundings. A simple brick wall demands a simple wood or iron gate, not a fanciful construction of turned and gilded spindles. A stucco or stone wall calls for a heavy plank gate or ironwork in a Spanish Revival design. A low rail fence needs a low rail gate, and a high fence needs an equally statuesque door. A very simple fence, or a low hedge, may not require a gate at all; an opening between two posts or geometrically sheared shrubs provides an ample sense of entry.

Rule breakers. Though these guidelines help avoid clashes between the garden's elements and boost their collective impact, don't be afraid to stray from the expected. Sometimes the most effective gates are those that break the rules or surprise the senses, particularly in the side or back garden.

If you crave Crayola-bright colors in your flowers, from zinnias to dahlias, paint an iron side gate school-bus yellow, fire-engine red, or periwinkle blue. The color alone will draw the eye, even when the flowers have faded and winter has frosted the scene. If your tongue is often firmly in cheek, paint a trompe l'oeil scene on your side gate that gives visitors a glimpse of Versailles, or erect a rusting iron gate in the middle of the squash patch, where none is needed. Or personalize a gate with a favorite floral motif, carved in wood or wrought in iron, or incorporate that cast-iron grillwork you unearthed at the junkyard.

If your existing front gate is perfectly serviceable but nondescript, dress it up with a glazed address plaque, carved welcome sign, or colorful piece of folk art.

Hang a living wreath on the gate's front, or a basket you can fill weekly with a garden-fresh bouquet. Alternately, heap that basket full with your excess zucchini, tomatoes, or cucumbers, then tack up a sign that says "Free" and wait for your garden's produce to disappear. Such a gate says, *This is a place of bounty.*

PRACTICALITIES

We ask a lot of our gates. They must stand up to heavy-handed mail carriers, kicks from grocery-laden spouses, and gusts from the winds of winter or fall. Kids are compelled to climb on them, hang on them, swing on them, and slam them closed. In the course of a single year, a garden gate must swing open and click securely shut a thousand times or more. So that your gate can survive such wear and tear, hang it from sturdy posts or piers, build it from durable

Carrots and onions adorn a wood gate that seems to bar snails from the garden (left). Clothed in Chinese red, a gate stands out from its surroundings (center). The peeling paint of an old gate (below) seems in tune with the ancient fossils embedded in its gateposts.

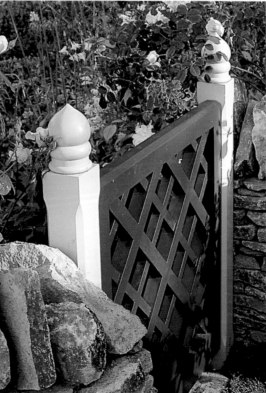
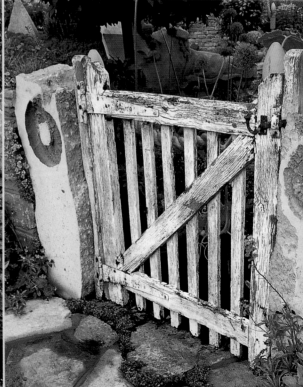

☰ HOW-TO BUILDING A BASIC GATE

Standard wood gates often can be purchased at lumberyards and home centers to match prefabricated fence panels. But, if you can handle a hammer and saw, you're better off building your own. If your fence and gate designs are too complex for your skills or available tools, call in a carpenter or fence contractor and relax while they do all the work.

Most gates are little more than a sturdy braced frame with fencing material attached and can be built as follows:

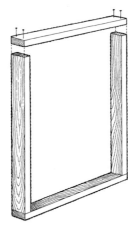

1. Assemble a rectangular frame of 2-by-4s, set on edge or laid flat, the width of the desired gate. The height of the frame usually matches the positioning of adjoining fence rails. When determining the width of the gate frame, allow for hinge clearance along one side (usually one-quarter to one-half inch, depending on your hinge type) and for swing clearance along the

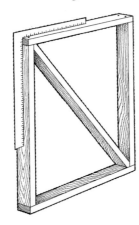

other (usually one-half to five-eighths inch).

2. Butt or half-lap the frame pieces at the corners, and secure them with nails or screws. The horizontal frame members should overlap the vertical members to protect the ends of the uprights from water damage.

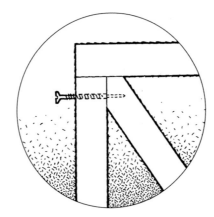

3. Add a 2-by-4 brace that runs from the latch corner of the frame to the lower hinge corner and is screwed or nailed into place inside the frame. Cut the brace to size by laying the gate frame on top of the brace. Mark the length, then cut the

angles with a circular or crosscut saw just outside your lines. Tap the brace into place, then check the frame to make sure it's square before securing the brace with nails or screws.

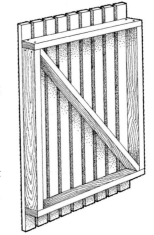

4. Lay out siding (pickets, boards, redwood palings, etc.) on the gate frame to determine optimal spacing, then nail to the outside of the frame. Use a square to check alignment as you proceed.

5. Predrill screw holes, install hinges, and hang the gate. Check to make sure it swings freely, then install the latch. Once the gate is hung, install a vertical wood stop on the latch post to keep visitors from opening the gate in the wrong direction and damaging the hinges.

materials, brace it properly, and finish it off with well-made hardware sized to suit the job. Skimp, if you must, in other places; gates must put the garden's best face forward.

Posts and piers.

Even a delicate gate needs sturdy posts. And the heavier, taller, and wider a gate is, the larger, stronger, and more deeply set its posts or piers must be. Most wooden garden gates are mounted between four- or six-inch square timber posts, set in concrete in the same manner as fence posts (see page 56). Choose decay-resistant wood for gateposts such as cypress, cedar, or redwood.

Plain gateposts are perfect for rustic gates, but fancier styles such as spindle fences should have dressier supports. Elevate plain wood gateposts by adding vertical grooves, chamfered edges, notches, or other trimwork, then topping them off with decorative caps or finials (see page 21). You can also enhance their stature (and their bulk) by encasing them aboveground with thinner lumber. For instance, turn a four-by-four post into a more imposing six-by-six by nailing or screwing one-by-fours to opposite sides of the post and one-by-sixes to the two remaining sides.

Heavy iron or wood gates with a broad span require piers of concrete block, stone, or brick, set on hefty concrete footings, and are best built by qualified masons.

Materials.

Wood is the standard for gate building, because of its cost, ease of use, and adaptability to countless designs. For painted gates, pine or Douglas fir will suffice; for unpainted gates that will weather to a pleasing silver over time, redwood, cedar, or cypress are preferable. Rustic gates often are made of willow, apple branches, red cedar poles with the bark still attached, or a combination of such woods.

Wrought-iron gates have been venerated by gardeners since the mid-1600s,

"One must not underestimate the importance of the garden gate in the general scheme of design. It is the connecting link between inner and outer conditions, and as such bears upon its shoulders much responsibility."
—CHARLES EDWARD HOOPER, 1913

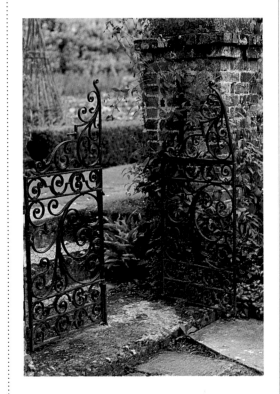

Massive brick piers keep a lacy iron gate on an even keel through centuries of enterings and leave-takings.

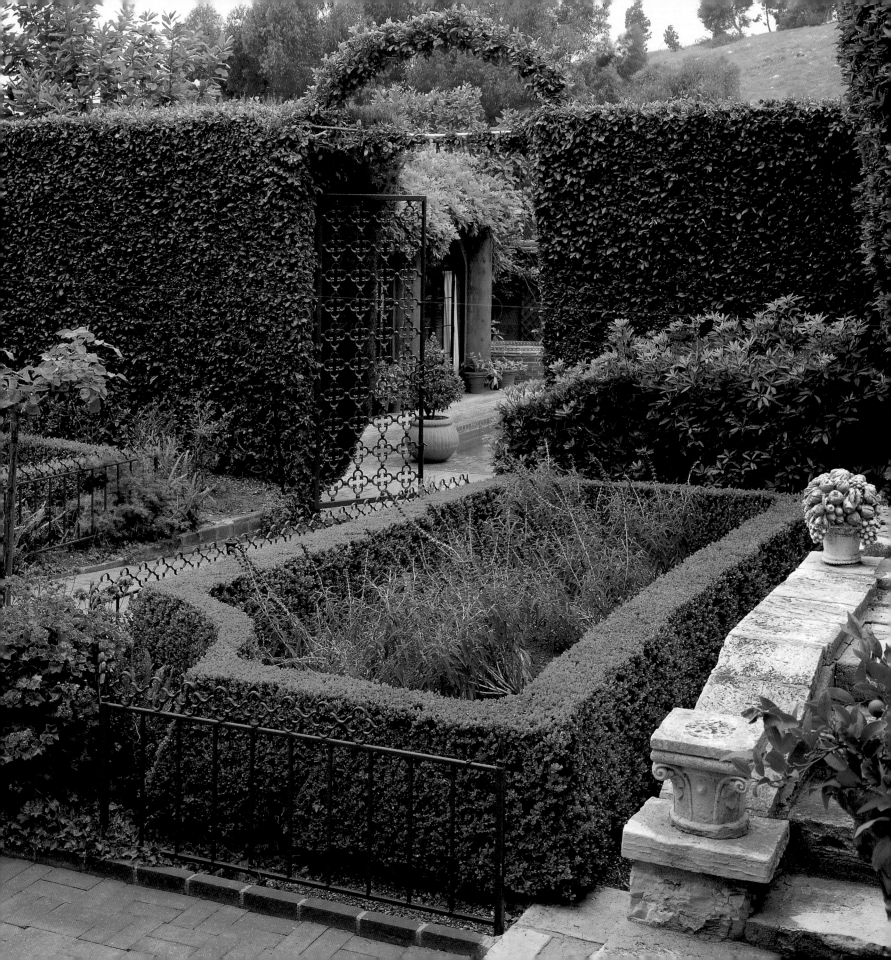

when elaborate Baroque screens, decorated with iron acanthus leaves, masks, scallops, and rosettes, first began to guard the gardens of Europe's elite. While you're not likely to stumble on a gate by famed Baroque master Tijou, wrought- or cast-iron gates from the late 1800s and early 1900s do sometimes surface in antiques shops or architectural salvage yards, and are worth hunting for and resurrecting. You can also commission a custom-made gate from a skilled blacksmith or metal-worker (look under Gates in the Yellow Pages), but be prepared to pay a hefty price. Alternately, seek out the simple, affordable iron gates—well suited to today's more casual gardens—that are available in many garden catalogs. Today, some manufacturers use lightweight cast aluminum or tubular steel to mimic wrought or cast iron in their gates.

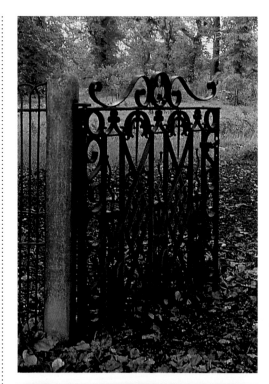

Bracing. Wood gates have a tendency to sag at the latch side unless they're properly braced. The brace, which generally is a piece of lumber that fits snugly inside the gate's frame, must run diagonally from the upper latch side of the gate to the lower hinge side in order to be effective. Alternatively, some rustic gates are braced with screw eyes, heavy wire, and a turnbuckle. This type of brace should be positioned so that it stretches from the upper hinge side of the gate to the lower latch side (exactly the opposite of a wood brace).

Hardware. The hinges a gate hangs on, and the screws or bolts they're attached with, will determine the gate's performance. Be sure all are big enough and long enough to get a good grip both on the gate's frame and on the gatepost. If in doubt, buy heftier hinges rather than smaller ones; undersized hinges will quickly lead to a gate's failure. Upgrade the screws or bolts if needed, choosing corrosion- and rust-resistant types.

The height and width of the gate will determine the number of hinges you use. Two hinges are fine for gates four feet and under, but taller gates will benefit

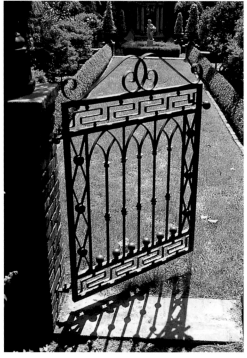

An iron gate matches garden edgings (opposite). Ornate iron gates (top and above) suit both natural and formal gardens.

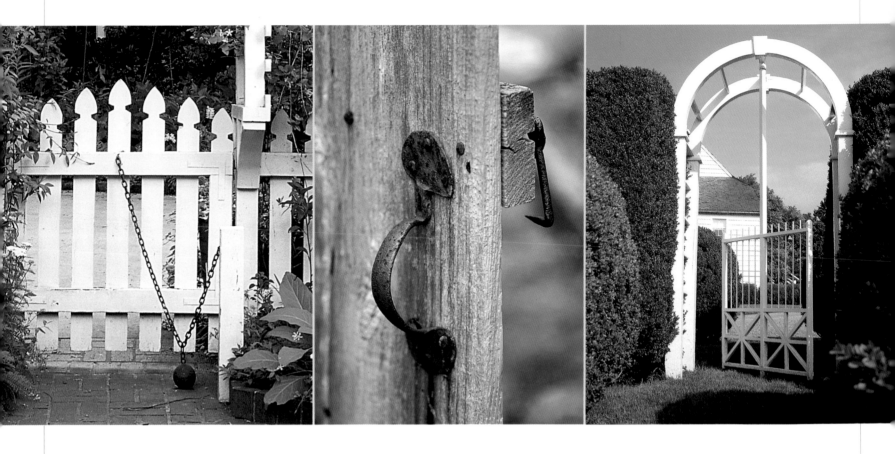

A ball weight automatically returns a gate to its closed position (above) no matter how forgetful the visitor who opened it. Simple hardware gains a patina of rust as a gate ages (center). This gate pivots on a center post attached to an overhead arch (right), needing only a nudge to open.

from a third hinge. Gates wider than the standard three feet also need the support of an extra hinge.

Search out hinges and latches that suit your gate's design. Hinges with a black finish, or galvanized hinges painted to match the color of the gate, often suit decorative gates best, while unpainted galvanized hardware may look more in keeping with utilitarian gate styles. Hand-forged hinges and latches may be the best choice for a rustic or period gate style.

Lag-and-eye or lag-and-strap hinges are among the strongest hinges you can mount a gate with, but they have an informal, rustic feel. Variations of butt hinges, strap hinges, and T-hinges work well on formal gates. Be sure the screws you use to attach these hinges extend deep into the wood of both gate and post.

Almost any latch type will work well for a low gate that's easy to reach over. But taller gates should be fitted with a through latch that works from both sides

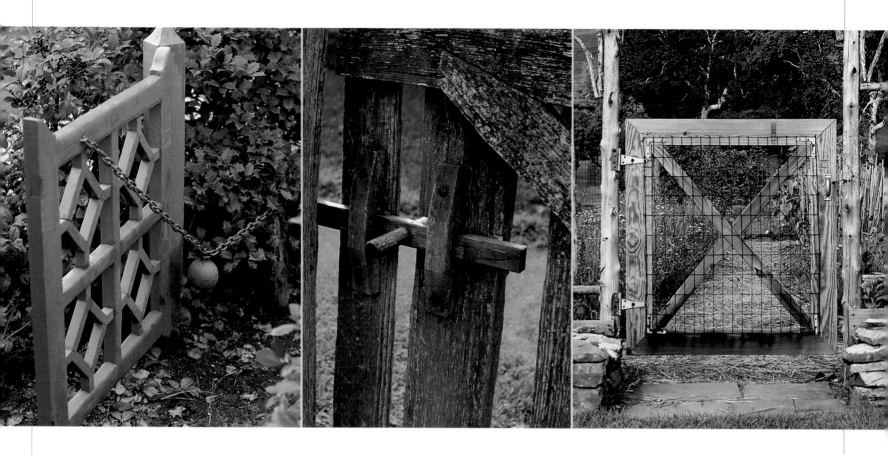

(unless security is a concern) or with a top latch that can be reached from both sides of the gate. Don't overlook the possibilities for simple wood drop latches or wood slide bolts; these are particularly effective choices for low picket or grape-stake fences.

Whatever latch style you choose, and whatever gate it goes on, remember this. The whisper as the bolt slides home or the click as the ring latch rotates into place is a sound of significance: humble music for a grand moment. Such sounds document our departures. They signal that our kids are home from school or our spouse is home from work. And they herald our crossing into the garden's magic realm.

When a weighted gate is opened (left) the ball rises. A handmade wood slide bolt matches a gate of unpainted pickets (center). Galvanized latches and hinges are at home in outlying sections of the garden (above).

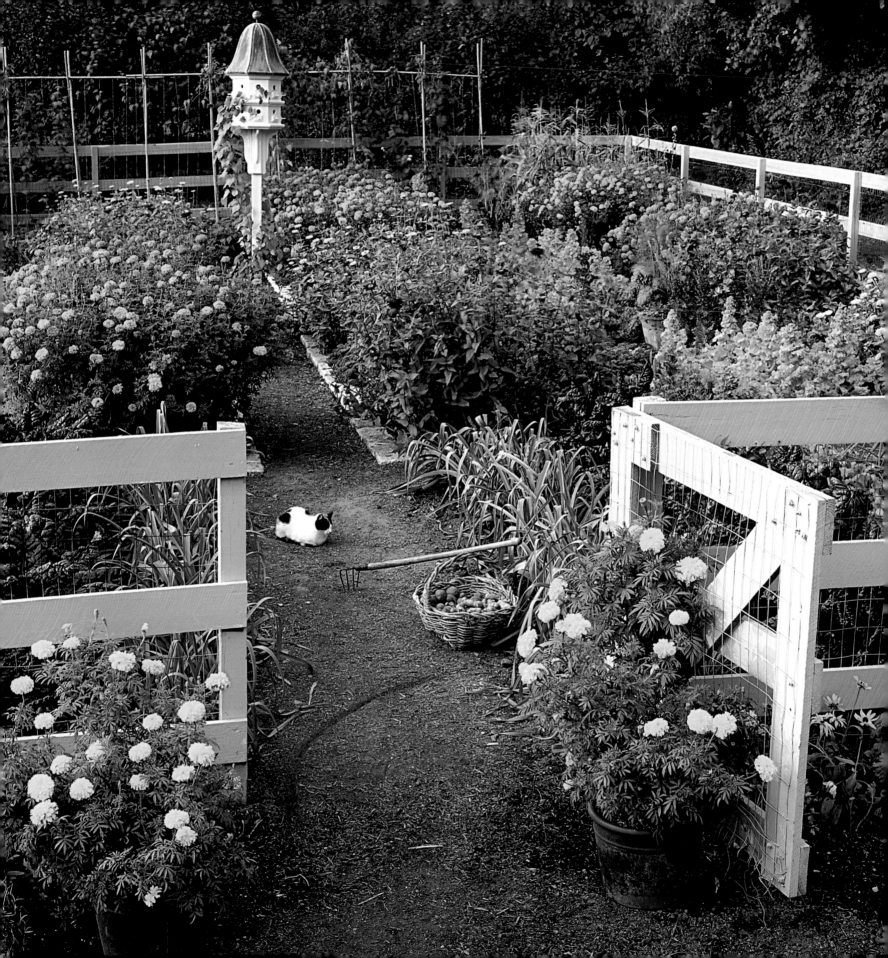

CHAPTER TWO # FENCES: *the garden's guardians*

"THOSE WHO ALREADY HAVE GARDENS, HAVE FENCES," wrote Englishman William Cobbett in 1821, as if without a fence, a garden ceases to exist. And maybe that is so. From ancient times, gardens by their very nature have needed the protection a sturdy fence provides. Corn and beans needed protection from wild beasts and rampaging tribes. Cabbages and calendulas needed protection from foraging pigs and cows. Blushing apricots and juicy peaches needed protection from tree-climbing boys. Even Victorian posies needed guarding from strangers brash enough to steal a bloom or two.

Fences supplied that defense and made it possible to provide many of life's essentials: food for the table, herbs for the pot, medicines for the body, flowers for the soul.

In our own garden-making, we live with that legacy. Fences make us feel safe. They give us a sheltered spot where we can plant and harvest. They supply privacy: we can dance through the sprinklers or have mud fights with our kids, and the neighbors will be none the wiser. Fences define what is ours and what is theirs, what is wild and what is tame, what is protected and what is unsecured. They shel-

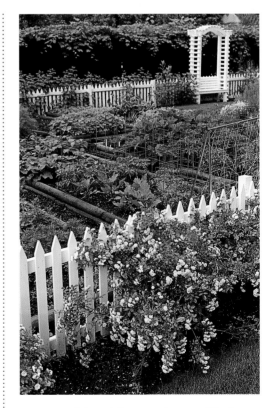

A post-and-board fence with an infill of wire mesh protects a vegetable garden (opposite); close-spaced pickets do the same (above).

Neat white pickets suit an upright Victorian (top). Low posts and a single rail set off the dooryard of a classically detailed house (above).

ter us from winter winds and shield us from marauders.

The merest suggestion of a fence can bestow this sense of security. A delicate row of pickets around a front yard. A knee-high fence of woven willow oziers around the vegetable patch. A bamboo lattice around the back garden. All are easily breached, yet fulfill our primal need for fencing, defining, and protecting what is ours.

LOCATION AND PURPOSE

The location and purpose of a new fence should largely determine its character. Will it bound a small front yard or surround a back garden that boasts an outdoor kitchen and lap pool? Will it create a barrier between a pocket garden and city alley, or form a rustic rampart between a stand of 'Silver Queen' sweet corn and the surrounding fields and woods? Does it need to keep the doberman in or the deer out? What kind of house will it augment, and in what kind of neighborhood? Should it provide privacy, protection, ornament, or all three?

Front yard fences. Like the frame around a picture, a well-chosen and maintained front fence has the power to enhance the architecture of a house and glorify the sections of a garden that are visible from the street. Like gates, such fences should compliment the character of the homes and gardens they protect, in design, scale, level of formality, materials, coloring, and overall demeanor.

A fence of sun-grayed pickets, for example, perfectly suits a weathered New England saltbox with a dooryard full of peonies and lilacs, while a split-rail fence is better matched to a Kentucky ranch house with acres of pasture. Decorative wire fences, rows of gothic-pointed pickets, or iron palisades all might set off a Victorian cottage with a garden of mignonette, foxgloves, and violets, while an old farmhouse is better served by a lattice fence of criss-crossed saplings culled from the nearby woods. And a picket fence of rusted rebar, bordering a minimalist garden of gravel

and cacti, is just right for a modernist structure, but looks like scrap from the junk-yard bounding a more traditional abode.

Front gardens bounded by fences that are too grand for the homes they augment, or too spindly, cute, crude, or poorly built, might fare better without a fence at all. Likewise, a well-chosen fence that is poorly maintained does little to boost a home's appeal. Few things look more derelict or forlorn than a front fence with missing slats, peeling paint, failing posts, or a gate that sags on its over-burdened hinges.

Though generally open in design, front fences momentarily stop the eye and say, all that lies within these bounds is of one piece. They're tall enough to establish ownership and keep out most roving canines, yet low enough to invite both viewing and visits, as well as conversations with the neighbors from the front porch swing. Most towns and cities have maximum fence heights for front yards,

> *"A yerd she hadde, enclosed al aboute with stickkes, and a drye dych with-out."*
> —CHAUCER

Green spindles, posts and rails, and a fence of metal waves augment houses of varied styles and locales.

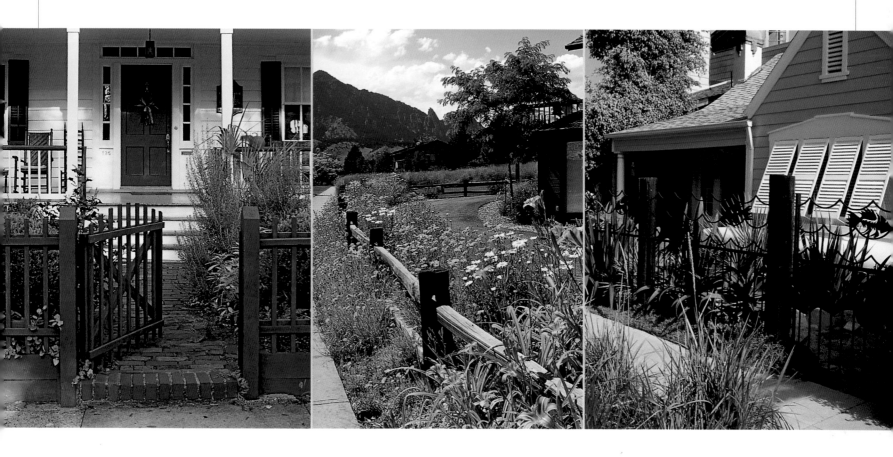

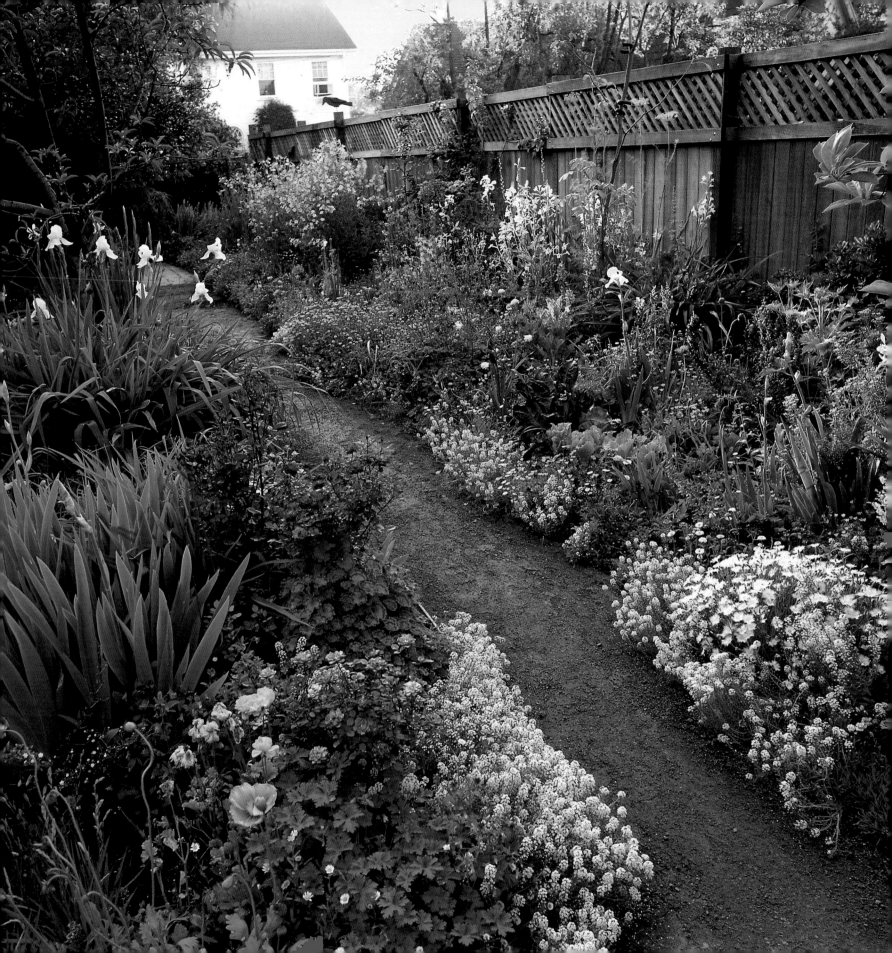

so be sure to check with your local planning and building department—usually found in the city listings in the white pages—before you begin to build.

Backyard fences.

We're more protective of our backyards than our fronts, particularly if neighbors live closer than a stone's throw. Behind the house is a private realm where we grow our pole beans and our 'Brandywine' tomatoes, turn our compost, and pot up our seedlings of eggplant and peppers. We wage friendly contests in badminton or croquet, relax with friends and family, barbecue ribs or grill fresh-picked squash, swim in the pool or soak in the hot tub, and safely corral our animals and kids.

High fences encourage such private outdoor pleasures; the backyard becomes another room of the house, with walls of close-set pine boards, cedar palings, bamboo poles, or redwood grapestakes.

Traditionally, fences have been built with the rails to the inside and the best surface of the fence facing out—ensuring good relationships between neighbors. If you want equal treatment, build a fence that looks well-dressed from both sides, such as a latticework panel fence or double-board fence.

Privacy fences range in style from old-fashioned to ultra-modern, and set off varied garden styles.

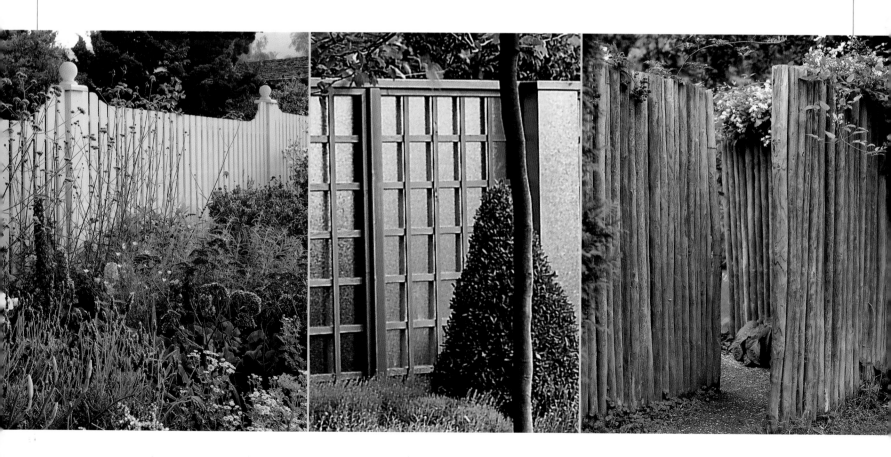

FENCE FORMALITIES

Be sure to take these steps before you set that first fence post:

• Check local building codes for allowable fence heights and other local restrictions.

• Talk to your neighbors. If you're tearing down an old fence, be sure it's really yours, and not theirs. Generally, the fence posts and rails face the yard of the fence's owner, but this isn't always the case.

• Discuss your planned design with your neighbors and try to address any concerns they might have. If possible, get their okay to do some work from their property. Many times, neighbors will share in the cost and labor of replacing a decaying fence between yards and in maintaining the fence once it's built.

• Confirm the actual boundary line between your property and your neighbor's. If there's any doubt, have the property surveyed.

• Locate utilities before starting to dig postholes.

A tall lattice screen bestows a sense of protection on a backyard clearing, yet lets in summer breezes and light (opposite).

For privacy, back fences should be at least six feet tall. Close-board fences and tightly set palings provide the most privacy but may seem too fortress-like, particularly if your garden is small. Fences constructed of closely set boards on the bottom with panels of lattice along the top have a lighter and more decorative feel; if desired, plant vines that can twine through the latticework and screen the view.

If summers are stifling in your area, consider a louvered or double-board fence that allows breezes into the garden, or pierce the fence in places with lattice-work screens or clairvoyées: decorative metal or wood grilles that provide a view and a breath of air. Latticework fences in a grid or diamond pattern let in the most air and have an elegant feel when framed and mounted between cased posts; with time, well-placed vines or climbers will provide a sense of privacy.

Fences that allow summer ventilation also are best for handling strong winter winds, which can wreak havoc with close-board fences and other solid fence types. Solid fences actually add to wind turbulence in a garden; with no place to go, the wind tumbles over the top of the fence rather than dissipating through it.

Where security is a concern, high fences of wood palings or vertical boards, built in standard fashion with the rails to the inside, are the best choice and give interlopers no foothold.

If you're trying to keep deer at bay, build a perimeter fence that's at least seven feet tall. Woven wire fences covered with vines work well for this purpose. If local regulations prohibit a fence higher than six feet, add battens that extend up and out from the fence and string wire or secure wood lattice strips between them. Or, install poles that extend above the maximum six-foot fence height and string them with wires. If you don't want a tall enclosure, and space permits, build a pair of four-to five-foot fences four to five feet apart. Deer don't like to hurdle a broad barrier. Alternatively, erect a temporary fence, then plant dense, fast-growing hedges.

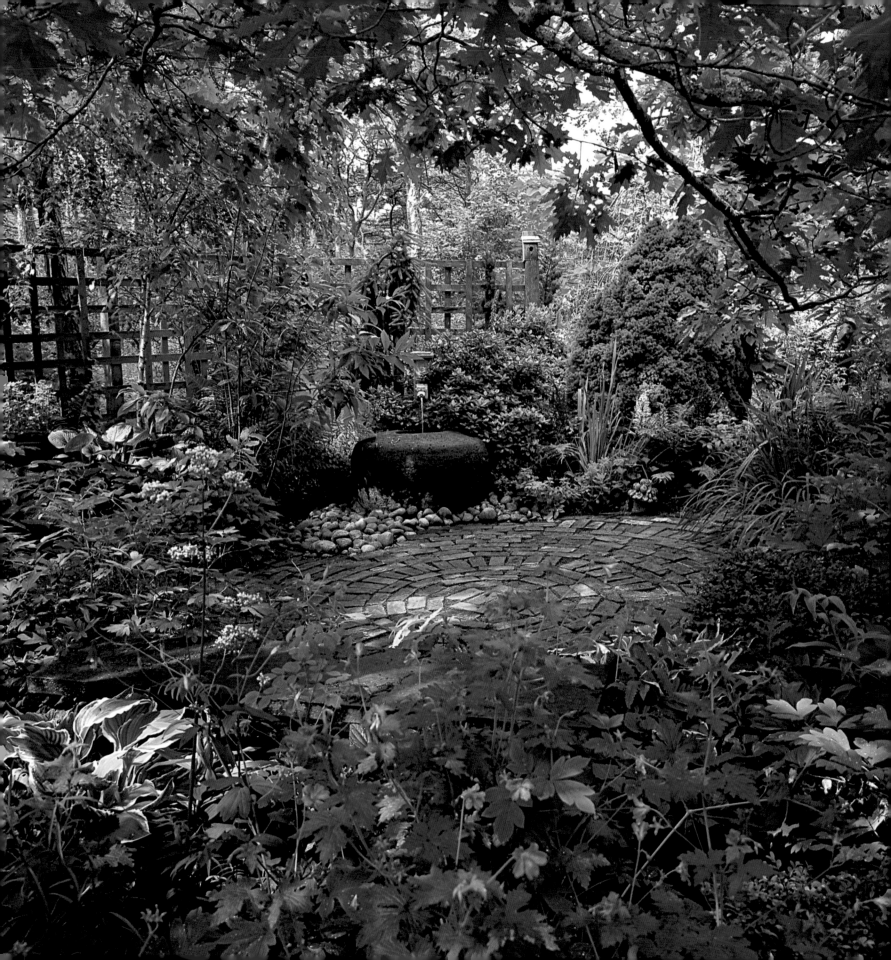

Dividing and screening fences.

Fences are also at home within the garden itself, setting off the vegetable patch from the flower border, screening the trash bins or the compost pile from view, dividing the garden into distinct rooms, or keeping visitors on the path and out of the pansies. Openwork designs work best for these purposes, from iron picket fences or screens of bamboo to rustic openwork panels crafted from unpeeled hazel or willow.

Low latticework fences have the lengthiest history in the garden proper, and were particularly favored by gardeners during the medieval and Renaissance eras. These neat, see-through barriers with their delicate posts worked perfectly for dividing up the garden into specialized compartments, and their patterns added to a garden's precise geometry. Early latticework fences often served as a backdrop for red or white climbing roses; today, latticework screens may double as growing space for squash vines or pickling cucumbers during the summer season.

Belying its sturdy nature, a screen of metal lattice looks lightweight (below). Timbers with lance-point tops frame in wood latticework and impart a medieval character (right). Lattice screens soften a deck's city surroundings (far right).

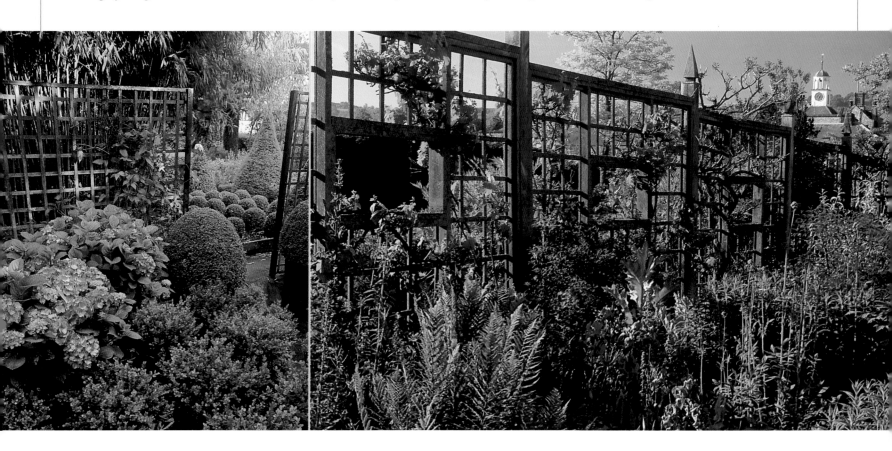

CHOOSING A FENCE

A perimeter fence is a sizable investment, even for a small piece of property, and greatly affects the character of your garden. You'll be looking at it for years to come, admiring its details or cursing its flaws, so take time to do some research before committing to a design. Start with the fence types discussed and shown here, then thumb through other books and mark favorites and their variations. Compile a file of magazine clippings. Visit the library and look at books on old houses. Seek out fence builders and look through picture albums of their work. Most importantly, walk through your neighborhood or drive around town and note the fences you like.

Pay attention to the kinds of houses your favorite fences are paired with, the way the fences are constructed, what they're made from, and how tall they are.

BORN TO REVIVE

Choosing a fence style is a bit like sitting in the driver's seat of a time machine. It's hard to know what period to set the dials for. Look around. Almost every popular fence design has a historic predecessor; most have changed little for centuries. Here's a trio of oft-revived classics:

LET US LATTICE. Beautiful lattice screens draped in roses dressed up medieval gardens; they're depicted in illuminated manuscripts as early as the 1400s and in Roman frescoes from the first century A.D.

CHINOISERIE. Thomas Jefferson had a penchant for fences modeled after Chinese Chippendale designs. Such geometric fretwork, formed by nailing multiple wood members within a heavier wood frame, was popular in fanciful garden structures from the mid-1700s well into the Victorian age.

ON BOARD. Fences of two or three horizontal boards between upright posts lined country lanes during the 19th century, as many folk art paintings attest. A post-and-board fence also dominates the last panel of the Unicorn Tapestries, woven around 1500.

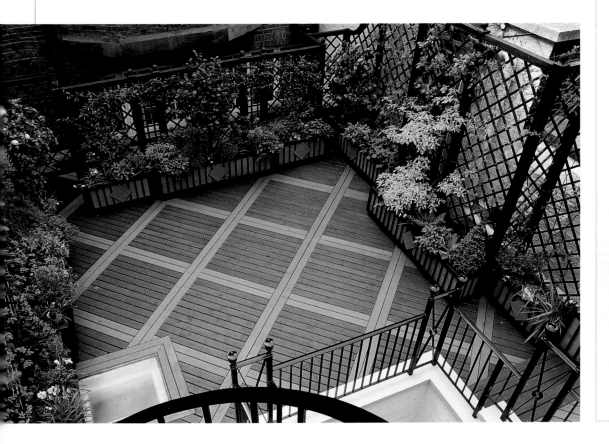

Notice how they've weathered and aged. What kind of finish, if any, do they have on them? Which ones look sturdy, and which have started to sag or sway? How do they affect the look of the house they belong to? Long, low fences help tie a house to the earth, while picket fences of metal or wood emphasize a building's vertical character. Likewise, low, horizontal fences stretch the visual dimensions of a yard, while tall, vertical fences make a large space feel more intimate.

Think carefully about maintenance. The pristine white fence surrounding that 1940s cottage will need freshening up every three to five years, while the grapestake fence that's been left to weather an appealing silver will take little additional care.

If you find a fence you particularly like, talk to the owner. Find out how old the fence is, who built it, and—if you dare—how much it cost. Have the owners had any problems with it? How much maintenance does it require? Is there anything they would do differently if they built it again? Take advantage of their experience in planning your fence project, then take pictures or make sketches for your own reference or to give to your fence contractor.

Though standard fence designs have proved their worth through time (you'll be surprised at how common some fence types are as you begin to look around), don't be afraid to experiment with your own design. Maybe you like the rhythm of a Colonial-style spindle fence but not its rigid formality. Duplicate its form with lengths of willow or cedar, bark still attached. Perhaps a close-board fence is needed for privacy in your backyard, but seems monotonous and dull. Spice it up with vertical battens, a decorative cap, brilliant enamel paint, wood cutouts of leaves and flowers, or a jute-and-nail trellis smothered with blooms. If a split-rail fence seems too rustic for your sleek, modern house, duplicate its horizontal leanings with wood posts and rails of copper pipe. There's always room for inspiration and innovation. And a few years from now, someone may come knocking, asking how to duplicate *your* fence.

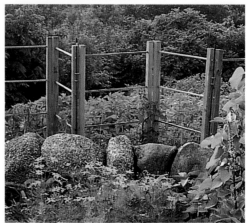

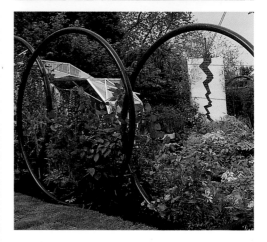

Bright colors and whimsical cutouts establish a garden's quirky personality (opposite). The fences above belong to similar innovators, who employed unusual colors, forms, and materials to set a mood.

FENCE FASHIONS

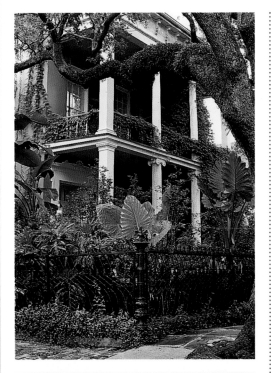

We've roved the surface of Mars, but our fences have changed little in centuries. We still erect rows of palings that mimic the protective fences of our nation's first settlements. Our picket fences have Colonial predecessors. And our wattle, lattice, and close-board fences pay homage to medieval times, as do the rail fences that surround many a suburban ranch.

Except for polypropylene and nylon pickets, fence boards made from recycled plastics, and industrial chain-link, even our fence materials have stayed true to the past. With every post we erect, every board we nail, we bound our gardens with history.

With hundreds of years of fencing design behind us, there's much to draw on. Here are some time-tested fence types well suited to today's gardens, as well as some newcomers and adaptations.

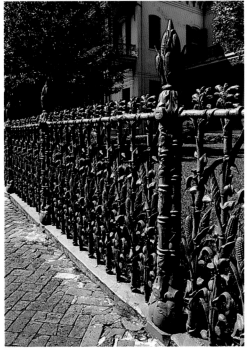

Cast-iron detailing dresses up both this fence and balcony (top). Cornstalks and pumpkins give an ornate city fence country roots (above).

Cast iron. Though made infrequently today, fences cast in iron were a hallmark of the 19th century, particularly around the town and city gardens of the well-to-do. Cast-iron fences of the 1820s to 1850s imitated earlier handmade wrought-iron designs, boasting delicate neoclassical motifs of crossed arrows, Greek keys, laurel wreaths, and pickets with a variety of lance-like points. After mid-century, Victorians favored weightier and more elaborate cast-iron fences around their front gardens, embellished with leaf, floral, and fruit motifs that new casting methods made possible. One famous New Orleans fence design even boasts cast-iron cornstalks, with posts that rest on fat iron pumpkins.

Because of their vulnerability to rust, cast-iron fences often are raised on low walls or curbs of stone or brick. Some cast-iron panels are set between simple brick piers; others have elaborate cast posts. Sections of antique cast-iron fences sometimes can be purchased at architectural salvage yards, and old panels can be replicated by cast-iron foundries.

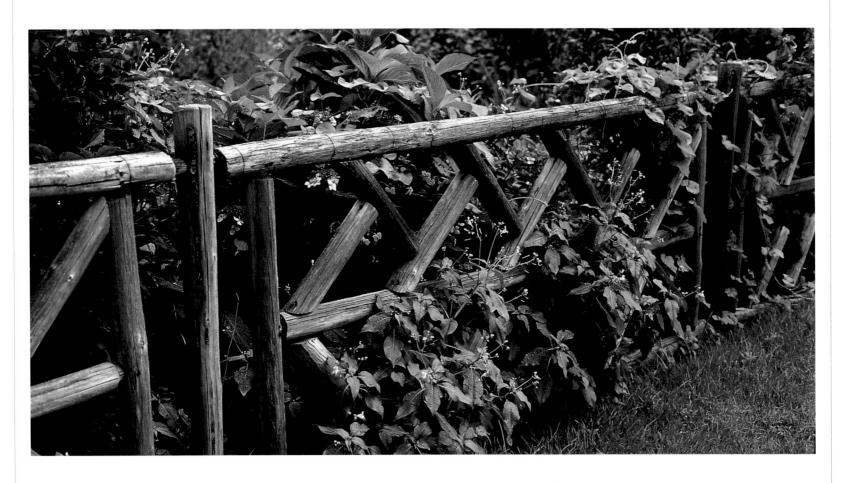

Chinoiserie.

Chinoiserie. Exotic, openwork fences and balustrades boasting Chinese-inspired lattice designs have starred in gardens since the 1700s and still bestow a Far Eastern flavor. In fences, railings, or gates of chinoiserie design, pieces of wood are secured within the frame of posts and rails to form a variety of geometric patterns, some simple and some ornate. One writer commented in 1756 that "at present fox hunters would be sorry to break a leg in pursuing their sport in leaping any gate that was not made in the eastern taste of little bits of wood standing in all directions."

Thomas Jefferson had Chinese railings at Monticello, and they are particularly well suited to Colonial-style architecture, but Victorians also had their penchant for chinoiserie. Many chinoiserie designs inspired makers of rustic-style fences and gates during the Victorian era.

Peeled saplings, nailed in a Chinese-lattice pattern, form an eye-catching border (above). A more ornate version bounds a Colonial-era dooryard (below).

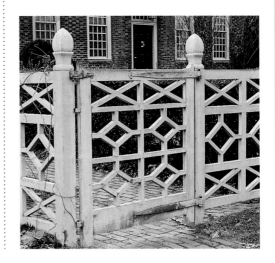

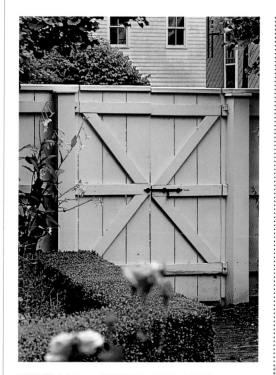

A close-board fence topped by a simple fence cap (top) has a finished look that complements formal plantings. Rough redwood grapestakes joined by slanting rails border an exuberant cottage garden (above).

Close-board. Once made in riven oak, set tight to discourage rooting pigs, close-board fences are now made from softwoods such as redwood, cypress, cedar, or pine. The boards abut, or overlap slightly, to keep cracks from appearing between the boards as they shrink, and can be applied to rails and posts vertically, horizontally, or even diagonally. Overlapping close-board fences are made from clapboard, shiplap, or tongue-and-groove lumber. Battens often cover the cracks of abutting close-board fences. Both types benefit from a decorative fence cap, and are common for backyard privacy use.

Close-board fences tend to look best when stained with opaque or semi-transparent colored stain, or when treated with a weatherproof sealer; milled boards, even of redwood, aren't that attractive as they weather.

Grapestake. Common in wine-growing country throughout the West, and ideal for country gardens, these fences are made from rough, split redwood stakes with a generally square cross-section. Some grapestake fences are little more than a row of stakes pounded into the ground and joined by a series of slanting rails, but grapestakes may also be incorporated into a more traditional fence frame, with posts, bottom rail, and top cap. Tall grapestakes can be set close, for privacy; shorter ones are well suited for building picket fences of rustic character.

Unfortunately, bonafide grapestakes are becoming prohibitively expensive and hard to locate, even in the West, as prices for redwood rise and producers abandon traditional hand-splitting techniques.

Redwood palings have a rustic feeling similar to that of grapestakes, but are thinner, lighter, less expensive, and have slightly rounded or pointed upper ends.

Hurdle. We owe our hurdle fences to early husbandmen, who developed portable fence panels to temporarily corral their sheep. These modular fences were bounded by two posts with sharpened ends that could be driven into the ground

with a mallet. Fences based on this early design are perfect for surrounding a lawn or meadow, or as an enclosure around a vegetable garden. During the late 19th century, the term *hurdle* referred to any portable fence panel.

Interlap or double-board. An exposed site calls for a fence that breaks the wind but doesn't stop it entirely. Many openwork fences will suffice, but if privacy is required, double-board fences may be best. In this type, boards are nailed alternately to opposite sides of the rails. The resulting internal spaces allow the wind to wend its way through, losing force on the trip, while the boards still block the view. Like close-board fences, double-board fences are at their best when stained or sealed.

Lattice. Lattice fences or screens have a long history in both Western and Eastern gardens, due in part to their geometric yet airy nature. Today, latticework typically is made with strips of redwood or pine lath or lattice (approximately one and a half inches wide by a quarter-inch thick), stapled or tacked together in a grid or diamond pattern, but many other variations are possible. Premade lattice panels in standard designs are available at home centers and lumberyards, but lattice panels can also be made at home with standard garden lath or with sturdier lumber such as one-by-twos. Because of their fragile nature, lattice fence panels usually are framed in with heavier lumber.

Louvered. Like double-board fences, louvered fences let breezes slip through, while taking the force out of the wind. But the angled boards of these fences also admit a view, just like the slats on a shutter. When planning a fence with vertical louvers, be sure to determine what you want to see from both inside and outside the fence, then angle the slats in the optimal direction. Stain or seal the boards for best long-term appearance.

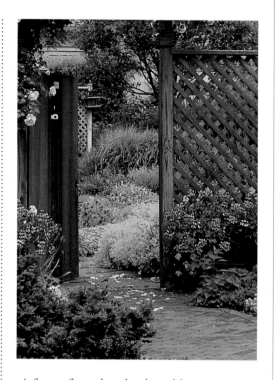

A fence of weathered redwood lattice sets a more casual mood than painted latticework and blends in with the geraniums. Such fences lend an air of privacy to small spaces without feeling confining.

If you plan to paint, seal, or stain your fence, do as much finish work as possible before the fence is assembled. That way, all sides of the rails, posts, and fence boards will receive a protective coat. Pay special attention to areas where pieces join, such as the point at which the rails join the posts. These are the spots where water gathers and decay first sets in.

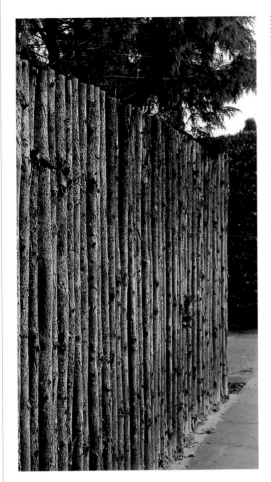

Unpeeled saplings form a classic palisade, paling, or stockade fence not unlike those that bounded early settlements and protected their residents from intruders.

"I have come home to look after my fences."

—SENATOR JOHN SHERMAN (1823–1900)

Paling or palisade. Paling fences made from saplings surrounded the earliest European settlements in the New World, then moved westward as settlers crossed the Mississippi. The butts of the palings were buried in the earth; the tops were pointed to deter wild animals or other attackers.

During the early years of the 20th century, paling fences also surrounded many a back garden. Marketed as "woven wood" fences, they were made in France of heat-treated chestnut palings, held together with Copperweld wire. Today, tight-set palings with pointed tops can seem a bit unfriendly in city or town, but out in the country they are right at home.

The word *paling* often is used interchangeably with the word *picket*, and most palings today have a picket-like cross-section rather than the round cross-section of a sapling. But unlike typical picket fences, most paling fences are closely set, without gaps between the uprights.

Panel. Panel fences provide the utmost privacy since there are no cracks or knotholes for passersby to peep through. Panel fences can be made of plywood, plastic, or hardboard, framed in with lumber and secured to posts that are well anchored in the ground.

Picket. The tamed descendants of the palisade, picket fences once managed to keep roving livestock out of the flower beds while ornamenting homes and small-town streets. (See pages 48–49.)

Post-and-board. Post-and-board fences are the dressed-up cousins of the old-fashioned rail fence, well suited for marking boundaries and setting off the yard, lawn, or horse pasture. Two horizontal boards between vertical timber posts is the standard, but some fences may have only a single board running

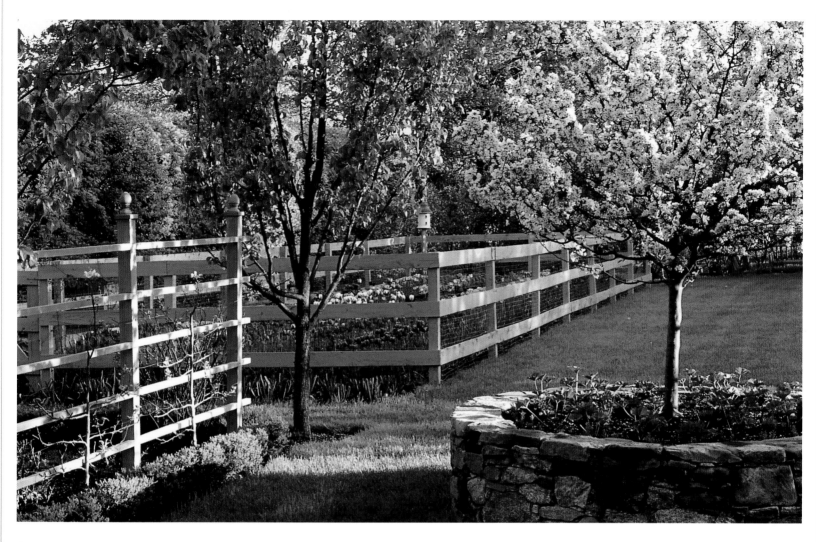

between posts, or as many as four or five. Others have horizontal boards at top and bottom, with two additional boards that crisscross between posts, forming a decorative diamond pattern. Unlike rail fences, post-and-board fences are often painted.

Post-and-swag. These minimalist fences, made of timber, concrete, or iron posts connected by swags of heavy chain or even vines, keep visitors on pathways or accent flower gardens. To dress them up, give the chain a coat of paint; to dress them down, substitute heavy rope for the chain or grow morning glories or black-eyed Susan vines up the posts and along the swags.

Two forms of post-and-board fences grace this garden (above): one for supporting espaliered fruit trees, the other for guarding the cutting garden. Thick-stemmed vines form swags on a low fence (below).

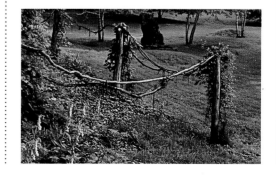

THE PICKET FENCE

They began as fortifications against the wilderness and became the hallmark of small-town domesticity. Today, picket fences place the unmistakable stamp of tradition on our gardens, whether we live in small towns or suburbs or in houses that are newly built or more than a century old.

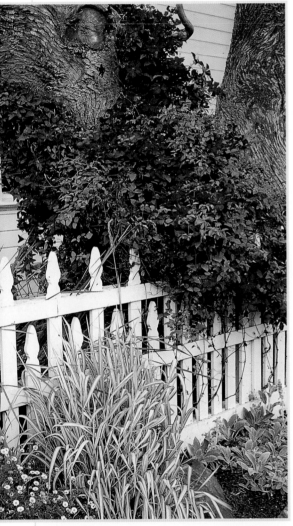

Alternating short and tall pickets give this fence rhythm, while the shapes of the picket points add a gingerbread feel.

"No style of fence . . . adds more to the beauty of a spacious dooryard, or lawn, than a tasty picket fence," wrote Edward Todd in 1860 in *The Young Farmer's Manual,* and it seems we still agree.

Homeowners in Todd's era were in love with old-time picket fences, which could add architectural flair to a humble house and garden at a much lower cost than the newfangled cast iron. Particularly well suited to late-19th-century building styles were Gothic-pointed pickets, or pickets with cutouts that echoed the gingerbread of the houses themselves.

But Todd's readers also favored earlier picket styles made of spindles, which lined up in formal fences to front elegant Georgian or Colonial abodes.

Both fence types were revived during the 1920s and '30s, when a passion for all things Colonial swept the land. Authors of the day recommended not only classic pickets and spindles, but also pickets made from unpeeled saplings or palings of chestnut. These rustic picket fences were not unlike those that defended early settlements from attack or kept hogs from the kitchen garden in Colonial times.

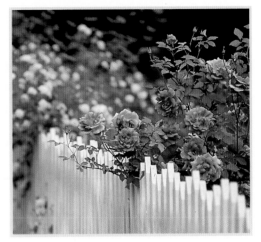

The picket heights in this fence are staggered, creating a scalloped effect.

We build our current picket fences on all those models. They are a mark of our own lasting presence on the land, and a clue to our concept of home.

PICKING A PICKET. Precut standard picket styles are available at some lumberyards and home centers, where you're also likely to find them assembled into ready-made fence panels. Such fences are quick to install, but possess little of the personality that pickets make possible.

Instead, consider designing and cutting your own pickets, or having them cut by a woodworker or at a local mill or cabinet shop.

Picket designs may be as simple as a 1-by-3 board with a peaked or slanted top, or as fancy as a 1-by-3 with its top cut in a fancy arrow shape, pierced by a hole and

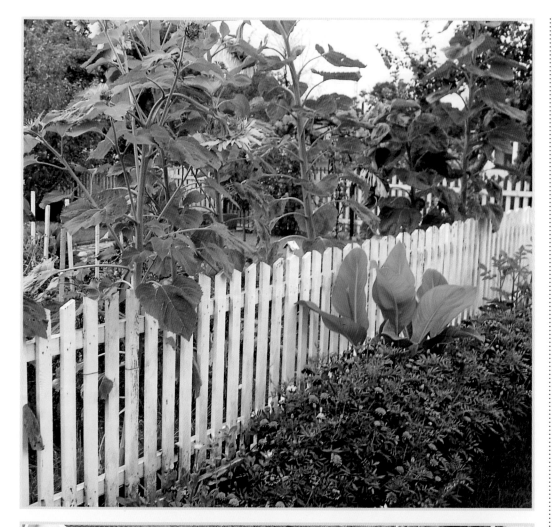

notched along the edges. There's no limit to the design possibilities.

Start by drawing a full-size pattern of the picket on paper. Then make a template out of a 1-by-3 board (it may take a few tries to get a template that's just the way you want it). Cut the rest of the pickets according to that template, using appropriate tools. You may need only a handsaw, but fancy designs may require a coping saw, jigsaw with a fine-toothed blade, hole saw, circular saw, radial arm saw, or saber saw.
(Clamp two or three uncut pickets together to make the work go faster.)

PICKET PLACEMENT. In general, pickets look best spaced tightly, with only a two- to three-inch space between them. Pickets narrower than three inches will need even closer spacing. A good rule of thumb is to make the space between the pickets narrower than the pickets themselves. Keep spacing consistent by using a piece of wood that's the same length as the pickets and as wide as the desired space. Nail a cleat onto the spacer near one end so that you can hang it squarely on the upper rail of the fence, with its top at the height you want the pickets' points to be. Square up the first picket and attach it to the rails, then hang the spacer beside it and position the next picket.

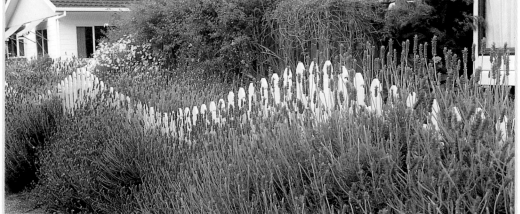

Simple pickets with slanted tops suit a garden of sunflowers and marigolds (top). These graceful pickets create waves in a billowing sea of lavender (above).

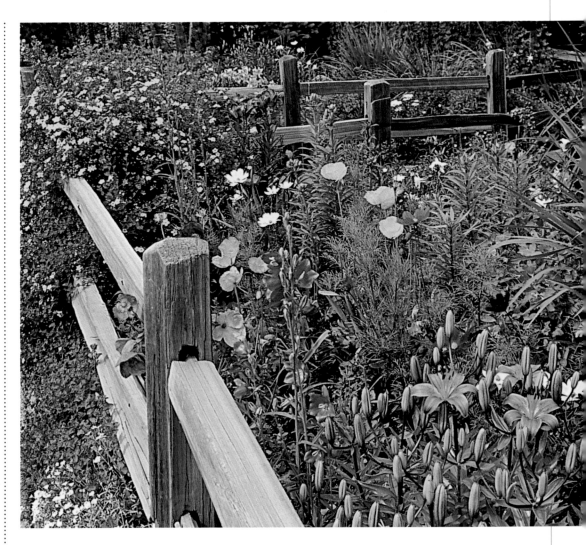

Post-and-rail fences evoke earlier days and are at home in a woodland, fern grotto, or flower garden.

Rail fences can follow the slope of the land, but most other fence types should step down a hill in even increments. Fill the gaps beneath with low stone or brick walls, or with wood gravel boards.

Prefabricated.

Some styles of fences are available in prefabricated panels at lumberyards and home and garden centers. You erect the posts, then attach the panels between them. Make sure the panels you buy are well constructed. If not, it may be cheaper over time to construct the fence from scratch.

The type most often available is the close-board fence with latticework top panel. Precut posts and rails for rail fences also can be found in some areas, as can pickets, rolls of woven split bamboo, woven reed, and welded wire fencing.

Rail.

Early settlers with timber to spare fenced in huge chunks of wilderness with zigzag barriers of hand-split rails, sometimes known as Virginia rail fences or

WOVEN IN WATTLE

When English settlers sailed to American shores, they brought with them a tradition of wattle fencing with roots that went back centuries. Early husbandmen found such woven fences easy to make with what they had on hand. They didn't need timber or saws to build such barriers; all that was required was a ready supply of coppiced shoots, saplings, or willow branches, and an ax.

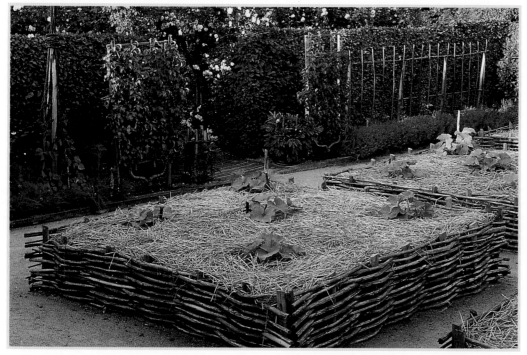

Wattle edgings woven from flexible saplings camouflage conventional raised vegetable beds, transporting this modern garden to a long-ago age.

Though the settlers' basket-like wattle borders lacked stout timber posts and sturdy rails, they were tight and strong enough to keep even the most persistent livestock out of the cabbages and carrots. As a result, they continued to be built in some rural areas long after other fence types of sawn lumber became the fashion.

Today, we look to wattle fences to lend our gardens a rustic, handmade touch, whether they're foot-high borders around the lavender and thyme or four-foot-high fences around the raised vegetable beds. Such fences require no car-pentry skills: just a penchant for weaving, a source for flexible wattles, and an appreciation for the ingenuity of gardeners past.

MAKING A WATTLE FENCE OR EDGING:

Collect a supply of willow branches, flexible saplings, or woody shoots of similar dimensions. These are called withies or wattles. Cut stakes from the thickest saplings and sharpen them on one end with an ax (or use sharpened timber posts or palings). The length of the stakes will depend on the finished height of your fence, and should include about a foot that will extend beneath the ground and four inches that will extend above the woven part of the fence. Pound the stakes into the ground at regular intervals (approximately a foot to two feet apart). The narrower and more flexible the withies you'll use for the weaving, the closer the stakes will need to be. Experiment to determine the best stake placement for your materials. Once the stakes are in place, weave the withies through them, starting behind one stake, going in front of the next stake, then behind the following stake in a simple basket-weave pattern. For the most craftsman-like wattle fence or edging, keep all the ends of the withies tucked to the inside.

BAMBOO BARRIERS

When it comes to fence building, bamboo is the redwood or cedar of Japan. This versatile plant material—actually an overachieving type of grass—is bundled into sturdy barriers that wrap traditional gardens in a stalwart yet elegant embrace.

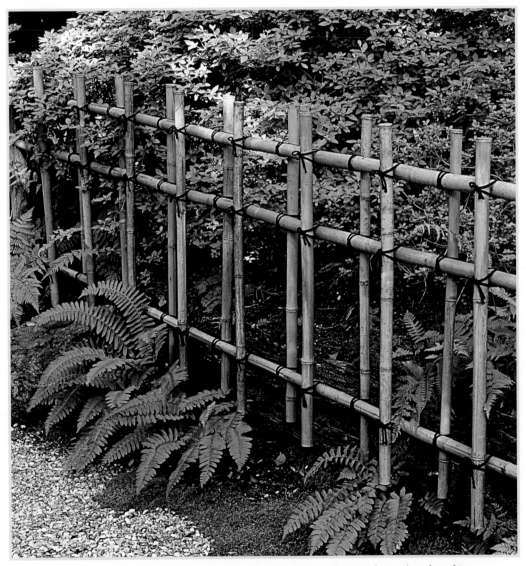

A low picket fence of bamboo takes a garden traveling across the Pacific to the isles of Japan. Such fences are most at home with plants that originated in Far Eastern climes.

Since the garden is an extension of the home, these outer garden walls actually are considered the wall of the house itself, and must have an appropriate sense of substance. In the garden's heart, however, ornament rather than privacy

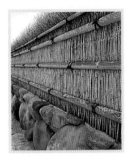

and protection is the goal, so practiced fencemakers form bamboo into screens and latticework as delicate as the tracery of a vine. Because bamboo tends to split when it's nailed, bamboo artisans tie their fences together with coir that has been dyed black; the repetitive knots add to the fence's beauty.

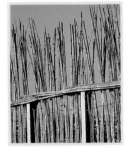

Both types of bamboo fences require a master's touch, and the skills used to make them are passed down like family heirlooms from one generation of fencemakers to the next. While the West currently has few of these practiced fencemakers, that is changing. And as an appreciation for their artistry grows,

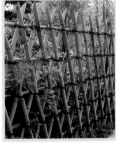

we're apt to see more bamboo fences surrounding the very gardens where pickets and posts once stood.

worm fences. As timber resources waned, straight rail fences replaced the zigzag, wood-wasting wanderers. Some rail fences have double posts that the rails slip in between; others have single posts with holes cut in them to receive the ends of the rails. Posts may be squared timbers, split timbers, round posts, sections of fat logs, or low stone or brick piers.

Reed. Reed panels are available at some home supply stores and lumberyards, and can be framed into either low or tall fences.

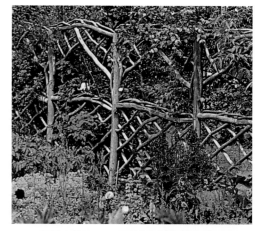

Rustic. During the late 18th century, formalized gardens gave way to a picturesque ideal, complete with benches, summerhouses, and fences built from gnarled branches and unpeeled saplings. Victorians inherited the rustic look and embraced it, churning out a plethora of gates and fences crafted from carefully pieced applewood, chestnut, beech, larch, or pine branches—the more gnarled the better—combined with bent willow, hazel, or alder. Picket fences, lattice screens, and palisade fences all take well to rustic styling.

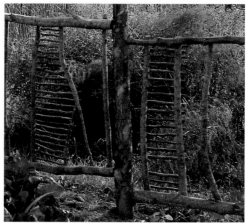

Shingle or shake. These solid fences often augment shingled modern houses, but can be designed to accent earlier architectural styles. Cedar shingles generally are nailed to three-quarter-inch plywood sheathing, fixed to a standard post-and-rail fence frame and topped with a fence cap.

Spindle. These elegant picket fences once lined the streets of New England towns and are still perfect partners for many Colonial, Colonial Revival, or Victorian homes. Spindle fences are formed out of slender pickets that are square or round in cross-section; tall and short pickets often are alternated in the same fence, forming a decorative pattern. Rails are often on the outside of the fence, or on both sides, and are decoratively grooved or chamfered (beveled on the edges).

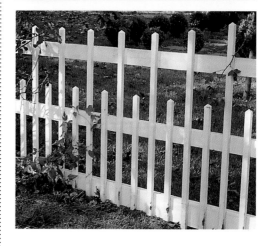

Rustic fences range from Victorian-inspired latticework (top) to artful examples that resemble spiderwebs (center). Spindle fences often feature spindles in two different heights (above).

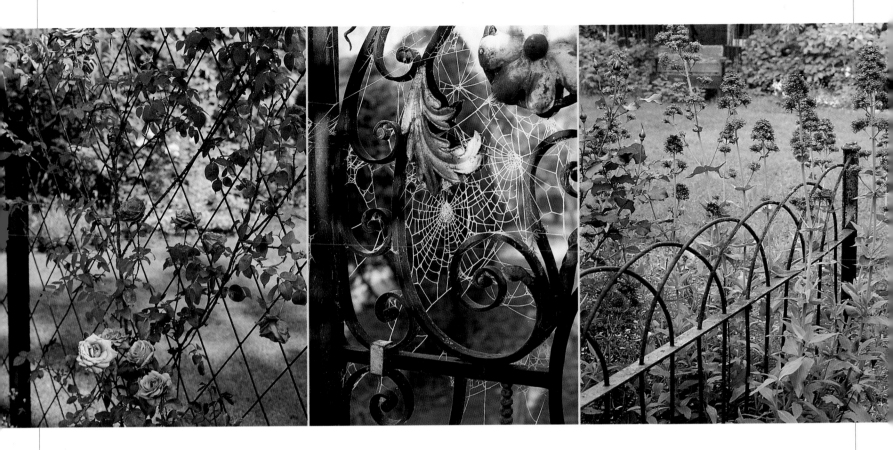

A wire latticework fence panel twined with roses (above) has a medieval feel. Handcrafted wrought iron (center) has long been favored by the elite. A simple iron fence (right) forms a garden border perfect for a Victorian cottage.

Posts are typically cased to give them bulk and stature, and topped with decorative caps and finials.

Wattle or wicker. Fences woven from supple saplings of willow, alder, hazel, or other flexible woods have protected gardens for centuries; such rustic barriers commonly were depicted in medieval works of art and protected many a garden in Plymouth Plantation and other early settlements. (See page 51.)

Wire. By the late 1800s, Victorians had mastered both the production of heavy wire fencing in decorative patterns and methods of galvanizing the fences to prevent rust. Some decorative wire fencing still is available, particularly in low heights designed for setting off flower beds, but most is purely utilitarian. A plain wire gridwork, however, is ideal for fencing out deer. Stretch and staple the fencing on

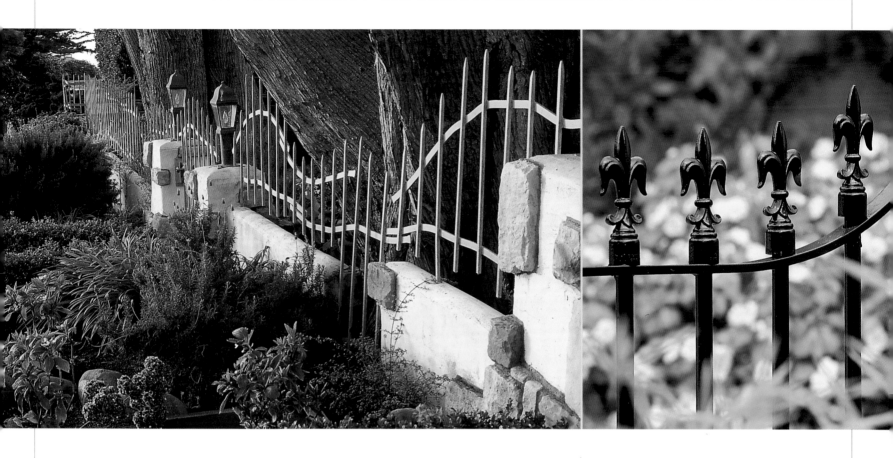

a sturdy post-and-rail frame seven or eight feet in height (check local codes), then plant perennial vines at its base. Wire fencing must be stretched using a fence puller or come-along, available at rental centers. Alternatively, hire a fence contractor to ensure that the fence is taut.

A custom-made metal fence with a verdigris finish tops a low wall (left). Finials for new metal pickets (above) are cast from steel, aluminum, or even plastic.

Wrought iron. Once the standard for elegant gates and fences, wrought iron briefly went out of favor with the advent of decorative cast iron during the early 1800s. Late in the 19th century, however, cast iron lost its cachet, and many well-to-do town-house dwellers returned to expensive, hand-wrought iron for their forecourt fences. The look was light and elegant after decades of heavy castings.

Wrought iron is both stronger and lighter than cast iron, and resists rust. Few fences are made from true wrought iron today because of the hand-forging involved. Instead, sturdy fences that resemble wrought iron are fabricated

The last thing 18th-century landscape designers wanted was fences interrupting their sweeps of meadow and woodland. Instead, they built ha-has—fences that were sunk in a ditch—to keep grazing sheep and cows at a safe distance from the strolling gentry without spoiling the view.

FENCE POST PRIMER

Properly set posts are the foundation of a sturdy fence. Keep the following in mind as you plan your fence project:

- Use decay-resistant lumber for fence posts, such as redwood or cedar.
- Sink the fence post in the ground one-quarter to one-third of its total length (a minimum of two feet deep).
- Tall fence and gateposts should be secured in concrete. Low fence posts (as for picket fences) can be set in tamped earth or earth and gravel, as long as the soil is stable and packs down firmly.
- Set the corner posts first, then add the line posts in between them.

SETTING A POST:

1. Dig a deep, narrow hole with a posthole digger, auger, power auger, or a combination of these tools. The hole should be four to six inches deeper than the level at which you plan to set the post, and it should be wider at the bottom than at the top. For a 4-by-4 post in well-drained soil, the hole should be eight inches across. Make the hole wider if the soil drains poorly.

If your fence is extensive, and the soil hard or rocky, you may want to hire a fence contractor to dig the postholes for you.

2. Fill the bottom of the hole with rubble or gravel to promote drainage. Tamp the gravel down.

3. Drop the post in the hole on top of the gravel and align it with other posts. If necessary, remove the post and add more gravel to raise the post to the proper level. Once the post is in place and aligned, add another few inches of gravel around the bottom of the post and tamp the gravel in place.

4. Add water to dry, ready-mixed concrete to achieve a stiff consistency, then shovel the concrete around the fence post until the hole is filled. Tamp the concrete with a broom handle or stout stick to eliminate air pockets. Alternatively, fill the hole with dry fence-post mix, following manufacturer's directions. Or add alternating layers of gravel and soil, well tamped into place.

5. Using a level, make sure the post is plumb, and recheck alignment with other posts. (Two people make these jobs easier.) Then add more concrete or soil around the post until it is an inch or two above ground level. Tamp and smooth the concrete or soil so that it slopes away from the post.

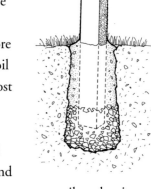

6. Let concrete cure for two days before attaching fence rails to the post. If you live in an area subject to frost heaves, consult a fencing contractor. You'll need to dig postholes that extend below the frost line (quite a chore in some areas), and boost the posts' holding power by nailing wood crosspieces to their bottom sections or by studding their lower lengths with large nails.

from hollow steel bars, solid steel bars, or rustproof extruded aluminum. Many traditional designs are available, primed and ready for painting or available in black, white, bronze, or hunter green finishes. Most decorative fence manufacturers also supply an array of cast-iron or cast-aluminum scrolls, finials, lance-points, and ball caps with which to ornament posts and pickets.

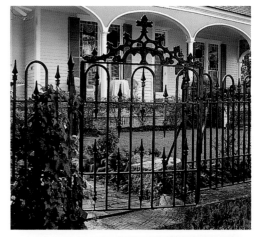

GETTING A FENCE

Once you've picked out a fence design that suits your needs and the style of your home, settle on someone to build it. Fence builders abound, ranging from contractors capable of corralling the back forty to jacks-of-all-trades of varying skill levels who advertise in the local paper. In between are craftspeople proficient at fashioning iron or steel into beautiful fence panels, and carpenters qualified to build in wood any design you can devise. Get recommendations, look at examples of previous work, then compare bids before you choose.

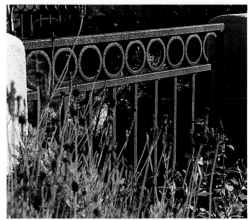

You may not have to look further than your own chair. If you're willing to tackle mixing quick-setting concrete and are handy with a hammer and a level, many fence types can be easily mastered, particularly if your garden site is level. There's deep-felt satisfaction in the work. As you personally fence off your garden, post by post and board by board, you participate in a primitive ritual, as old as gardening itself. With each nail that hits home the gap in the fence grows smaller, and the hammer pounds out an ancient refrain.

This is mine. That is yours. And never the two shall meet.

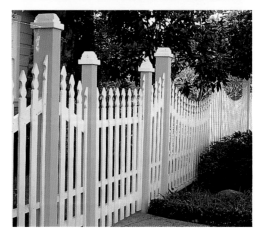

A new metal fence mimics expensive wrought iron (top). A low boundary fence (center) features a rusted finish. Perfect rows of pickets define the limits of this garden, yet present a friendly face (above).

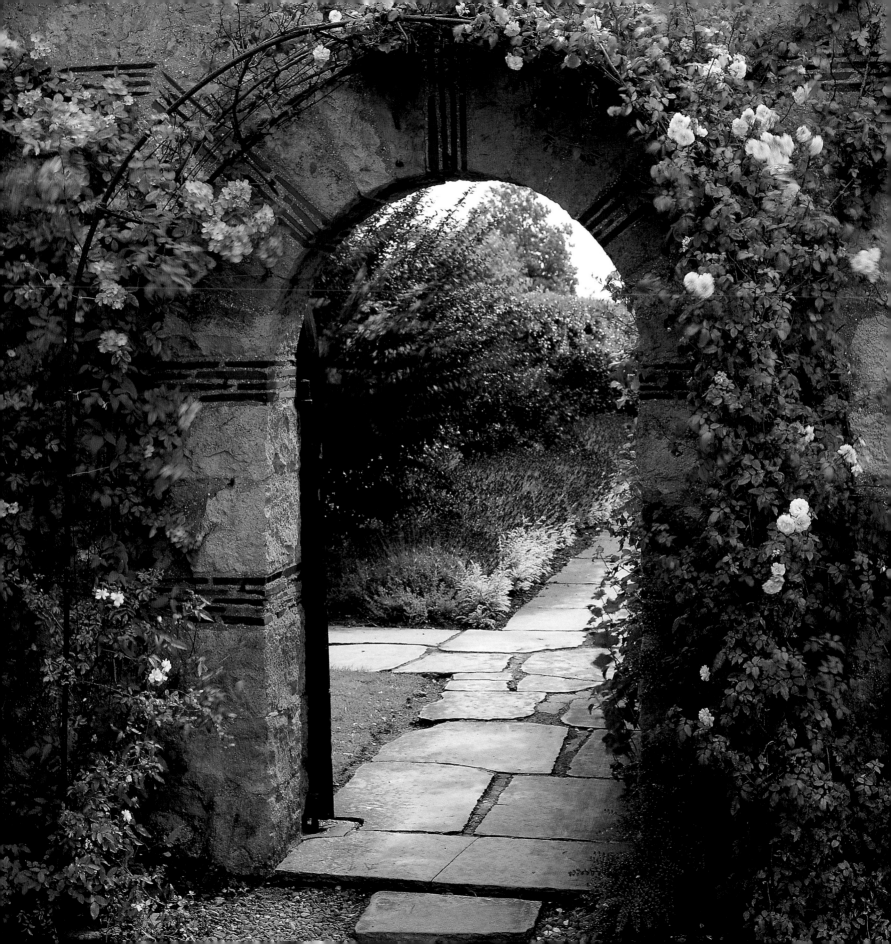

CHAPTER THREE # WALLS:

shaping

a sanctuary

WALLS GIVE SHAPE TO OUR GARDENS. They rise up as if Nature herself had formed ramparts from the earth, enclosing a space so protected it feels like a church. They lay claim not only to the land but to the air above, defining the garden's volume as well as its dimensions. Walls form a haven, a refuge, an asylum: a place where we can plant potatoes in peace and train the climbing roses secure in the stalwart embrace of mortared stone or brick. No curious kids will peek through the knotholes; no termites will compromise the fence posts; no brazen rabbits or woodchucks will squeeze beneath the fence rails to devour lettuce in the dark of night.

In the heart of the garden, walls shape the land itself. They hold back the earth to tame a slope. They rein in the earth to fashion a planting bed. They deflect the earth to protect a tree trunk or create a sunken patio. Their strength and weight balance the forces of nature and counteract the earth's insistent angle of repose, molding the garden to our needs.

Even the climate succumbs to the shaping power of a wall. Well-built perimeter walls stand up to the fiercest winds without complaint, forming pock-

A venerable stone wall (opposite) connects a garden to the past, as does a romantic wall-mounted medallion (above).

Low retaining walls may be made of dry-stacked stones (top), but masonry in higher walls should be well mortared together (above).

ets of calm and protecting the plants directly in their lee. Facing south, they soak up the sun, then radiate its warmth to ripen espaliered apricots or nectarines in cooler climes; facing north, they form a shaded oasis that lets hydrangeas climb. Retaining walls likewise alter planting conditions, forming sunny or shady pockets among the rocks where we can tuck campanulas or saxifrages, or fostering quick drainage around the roots of top-planted hypericums or sedums. They extend the planting season and encourage the garden's bounty.

EDEN, SURROUNDED

The foundations of our garden walls reach deep into history: mute testament to our timeless need for structure and sanctuary, and to our ageless quest for paradise on earth.

The very word *paradise* means an enclosed park, with walls all around. Walled Islamic gardens in Iran, India, and Spain literally emulated Paradise in an inhospitable and arid world; their brimming pools and geometric watercourses were patterned on the rivers that flowed from Eden, and their sunken garden beds were rich with roses, peonies, figs, oranges, jasmine, pomegranates, and other elysian delights. Within the gardens' towering stone walls, and beneath the refreshing shade of their poplar and plane trees, honored visitors were entertained, music was played, bathing was enjoyed, and sumptuous feasts were cooked and relished.

Similarly, the medieval European castle garden, centered on a stone fountain and protected by crenellated walls of dressed stone, grew lush with violets, iris, columbines, strawberries, roses, bay, almonds, and apples. Inside the walls (which symbolized chastity), women of the gentry read, plied their needles, and whiled away their leisure hours. Beauty, order, and purity prevailed; Dutch and Flemish painters often depicted the Virgin Mary and baby Jesus safe within such stone

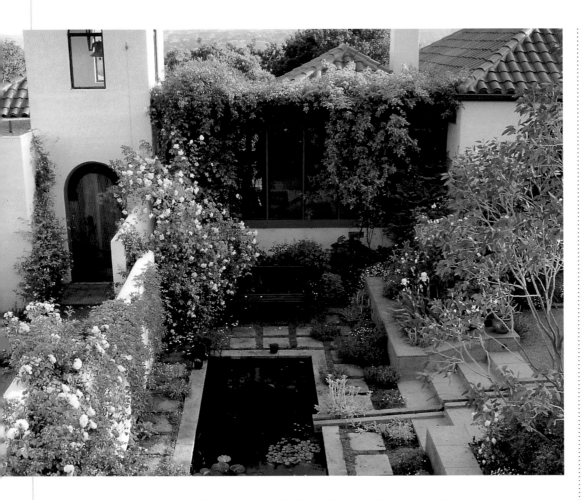

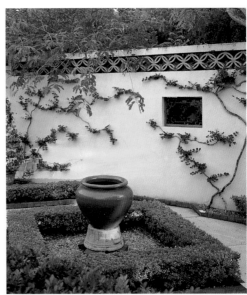

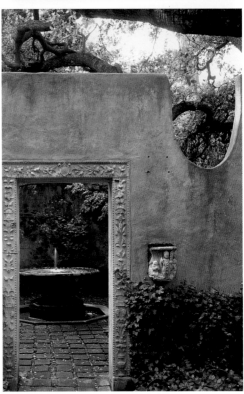

enclosures. Masonry walls also guarded medieval pleasure parks that were populated with menageries of wild animals (distinct from deer parks, where kings and princes pursued their fleet-footed prey) as well as vineyards, small orchards, and kitchen gardens.

In *The Gardener's Labyrinth,* first published in 1577, Englishman Thomas Hill wrote of garden walls ancient even in his time: ". . . of Free-stone artly laid, and mortered together, and . . . baked bricke like handled." Whether early gardeners built walls of stone or brick depended largely on their location and economic status. Those near brickyards in clay-rich regions chose the latter for their garden ramparts. Those near quarries chose the former. Those too poor to afford either material built walls from "mudde of the ditch, dung, chaffe, and straws cut short, and wel mixed together."

Tall stucco walls enclose a pleasure garden in a secure embrace (left). Stucco walls lend themselves to additional ornament, such as a band of clay tiles (top) or bas-relief detailing (above).

"*When its beautiful old walls shut her in no one knew where she was. It seemed almost like being shut out of the world in some fairy place.*"

—FRANCES HODGSON BURNETT,
The Secret Garden

Towering brick walls surround many an old English garden, providing warmth to plants trained up their ramparts as well as directly in their lee (below and center). Espaliered fruit trees and roses are favorites for wall-growing (right).

Brick or stone walls, 12 or more feet tall and coped at the top to throw off rain, eventually became an English garden hallmark, particularly around the kitchen garden. The British Isles' maritime climate lacked the summer heat necessary for ripening favored fruits in the open air. But when these trees were trained against properly oriented stone or brick walls, they produced delicacies that overflowed the tables of the well-to-do.

The cost of a wall was a small price to pay for such gustatory pleasures. "I grant that [a wall] is the greatest expense that attends the making of a small garden," wrote Thomas Hitt in his *Treatise of Fruit Trees* in 1768, "yet as no other fence is so good, either against man, or beast, and no other method so proper for the production of good fruits, the lovers of such will readily dispense with the charge."

On this side of the Atlantic, colonists were blessed with abundant timber

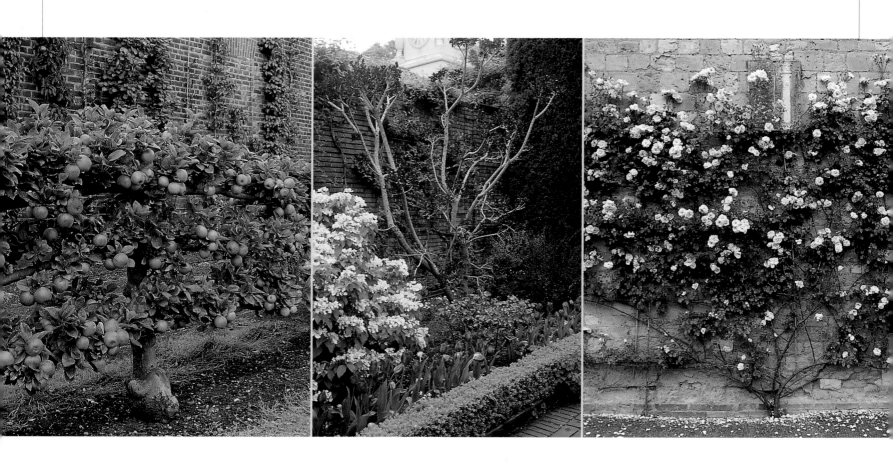

supplies and soaring summer temperatures well suited to fruit culture, so they mostly chose fences to surround their garden plots and orchards. But even here, masonry walls of assorted heights and descriptions crisscrossed the land as the country expanded.

Where rocky farmland impeded planting, farmers laboriously gathered stones and stacked them in dry-laid boundary walls, tall enough to corral livestock but low enough to look over. Privacy was hardly needed in far-flung fields and pastures. Elsewhere, bricks were baked, or native granite, slate, sandstone, and limestone were chiseled from the earth, all to form garden walls for the nation's elite. Such formal masonry structures bestowed elegance, prestige, and privacy on townhouse, villa, and estate gardens, and shielded their owners from the incursions of the growing middle class. Even in America, a walled paradise was primarily a privilege of the wealthy.

The character of a dry-laid boundary wall is dependent on the type of stone it's stacked with, its width and height, and the season of the year (left and below).

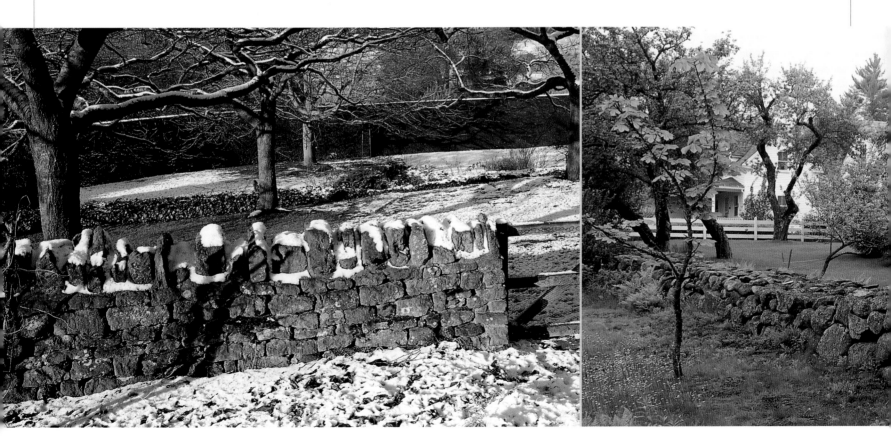

CLAIRVOYÉES: WINDOWS ON THE WORLD

Estate owners in earlier times who wanted to see beyond their towering garden walls planned in openings known as clairvoyées. Along with glimpses of the surrounding countryside, such windows on the world also allowed breezes to filter into the garden and lessened the turbulence of persistent winds.

Intricate brickwork surrounds a grille that guides the gaze toward infinity.

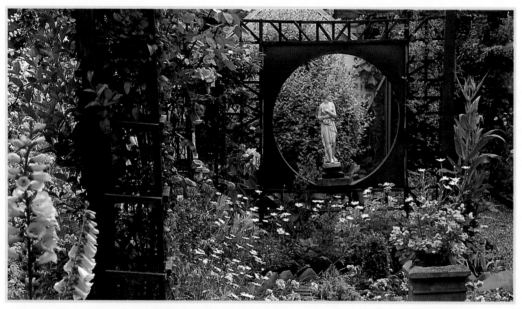

Like the frame around a picture, a screen with a circular window isolates a statue against a backdrop of green at the garden's heart.

surrounding greenery. Build a latticework grid into a tall gate to allow a quick reconnaissance of approaching visitors or a peek of the garden beyond. Or use old wood window sash—minus the glass—for your clairvoyées. Framed with curtains of clematis or drapes of passion flower, they'll hardly need a view.

Some clairvoyées were left unscreened. But to maintain the sense of protection and privacy an unbroken wall provided, masons often fitted clairvoyées with decorative grilles. Many were of brick, laid in honeycomb bond, and were integral parts of the wall structure. More were inserts: sturdy wood latticework or wrought-iron traceries of vines and leaves that were fitted securely into place when the wall was built.

Today, clairvoyées still play a vital role in garden walls, fences, and even gates. Plan a circular opening in a wall or lattice fence, for instance, for a view of an adjoining garden room or a framed vista of distant hills. Seek out old cast-iron grilles and incorporate them into a close-board fence or new brick wall for a glimpse of

This clairvoyée provides a leaf-framed peephole on another garden world.

CHOOSING A MASONRY WALL

The economics of wall building haven't changed much. Even with modern shipping methods, masonry walls are still expensive to construct, sometimes prohibitively so in areas with no quarries of native stone or nearby manufacturers of brick. Yet a masonry wall remains the ultimate garden structure: an investment in your garden's future that resonates with the traditions of the past.

The style of wall you have built, and the materials it's made from, will be dictated in part by where you live. If your home is in granite country, sandstone may be in short supply or more expensive than native stone. If you live where bluestone is quarried, limestone may be a rarity. If your garden is in the western half of the country, the style of bricks you saw on a trip to the east coast may be hard to find and cost more than you want to spend. Though the regional aspect of

Well-laid walls and planting beds add new dimensions and a sense of permanence to this garden (left). Blocks of sedimentary stone rise up to frame a statue and weathered door, forming an ornamental wall that evokes The Secret Garden *(below).*

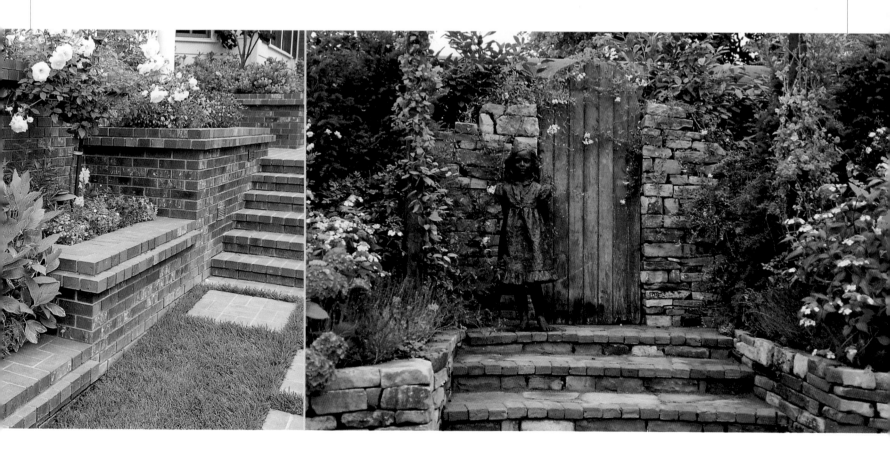

masonry pricing can be frustrating, there's one benefit. Locally quarried stone or manufactured brick is more likely to blend with the native plants, natural landscape, and other structures around your home than materials imported from across the country, or even from across the state.

Spend some time exploring local neighborhoods and take note of the stone, brick, or other masonry materials you like, including stucco and concrete. Don't look just at garden walls; the masonry used regionally to build houses also should be readily available. Take pictures and make inquiries. Gather names of masons and

This new stucco wall was aged with the help of old bricks, cunningly set to appear as though parts of the wall have broken away.

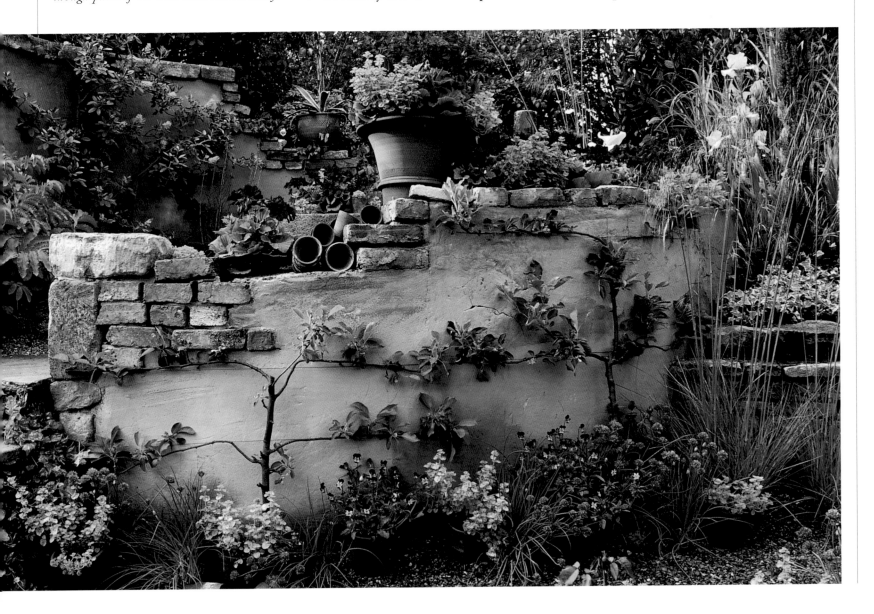

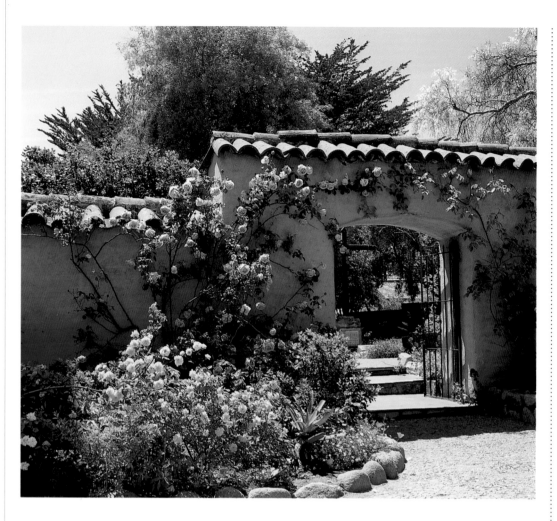

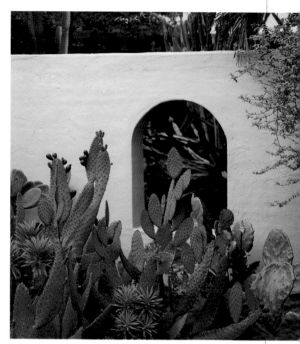

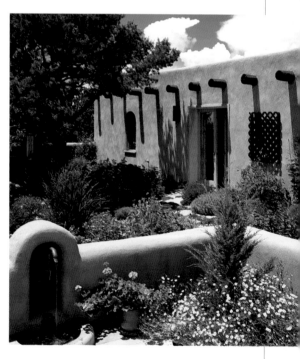

suppliers, then talk to them about what materials they prefer and why. You may start out coveting limestone walls like those you admired while visiting England, only to find yourself falling in love with the local slate or sandstone instead.

Remember to consider the materials from which your house is built, along with any existing paved areas such as patios or driveways. Because perimeter walls have such a sense of substance and will be seen as an extension of your house, they should blend with any existing masonry rather than compete with it. That doesn't mean you have to build a brick wall if your house is faced with brick—sometimes too much of one material can be monotonous and overbearing. Instead, you might consider a stone or poured concrete wall with a brick coping, or a brick wall with a foundation or supporting pilasters of river rock.

Adobe walls were often coped with tiles to keep rain from dissolving the mud (left). A stucco wall suits the xeriscaping of the Southwest (top). A low wall matches this pueblo-style dwelling (above).

The style of wall you build should also be keyed off the style of your house. A formal Georgian mansion calls for a formal brick or dressed-stone wall; a New England saltbox may seem more at home with dry-laid rubble, stacked fieldstone, or rough, semidressed stones. A wall of river rock, clinker brick, and rough stucco will set off a Craftsman-style bungalow, while a sleek wall of tinted stucco or concrete may best suit a contemporary structure. Again, don't feel bound to build the expected. Instead, you may want to echo the style of your home—it's dominant lines or architectural features—in less-than-traditional materials or forms.

WALLS FOR THE AGES

It's the oldest walls that gardeners most appreciate, veiled in green moss, crusted with lichen, softened by time and weather. Like an eroded bluff or craggy ram-

A stonemason's expertise is evident in the dressed stones and finely crafted arch of an old garden wall (below). The sun-baked adobe of an aged wall sets off old-fashioned hollyhocks (center). A lancet arch pierces a wall of rough stones (right).

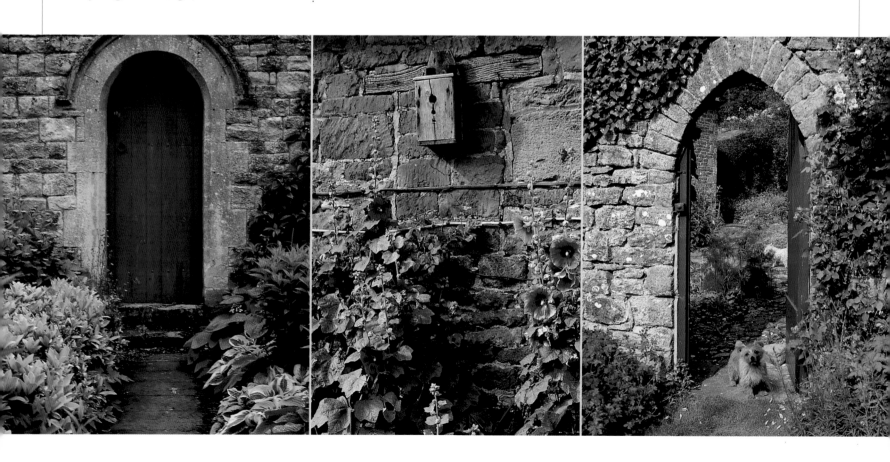

part, they lend strength to the landscape while blending into the background, allowing the blue of the ceanothus or the chartreuse of the blooming euphorbia to shine. In order for our own walls to achieve such mature splendor, they must be built to last beyond our lifetimes.

A handful of elements interact to lend strength to a masonry wall and ensure its endurance through the ages, including the following:

Bonds. Bonds are stone- or bricklaying patterns that stagger the vertical joints in a wall and tie the back and front of the wall together to give it strength. They also add to the masonry's visual interest. The simplest bond pattern, in which one stone or brick spans the joint of the two below it, is used in both brick and stone walls. But other patterns abound, particularly in brick masonry construction. (See pages 70-71).

Frogs. Within the wall itself, depressions called frogs in molded bricks or holes called cores in extruded brick strengthen a wall by more firmly keying the mortar to the brick. Surface irregularities in uncut stone do much the same.

Footings. Stone or brick garden walls more than two feet in height require a stable poured-concrete footing, or poured-concrete and concrete-block footing, that is one and a half to three times the width of the wall. The exception is a dry-stone wall, which is built on a foundation of stones set just below the level of the earth. In cold climates, concrete footings should extend well below the frost line so that the alternating freezing and thawing of the earth doesn't push the wall out of alignment. All footings should be constructed on undisturbed native soil or properly compacted fill, and should be reinforced with rebar (metal reinforcing rods). In general, walls taller than three feet must be engineered and will require a building permit.

Shadows across old stone (top) add mystery to a garden scene. Masons enamored of the Craftsman style built walls of river rock and clinker bricks (center). Rosemary spills over a low wall of ledger stones (above).

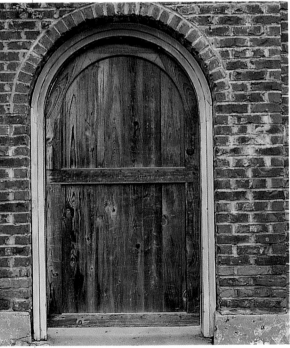

Clay tiles stand in for brick where breezes are welcomed, and form an intriguing pattern (top). A plain brick wall gains interest from an arched door (above).

LASTING BONDS

All types of masonry walls rely on bonds—the overlapping of the individual masonry elements and mortar joints—for their strength and beauty. One stone is laid over the two below it; then two stones are laid over the one. Most of us learn this principle at a tender age, playing with our blocks or Legos.

While simple bond patterns work best for most stone walls, bricklaying lends itself to many bond patterns and decorative arrangements, including the following:

STRETCHER BOND. This is the most basic of bond patterns and is made up entirely of stretcher courses (single horizontal layers showing the long edges of the bricks). In stretcher bond, each stretcher course is offset half a brick sideways from the stretcher course below it, creating the classic two-over-one, one-over-two pattern.

ENGLISH BOND. In English bond, each stretcher course alternates with a header course (a layer showing only the short ends of the bricks). The headers are positioned so that they span the mortar joints between the stretchers. By their very nature, walls laid in English bond are two bricks thick, unless the headers are cut in half. The headers tie the two faces (or wythes) of the wall together just the way tie-stones do in stone masonry. This is one of the oldest bond patterns, thought to date to medieval times.

FLEMISH BOND. In Flemish bond, which dates to the 17th century, each course of the wall is made up of alternating stretchers and headers. Flemish bond walls also are two bricks thick.

HONEYCOMB BOND. Honeycomb bond is similar to stretcher bond, except that open spaces are left between each stretcher in the course, creating an openwork screen rather than a solid wall.

OTHER BOND PATTERNS. Many other bonds and decorative patterns are possible, including ones that use courses of bricks set on end (known as soldiers), bricks in a herringbone pattern, or bricks in a basketweave pattern.

PROJECTING OR RECESSED BRICKS. A single course of brick that projects from the face of the wall will cast an eye-catching shadow line, as will a header course in which each brick is twisted so that one of its corners sticks out, forming a zigzag projection. Other possibilities include laying the bricks so that every other header in a course near the top of the wall projects or so that selected headers project in a decorative diamond motif. Alternatively, bricks can be recessed into a wall to form shallow alcoves that catch the light or capture intriguing shadows.

CONTRASTING BRICKS. Consider, too, the use of brick in a color or texture that contrasts with the main body of the wall. Innumerable patterns are possible, from a single horizontal course of darker or lighter brick to an overall diamond lattice pattern formed by substituting contrasting bricks for a selected group of headers. Experiment with possible patterns on graph paper. Draw a variety of bonding patterns, one on each sheet of graph paper, then photocopy the sheets. Color in various patterns in pencil until you discover one you like. One of the best sources for ideas are old brick buildings, which often show off half a dozen decorative brick patterns in their walls.

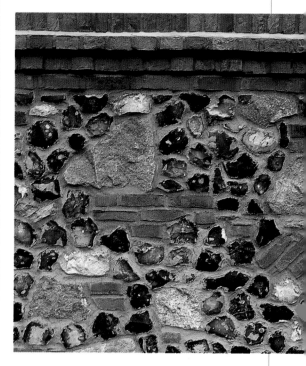

Bricks, flints, and larger stones add color and texture to this garden boundary wall (top). Bricks laid in honeycomb bond invite creeping fig to wander (above).

Drainage. Retaining walls must have good drainage. Behind the wall, plan for a foot-thick layer of drain rock that rises to within a foot of the soil surface, has a PVC drainpipe (with the holes facing down) at its base, and is wrapped in filter fabric. Mortared walls also should have openings where excess water can drain, such as weep holes or pipes that pierce the wall every two feet along its base, or gaps created by leaving the mortar out of every other vertical joint in the bottom course of masonry.

A brick garden wall benefits from a smooth coping, curved cutout, and cast-stone ornament (below). Rough stonework forms a retaining wall well suited to a country garden (right) and is topped with blooms and tree-like trellises.

Coping. A protective cap is needed for both brick and stone walls to shield them from moisture damage. A well-designed coping, which may be a top course of broad, flat stones, flat tiles, or a fancy layer of rounded bricks, quickly sheds water from the top of the wall so that it doesn't seep into the masonry or the mortar joints.

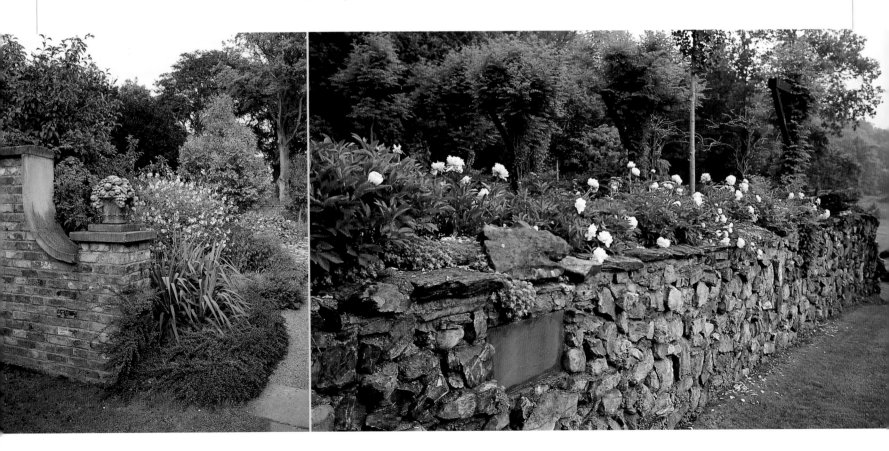

Mortar joints. Mortar, a mix of cement, sand, and water, is the glue that holds most walls together. The way the mortar joints are shaped affects both how the wall looks and how well it resists moisture damage.

Flush mortar joints, where the mortar is even with the surface of the brick or stone, tend to give walls a flat appearance. Keyed, weathered, or recessed joints, in which the mortar is indented, give more texture to walls. Keyed joints, which look like they've been cleaned out with the tip of a spoon, and weathered joints, sloping from the top edge of the lower course of masonry back underneath the upper course of masonry, are among the best at shedding water.

Thickness. A single thickness of brick suffices for low border walls, but taller walls need to be at least two bricks thick, tied together with bricks laid across the width of the wall. (Such bricks, laid crosswise with their ends showing, are

The sinuous "crinkle-crankle" wall at left is only one brick thick, yet is just as sturdy as the broad dry-laid wall below due to its curves. Such walls once offered sheltered niches for fruit trees, but are rarely built today due to their high cost.

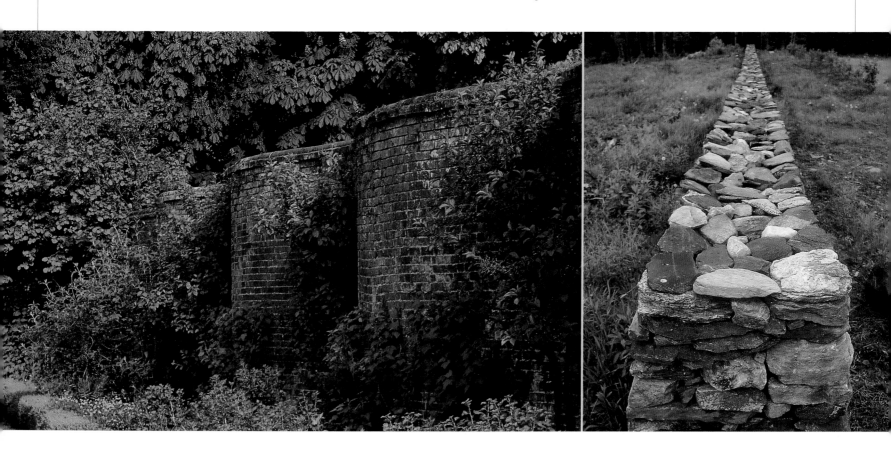

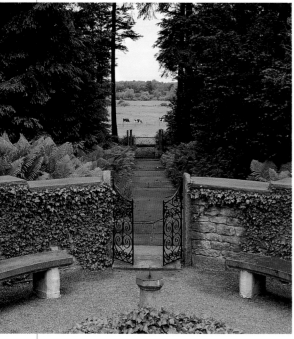

A pilaster gives support to a brick wall (top); skewed bricks just under the coping add texture to the masonry. A formal wall of dressed stone contrasts sharply with the pasture in the distance (above).

called headers.) Likewise, tall stone walls generally require two wythes (stacks of stones—or brick—one unit deep) bonded together with tie stones or through stones that span the wall's thickness. Serpentine brick walls, called crinkle-crankle walls in England, can be built one brick thick; they gain their strength from their curves. (Many types of metal fasteners also are used today to give strength to masonry walls.)

Supports. Tall walls usually require the support of pilasters: vertical braces of brick or stone that project from one or both sides of the wall to provide additional stability.

BUILDING BLOCKS

The skill with which a wall is built affects its longevity. But its strength and character also arise from the materials with which it's made. Stone carries the imprint of the earth and the stamp of eons; brick has a more domesticated air. Both form an endlessly varied palette that masons have drawn on since ancient times.

STONE

A wall of loosely piled fieldstone is as different from a dressed-stone wall as a petunia from a peony, and each is suited to completely different settings. Before choosing stone for your own garden walls, consider how the geologic origins of the stone, the stones' shapes, and the way the stones are placed all affect the nature of the finished wall.

Geology. The geology that gives rise to the speckles and sparkles of a granite cobble or the soft striations of southwestern sandstone also bears upon the look, strength, and construction possibilities of the stone. *Igneous rock* such as basalt or

POCKET PLANTING

Give plants a toehold and they'll grow almost anywhere. Sown by wind, water, or visiting birds, seeds will sprout and grow in the crevices between dry-laid rocks, in the weep holes of mortared brick, or even in tiny cracks in the mortar of dressed stone. Given time, their serendipitous choice of a home lends a sense of surprise and a touch of nature's beauty to even the plainest garden retaining wall.

Many plants prefer the confines of a wall to the wide-open spaces of the garden.

But why wait? Make hospitable pockets for plants as your retaining walls are built, so they'll quickly seem a part of the garden.

For the most natural look, space planting pockets randomly, rather than in a predictable, evenly spaced fashion. Then group plants so that it seems they've colonized the wall on their own.

Remember the microclimate that a wall creates. South-facing walls will be dry and warm, requiring plants that don't need a lot of moisture. North-facing walls are best suited to ferns and other shade lovers. The top portions of walls tend to be drier than their bottoms, making them the perfect site for many alpine plants.

DRY WALLS. When building drystone retaining walls, plant some of the cracks between the rocks as you go. Tamp in a small amount of rich, sandy soil, lay the roots of the plant on top, then add more soil. Rooted cuttings adapt best to these sites. Fill in the gap behind the wall and the bank with a rich, fast-draining soil mix.

You also can start plants by seed in the wall itself. Hold a small amount of seed near the crevice of a drystone wall, either on a piece of cardboard or your hand, then blow the seeds into the crack. Blowing through a straw or tube will help you aim seeds in the right direction.

Avoid bedding all the stones in soil, as is sometimes suggested. With ample soil between the rocks, weeds are much more likely to become established.

MORTARED WALLS. Form pockets for planting in mortared brick or stone walls by leaving out small stones or half-bricks when the wall is built. (You can also pry or chisel them out of existing garden walls.) Tuck in soil and plants once the mortar has cured. Some gardeners start plants in peat pots or pellets, then transplant them as is.

PICKING PLANTS. Some plants are better suited than others to wall life. Countless alpine and rock garden plants will thrive in the crevice of a rock wall because it mimics their natural home. Other plants simply aren't choosy about their accommodations.

Plants that usually take to the faces of sunny walls include arabis, aubrieta, alyssum, dwarf campanulas, erigeron, some gypsophilas, helianthemum, iberis, some evening primroses, saxifrages, and sedum. Plants that prefer shadier pockets include pulmonaria, viola, ajuga, and numerous ferns. Baby's tears will climb upward from the ground to clothe the foot of a wall, and *Alchemilla mollis* will often self-sow at a wall's base, providing a frilly skirt of greenery that ties the wall to the earth.

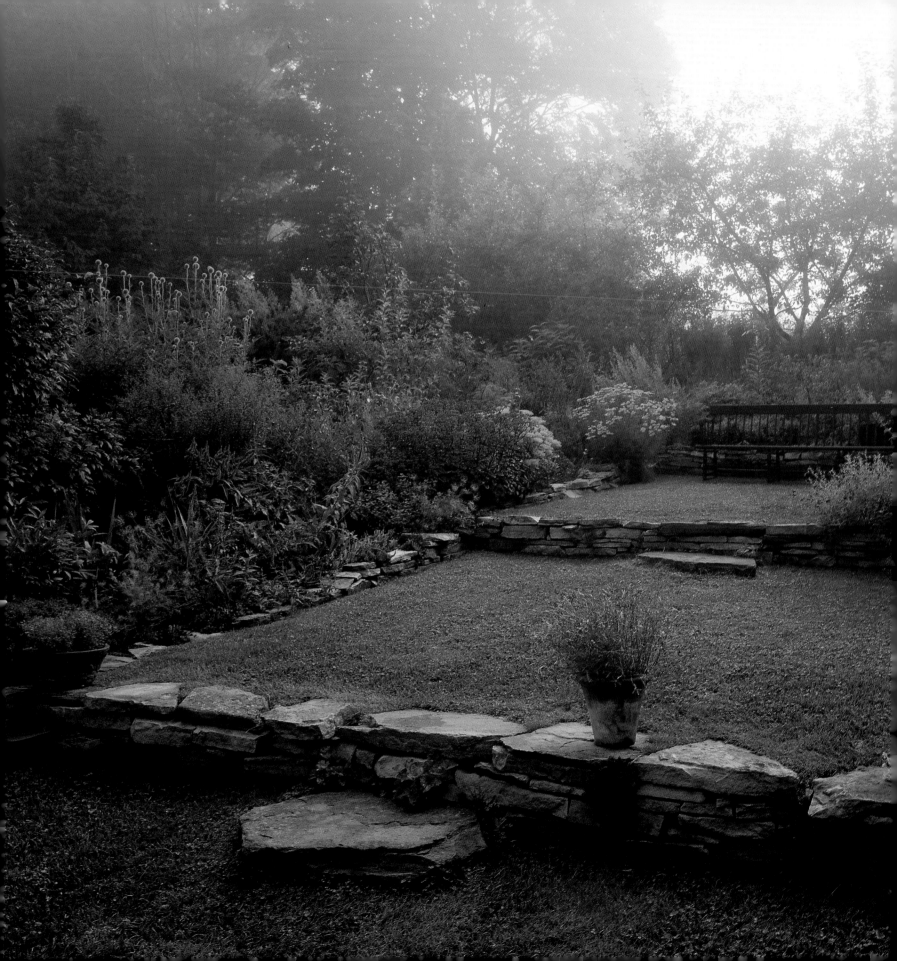

granite began life as liquid magma deep beneath the surface of the earth. It is water-resistant, extremely durable, and won't weather with age. Igneous rock will maintain a crisp look through time, and hosts both lichens and moss. It is often used in the form of rubble, since it is difficult to shape, although granite sometimes is cut into uniform blocks.

Sedimentary rock is formed from decomposed rock or organisms that have, through the ages, solidified into layers. Sedimentary rock such as limestone or sandstone is easily split or cut, and generally will weather attractively over time. Sedimentary rock is apt to absorb moisture, which supports the growth of moss. Some of the softest types deteriorate within a few years, while others last centuries without showing undue wear. Sedimentary rock often is dressed into uniform blocks and laid in a formal manner, though rough split pieces may be stacked in dry stone walls.

Both igneous and sedimentary rock sometimes are transformed into *metamorphic rock* by intense pressure, heat, or chemical action. Marble, for instance, is metamorphosed limestone; slate is metamorphosed shale.

Shape. Rock for wall building is available in many shapes. Loose rock in its natural state is often referred to as rubble or undressed stone. River rock is rubble, as are stones dug from fields or garden beds. Rubble walls, whether laid dry (known as dry walls) or with mortar (known as wet walls) have a rustic, unstudied feel to them that is perfectly suited to country, cottage, or woodland gardens. Both types of rubble walls also perform well to retain earth.

Quarried rock that has been cut and shaped for use in walls is known as ashlar, cut stone, or dressed stone. Semi-dressed stones have rough faces and are relatively uniform in size; fully dressed stones may have machine-cut faces or heavily worked surfaces. They are uniform in size and shape. Walls built from dressed stone have a more formal feeling than rubble walls and are also more costly, as the

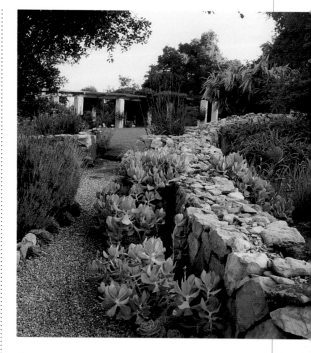

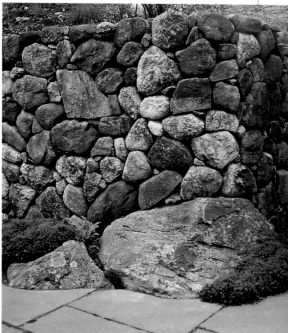

Depending on the stone they're made from, dry-laid walls may be layered like cakes (opposite), stacked like building blocks (top), or painstakingly fitted together like an intricate jigsaw puzzle (above).

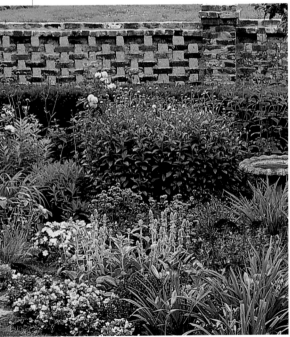

Brick walls laid in honeycomb bond serve well as balustrades or garden screens in a variety of garden settings. Their openwork designs make weighty brick seem light and airy.

price of stone increases in proportion to the amount of work used to finish it.

Sedimentary or metamorphic stones that are cut or split into slabs are known as flagstones or ledger stones. Ledger stones are more blocky in shape than flagstones, and are particularly well suited for building low boundary walls in the garden that also double as benches. Thinly cut flagstones also form the veneer that dresses up many a concrete boundary or retaining wall.

BRICK

Like stone, brick is available in a multitude of different shapes, styles, colors, and strengths, depending on the composition of the clay, the additives used, the way the brick is formed and cut, and the way it is fired. All will affect the demeanor of the wall you build.

Quality. Brick is graded according to its appearance and its ability to withstand winter's iciest days. Face brick is high-quality brick suited to visible, finished surfaces, such as the facades of buildings, and comes in a variety of styles and finishes. Building or common brick is of lesser quality. Though either type can be used for building garden walls, common brick is the usual choice. Severe weathering brick (SW brick) is often used in frigid climes and should be used for retaining walls where the brick will be in contact with moist soil, but you can build most garden walls from moderate weathering (MW) brick.

Size and shape. Part of the magic of bricklaying stems from the fact that bricks are sized so that one brick laid lengthwise (with its stretcher face showing) takes up the same space as two bricks laid with the short ends (or header faces) showing. This allows for any number of bricklaying patterns (known as bonds) that stagger the vertical mortar joints to strengthen the wall. Bricks also may be laid with their bedding faces showing (the broad top or bottom surface of the brick that normally is bedded in the mortar).

Standard building bricks are often described nominally; the dimensions aren't the actual size of the brick but include both the brick and the thickness of one vertical and one horizontal mortar joint. The nominal dimensions of standard bricks are generally four inches wide, two and two-thirds inches thick, and eight inches long.

Many nonstandard brick sizes and shapes also are available, including veneer bricks designed for facing concrete block walls, oversize adobe bricks, and rounded or angled bricks specifically for use as coping (the crowning layer of the wall, designed to deflect rain).

Color and texture.
Bricks range in color from black or deep purple-brown, through many pink, red, and orange tones, to the sandy buff color of firebrick. Many bricks are mottled or "brindled," showing blotches of black, blue, and brown; brindled bricks often blend better with older brick types than do the standard uniform brick colors. Some so-called bricks are actually formed from concrete tinted to look like clay, and are available in gray and other colors. Concrete bricks tend to be less expensive than their clay counterparts, have a coarser texture and more uniform color, and won't weather the same way as clay bricks over time.

A few traditional brick manufacturers still offer handmade bricks, which are slightly irregular in size and have a soft, weatherworn feel that's beautifully suited to the garden. Most modern bricks, however, are either molded by machine or extruded in columns and then cut by wires. Shapes and textures differ. Some bricks have a hard, cold, formal character, while others have softer edges, seem more mellow, and are right at home around the daphne and the hellebores. Look around, and pay attention to how the color and texture of different bricks make you feel, particularly when they're stacked in large quantity.

Used brick—salvaged from structures built before approximately 1935—tends to have a softer texture and more variable color than new brick, thanks to

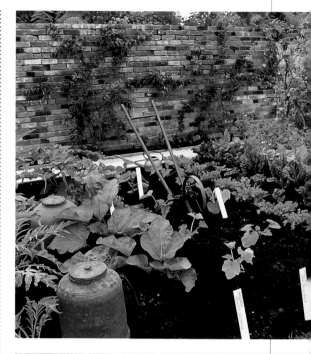

Multiple hues of new brick add interest to the wall that bounds a kitchen garden (top). Old brick boasts the softer tones that can only come with time (above). Both serve to divide one garden section from the next.

*"The sun already burns
resplendent
Between the shadows of the fig tree,
makes the low wall of coarse
Granite warm to the touch."*

—HERMANN HESSE

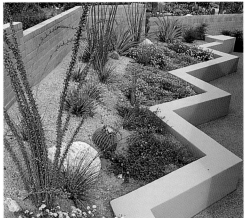

It's hard to believe, but the beautiful masonry in this wall (top) is actually tinted and molded concrete, known as cultured stone or cast stone. Concrete adds clever geometry to this bed (above).

decades of weathering. It is widely available at architectural salvage yards and large building supply yards, but costs substantially more than new brick. Keep an eye out for demolition work on old buildings around town; the owner may be willing to let you have old chimney, wall, or paving bricks for free or a token charge. Before you haul them away, try breaking off the old mortar with a hammer. Mortars used from about 1935 on contain cement and can be next to impossible to remove without damaging the brick. Simulated used brick, which mimics the efflorescence, stains, and bits of old mortar so coveted on real used brick, also is available but can look somewhat artificial.

OTHER MASONRY CHOICES

Most of us would choose real brick or stone for our garden walls if we could. These traditional materials have been tested through centuries, and suit the garden like a hand suits a glove. But where factors such as high cost or lack of availability prohibit their use, other masonry choices may fill your needs.

Cast stone. Surprisingly, artificial stone is not a newcomer to the garden. As early as the mid-18th century, enterprising craftsmen blended stone aggregates with cement to cast garden ornaments that convincingly imitated carved limestone, or mixed lime, plaster, and sand to make artificial stones for walls. "[They] are much cheaper than stones brought from far distant places," observed Thomas Hitt in his *A Treatise of Fruit Trees* (1768). Today's manufactured stonemakers follow in their footsteps.

High-quality manufactured or "cultured" stone is made in molds taken from real stone, whether dressed or in its natural state. Manufacturers use a variety of aggregates, iron oxide pigments, and molds in casting the artificial stone in order to achieve a surprisingly true-to-life look. In general, manufactured stone costs less than the real thing, weighs substantially less, and is faster to install (manufactured

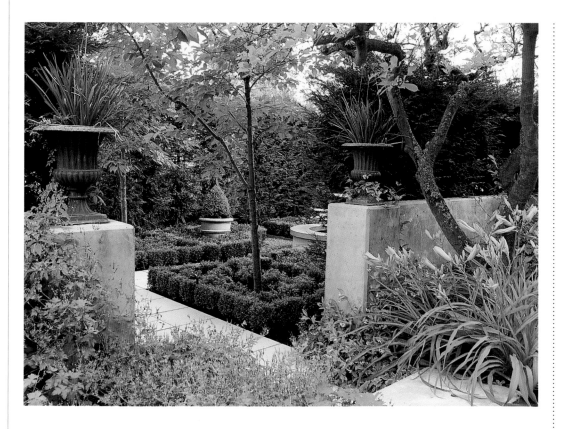

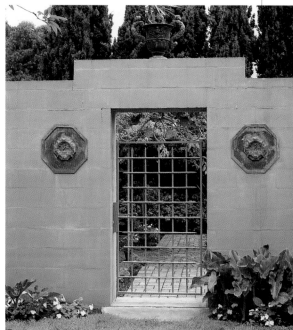

stone often is applied as a veneer to other materials such as concrete block). And, thanks to a variety of clever joining methods, it's possible to lay up certain styles of manufactured stone without mortar, creating a drystone look even in tall applications.

Because cast stone is basically colored concrete, it stands up well to the rigors of the great outdoors and performs admirably in garden boundary or retaining walls. Among its attributes is its ability to dress up existing—but unsightly—walls of brick, stucco, or concrete.

Concrete block.

Concrete building blocks, reinforced with steel rods, often have an industrial feel when left to stand on their own in the garden, but can form the sturdy core of a stucco garden wall or support a pleasing veneer of stone, brick, or manufactured stone. Because the structural part of a concrete block wall is inexpensive to build, the overall cost of the wall is lowered.

Concrete garden walls, whether cast in forms (left), painted (top), or skimmed with stucco (above) have a modern air. But they impart a sense of substance akin to that of stone or brick.

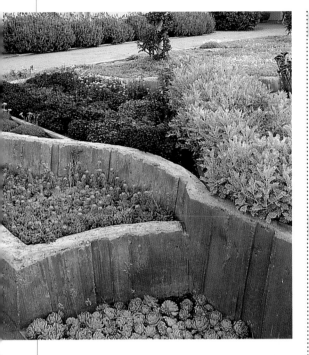

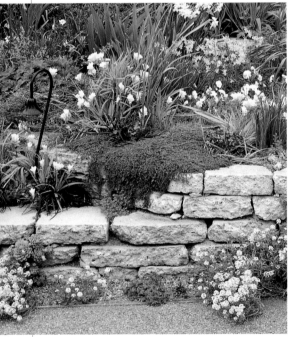

Cast concrete takes on the look of stone in these compartmented planting beds (top). Broken concrete from demolished sidewalks or driveways was recycled into a low-cost garden retaining wall (above).

Poured concrete. Don't overlook the decorative possibilities of poured concrete, particularly for low dividing or retaining walls. While a plain concrete wall may seem out of place in an old-fashioned garden, a variety of tints and aggregates can be added to the concrete to blend the wall successfully with the lilies and the lavender. Surface patterns also can be created with shells or pebbles, or you can dress up the wall with a coping of flagstones, tile, or brick.

Broken concrete. Many a cracked concrete sidewalk or demolished driveway has been recycled into retaining walls by resourceful gardeners; the uniform depth of the concrete pieces makes such walls easy to lay. Use drywall construction methods, then add trailing plants along the top of the wall or in soil-filled pockets among the concrete chunks to camouflage rough edges.

Retaining wall systems. Most retaining wall systems rely on modular concrete blocks, curved and colored to resemble dressed stone (if you have a good imagination). Using a variety of methods, each course nests into the course below it. Some systems are designed so the blocks step back slightly with each course, battering the wall gradually toward the slope. With most systems, no mortar is required.

Wood and plastic. You can also build rustic retaining walls from used railroad ties, logs, rough-cut boards, or specially made landscape timbers, held together or braced with metal pins, lengths of galvanized pipe, or lengths of metal rebar. Retaining walls of these materials give the garden a linear look, since they can't follow the landscape's natural curves.

Railroad ties are the bulkiest of the bunch, usually eight by eight inches and approximately eight feet long. If you purchase used railroad ties (available at building or landscape supply yards), avoid specimens that are oozing lots of black creosote, a preservative that harms plants.

Landscape timbers are smaller than railroad ties, measuring five by six inches by eight feet long, or six by six inches by eight feet long. Most are softwood, but hardwood timbers also are available. In general, most landscape timbers have been pressure-treated with preservatives, and should not be used around fruits, herbs, and vegetables, or when building playground equipment; organic gardeners tend to shun them throughout the garden. Some suppliers do offer untreated cedar landscape timbers.

An alternative is timbers made from postconsumer and postindustrial recycled plastics. *Plastic landscape timbers* generally measure five by five inches by eight feet long, sometimes are designed to interlock, and are totally impervious to moisture and insects. They can be cut with normal woodworking tools. While desirable as a renewable resource, plastic timbers look like what they are—plastic. If possible, reserve their use for areas of the garden where they'll be camouflaged behind the artemisia and the poppies, or otherwise kept out of sight.

EXPERIENCE COUNTS

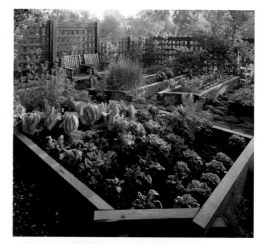

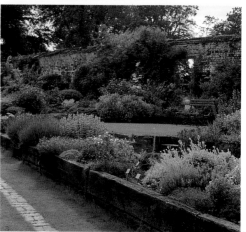

Don't hesitate to consult with a landscape architect, or even a structural engineer, when designing and planning your garden's walls or other structural features. An expert's contribution can make the difference between a boring barrier that fails due to soil conditions or poor engineering and a structurally and visually appropriate wall that creates the kind of haven gardeners long for. Landscape architects and engineers also can be invaluable when it comes to sculpting the land with retaining walls of adequate strength and in determining their drainage needs.

Most vital to the beauty of a garden wall, however, is the skill of an experienced mason. Building an attractive brick or stone wall that will stand up to climbing kids, aggressive vines, storms, and frost heaves, and remain structurally sound through the decades, takes talent, expertise, and a feel for the materials that few of

Interlocking landscape timbers, railroad ties, highway timbers recycled from guardrails, and logs all serve to terrace the garden or form raised planting beds.

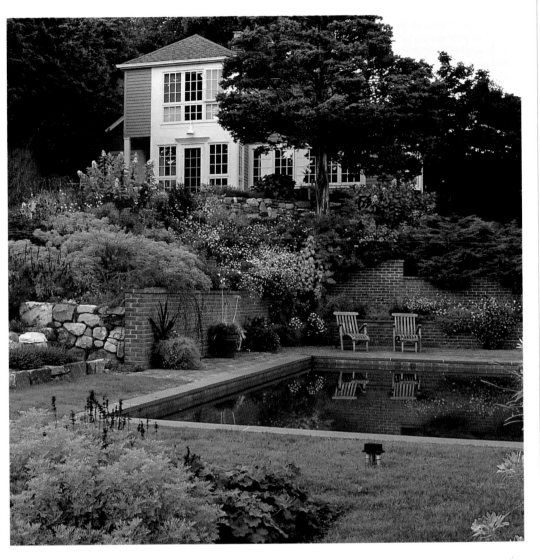

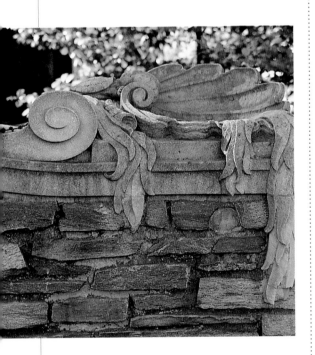

This hillside garden grew from a carefully engineered foundation of retaining walls built in both brick and stone (right). The stonemason's art endures (above).

us will ever have the chance to master.

If you long to fit stone on stone or mortar a course of bricks, satisfy your craving by building edgings for garden beds or low dry-laid walls of rubble or ledger stone until your skills are finely honed. A poorly built wall, locked in place with mortar, will be less an asset to your garden than an enduring reminder that some things are best left to the experts.

There's a reason masons have been relied on for millennia. Pay homage to their ancient craft, and your walls will reward you with benevolent protection, enduring substance, and the timeless pleasures of a private paradise.

STONE BY STONE: DRYSTONE RETAINING WALLS

HOW-TO

The drystone walls that border New England gardens and fields were born of two parents: the need to clear the soil of rocks and the desire to keep livestock out of the beans and corn. Some were mere rock piles, thrown up in a hurry. Others were assembled like jigsaw puzzles, each stone nestled snug against its neighbor and held in place by gravity. Both types have lasted for centuries.

Few of us today have access to the tons of stones it would take to build a dry-laid wall that bounds an acre. But a drystone retaining wall to shore up a raised planter or terrace a gentle slope may be well within our reach, both in terms of skills and materials. Flat fieldstones are easiest to work with, but river rock, rubble, and even broken concrete paving all can be fashioned into suitable low walls.

THE FOUNDATION. Remove sod or plantings and cut slightly into the slope, if appropriate, then tamp and level soil. Lay your largest stones, keeping flat edges to the front and a flat surface to the top. If necessary, scoop out soil beneath each stone to accommodate rounded areas. Fill in spaces with smaller stones. Check all for level.

THE WALL. Using large-to-medium-size stones, lay the bottom course of wall, always placing one stone over two and two stones over one. Again, keep flat edges to the outside. As each stone is laid, check to see that it sits securely on the stones beneath it. If it wobbles, use smaller stones to chink it, tapping them into place from the inside if possible.

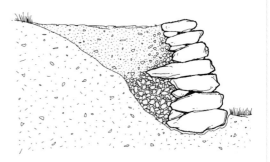

Proceed with successive courses, setting each course slightly back from the one below it and filling in behind the wall with gravel and soil as you proceed. The finished wall should slope back approximately one to two inches for each foot in height. This is called battering the wall; the slope increases the wall's ability to withstand the force of wet soil behind it. Enlist the aid of gravity by tilting each rock slightly down toward the bank. Lay tie-stones (long stones that extend from the front of the wall back into the gravel) every few feet.

DETAILS. To give the wall a balanced look, place the largest stones at the bottom and the smallest ones near the top. Save large flat stones for the uppermost layer, to serve as a coping.

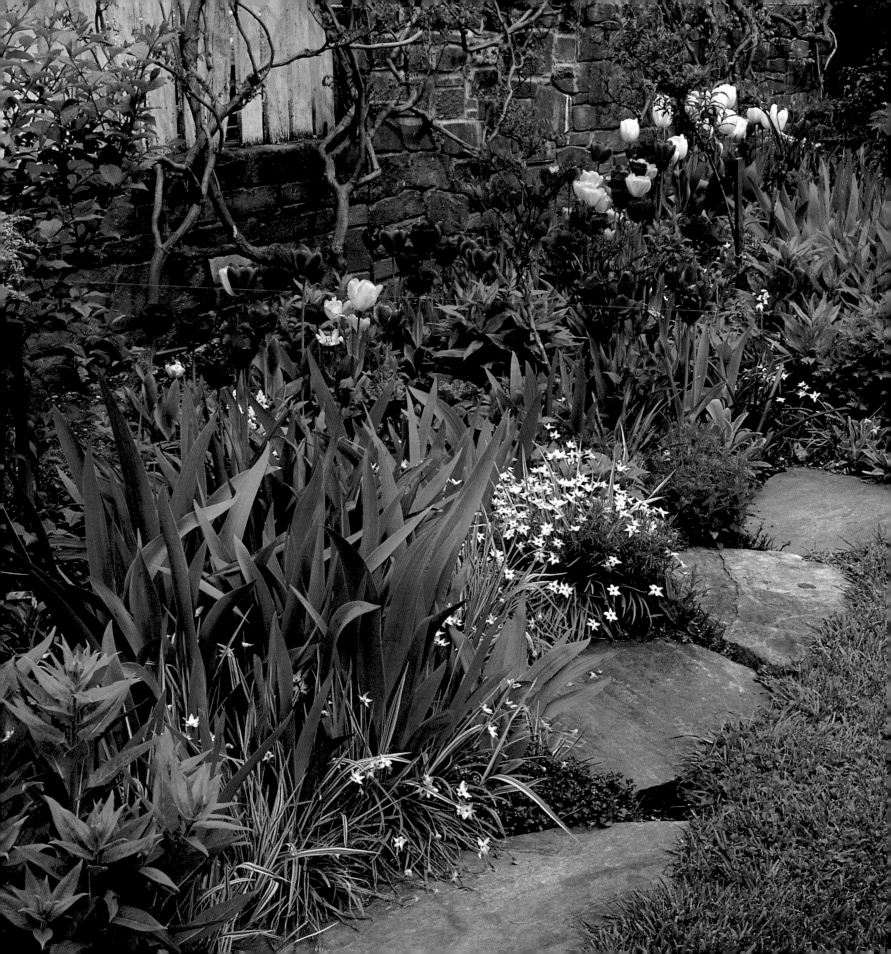

CHAPTER FOUR EDGINGS: *setting limits*

GARDENS ARE LIKE CHILDREN; they need consistent discipline. The Kentucky bluegrass needs to know the bounds of its territory and learn to stop short of visiting the perennial borders. The spearmint must learn not to poke its eager runners into the vegetable beds where they don't belong. The acanthus needs to be put in its place and discouraged from rambling. And the gravel needs to stay on the pathway where it's welcome, not mingle with the cedar mulch or scatter on the paving.

Gardeners, too, need limits. Our work thrives within the well-outlined perimeter of a garden bed, while we flounder when planting unbounded spaces. We want curbs for our ambitions and definitions for our labors. We prefer clear confines.

Edgings give both the garden and gardener what they need: a well-defined space within which to work and grow. They are lines drawn in the dirt, then formalized in wood, brick, stone, or plants, that say stop here and go no farther. They help preserve the shape of a garden through years of planting, mowing, digging, and trimming, bringing an internal logic and visual plan to a naturally unordered space.

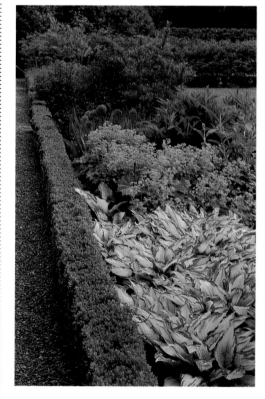

Flagstones segregate the lawn from the tulips (opposite); a border of box does the same for perennials and path (above).

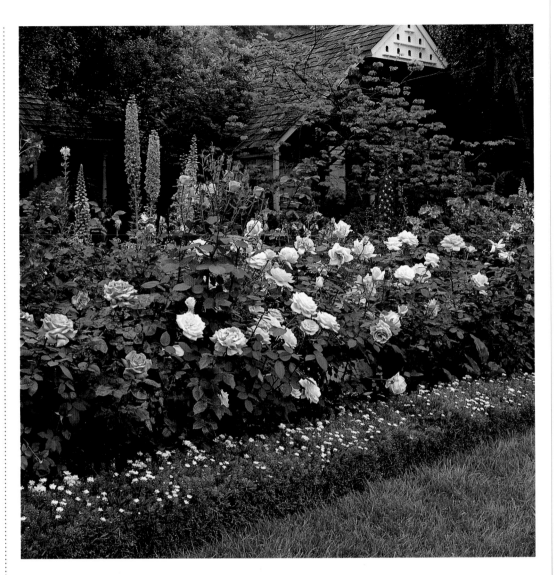

Old edging tiles need the protection of a stone or concrete border (above); living edgings need no coddling (right).

EDGINGS, DEFINED

Edgings are the miniature walls and fences that define the garden's internal contours: the curves of its planting beds, the straightaway of its walks, the outlines of its special features. Their primary job is to define and limit, but they also protect and set off. They guard saplings from whirling mower blades or spinning string trimmers. They remind visitors to stay on pathways and warn kids not to tromp on the violas. They frame compositions of anemones or ornamental grasses as if they were fine art.

Sometimes an edging is only an edge, cut into turf with a sharpened spade or edging tool. Yet the crisp delineation between grass and adjoining soil is as distinct as sunlight and shadow. Most gardeners, however, want to make a more permanent mark. A row of cobbles, embedded in the earth. Bricks set on an angle, their corners trimming the ground like rickrack. An inconspicuous curve of benderboard or an eye-catching lineup of terra-cotta tiles. All clarify the gardener's plan and commit it to solidity.

Because of their low profile, edgings don't require the structural strength of a higher garden fence or wall. There's no danger of them toppling during earthquake or windstorm, or collapsing under the weight of climbing kids or plants. Instead, their simple forms and structures cry out for the gardener's touch rather than the ministrations of the architect, carpenter, mason, or engineer.

If your garden is a blank canvas of soil or lawn, edgings can add structure and interest even before you plant that bed of hostas, hydrangeas, or hybrid teas. In fact, adding edgings before you begin to plant is one of the best ways to ensure that your garden will unfold in a pleasing, manageable manner. Such edgings help define the portions of a gardener's work: that which can be prepared and planted in a weekend, month, or year.

If your garden is already well established but seems muddled or ill-conceived, adding outlines of stone, brick, or other materials may help bring it into focus.

Start by assessing your garden's needs. Are your beds clearly defined, set off from lawn, ground covers, or walkways? Or does one area blend mushily into the next? Is it easy to follow and maintain your garden's paths? Or do they melt into their surroundings? Are mulched areas neatly confined? Or is raking errant cedar chips one of your usual garden tasks? Is there some subtle or obvious underlying order to your garden that can be discerned, even unconsciously, by visitors? Or is it a confusing jumble of plants, without logic or visual power?

Determine where edgings will have the most impact and effect. You can

TRENCH TACTICS

Some English gardeners edge their beds with a simple moat: a V-shaped trench in the soil that keeps turf grasses from storming the perennial beds.

Mark out the line you'd like your moat to follow, then put your spade into action. Working from one side, make angled cuts about four inches deep along the line. On the return trip, make angled cuts from the other side and remove the soil from the moat. The finished moat should be four to five inches across and four to five inches deep.

Patrol this border during the growing season; it will be easy to spot interlopers. Trim the grass if it starts to infringe, or make new spade cuts if necessary. If you have grasses that spread by runners, you'll need to be vigilant. Clumping types of grasses will be more respectful of the edge you've established.

draw a garden plan on paper, but it's of more use to draw your lines directly in the garden, where you can observe the impact from the patio or dining room window. Sketch lines in the dirt with a sharp stick, lay down lengths of garden hose to outline possible contours for beds or pathways, or mark out a plan on an existing lawn with a can of landscape spray paint. If the form of your garden is already clear, add edgings to emphasize the existing contours.

Edgings will be more obvious in some gardens than in others, and rightly so. In a cottage garden that's a cloud of blooms in spring and summer, river rock edgings may be completely obscured until the frosts of fall melt away excess growth and reveal the garden's bones. Such edgings are suggestions, gentle reminders that there is some planting plan: that the iris have their home on one side of the pathway and the peonies on the other. The brick or dressed stone edgings of a more formal garden, however, bring a reassuring order to the space throughout the year.

Linear brick and curved river-rock edgings form limits to both pathways and planting beds (below and center). Cut stones keep discipline in an expansive vegetable garden (right) and double as mini paths.

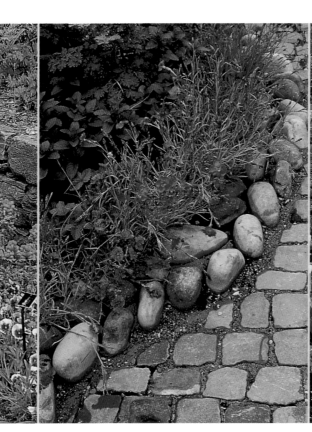

They are the rules both the gardener and the garden live by.

Sometimes the best edgings are almost invisible, obscured by time and moss until they're a mere tracery of brick beneath the sprawling mallow and phlox. But they are there, pulling us back in time to the garden's birth and guiding us as we weed and plant.

GETTING THE EDGE

There are as many types of garden edgings as there are walls and fences. Some have passed the test of centuries, others are as novel and surprising as a swath of yellow impatiens or a true blue rose. Many are subtle, hardworking forms perfectly wedded to romantic cottage or elegant formal gardens; others reveal the gardener's quirks and creativity. Still others are dictated by a dogged practicality and whatever edging material is close at hand.

"Keep within bounds."

—CERVANTES

Large stones mortared together serve as both edgings and retaining walls for garden beds (left). A mortarless edging (below) is easily altered as the garden grows.

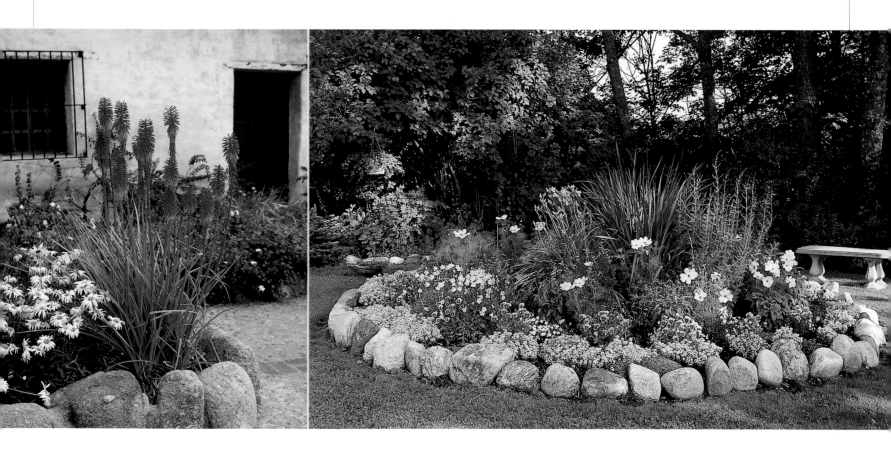

ROOT-PROOF EDGINGS

Sometimes we *want* plants to breach the edgings we provide, rooting in the cracks of the walk, caressing the stones, and tumbling into the pathways. Other times, we prefer that our garden's occupants stay in their proper places. Usually, plants cooperate: a few gentle reminders with the pruners is all it takes to keep them in bounds.

Some perennials, however, rebuke our attempts at discipline. For example, mints, acanthus, running bamboos, *Rudbeckia laciniata,* and *Lysimachia punctata* are dogged travelers, wandering at will by means of underground roots, stolons, or rhizomes. You'll need to anticipate their roving ways and build edgings like icebergs—with most or all of their structure hidden below the surface of the earth.

Sink strips of galvanized sheet metal a foot or more into the ground, around the section of bed where you'd like to the plant to stay. Or pour concrete barrier walls belowground that rise to just above the soil level. Alternatively, you can contain plantings in large sunken pots that are at least a foot deep, in lengths of fat clay pipe, or in large drums or plastic trash cans that have their bottoms cut out.

Stone. From earliest times, stones have turned up with annoying regularity as soon as a gardener begins to break ground, and *something* must be done this windfall. Stone edgings have varied, according to the gardener's whim and the area's geology, from jagged rows of upended slates or fieldstones to casual necklaces of river rock or cobbles. Other gardeners have preferred low, dry-laid edgings of rubble or formal borders of dressed stone, mortared permanently into place. Whatever the type of stone, its natural colorings, forms, and weighty substance seem as suited to the crown pinks and forget-me-nots as sun and soil.

Outspoken English gardener William Robinson, writing in the late 1800s, was adamant that stone be used for edging, for it was not only beautiful but required little labor once in place. "Natural stone," he wrote, "is the best of all materials for permanent edgings for the flower garden, or any garden where an edging is required, and no effort should be spared to get it."

Though rock yards or nearby quarries can supply the needed materials for a fee, many gardeners continue to collect stone for edgings, keeping an eye on nearby construction sites, mountain roads after storms, neighboring yards or fields, or even their own garden beds for likely specimens. Such scavenged edgings may take years to complete, but they bear witness to a modern sort of self-sufficiency and honor a long-standing garden tradition.

Stones that are mortared into place will stand up to misaimed spades, recklessly driven wheelbarrows, or wayward rototillers, and weeds won't make a home between them. But unmortared stones have a less rigid, natural feel in tune with the cottage garden and can easily be reset if jogged by frost or feet, or shifted if your vision for your garden changes.

Brick. Thanks to its uniform size and shape, fired clay brick has a more formal feel than undressed or semidressed stone, but its earthy quality seems equally well suited to the garden. Even Robinson admitted its use in areas where stone could not

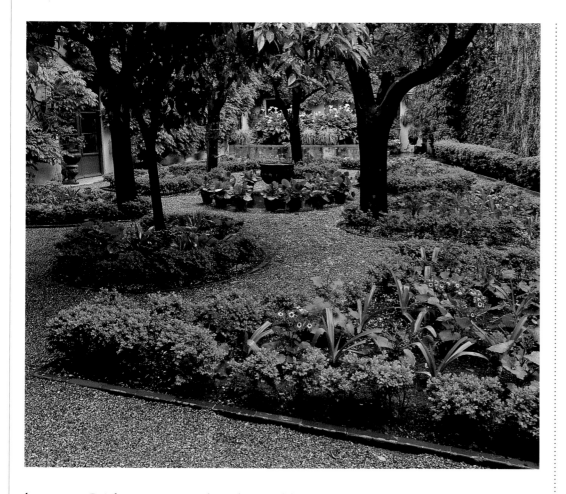

be gotten. Brick is easy to work with, suitable to a variety of edging designs, long-lasting, and less expensive than purchased stone. Gardeners have long made simple edgings of brick by laying bricks end to end along a bed or garden walkway, or by digging a trench and angling the bricks so that only their upended corners are exposed. Make more formal and permanent brick edgings by setting bricks side by side on a bed of sand, forming a broad band that will support the lawn mower's wheels at the edge of the lawn (see page 96). Such borders will also restrain the gravel of a pathway.

Brick is available in dozens of different styles and many degrees of visual softness or crispness. An edging made from wire-cut extruded brick or shiny glazed brick will have an entirely different character from that of one laid with handmade or machine-molded brick. As with stone, gardeners often collect used brick. While you may not be able to collect enough used brick to build a six-foot-high garden

Glazed edging tiles (left) have Moorish roots. Upended bricks neatly contain a regiment of onions (top). Mortared bricks bound a bed (center). A rickrack of bricks (above) is a garden tradition.

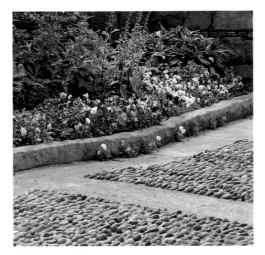

Half moons of concrete (top), a pocked concrete border (center), and a concrete curb (above) form neat, durable edgings.

wall, you probably can track down an ample supply for framing your herb beds or outlining the dusty path from the patio to the pear tree.

Like stone, brick may be mortared in place, set in sand, or simply firmed into the dirt. Permanent lawn edgings may be set on a concrete foundation and mortared, so that the lawn doesn't creep into the cracks between the bricks and the mower wheels don't bump the barrier out of place. A brick mowing strip also works well in conjunction with a loose-set river rock border or medieval-looking wattle edging. Secure the bricks in place, then lay your stones or erect the wattle edging snug against them. The bricks will provide a protective barrier and keep the stones or wattle on the straight and narrow.

Concrete. Molded concrete edgers, traditionally gray as a sidewalk and scalloped along their tops, are less expensive than either brick or stone and can be found at any home and garden center. But these mass-produced border blocks rarely blend well with plants and shouldn't be used to outline curves. More pleasing to the eye are cobbles of manufactured stone or manufactured stone pavers, both suitable for edgings and available from suppliers of cast stone or pavings.

Other cast-stone edgings include scalloped border sections adorned with floral motifs that look like they've fallen to earth from the ornate cornice of a Gothic church. Save these beauties for small beds near a patio or seating area where their detail can be savored. In the same vein are molded concrete edgers bearing Victorian rope designs that mimic traditional terra-cotta edging tiles.

Often overlooked as an edging option are curbs of poured concrete, which provide a clean finish for a path or planting bed and can be tinted soft stone colors to set off the sprawling valerian or even the prim dianthus. Curbs may project three or four inches from the soil surface or be poured flush with the level of the ground, and can be curved, straight, or zigzagged—whatever is required. Broken concrete also can be used in a pinch to border a bed, but will generally have a makeshift feeling.

ARISTOCRATIC EDGINGS

Edgings of box (or boxwood) have since become synonymous with the neatly manicured formal garden, which was revived in the Renaissance, flourished in pre-Revolutionary France, burgeoned in Victorian times, and promises to thrive in the 21st century.

English gardeners owe a weighty debt to the ancient Romans, who reintroduced box, which had been scoured from the landscape by the last ice age, to northern climes. The undisputed king of edging plants, box (*Buxus*) was used to border Egyptian garden beds as early as 4000 B.C., flourished in the first century A.D. (Pliny had a box-edged bed), and was brought north to Britannia by the Romans during their extended occupation.

Trim edgings of box (or boxwood) have since become synonymous with the neatly manicured formal garden, which was revived in the Renaissance, flourished in pre-Revolutionary France, burgeoned in Victorian times, and promises to thrive in the 21st century.

"The box is at once the most efficient of all possible things and the prettiest plant that can possibly be conceived," wrote William Cobbett in his *English Gardener,* published in 1833. "[I]f ever there be a more neat and beautiful thing than this in the world, all that I can say, is that I never saw that thing."

Cobbett was impressed with the color and form of the plant's leaves, its "docility as to height; width; shape;" its compactness and durability, as well as its ability to thrive in diverse conditions from sun to shade and on numerous soil types. In addition, the thickly branched plants excelled at keeping dirt out of the neat gravel pathways that Victorian gardeners so prized.

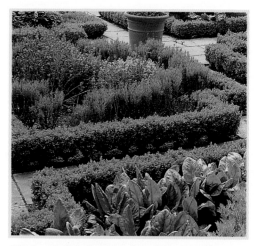

With careful clipping, box takes on the neat geometry of the beds it borders.

These same attributes captivate gardeners today, whether they want a neat shin-high edging, waist-high hedge, or expertly sheared topiary obelisk or sphere.

Three species of box prevail in modern gardens: *Buxus microphylla* var. *japonica,* *Buxus sinica* var. *insularis* (korean boxwood), and *Buxus sempervirens,* the common or European boxwood. There are varieties suited to cold-winter climes, hot summer areas, and combinations of the two, as well

as variegated, golden, and true dwarf forms (best for low edgings). *Buxus sempervirens* 'Suffruticosa,' also called English boxwood, is the traditional dwarf variety most commonly planted for edgings, but others are available. Consult your local nursery professional or the American Boxwood Society for the varieties best suited to your area.

Establishing a boxwood edging takes dozens of plants, since they should be set closely. Luckily, box is readily propagated from cuttings, which in some areas may be started in place in late summer. In other locations, a cold frame may be necessary for winter protection while cuttings root. For more information about boxwood, contact The American Boxwood Society, P.O. Box 85, Boyce, VA 22620.

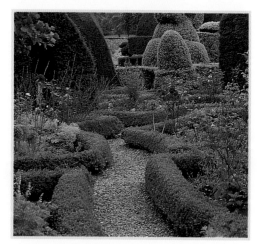

Curved box edgings define both planting beds and gravel pathway.

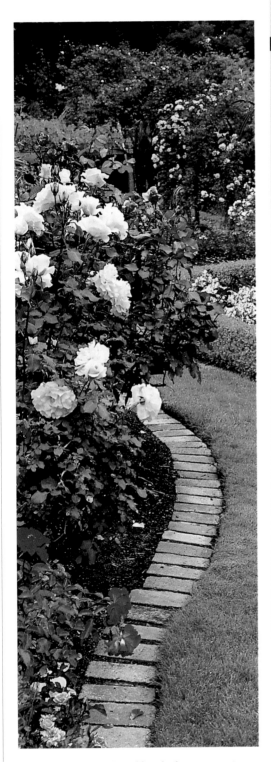

A serpentine border of bricks keeps roses in bounds and the wheels of the mower out of the mulch.

HOW-TO

BASIC BRICK

A brick edging set in sand or soil is one of the easiest types to install, yet is noticeable enough to define your beds or paths and sturdy enough to guide the mower's wheels. A bonus? If bricks are dislodged by wintertime cycles of freezing and thawing, they can quickly be reset.

First, outline the path the edging will take. For straight edgings, stretch twine between stakes. For curved edgings, lay a rope or a garden hose in the desired position. Or, mark the ground with landscape spray paint.

Step One: Using a spade, excavate a straight-sided trench that's three to eight inches deep. The width of the trench should be determined by the finished

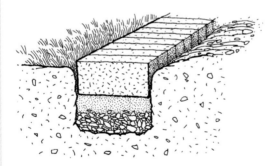

width of the edging. An edging that consists of a row of bricks set at right angles to the path or bed, bordered by a single row of bricks set parallel to the path or bed, will require a trench that's one and a half bricks wide. An edging of bricks laid end to end will require a much narrower excavation.

Step Two: Fill the bottom third of the trench with base material (also called base rock, crushed rock, or aggregate base), and tamp it down. (If your soil is fast draining, you can forgo the base and lay the bricks on a one-inch bed of sand right over the soil.)

Step Three: Top the base with course-grit sand, tamp it, and make it as firm and level as you can. Add enough sand so that when you lay the bricks on top, they will stand slightly proud of the soil surface.

Step Four: Lay bricks, then tamp down and level. There's no need to leave spaces between them.

Step Five: Water the edging to settle the sand, then reset any bricks that are lower or higher than the others. Fill any remaining crevices between the bricks or alongside the bricks with sand.

Lay edgings of cut flagstone, adobe brick, or cast concrete pavers in a similar fashion, altering the size of the excavation to match the width of the finished border. For rough flagstones, lay out the stones first, then excavate to match their shapes.

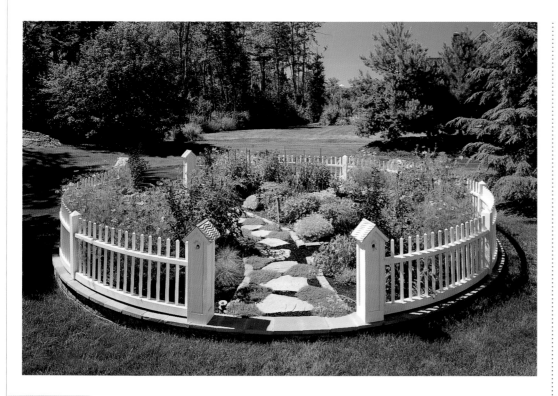

Wood. Like stone or brick, wood edgings have an organic air that complements the wandering ajuga, billowing alchemilla, or creeping thyme. They can be substantial or slight, long-lived or ephemeral. Edgings formed from flexible benderboard, for instance, can be a permanent garden fixture or may be used as placeholders until more substantial edgings are installed. Either way, they form a neat, unobtrusive outline. Look for them at home centers or lumberyards, and hold them in place with wood stakes. Most benderboard will have to be replaced about every five years. More permanent composite benderboard also is available.

You can also segregate your planting beds with lumber, wood or plastic landscape timbers, or used railroad ties, partially embedded in the dirt and secured with wood stakes, metal spikes, lengths of rebar, or sections of galvanized pipe. Such rigid timbers limit the design of beds to rectangles or squares but provide quick, inexpensive, and sturdy results. If possible, seek out wood that isn't pressure treated with preservatives. Otherwise, be sure to limit its use to areas where ornamentals—rather than edibles—are grown.

A knee-high spindle fence with birdhouse posts edges a garden within a garden (left). Ready-made wood edgings (top) and borders of felled saplings (above) are suited to the garden's wilder spots.

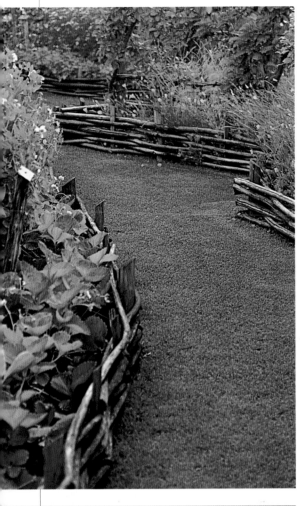

Basket-weaving skills come in handy for making wattle borders (top). This bamboo edging (above) is delicate as lace.

Medieval gardeners outlined their garden beds with woven wattle edgings: such basket-weave borders have enjoyed revivals through the centuries. Fashion simple wattle edgings by weaving willow branches, hazel saplings, or other flexible branches between knee-high palings of red cedar, locust, or redwood pounded securely into the ground. Wattle edgings bring nuances of history to a culinary or medicinal herb garden, but also may be used to ornament brick-bordered tree wells or formal planting beds.

Of similar rustic demeanor but Oriental heritage are low arcs of split bamboo, poked into place to form a visual delineation, or short lengths of bamboo close-set in a row.

Other edging choices. A multitude of edgings fills the pages of today's garden catalogs, from terra-cotta rope tiles and miniature iron fences veiled in rust to openwork iron panels decorated with fleur-de-lis. All will add sparkle and interest to small-scale plantings, but won't withstand the abuse that more practical edgings must endure. At the other end of the decorative spectrum are no-nonsense edgings of U.V. stabilized polyethylene, PVC vinyl, or other resins, most of which come in flexible sections that lock together and can be pounded into place. They get the job accomplished, but do little to enhance a garden's character.

EDGING ARTISTRY

While the materials outlined above are standards, almost any material can be pressed into service as a garden edging. Gardeners near the sea may find a way to use driftwood around their windblown, salt-rimed beds, the way Victorian and early 20th-century gardeners once outlined gardens with gleaming abalone shells or sun-bleached whalebones. In the Southwest, gardeners may line up discarded terra-cotta roofing tiles around their beds of succulents and cacti or enlist

clay drainage pipes for border use. Iron horseshoes border some small-scale flower beds, and daring gardeners have been known to outline pathways with upside-down wine or gin bottles, buried in the ground with only their bottoms bared.

One gardener even rims her beds with old plates, bought for a dime or quarter at thrift stores and garage sales. In future years, perhaps she may segregate her finds according to their formality: bone china for the flower borders, stoneware for the vegetable beds, melamine for the xeriscaping. Don't hesitate to take her cue, and draw your lines in the earth in any manner you please. Turn terra-cotta pots on end and bury their rims in soil. Alternate granite cobbles with old billiard balls or blue glass bottles. Build a miniature fence of thrift-store forks.

Such edgings provide us with an opportunity: for order, discipline, and emphasis—yes, but also for innovation, artistry, and laughter. And as we plant or tend the beds they border, they lighten our labors, and our spirits soar.

Ornamental edgings have 19th-century predecessors. Some original rope designs have been replicated in colored concrete; others are made in authentic terra-cotta.

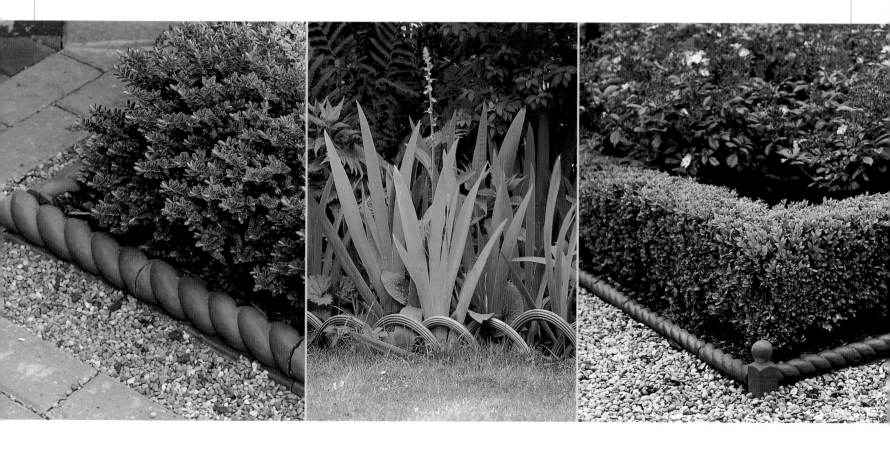

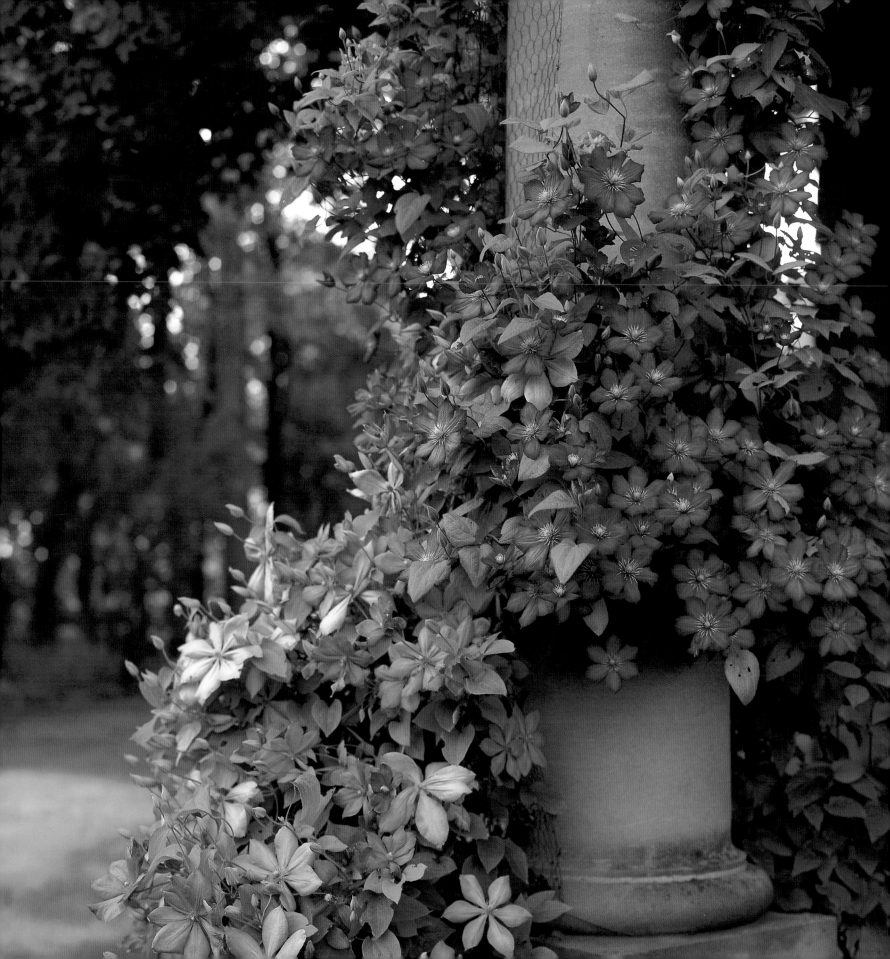

CHAPTER FIVE # TRELLISES: *climbing lessons*

Trellises are the teachers of plants; they take young sprouts and shoots firmly in hand and guide them along whatever path we dictate. They prompt the wisteria up the porch posts and along the eaves of the house. They encourage Scarlet Star morning glories up the side of the barn and over the shingle roof. They train the lima beans to clamber into the sunlight and tutor the clematis in climbing.

Deployed throughout the garden, they perform their pedagogy whether we are there or not. In spring they coax the first groping tendrils of the sweet peas to grab hold, and provide a ladder skyward for a fragrant cloud of blooms. In summer they support the weight of a bushel's worth of pickling cukes, a ton of tomatoes, a gross of cantaloupe. In fall they display the remains of the garden's glory: the bleached haulms of the beans, a late crop of English peas, the last flush of the Graham Thomas roses. Even in winter trellises perform their duties, watching over the dormant climbers and preserving the garden's shape while their once-exuberant pupils subside for the season.

But trellises do more than school our plants. They maximize the way the

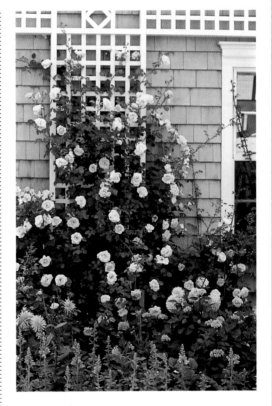

A discreet trellis of chicken wire gives clematis a boost (opposite). Roses get support from a crisp lattice grid (above).

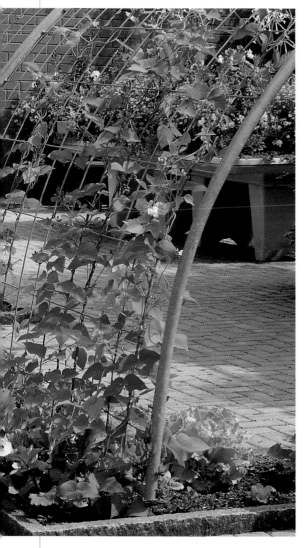

Beans are equally happy twining through the wirework of an arched tunnel frame (above) or up the legs of a bamboo tepee (opposite).

space in the garden is used, allowing us to grow butternut and 'Delicata' squash as well as Charentais melons, sweet potatoes, and other greedy ramblers even if we only have a postage-stamp-size plot. They turn a half whiskey barrel into a vegetable garden, a sun-baked wall into an orchard, an overhead shade screen into a vineyard. Each square foot of the garden suddenly becomes eight square feet of vertical possibility.

In the process, trellises foster the health and vigor of our plants. When raised up from the ground, dew-drenched leaves are dried by the barest of breezes. Mildews, rusts, and various nasty spots are less likely to find a foothold on the blackberries or roses. And every fruit, flower, or vegetable gets an optimal dose of sun.

With the plants up on a trellis, it's also easier to clean away the litter on the ground that harbors insects and diseases and to inspect the plants for aphids, bristly rose slugs, or voracious Mexican bean beetles. Likewise, friendly lady beetles, green lacewings, and minute pirate bugs will be easier to see and appreciate when up at eye level.

Even the spraying of insecticidal soap or kelp foliar feeds is faster when the plants are in the air rather than sprawled across the flats, as are the pruning and shaping that many plants need to reach their full potential. And watering and weeding chores are limited to the small plot of ground at the base of the trellis, not the acreage under a typical squash or melon vine, allowing time for more rewarding work.

Trellises aid the harvest, too. No more trampling the vines when beelining toward a prime acorn or spaghetti squash, or risking your neck when picking the pears from a ladder at the top of a conventionally grown tree. When trellis-grown, tender green beans dangle at your fingertips, melons nestle into easy-to-reach slings, and thorny vines surrender berries to your basket with hardly a defensive scratch.

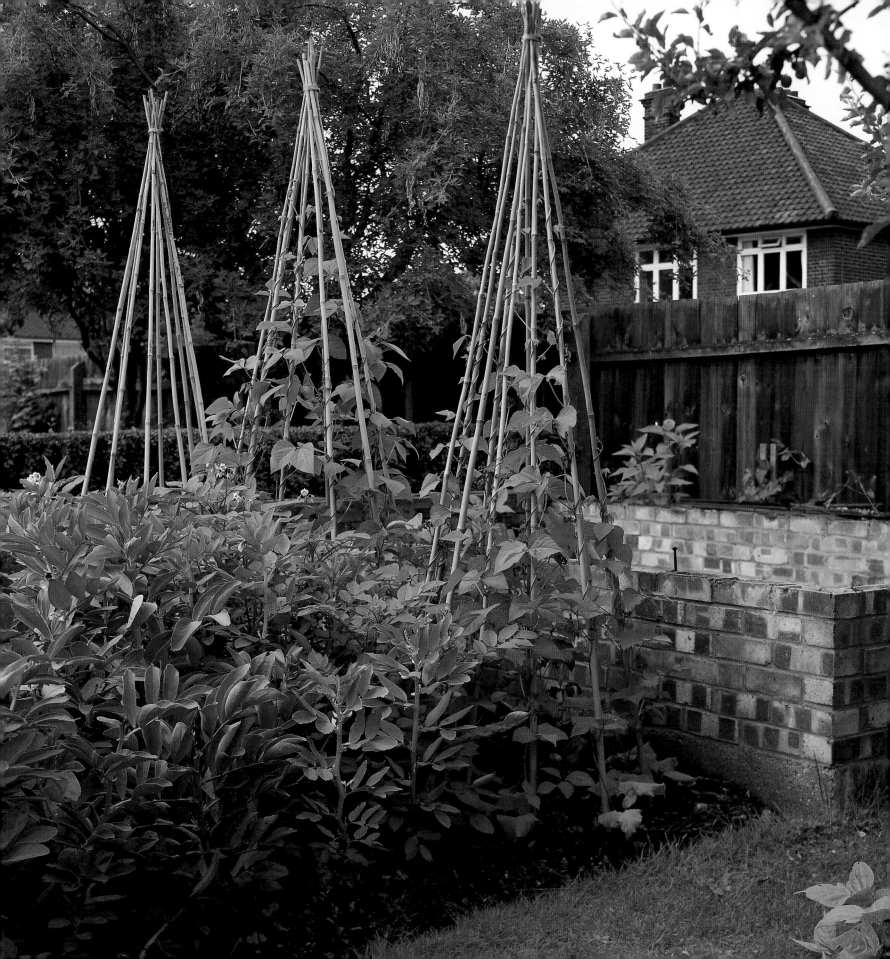

Morning glories are twiners, winding their stems in and around a chicken-wire trellis, while sweet peas grab hold with strong but delicate tendrils.

THE CHARACTER OF CLIMBERS

One size—or type—does not fit all when it comes to trellises. That's because different plants need different types of trellises to foster their development. Some plants don't need a trellis at all; they'll scale a wall or climb a tree with only a hand up to get them started. Others need their shoots or branches tied to a framework, repeatedly, to keep them growing vertically. It all depends on how much the plants are naturally inclined to climb.

Twiners. These sinuous plants wrap their shoots around whatever they can: fence posts, narrow tree trunks and branches, trellises, even a string. They're not picky about the girth of their support, though they may need a temporary foothold or guide such as plastic netting or strategically placed bamboo canes to get them started. Some, like wisteria, will grow into muscular behemoths that become a permanent part of the landscape; others, like annual morning glories, will come and go with the seasons and can be placed with less planning. Twiners have a natural direction of curl; don't try to make them grow opposite their inclination.

Twining vines include morning glories, honeysuckle (*Lonicera*), hops (*Humulus lupulus*), Dutchman's pipe (*Aristolochia*), kiwi (*Actinidia deliciosa*), hyacinth bean (*Lablab purpureus*), scarlet runner beans, pole beans, black-eyed Susan vine (*Thunbergia alata*), silver lace vine (*Polygonum aubertii*), common white jasmine (*Jasminum officinale*), herald's trumpet vine (*Beaumontia grandiflora*), most clematis, Malabar spinach (*Basella alba* and *B. alba* 'Rubra'), and fiveleaf akebia (*Akebia quinata*).

Tendrils. Many favored garden vines reach out for support with delicate corkscrew tendrils or curling leaf stalks. These vine types appreciate narrow supports on which they can easily get a grip, from wire mesh or string trellises to narrow latticework or bamboo tepees lashed with jute twine. Some, such as garden

peas or sweet peas, need help getting from the ground to the first rung of the trellis and don't like to negotiate gaps greater than four inches. Traditionally, gardeners have saved brushy sticks—called pea brush—and hung them from the trellis to give sprouting peas something to cling to.

Tendril-equipped plants include many tender tropical vines such as passion vine (*Passiflora*) and cup-and-saucer vine (*Cobaea scandens*), as well as sweet peas (*Lathyrus odoratus*), garden peas, *Clematis armandii,* and cucumbers. Given a good start, clematis and sweet peas both star at working their way up through shrubs or informal hedges, spangling the greenery with soft blooms. Wild grapes use tendrils to pull themselves toward the sunlight, but most garden-grown grapes are trained by the gardener around posts and up over an arbor or espaliered on a wire trellis.

Clingers.

All the trellis these plants need is the vertical surface of a stone, brick, or masonry wall, or even a fence. Though they may require some help to get started (point them in the right direction with bamboo or wood stakes), once their shoots contact the wall they'll hold on with the help of adhesive-tipped tendrils or with aerial rootlets. Most won't harm a solid wall, but the rootlets of some clinging plants will find a toehold where mortar is crumbling and loosen it further. And if the plants reach the roof, they may shoulder their way beneath the shingles.

Favored clinging vines include English ivy (*Hedera helix*), Virginia creeper (*Parthenocissus quinquefolia*), Boston ivy (*Parthenocissus tricuspidata*), climbing hydrangea (*Hydrangea anomala*), trumpet vine (*Campsis*), and winter creeper (*Euonymus fortunei*—also sold as *Euonymus radicans*).

Leaners.

Some vigorous and thorny roses will clamber on their own through the branches of trees or over the potting shed or garage, but most so-called climbing roses need our help—and a trellis—to reach their full potential. As the canes grow, it is up to the gardener to tie them gently to a sturdy wood trellis, twine them

Like sweet peas, garden peas climb with the aid of corkscrew tendrils (above). Roses need help in rising to the heights (below) and must be tied to their supports.

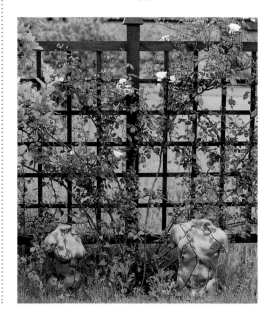

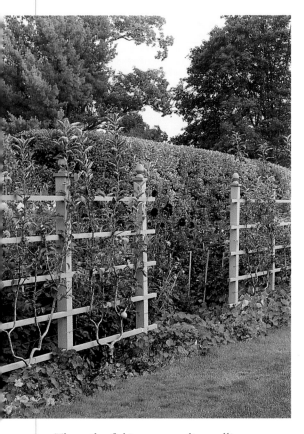

The rails of this neat espalier trellis are set into the posts so their surfaces are flush. A pastel coat of paint distinguishes the structure from its backdrop of green.

around strategically anchored fishing line or wire, or secure them around broad pillars with staples and ties.

Other plants are similarly ill-equipped to climb, and will simply sprawl without support, including raspberry and blackberry vines, winter squash, melons, tomatoes, bougainvillea, Spanish jasmine (*Jasminum grandiflorum*), and cape plumbago (*Plumbago auriculata*).

Non-climbers. Vines and climbers aren't the only plants that thrive with the support and guidance of a sturdy trellis. Many trees and shrubs can be trained to grow in a flat plane on a wood or wire trellis, a process known as espalier (see Chapter Nine). These take the most attention from the gardener of all trellis growers, often requiring rigorous tying, training, and pruning. But the decorative effect and increased display of fruit or flowers are well worth the hours spent with pruner and ties in hand.

Fruit trees are often espaliered, rewarding the gardener with a tree of minimal size—and taking up minimal ground space—from which plump pears or apples dangle like so many Christmas ornaments. But shrubs are excellent subjects for espalier, too. Some of the easiest to espalier include flowering maple (*Abutilon*), some types of camellias, cotoneaster, sweet olive (*Osmanthus fragrans*), pyracantha, *Sarcococca ruscifolia,* and *Viburnum plicatum.*

TRELLIS TRADITIONS

Trellises have undisputed tenure in the garden; they've tutored grapevines and other plants for at least four thousand years. Through the centuries, as gardens evolved from necessities for survival to pleasure grounds, simple grids for supporting climbing plants blossomed into arbors, pergolas, latticed garden houses, or purely decorative treillage. But wherever food was grown for the table, simple utilitarian trellises continued to prove their worth.

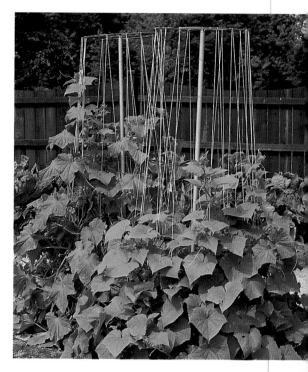

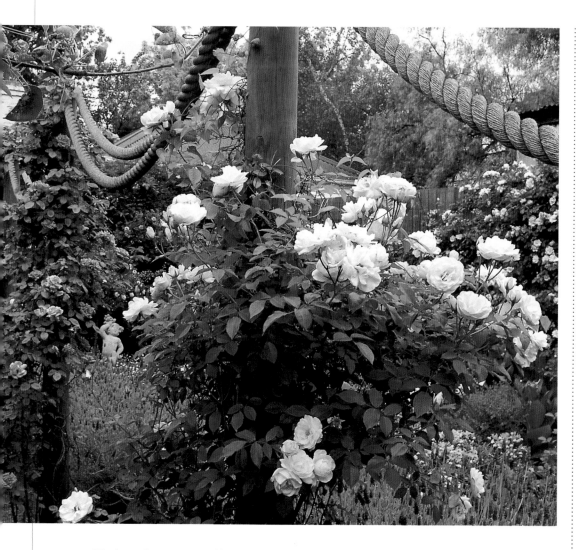

Today, there are trellis designs well suited to whatever plants you pine for, whether they be roses, sweet-scented tropical vines, or kitchen garden staples such as squash, cucumbers, peas, or tomatoes. Here are some of the classics:

Stakes and poles. Pound a redwood or cedar stake in the ground, plant a pole bean at its base, and you have the simplest trellis around. Annual vines that twine will climb a stake, as well as a clothesline pole, lamppost, porch post, or any other slim upright. Consider making a floral stonehenge by pounding stakes in a circle and planting morning glories at the base of each. Tie ropes from one stake to the next, so that the graceful shoots, spangled with blue or pink, can bridge the

Rope swags will soon be abloom with roses (left). String trellises have many designs, and are optimal for twiners such as beans (top) or sweet peas (above).

gaps. Or make a permanent maypole by anchoring a decorative, finial-topped post at the center of the garden. Secure jute ropes to the top of the post with screw eyes and anchor them out from its base, then grow a different flowering vine up each. Or erect poles thick as tree trunks along a path to form an open-roofed colonnade; each will support the glory of a wraparound pillar rose.

Tepees. A tripod, quadripod, or tepee performs the same role in the garden that a steeple does on a church; it points our eyes toward the heavens, lifting the garden up, out of the muck and manure and into the light. As such, a tepee is more than a trellis; it is a timeless garden ornament with the power to direct our gaze and focus our attention.

In the perennial bed, a simple stake tepee becomes an upright fountain of bloom when home to a 'Mme. Alfred Carrière' rose or bleeding heart vine

The design of garden tepees is limited only by the materials at hand. Here, one is woven from saplings and flexible vines or clippings (below); another is made from twiggy sticks, poked into the ground for stability (center); a third design depends on saplings and garden twine (right).

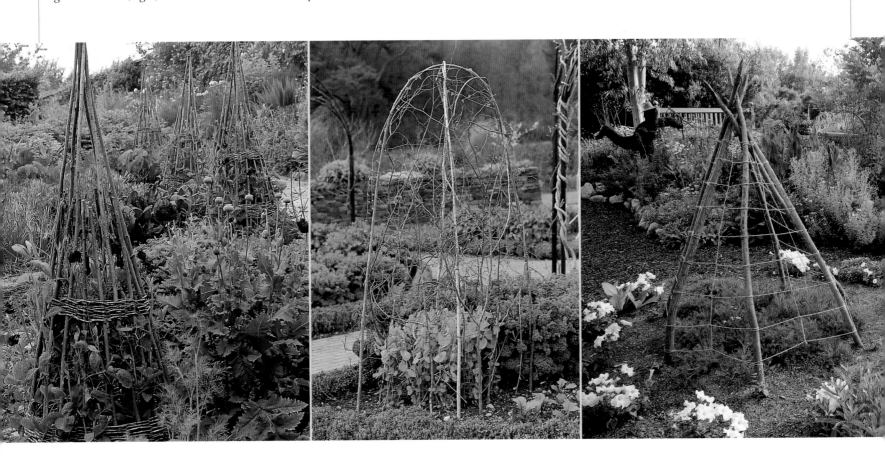

(*Clerodendrum*). Its vertical form draws the eye and lends a certain formality to the garden, even when entirely bare of vegetation. Flanking a pathway, two narrow, four-legged tepees take on the ancient power of the obelisk, once the sacred symbol of the Egyptian sun god; they call us to pass between them. At the outer limits of the garden, a whole row of vine-clad bamboo tepees becomes an enchanted encampment, a vision conjured from some prehistoric age.

Tepees are equally at home in the vegetable garden, overrun with *haricots verts* or heirloom 'Green Annelino' beans. Many a gardener's child has laid claim to such structures, dallying there with a friend or two until the sun fades and the call to head indoors floats across the lawn. Beneath such tents of green, secrets have been shared, ritual games played, dreams dreamed, and gardeners born—weighty goings-on for structures made of stakes, sticks, bamboo poles, or palings, lashed together at one end and splayed outward at the other.

> "*A morning-glory at my window satisfies me more than the metaphysics of books.*"
> —WALT WHITMAN

Towering bamboo tepees (left) flank a garden walk and lend a vertical emphasis to a flat garden space. Likewise, parallel rows of cedar obelisks play an ornamental role when bare, but will also provide support for sprawling roses later in the year (below).

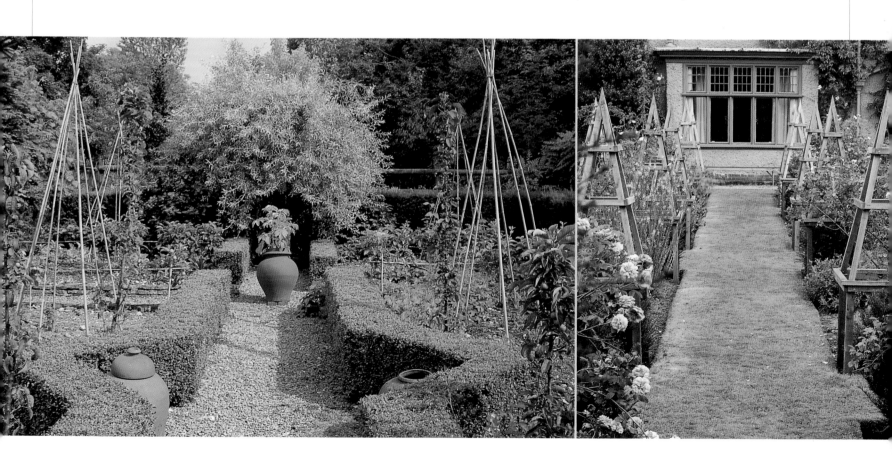

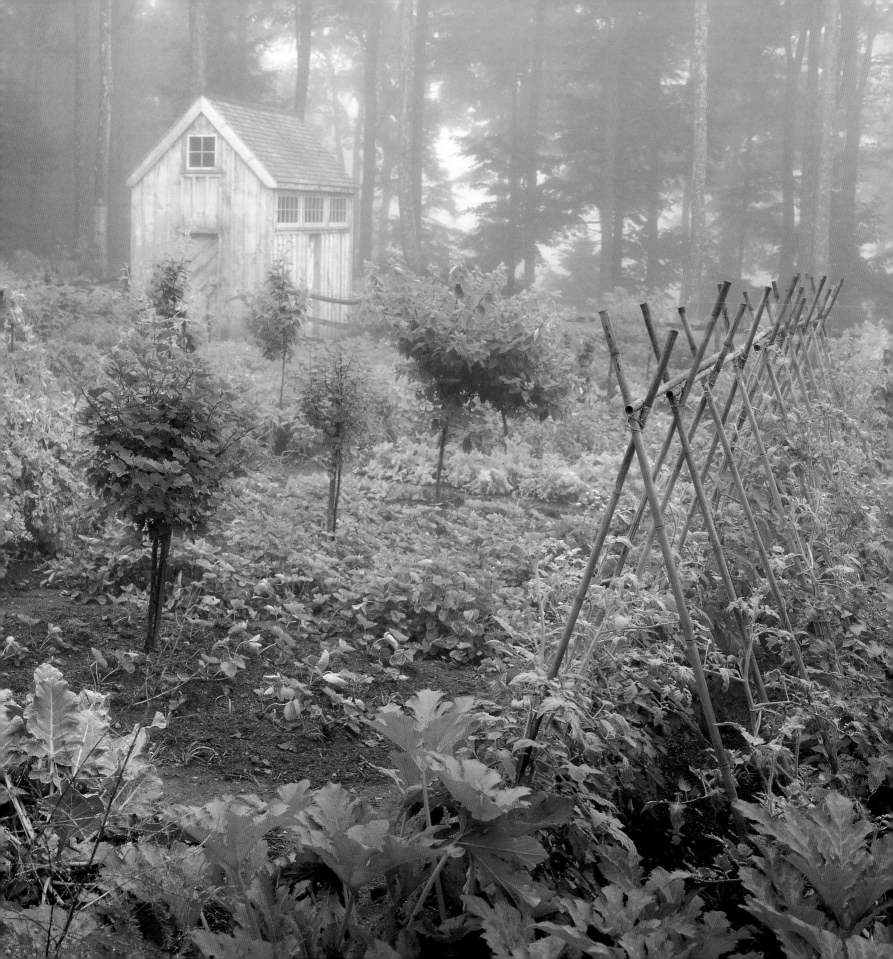

Some vines need horizontal footholds to climb a tepee's vertical form. Secure jute twine or rope around one of the tepee's legs, close to ground level, then stretch it to the next leg, loop it around, and tug it tight, then stretch it to the next leg. When you return to the leg you started with, angle the twine up and make another pass around the tepee three or four inches up from the first rung of your twine ladder. Continue until you reach the tepee's top, then tie off the twine. If you want to leave a doorway in a large tepee, you'll need to wrap rope or twine around one way, then back in the opposite direction, always leaving an open space on one side.

For stability, the legs of tepees should be firmed into the ground to a depth of one or two feet. Better to anchor a tepee securely than to arrive in the garden after a stormy night and find your structure and your just-matured bean vines or blooming roses toppled.

A-frames.

Campers will recognize this pup tent look-alike. It's one of the most versatile of garden structures, capable of performing a variety of jobs throughout the seasons. Cover a wood A-frame with plastic sheeting, and it becomes a mini-greenhouse. Cover it with shade cloth, and it shields a whole bed of seedlings or transplants from the sun. Drape it with bird netting, and it foils hungry crows or starlings in search of seeds. But mostly, put it to work as a sturdy movable trellis that can be set up one year for growing squash and another year for coddling cucumbers.

A-frames are formed from a pair of rectangular frames, built from one-by-twos, two-by-fours, or a combination of lumber sizes, that are hinged together along one side so they open and close like a book or a sandwich board. It's best to fit your A-frames with crossbars or ropes so they only open to a certain angle.

Cover the frames with galvanized wire mesh, nylon netting, lattice, or lengths of twine, depending on the crop you plan to grow. Make your A-frames tall enough so that you can easily reach inside them at harvest time; vegetables such as cucumbers will dangle down inside.

This A-frame trellis (opposite) is an extended version of the tepee form. The slatted A-frame trellis at top is built more like a sandwich board, as is the string trellis above.

TREILLAGE: PAST PERFORMANCES

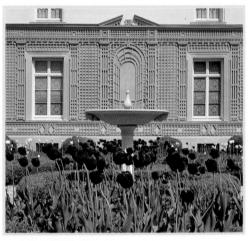

For millennia, trelliswork had a supporting role in the garden, allowing vining plants to climb or dividing one section of the garden from the next. But in the royal gardens of 17th-century France, grids of wood suddenly took a star turn, blossoming into elaborate pavilions, panels, walls, alcoves, doorways, and arches that mimicked classical architecture.

Trelliswork as elaborate as this was never hidden under a cloak of clematis or roses.

Like divas onstage, such carpentered works dominated royal grounds, void of the demure costuming of plants they had previously worn. Known now as *treillage*, these architectural conceits turned heads of peasants and royalty alike. Most of all, they signaled to all who viewed them that man's artistry was superior to nature's handiwork—just what their builders had in mind.

The Dutch followed the French lead, then added their own exclamation points in the form of treillage obelisks, painted white. These eye-catchers towered over the flat landscape and marked the beginnings of paths, stood at the center of parterres, or topped the corners of treillage walls.

French *treillageurs* (trellis makers) continued to excel during the 18th century, mimick-

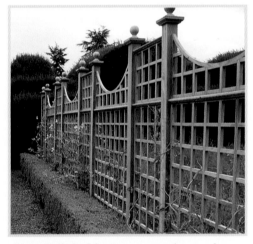

An embellished lattice screen takes on the weight of architecture in the garden.

ing Palladian pavilions and creating arched doorways-to-nowhere that fooled the eye with faked perspective. But more naturalistic styles, prompted by England's landscape movement and a penchant for the rustic and picturesque, soon brought trelliswork back to earth, where it stayed through most of the Victorian era. It wasn't until the late 19th century, and the early years of the 20th century, that treil-

lage had its long-awaited encore.

Today, few us could afford the elaborate—and ephemeral—carpentered work of days gone by; we'd rather invest in nature's glories. But don't overlook the possibilities of this elegant art. Modest treillage panels will lend architectural drama to the walls of city gardens, conjure up doorways or windows in impenetrable brick, or emphatically curtain off one part of the garden from the next. Likewise, treillage obelisks will evoke more substantial monuments and garner immediate attention, whether flanking walks or

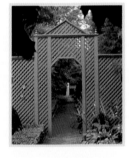

crowning paneled planter boxes. Home-built or purchased, and painted traditional white, blue, or blue green, all will lend a hint of 17th-century theatrics to the garden.

A-frames can also be made from lengths of stiff wire mesh, folded down the middle to form the A-frame shape, or from poles or stakes lashed together in a sort of extended tepee form.

Cages.

Plants such as tomatoes thrive in a cagelike trellis that gives the plant support for climbing upward as well as protection from wind damage. Most tomato cages are made from metal mesh. Make sure the squares of the mesh are big enough to slip your hand through for harvesting those crimson beauties (6-to-8-inch openings are optimal), and that the wire is stiff enough to support itself and the weight of a vine laden with hefty 'Brandywine' or 'Purple Cherokee' tomatoes. You'll need more wire mesh than it seems; a 3-foot-diameter cage requires a 9 ½-foot length of wire mesh, a 4-foot-diameter cage a 12½-foot length. Tomato cages or stakes should be 40 inches tall for determinate varieties and 72 inches tall for indeterminate types.

Cages can be circular, triangular, square, or tunnel-shaped. Some gardeners simply coax the wire mesh into a circular shape, then bend the cut wires along one edge to secure the ends to one another. Others secure the cut ends of the mesh to wood uprights that can be joined together with hooks and eyes and unhooked when the season ends. Tomato cages should be staked in place to provide extra protection from wind.

Numerous commercial tomato cages are available at garden centers and nurseries and through mail-order catalogs. Look for sturdy construction, but the most important thing is adequate size. Tomatoes will soon outgrow puny supports.

Double trellises.

Blackberries and raspberries take to a double-sided trellis that keeps the canes upright while still allowing air circulation and sun into the berry patch. Think of two double-armed telephone poles at either end of the berries, with two pairs of wires running from one to the other; one set connects the upper pairs of cross arms and one the lower pairs of cross arms. The parallel wires form a modified cage around the berry canes. If desired, use turnbuckles to keep the wires taut.

Purchased metal rose pillars double as classy cages for cherry tomatoes (top). These hand-woven cages (above) would support the growth of many floppy garden mainstays in rustic style.

Store-bought lattice, painted and framed in at the edges (below), sets off pink and lavender climbers. Rope gives roses a ladder to climb (center). Purple-painted lattice dresses up a vegetable garden (right) and matches the hues of the cabbage and eggplant.

Rectangle trellises. These are the trellises that rise beside many a doorway or embellish many a garden fence or wall. Garden workhorses, they're generally made of a sturdy wood frame surrounding a panel of lattice strips in a grid or diamond pattern. Such lattice panels, formed from thin strips of wood that are stapled or tacked together, can be purchased in two-, three-, or four-by-eight-foot sheets at most garden centers, but also can be made at home from sturdier stock such as one-by-twos. Rectangle trellises also may be mounted between two posts to create a freestanding trellis screen and can be custom-made to fit any space.

Other options for rectangular trellises include wood frames filled in with string, wire, nylon netting, or wire mesh. Frames for rectangular trellises also can be made from PVC pipe (paint the pipe to protect it from UV damage), galvanized pipe, or copper pipe.

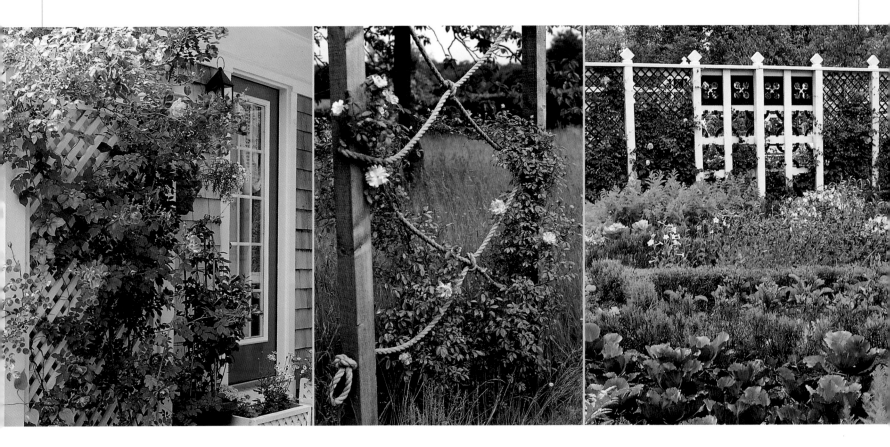

Decorative trellises. The bare expanse of clapboards beside the back door, or the naked expanse of fence at the culmination of a pathway, is a prime location for a trellis with some architectural flair of its own. The decorative potential of such trellises is almost without limits; give a gardener a handsaw, some galvanized screws, and some lengths of one-by-two lumber, and almost anything can happen. One gardener's trellis may flare out like a kite at the shoulders, its five vertical members and paired rungs culminating in eye-catching concentric diamonds. Another gardener might create a pierced screen with diamond-shaped openings; yet another might screw together a bold fan, sturdy enough to support a 'New Dawn' rose.

Gardeners who pine for a woodsy look may form their trellises from discarded prunings and supple saplings, bent and nailed into artful arches and diamond grids. Still others prefer bamboo for their decorative trelliswork.

Decorative trellises can be left unfinished to weather over time (rustic trellises

A simple lattice ladder encourages roses upward (left), softening the edges of a porch. The side of this arbor was filled in with sturdy latticework to form an oversized trellis (below).

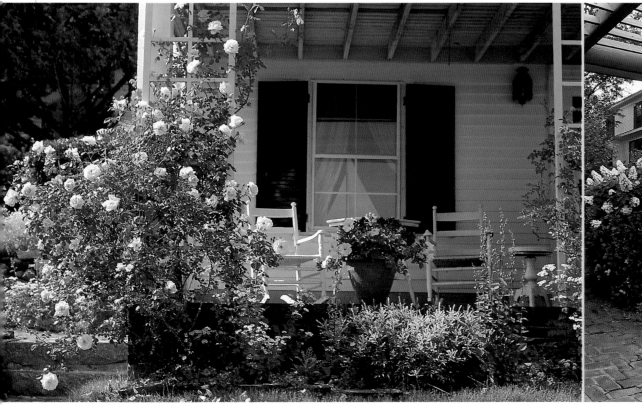

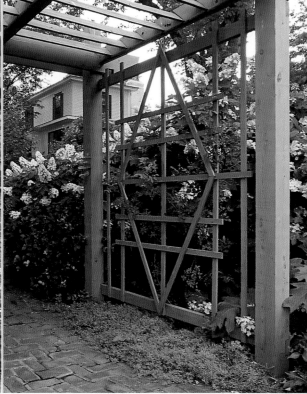

HOW TO

FASHIONING A TRADITIONAL TRELLIS

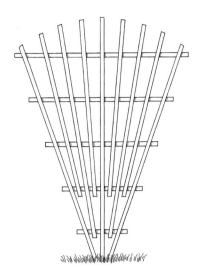

Traditional trellises have more muscular frames than those sold at most garden centers, and will welcome the twining grasp of the morning glory as well as the upward thrust of the most vigorous climbing rose.

A decorative trellis is just as easy to build as a trellis with a simple grid or ladder design, so take some time at the beginning to sketch out the possibilities on graph paper. Aim for a finished trellis that's two to three feet wide and six to seven feet tall. Experiment with different spacings of the uprights and horizontal members, making them anywhere from three to nine inches apart. Overlay diamond shapes. Splay the uprights outward slightly into a narrow fan shape. Make some horizontal members longer than others.

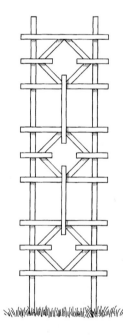

Once you've settled on a design, calculate the amount of lumber you'll need. Trellises for lightweight vines can be built from lath, lattice, or flat molding (approximately ¼-inch by 1½ inches); trellises for roses or other heavyweights should be built from 1-by-2s (which actually measure ¾ of an inch by one and a half inches). Seek out rot-resistant woods such as cedar or redwood for trellises that will be stained or left to weather. Pine or fir will suffice for trellises that will be painted.

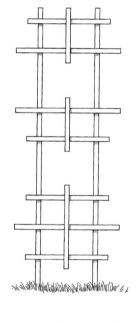

Cut the lath or 1-by-2s to length according to your design with a handsaw, circular saw, or backsaw and miter box, then lay the pieces out for a dry run. Adjust spacing as desired. If you plan to paint or stain your trellis, now's the time, so that all the surfaces can be coated.

Assemble the trellis using galvanized or brass wood screws at every point that two pieces of lumber cross. Predrill screw holes to avoid splitting. Touch up paint as needed.

Traditional trellises are most at home dressing up the exterior of a house. Attach the trellis to the wall at top and bottom with lag bolts, using wood blocks behind the trellis to keep it at least four inches from the wall surface. For masonry walls, drill a hole in the wall with a masonry bit, insert a dowel or plug, then screw in the lag bolt.

almost always are left in the buff). But traditionally such garden artworks were painted either white or dark green to set them off from their background and show off their form. Today, there's no reason they can't be painted cerise or chrome-yellow, or stained a dusky teal or purple, if those colors suit the spirit of your garden.

Well-built trellises are available through many garden catalogs and at nurseries and garden stores. Particularly elegant are arched-top iron or steel trellises with simple decorative motifs, or ready-made rustic twig trellises formed from flexible saplings or vines. In general, avoid the flimsy decorative trellises, such as fan trellises, sold at many garden centers; they won't last long and can't support either the weight or the bulk of many varieties of climbers.

In addition to commercially available trellises, or ones you make yourself, a carpenter should be able to tackle almost any design, and may even add some innovations of his or her own.

Wire trellises.

Galvanized wire often forms the gridwork of a garden trellis, but also can be used to make an inexpensive trellis for growing roses against a house or for espaliering fruit trees or shrubs against a wall or fence.

For a fan-shaped wire rose trellis, anchor eight or more strands of 12-gauge galvanized wire to the ground and eaves of the house in the following manner: Place a three-inch metal ring on the ground about a foot out from the wall and use a sledgehammer to pound two pieces of rebar, each at least one and a half feet long, through the ring and into the ground at opposing angles. Leave the top six inches of the rebar protruding from the soil in a V to hold the ring in place. Twist one end of each wire securely around the metal ring. Thread the other ends of the wires through screw eyes spaced out along the fascia board, rafters, or top plate of the wall, pull to tighten, and secure. Plant your rose about a foot in front of the wire fan, making sure it's not directly under the drip line of the roof.

You can also concoct a horizontal wire trellis out of galvanized wire that's well

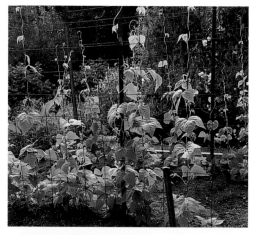

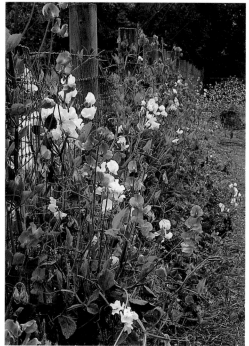

Bean vines thrive on a wire trellis made from metal stakes and wire mesh (top). A boundary fence of round posts and wire mesh becomes a colorful trellis when sweet peas are allowed to climb (above).

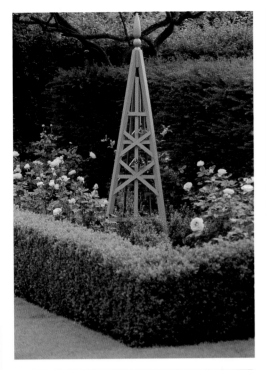

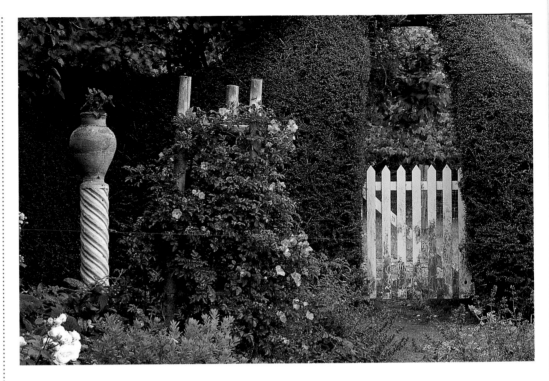

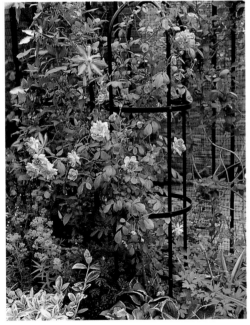

A painted obelisk is both ornament and trellis (top). Rose pillars (above) come in a variety of sizes and designs. A sturdy, three-legged trellis (right) will soon be smothered in blooms.

suited for many espalier designs, as well as for training rose canes horizontally for maximum bloom production. Screw six-inch-long screw eyes two inches into the posts of a fence, then run wire between them. On masonry walls, use special masonry fasteners. Space the horizontal wires about a foot apart. For flimsier vines, use smaller screw eyes and connect them with fishing line or plastic clothesline.

Specialized rose trellises.

Victorian gardeners were wild about roses, and metalworkers and garden suppliers catered to their passions with a plethora of specialized trellises or trainers. Some were shaped like umbrellas; the rose was trained up the handle and then out and over the canopy. Some were made from oak and iron and shaped like vases, and were designed to be set at the center of a paved stone circle. The rose grew up the openwork center of the vase, then overflowed the rim like a sumptuous bouquet. According to one 1906 catalog, such trainers were "far preferable to ordinary pea sticks or bamboo rods, as they are never unsightly, even when the plants are growing or when the foliage begins to disappear."

LATTICE PATTERNS

Latticework does more than seduce the clematis or give a leg up to the twin-ing hops; it also changes the way the garden is perceived. Lattice in a simple grid pattern has a calming effect, and directs the eye either up and over or from side to side. Lattice in a diamond pattern is more stimulating by nature because it lures the eye in many directions at once.

When erecting a simple lattice grid, determine which side should face the viewer. If your garden is on the cramped side, or you want to draw attention away from the compost bins or neigboring house behind the lattice, place the grid so the horizontal strips are to the front. The horizontal emphasis will help stretch the garden's dimensions, stop the eye from moving past the trellis, and balance vertical garden features such as trees or upright shrubs.

Conversely, place the grid with the vertical strips to the front if you want to draw the eye upward and into the distance

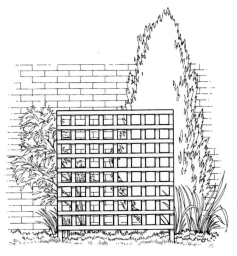

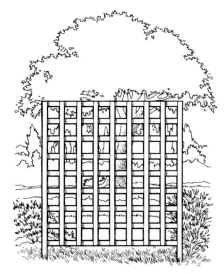

beyond, to make a large garden seem more intimate, or to complement plantings that sprawl and spread.

Diamond-patterned lattice conjures up the elusive Middle East and recalls delicate garden dividers of medieval design. Its effect is more decorative than square grid-work, since it doesn't echo the predominant lines of other structures or of its frame and supporting posts. If you purchase ready-made lattice panels, be sure to frame them in so that the ends of the lattice don't stick out.

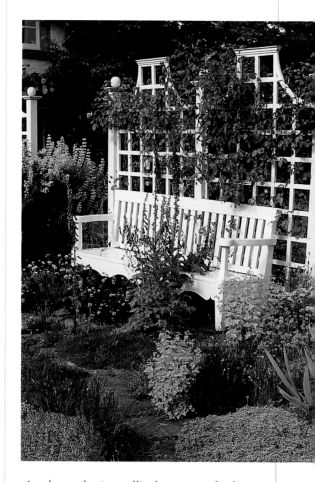

An elegant lattice trellis, home to a climbing rose, forms a dramatic backdrop for a garden bench. Along with adding architectural ornament, the trellis screens one garden room from the next.

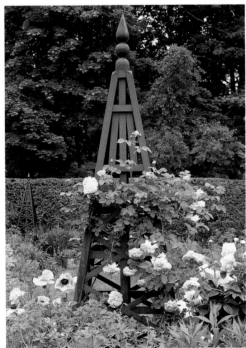

Whether made of metal (top) or cedar (above) obelisks or tuteurs have undeniable impact in the garden. Here, their visual allure is heightened by a colorful coat of paint.

▐ HOW-TO ▌ TWIG TRELLISES

A s an antidote to the Industrial Age, Victorians developed a penchant for the wild. They built rustic gazebos to overlook lakes, rustic bridges to arch over streams, and rustic fences and gates to frame their country cottages. All were fitted together like jigsaw puzzles from gnarled trunks or branches.

Today, gardeners recapture the wilderness spirit of the 19th century by building trellises from tree trimmings, saplings, suckers, or other flexible green woods. So get out the loppers and pruning saw, and gather your materials from the woods or garden. Then, experiment with possible designs. Start with a pint-size trellis for ornamenting an oversize pot or half whiskey barrel, then graduate to full-size rustic works.

Select two uprights and cut them to the desired trellis height (three feet for a small trellis or six to seven feet for a full-size trellis). Uprights for a small trellis should be three-quarters of an inch to one inch in diameter at the base; uprights for a large trellis should be one and a half to two inches in diameter at the base. For an arch-top trellis, the uprights should be approximately half again as long as for a flat-top trellis, and should taper. Flexible green wood is a must.

Lay the uprights parallel to one another, one to three feet apart, depending on the trellis size. Using galvanized nails, attach two crosspieces to the uprights. Position one crosspiece near the bottom of the trellis and a second crosspiece near the top of the trellis to form a rectangular frame. Lash these primary joints with wire to stabilize them. If the trellis will have an arched top, bend the ends of the uprights over and attach with wire to the opposite upright. Or, wire a separate flexible piece of wood to both uprights to form the arch.

Add additional crosspieces, a diamond-patterned lattice, inner arches or half-arches, or whatever your imagination and materials dictate. Fasten the trellis to heavy rebar (metal reinforcing rod) pounded securely into the ground.

Other ready-made trainers were fashioned from wirework and shaped like hot-air balloons or baskets. Smaller wire trainers, shaped like today's tree guards, were designed for training sweet peas, while fan-shaped wire trainers were designed for sticking in flowerpots. They came with a galvanized finish or were japanned green.

More formal were "treillage pillars" around which a climbing rose could twine. Some were like openwork obelisks in form, capped with ball finials; others were more architectural in feeling. All were sheathed in lattice and made from sturdy oak or painted pine or fir.

Today, we're once again enamored of the old rose types, and many of the specialized trellises their blooms once graced have been revived. Catalogs and garden stores abound with beautiful obelisks with ball finials, forged steel rose towers (which resemble tree guards), cedar tuteurs (like glorified lattice tepees), and black steel rose pillars in heights ranging from four to eight feet. Remember: roses won't take naturally to these trainers. You'll need to lead them where you want them to go, and loosely tie their canes in place with twine or stretchable plastic garden ties.

Oddball trellises.
You needn't follow tradition when choosing teachers for your plants; peas will just as happily swarm over an old bedspring, set on edge, as up the finest wood-and-wire trellis around. Secure an old iron gate to a wall and let the morning glories earn their degree in climbing. Salvage a revolving metal display rack and let your beans explore its nooks and crannies. Set an old fruit-picking ladder against an aged apple tree, as if forgotten by a long-ago gardener, and let a 'Garland' rose negotiate its rungs and graduate to tree climbing.

Sometimes the unexpected things in life are the best teachers of all.

COLORS FROM THE PAST

The white-painted treillage obelisks that pointed skyward in 17th- and 18th-century Dutch gardens glowed with an almost ethereal light—at least as painters of the time depicted them. In real life, however, white latticework quickly loses its freshness and allure unless given a new coat of paint every year or so—a difficult task if the trellis is home to a rose or other perennial climber.

Traditional colors that stand up better in the garden include gray-blue, blue-green, British green (a green so deep it's almost black), sage green, Monet green (which colors the famous bridge at Giverny), lacquer red (for Chinese-style lattice), or Repton blue, a soft hue made famous by English garden designer Humphry Repton in the early 19th century.

Save white for architectural structures you wish to have stand out from their backdrop, such as an arbor in a shaded garden corner.

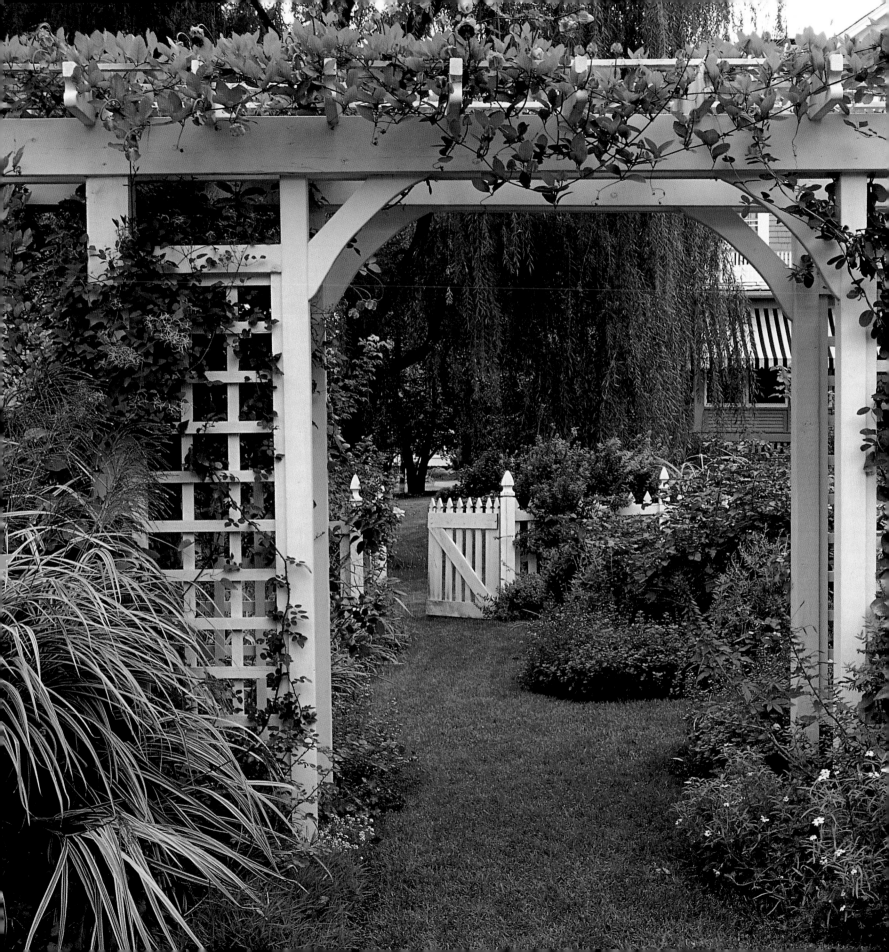

CHAPTER SIX ARBORS, PERGOLAS, AND ARCHES: *seeking shelter*

THE SUN BAKES OUR SHOULDERS THROUGH THIN SUMMER COTTONS as we hoe the latest crop of weeds and cut back the canes on the berry vines. Perspiration trickles between our shoulder blades. Our throats grow parched. The arbor beckons like a siren: cool, blue-green, alluring.

We snag a bottled water from the fridge and retreat there, hat and gloves thrown aside, work on hold. The leaves of the surrounding honeysuckle or clematis break the brightness into a hundred shades of light and dark. The breeze fingers its way through the vines and whispers against our skin.

From the arbor's sheltered bench, the garden is a feast for devouring. We look out from the shade and savor the neat geometry of the vegetable beds. We relish the riot of blooms in the perennial border and the brilliance of the dahlias. A warbler stands in the birdbath like a gaudy statuette, then flails the water into a

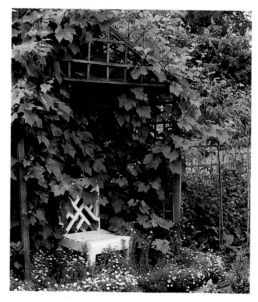

Arbors lift plants up and overhead, providing welcome shade.

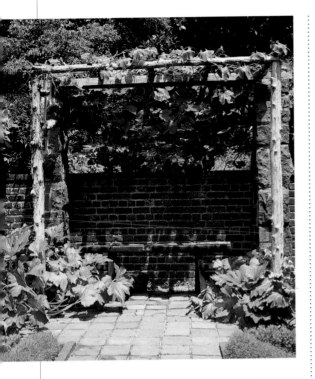

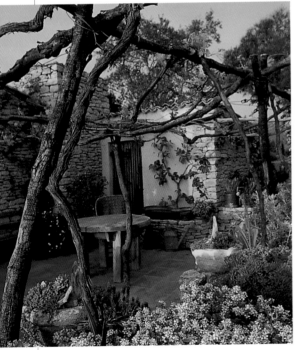

Rustic poles form fitting arbors for grapes (top and above). Part arbor, part pergola, and part pavilion (opposite), this structure encourages lingering in the garden.

burst of droplets that turn to diamonds in the sun. We note how the blue-star creeper has filled in the gaps between the hellebores and overrun the pathway.

The hoeing calls but we linger, for 15 minutes, then an hour. It isn't laziness—it's *living:* savoring this day, this hour, this moment in the garden. "How many, many gardens are wasted!" wrote Grace Tabor in 1911 in *The Landscape Gardening Book.* "How many gardens are planned and planted and carefully tended—but never *lived in* by anyone."

Arbors, and their relatives the pergola, arcade, pavilion, and even the simple garden arch, are about *living* in the garden: enjoying its ephemeral pleasures and rewards while strolling along a sheltered path, dining under a canopy of dangling grapes, pausing beneath a double arch of 'Old Blush' roses, or sharing a lemonade or a handful of *fraise des bois* in an arbor's quiet embrace.

None of these garden structures has a conventional roof to keep off the rain, which sets them off from gazebos, summerhouses, and the like. Instead, they shelter us with the layered leaves and blossoms of the rose, the clematis, the apple, or the wisteria, twined through lattice, tied to arching poles, or trained up stone pillars and across a sturdy framework of timbers. They are kin to the leafy bowers of the woods, brought out into the garden's light.

THE ARBOR

This is the term most widely used for any climber-clad garden structure. But in its classic form, the arbor is a seat shaded by a canopy of trees or shrubs, or a structure covered with vines that shades a seat or table. As such, arbors harbor an air of romance, inherited from their medieval and Renaissance associations as trysting places, spots for private amusements in the gardens of the nobility, or retreats where noble ladies could protect their complexions from the sun.

Life was relished beneath the arbor's dappled shade. An engraving from

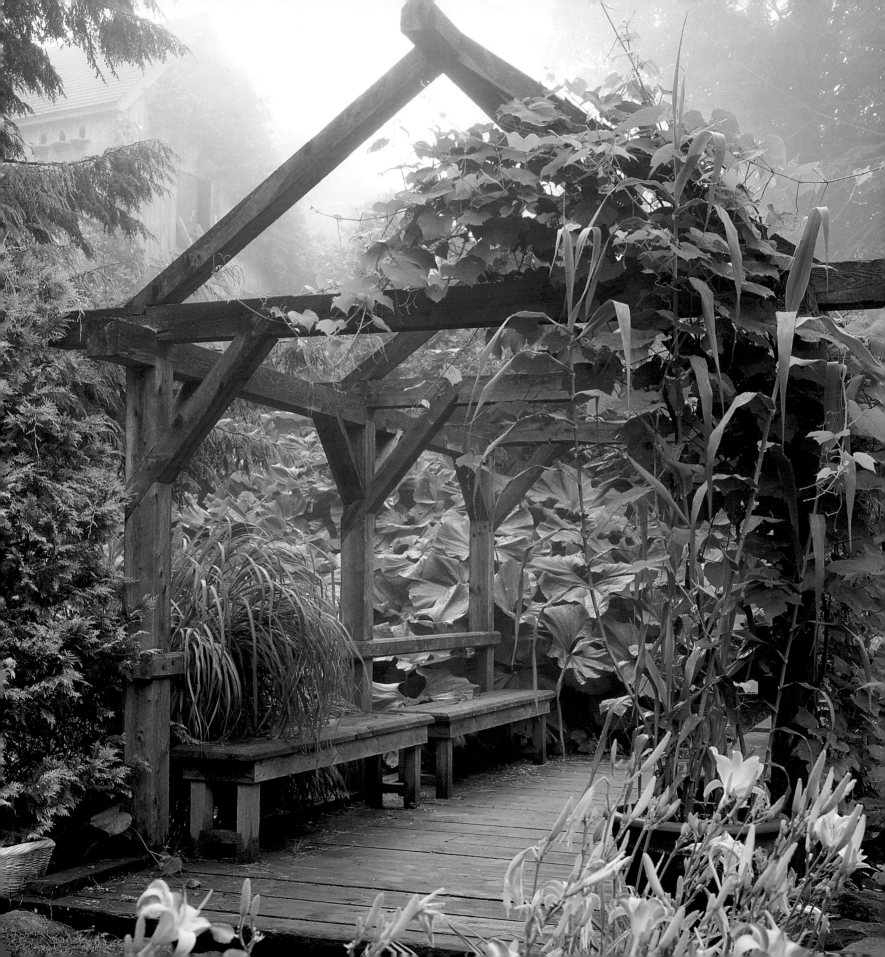

1626 depicts an arched, vine-clad arbor beneath which six gentlemen and ladies are dining on stuffed fowl and drinking from goblets while one of their company entertains them with his lute.

Such sylvan garden shelters, framed with ash or willow poles, were called herbars and were overrun with the "Vine, Mellon, or Cucumber," according to *The Gardener's Labyrinth,* written by Thomas Hill in 1577. "The owner also may set the Jasmine tree bearing a fragrant flower, the musk Rose, damask Rose, and Privet tree," Hill wrote, "to shoot up and spread over this herbar, which . . . not onely defendeth the heat of the Sun, but yieldeth a delectable smel, much refreshing the sitters under it."

Though arbors have gone in and out of favor since Hill's time (one 18th-century writer complained that the seats were damp and unhealthy), these shaded retreats particularly captivated Victorian and early 20th-century gardeners, who

Arbors take many forms, from classically inspired arches (below) and treillage booths (center) to simple bowers of rustic poles and climbing roses (right).

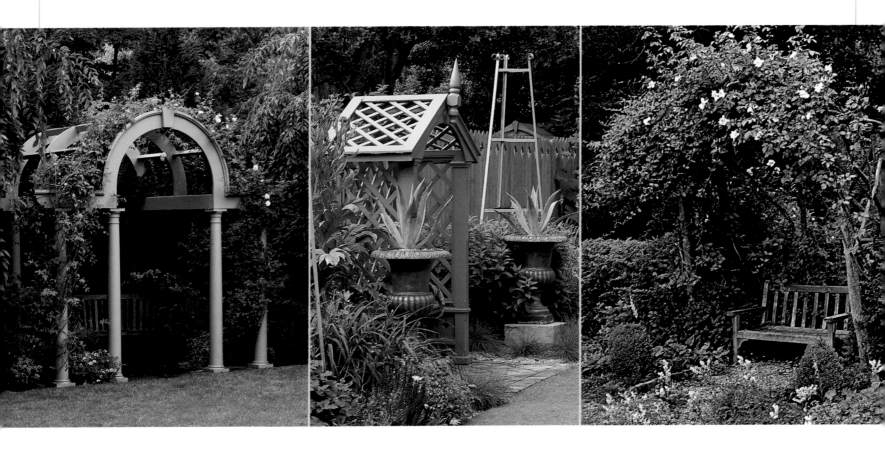

chose from traditional timber designs as well as newfangled iron or wire constructions. Today, arbors remain a beloved garden feature, smothered in jasmine, roses, or other climbers that bestow the same heady scents they did so many years ago.

Arbors typically are situated with their backs against a wall or fence to increase their sense of privacy and shelter. But they also may be set in the middle of the garden and backed by shrubs, or oriented to span a pathway and fitted with opposing built-in seats. Their design is variable; they may have flat, arched, or peaked tops and may be open on two sides, three sides, or only at the front. Likewise, they may be of slight construction that disappears beneath a mantle of 'Heavenly Blue' morning glories, or of a more architectural nature that can handle the brawny embrace of a mature wisteria.

The term *arbor* also refers to leafy shelters of overhanging tree branches or niches cut into shrubs and fitted with seats, as well as to canopies of vines raised

"Cool refreshing Ayres are found in close Walks, Seats and Arbours under and about the trees, which keepe off the burning heat of the Sunne. . . ."
—RALPH AUSTIN, 1653

An extended arbor will seat a crowd (left), while a double arbor (center) is built for two. A rectangular arbor (below) forms a focal point at the garden's boundary and supports a host of climbers.

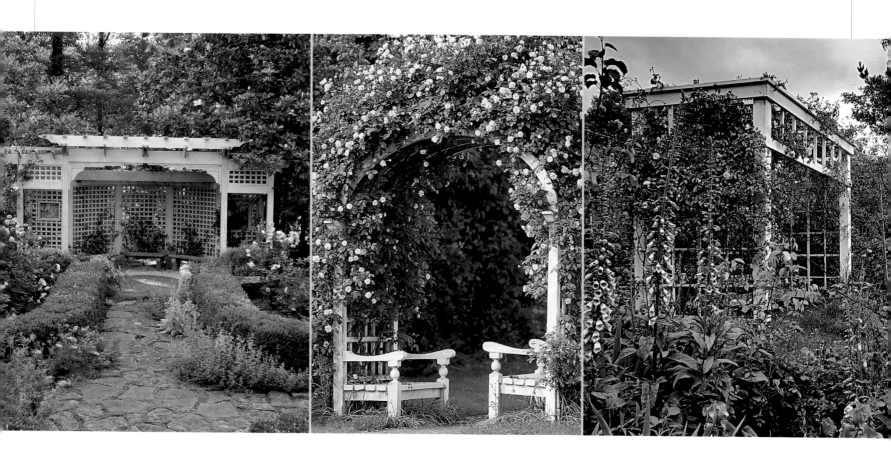

GARDEN RETREATS

The dream of retreating to a sheltered spot in a secluded corner of the garden is as old as Pliny, who liked to recline on the couch in his Roman garden house and fancy himself in a wood. Gardeners and garden designers ever since have indulged their escapist longings in an array of roofed architectural forms, from sheltered seats to scaled-down mansions.

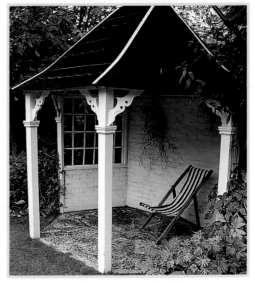

This summerhouse is protected from chilling breezes, but boasts a garden view.

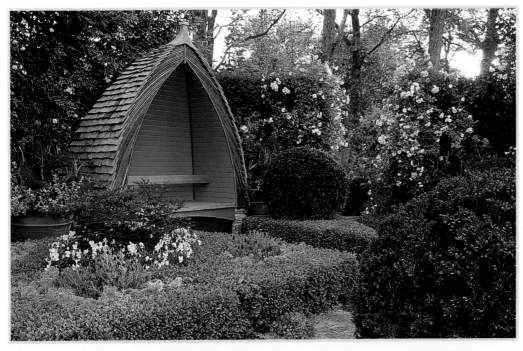

Inspired, it seems, by an upended rowboat, this sheltered seat with its watery blue interior would suit a garden anywhere near a lake or seashore.

forms from which to savor the mirrored surface of a lake, the falling blossoms of the cherry, or the roundness of the moon.

In both European and American gardens, enclosed garden houses or open summerhouses provided welcome shelter if a sudden downpour threatened to ruin an extended garden outing. But these hospitable structures also were destinations in and of themselves. Snug in their embrace, one could do needlework while listening to the birds, read or nap while lulled by the breeze, or take tea with visitors surrounded by the garden's splendor.

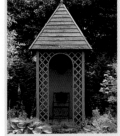

Early in their tenure, most garden houses or summerhouses mimicked a property's main house

Renaissance Europeans built grand banquet houses in the garden, to which they could retreat with their guests for postprandial wines and sweetmeats. Dutch landowners of the 17th century constructed gazebos: roofed masonry houses atop the corners of their garden walls from which they could gaze out over the surrounding landscape or oversee their formal gardens. The Persians built elaborate pavilions complete with water channels; the Chinese had *t'ings*, open pavilions perfect for appreciating the garden's views. The Japanese crafted sheltered garden plat-

in architectural style. By the mid 18th century, however, they had become an opportunity for exoticism and fancy, particularly in English and European gardens. Backed by towering elms and oaks, and surrounded by acres of land, garden houses with classical, Oriental, Moorish, Egyptian, or Gothic detailing caught the eye and proved the owner's cultivated taste.

Victorian-era summerhouses often were built in the rustic mode, of gnarled branches or shaggy logs, and provided shade for players alongside the tennis courts or bowling greens that had begun to augment many a garden. Also 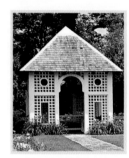 rustically inclined were the large, airy gazebos that grew in popularity during the 19th century, though many were ornamented with pristine painted lattice and fretwork. These roofed pavilions had only a low railing to close them in, unlike their solid Dutch predecessors, and provided summer gathering spots within the garden. Some boasted breathtaking views over a pond or hills; the views of others were limited to beds of brilliant cannas, sweet-scented nicotiana, or roses at the garden's heart.

Some garden houses were originally built for other uses: as coops for chickens, sheds for tools, stables for horses, or even as privies. Gertrude Jekyll described one such converted structure in *Gardens for Small Country Houses*, first published in 1912: "It was originally intended for a tool-shed, but the tenant converted it into a charming little summer sitting-room, and it is now the second summer-house. It is built of oak timber and brick, with a tiled roof, and has the appearance of a miniature old Surrey cottage." A *third* summerhouse on the property was equally inviting: "A wide window with casements and lead lights looks out onto a meadow. The little place is of a queer shape, and yet seems roomy. It is thickly roofed with

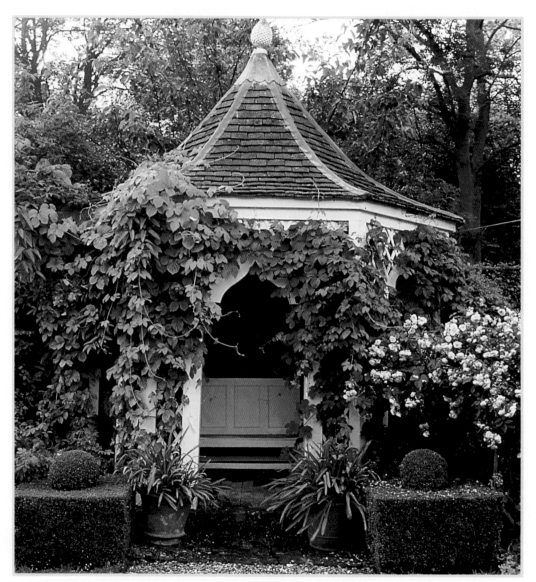

A pavilion smothered in vines offers cool comfort on searing summer days and serves as both a destination and a garden focal point.

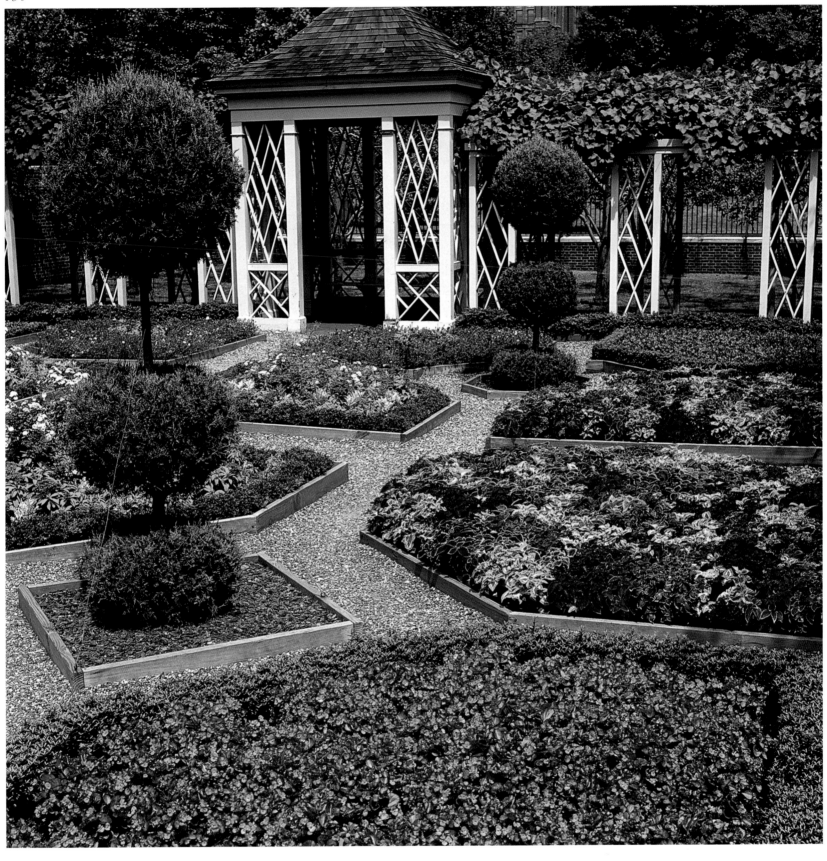

straw thatch. In winter it is curiously comfortable—always feeling dry and warm."

All these historic forms provide inspiration for those who long for an afternoon's blessed seclusion or simply want a sylvan refuge in which to read, write, or entertain friends. If such a spot figures in your imaginings, keep the following in mind:

• *Proximity and style:* Garden shelters close to the house should follow its architectural lead, while shelters that are out of sight allow for architectural ramblings. No matter where they are, however, shelters generally should suit the flavor of the garden: for example, a Georgian summerhouse for a garden of parterres lined with box, a rustic gazebo for a woodland glade, or a wood-and-bamboo viewing shelter for a Japanese-style garden.

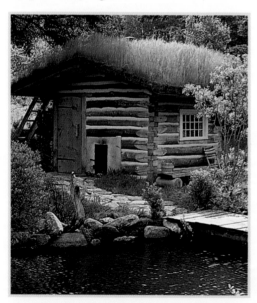

A garden house (above) can be enjoyed year-round, while a chinoiserie pavilion (opposite) is a retreat for warm weather only.

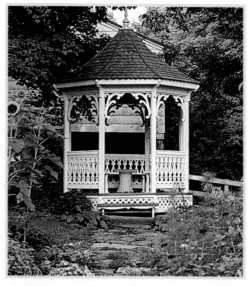

A classic Victorian gazebo has a railing and is raised for a better view.

• *Size:* If you crave a private spot to sit and watch the raindrops dimple the pond, build a sheltered seat or small viewing platform. If you want a gracious shelter where you can dish up Sunday brunch to a dozen friends, construct a gazebo, large summerhouse, or open-sided pavilion. Don't skimp on the floor area or the pitch of the roof of these hospitable shelters; feeling cramped or closed in is at odds with nature's unbounded character.

• *Climate:* Open-sided gazebos aren't well suited to gardens with cool climes. Instead, consider a garden house with French doors

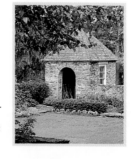

that can be closed when the thermometer's mercury drops below your comfort range. In hot-summer areas where mosquitoes

prevail, opt for a screened summerhouse, gazebo, or pavilion so you can bask in the garden's breezes without battling the insect hordes.

• *Camouflage:* Because of their size, garden shelters dominate their setting. If your garden isn't spacious enough to build a shelter out of view of the house, locate it at one edge of the garden and partially screen it with trees and flowering shrubs.

Such artful camouflage will keep the shelter in balance with the garden's other elements. Most importantly, however, a partially hidden shelter will

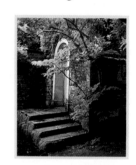

feel more like a refuge than one that is readily observed from the house.

• *Amenities:* A garden shelter is a home away from home, where we can read Brontë or Grisham, watch an approaching storm, play jacks with our kids, quaff a good cabernet, spark romance, or tuck in adventuresome overnight guests—all within the garden's healing embrace. Furnish your shelter accordingly, with seats, pillows, throws, shelves, cupboards, tables, window seats, comfy chairs or daybeds, along with power, water, a woodstove, or whatever else increases convenience or enhances your delight. That way, its comforts will lure you into the garden no matter what the weather.

up above the earth on a framework of poles, lumber, or wires. The most common example of the latter type is the traditional grape arbor, often open on three sides and attached on one side to the house. Such overhead arbors also may be free-standing and supported by posts, like the brush-covered *ramada* of the Southwest. Few moments match the pleasure of celebrating in their cool shelter with friends or family, at a table laden with the garden's bounty.

An arbor's air of privacy and seclusion is one of its most enduring charms. To enhance that attribute, locate arbors with seats where they can't be seen directly when entering the garden but still will afford a view. Arbors that shelter dining areas, however, should be convenient to the kitchen, unless you're willing to do lots of tray-toting or prefer to picnic. Make sure they're located on the sunny side of the house; a north-facing arbor can be too cool and damp and lack the contrast between sun and shade that makes arbors so seductive.

Arbors provide structure and ornament even when the seasons change (below and center); fall brings changing foliage color, winter a crystalline coat of ice. Young grapes dangle from an extensive arbor (right), setting the mood for an alfresco meal.

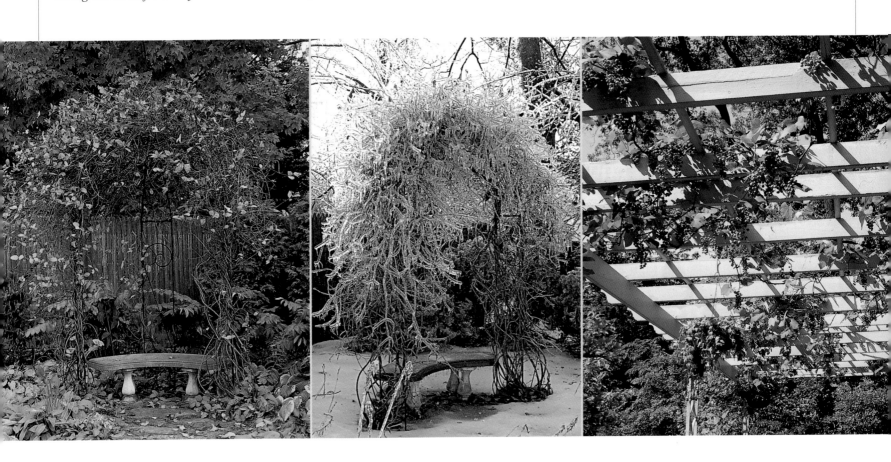

Traditional wood and lattice arbors may be purchased at some nurseries and garden centers or may be mail-ordered, custom-made, made from kits or plans, or designed and built in your own backyard. You can also assemble a simple arbor from a purchased wire or wood double arch, set over a garden bench.

In climates with lots of summer rain and high humidity, arbors are best clothed lightly in climbing plants, so the seat will dry out quickly after a summer storm and be open to the gentlest breezes. In locales with mild summers, orient the arbor with its back to a south-facing wall or fence and cloak it heavily on the sides to deflect the wind, so you can bask in its shelter even on cool days.

Note: Many gardeners and garden catalogs today refer to double wood garden arches, particularly the ones with flat tops, as arbors. Because these have a different purpose in the garden than a traditional arbor, whose job is to provide shelter, they're included here in the discussion of arches (see pages 140–144).

" *There is nothing more agreeable in a garden than good shade, and without it a garden is nothing.*"

—BATTY LANGLEY, *New Principles of Gardening*

Table-shading arbors can be made from a range of materials, including painted boards with shaped ends (left), metal bars with wire infill and ball finials (center), and rough cedar poles with the bark still attached (below).

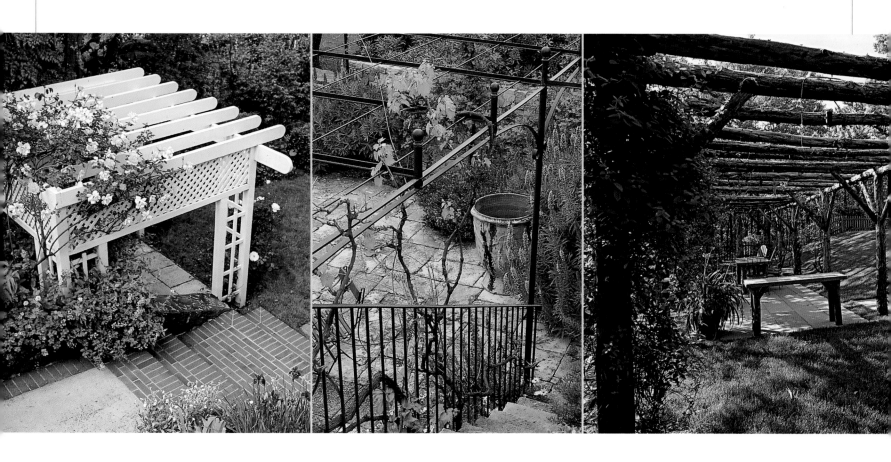

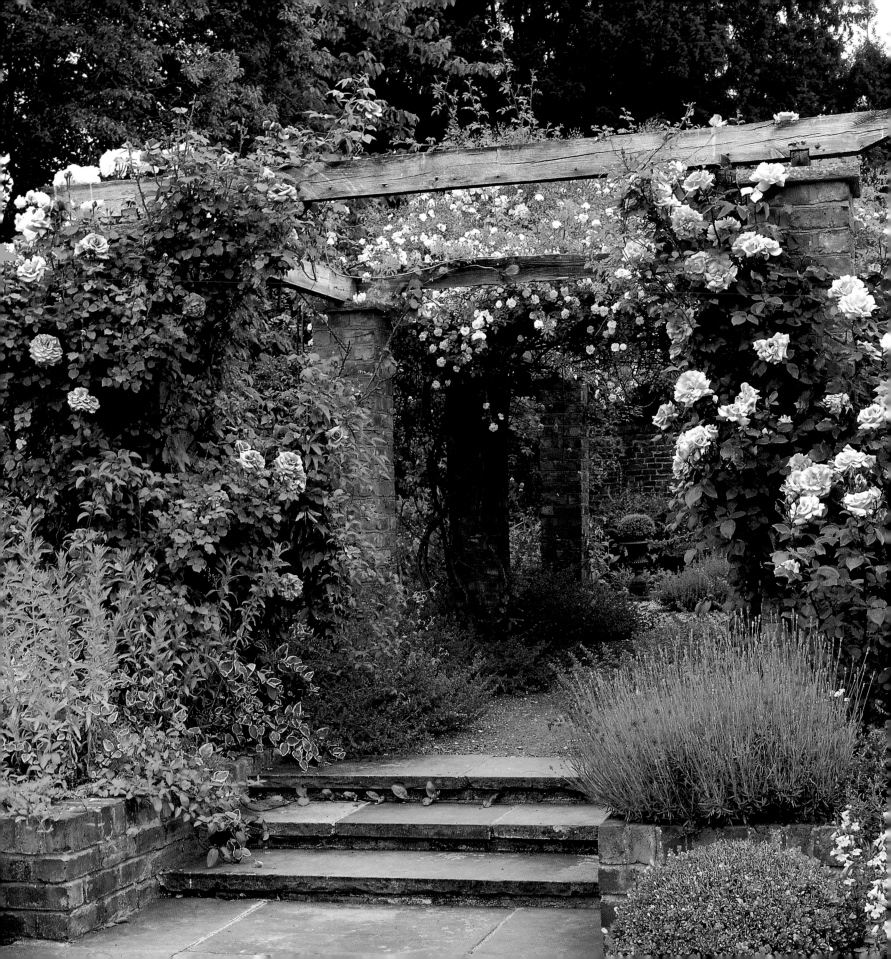

THE PERGOLA

A stroll beneath a shaded pergola, drenched in a wave of wisteria or dangling dusty clusters of ripening grapes, is one of leisure's sweetest rewards. Though riders once exercised their horses beneath extended versions of these structures, today no one hurries between the sturdy columns. Instead, they amble. It's a grown-up's version of exploring overgrown pathways in the woods or the cool thickets in a neighbor's shrubberies.

Pergolas hail from sun-drenched Italy and are of ancient lineage; murals at Pompeii depict this favored garden form. Originally designed for growing grapes (providing built-in shade for harvesting the bounty of the vines), these structures proved a particular blessing in steep terrain, where narrow terraces had formerly allowed one to grow grapes, or walk, but not do both. As pergolas moved off the rocky hillsides and into expansive ornamental gardens, they evolved into open structures roofed with ornamental vines, placed to shade straight lengths of walkway.

Today, pergolas generally consist of two rows of opposing pillars or posts, set on each side of a path or walk. Each pillar or post in the row is connected to the next one by timbers, across which are placed rafters or thin poles that span the path and support the overhead sprawl of the vines. While sometimes light in appearance (when constructed entirely from poles or narrow timbers), pergolas often have a decidedly architectural feeling, particularly when joined to a house. In this position, the uprights often are heavy masonry columns or timbers, and the rafters usually have decoratively shaped ends.

Though rarely seen in garden catalogs today, elaborate ready-made pergolas used to be available from garden suppliers. One 1890 catalog offered an Italian-style pergola complete with fluted columns with Corinthian caps, a white-painted Queen Anne-style pergola that was "perfect to employ on an entrance path from

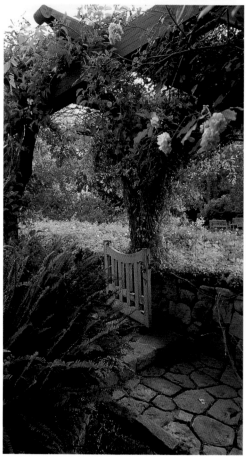

Brick pillars and weathered rafters, all swathed in roses, conspire to form a perfect pergola (opposite). Classic columns (top) and shaped timbers (above) also suit the pergola form.

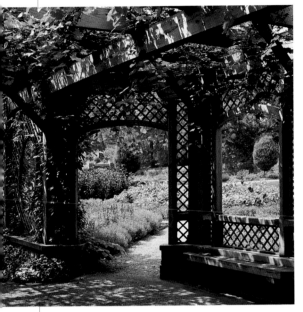

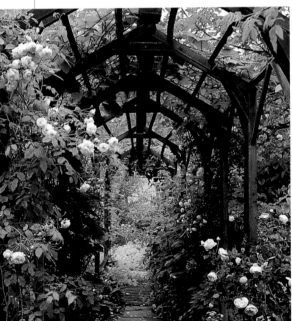

Latticework frames windows to the garden in this elaborate pergola (top). An arched form makes this structure halfway between a pergola and a tunnel (above).

HOW-TO
AN ABLE ARBOR

To build a basic arbor for shading a garden seat, erect two 4-by-4 posts on each side of a garden bench. Join the two back posts and the two front posts at the top by sandwiching them between pairs of 2-by-4s bolted into place through the tops of the 4-by-4s. Nail or screw crosspieces made of 2-by-2s, grapestakes, or round poles up the sides of the arbor and across the top. Alternatively, frame in lattice panels on the arbor's sides and secure 2-by-4 rafters with shaped ends across its top.

Arbors that shelter seats should be approximately seven feet high and five to seven feet wide, depending on the size of your garden bench, and from two to four feet deep. If you build the same structure spanning a pathway, make it eight feet tall.

Note: The best way to secure 4-by-4 uprights for a garden arbor is with steel post bases anchored to poured concrete footings. Buy types designed to elevate the end of the post off the footing, keeping the wood out of pooled rainwater.

gate to house," and a Japanese-style pergola that boasted lattice side railings in a chinoiserie pattern and rafters with upturned ends.

Most of these classic structures now are custom-built on-site, and follow the design lead of the revered Arts and Crafts-era team of Gertrude Jekyll and Edwin Lutyens, who favored simple columns of brick, stone, or timbers, and an unadorned roofline.

"It should be remembered," wrote Charles Edward Hooper—a like-minded contemporary to Jekyll and Lutyens—"that as the pergola is intended as a support for vines any excess of architectural detail would be lost, and consequently the most successful types are comparatively simple."

Modern pergolas aren't well suited to small or sloping gardens; they need flat ground or a broad terrace, and plenty of space, to reach their full potential. Pergolas create expectations because of their strong character, so they should always shelter a walkway that leads from one significant place to another: from the house to the guest house, from the patio to a garden fountain, from the street to the front door. In a large garden, pergolas may also serve to separate one garden room from another, while allowing unimpeded views into each.

A lightweight pergola may be built using basic fence-building techniques, but the heavier the construction, the more impact the pergola will have and the longer it will last without major repairs or total reconstruction. Pergolas should be a minimum of five feet in width (seven or eight feet is better), allowing two people to stroll comfortably side by side, and seven feet in height. If you intend to cloak your pergola with wisteria, laburnum, or any other plant with flowers and fruit that will dangle romantically from the pergola's ceiling, it should be even taller than seven feet.

Pergolas also are well suited to construction in the rustic style, using tree trunks or rough timbers for uprights and bark-clad saplings or rough palings for the roof framing.

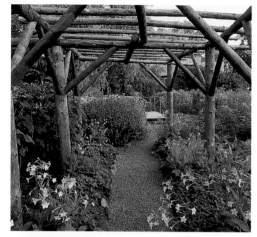

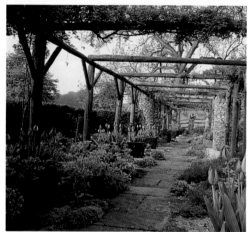

Rustic pergolas are probably closest in form to early pergolas used for growing grapes on terraced hillsides. Most are formed from timbers or saplings with the bark still attached.

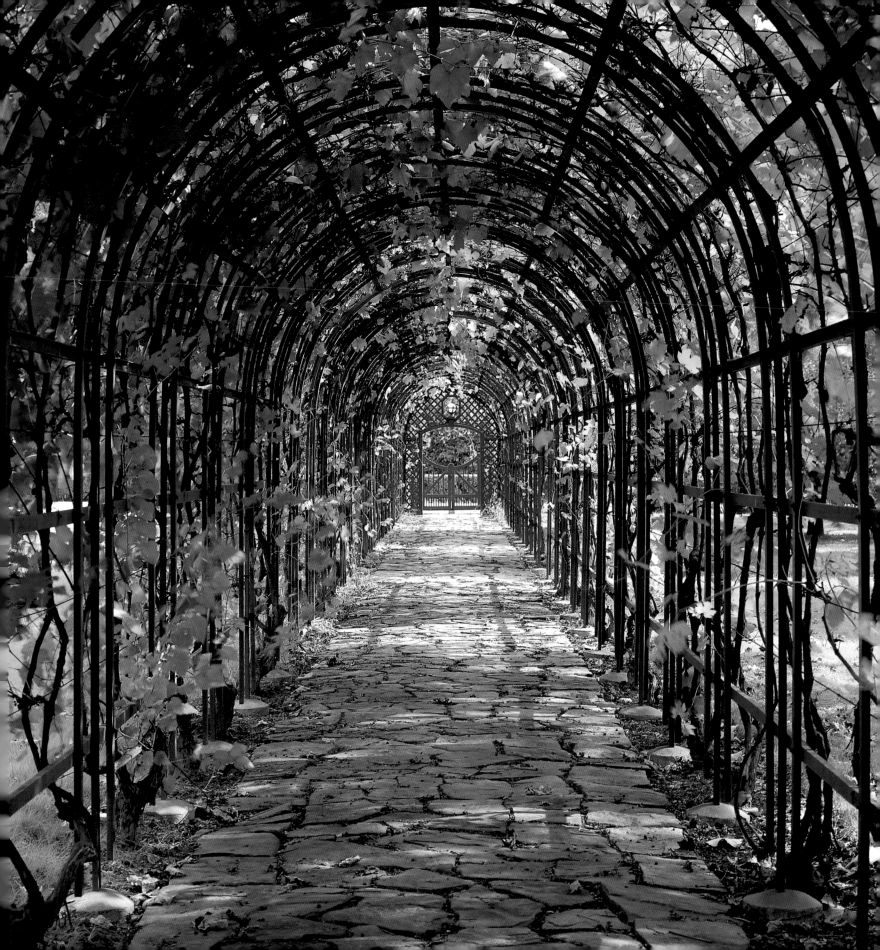

THE TUNNEL, TUNNEL ARBOR, OR COVERED WAY

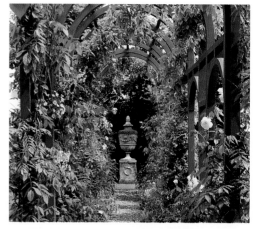

Unlike a pergola, which is open to the garden on both sides, a tunnel or covered way is a shaded passageway completely walled off from the garden by vines, well-trained trees, or clipped shrubs. Like arbors, tunnels blossomed during the late Middle Ages and the Renaissance, at first formed on arched frames of willow or hazel and later on elaborate curved wood trellises. Promenading was a daily pastime of the nobility, and the cool green tunnels provided a welcome escape from glaring, sunbaked walkways of immaculate, well-rolled gravel.

Elaborate tunnels often completely surrounded or dominated sections of royal gardens. Some were heavily cloaked in closely clipped elm and had windows cut in their sides to allow for garden views. Others, called tunnel arbors, had enlarged center sections or corner pavilions broad enough to shelter seats or a table and chairs.

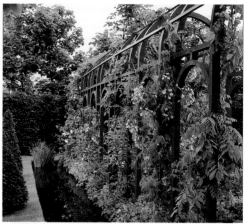

Due to the expense of their upkeep, the extensive tunnels of the past are rarely seen today except in large, well-funded historical gardens. But shorter tunnels, akin to the simple structures of medieval times, sometimes dress up more modest plots, clad entirely in roses, grapes, or carefully espaliered apples or pears. Like pergolas, tunnels always should cover a walkway and lead somewhere special, so there's a sense of satisfaction at the end of the journey.

A simple tunnel frame can be constructed by joining three to six ready-made wire double arches. Knit them together along their abutting edges with lengths of galvanized wire, anchor them in soil or concrete over a straight, flat pathway, then grow climbers up from each side. Don't be constrained by tradition in your planting choices; tunnels needn't be formal affairs of clipped leaves, shutting out all light. Instead, try growing squash, cucumbers, gourds, peas, or beans (if the tunnel is tall enough), then harvest the dangling produce while you take your evening stroll around the grounds.

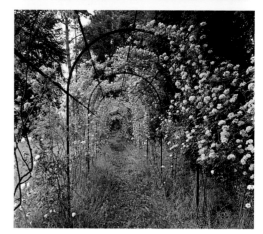

Sunlight filters into a tunnel of grapevines as if through stained glass (opposite). An artful metalwork tunnel (top and center) is as ornamental outside as in. Roses soon will drape this frame in white (above).

THE ARCH

From the Victorian era well into the 1900s, arches curved over every gate, punctuated every pathway, arced over every meeting of the ways, and marked the culmination of every walk. They stood side by side in the perennial border, framed views, pierced tall hedges, or formed spectacular circles called rosaries at the garden's heart. Arches were *the* method of choice for getting flowers, particularly roses, up into the air, and most gardeners couldn't do without them.

"There is hardly a garden, small or large, where one or two arches would be out of place," wrote Walter Brett in *The Book of Garden Improvements* in 1940; "there is scarcely an archless garden which would not take on additional charm were arches to be installed."

A garden arch is a brief rather than extended structure, a symbolic doorway

Like other garden structures, arches can be made from numerous materials, including painted wood (below), metal (center), and masonry (right). The structure at center is called an ogee arch.

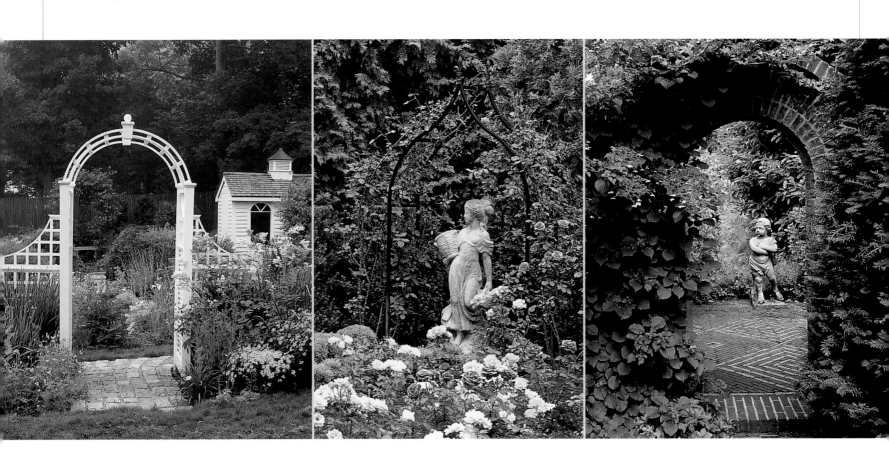

in the garden—always open in welcome—that beckons us to pass. True arches have straight sides and arched tops, and rise up in a flat plane. The styles of their tops may vary. Some take the form of half-circles; others boast a flatter curve and are known as basket-handle arches. Still others have a Gothic pointed ogee shape, topped with a decorative finial, or the gentler point of a Tudor arch.

When two arches are placed back to back and joined together with lattice-work or a wire grid, they form a double arch, which provides more room for a burst of blooms and casts a moment's shade. Structures that play the same role as double arches also may have flat tops or peaked tops (often with supporting brackets that give the structure's opening an arched feel). Flat-topped double arches are sometimes called pergola arches because of their resemblance to a section of a traditional pergola. Because all these double structures can be fitted with benches, they're often referred to as arbors, even when the requisite seat for basking in the shade is missing.

Both formal and rustic arches star at framing pathways and the focal points they lead to, whether another arch (left), a standard or topiary (center), or a sundial in a sunny clearing (below).

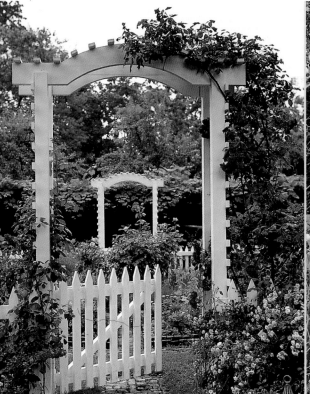
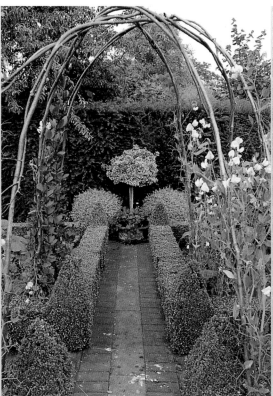
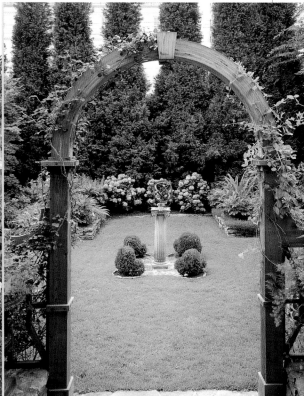

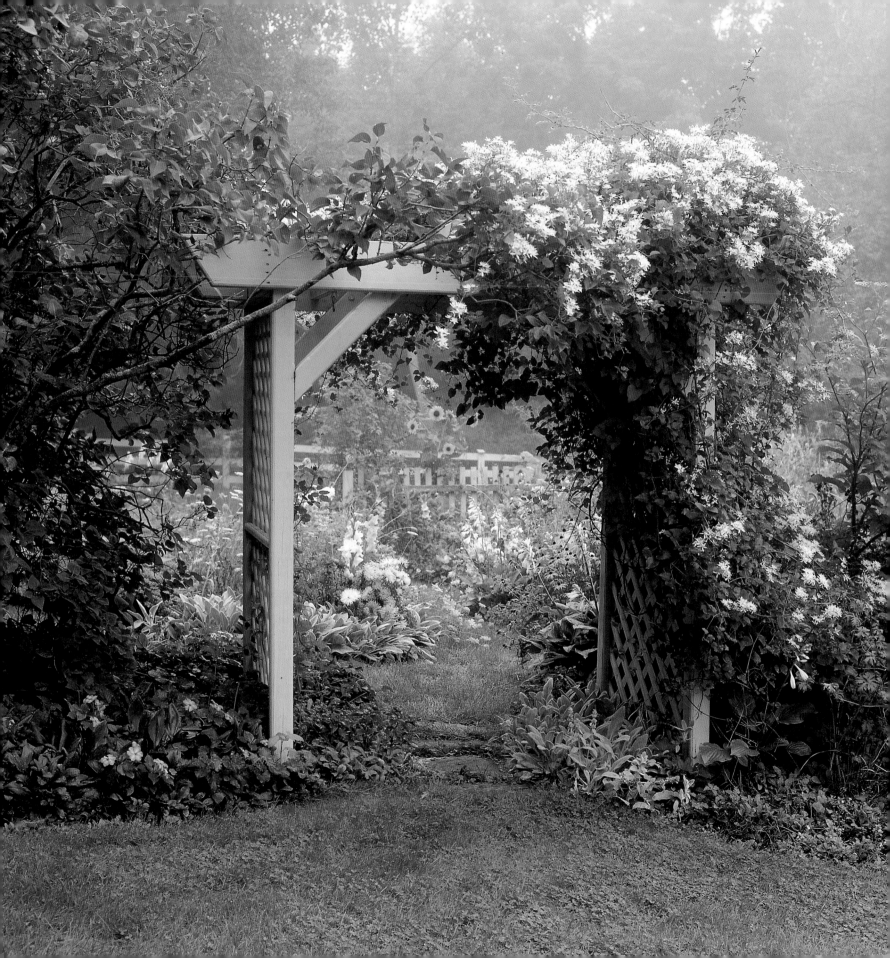

Like other garden structures, arches should be placed in the garden with careful regard to their primary purpose of promoting passage or emphasizing a sense of entry or exit. A rustic arch might mark the transition a path makes as it enters a wooded corner of the garden. A formal arch of cased wood posts with a curved wrought-iron top (a favored Victorian form) might frame a path from the front garden to the back, emphasizing the spot where the path cuts through a low hedge of box. And a double arch might front a mirror or trompe l'oeil scene painted on a close-board fence, providing the illusion that the garden continues if only we will pass through the structure's vine-clad opening.

Just as in Victorian times, ready-made arches of wood or other materials are widely available, in catalogs, at home and garden centers, and at nurseries or garden specialty stores. Both single and double steel arches can be found in a handful of arch styles, many coated in weatherproof black nylon and others made of steel

Home-built arches usually have flat tops and are often called arbors (opposite and below center), but perform the same duties as their curve-topped relatives (below left). A peaked arch (below right) adds height to a passageway.

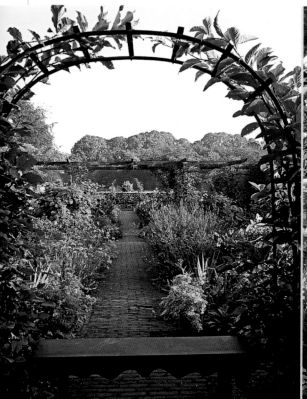

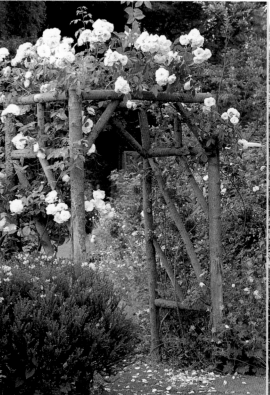

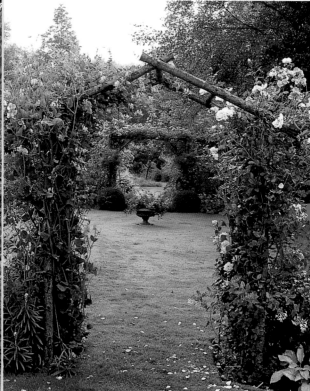

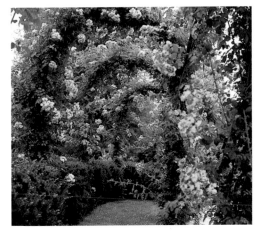

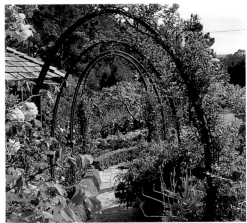

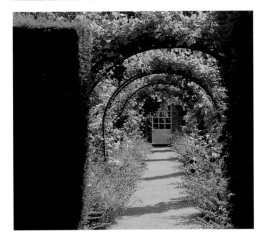

Rose-clad arcades create glorious passageways in the garden, and can be fashioned from a series of metal arches (top and above) or from bent and painted pairs of PVC pipe (center).

that will gain an earthy surface patina of rust.

Make sure that the metal arch you buy will stand at least seven feet high when the lower foot of it is anchored in soil or concrete for stability. Arches shorter than seven feet block the view and have a claustrophobic feel. If an arch you already own is too low, consider raising it up on brick or stone footings.

Double wood arches should be well constructed of sturdy lumber, preferably a rot-resistant species such as redwood or cedar. A rose-clad arch can become a sail in the wind, so anchor it to a footing of concrete, or build it in place and embed the uprights in concrete as you would tall fence posts.

Though an arch doesn't provide shelter in quite the same way as an arbor or pergola, it can have its rejuvenating moments. Hide a mister in the foliage of the scarlet runner beans or morning glories at the top of your arch, then turn the water on when you're in the garden on hot days. The mist will attract the birds and form a cool curtain that's guaranteed to refresh.

THE ARCADE

According to prevailing Victorian passions, if one arch was good, then 8 or 10 arches were even better. Many a Victorian rose garden boasted an arcade, a series of arches spaced out along a pathway and spanning its width. All the arches might be cloaked in a single variety of rose, or each one might show off a different-colored climber, ideally timed to bloom at once. When the roses were in full flower, strollers through the garden felt like participants in some glorious wedding party or *grande fête*.

For climates that don't suffer from excessive heat, arcades are a better choice than pergolas or tunnels for creating a sense of dramatic passage because they don't block out the sun. Instead, they cast a pattern of shifting light and shadows and show off their flowers from all directions. In a tunnel covered with rambling roses, for

instance, you'd see mostly the canes and leaves while strolling from one end to the other—most of the blooms would be on the outside. But from beneath an arcade, the roses or other blooms are clearly visible, each new arch of them drawing you onward down the garden path. In addition, the plants on the north side of the arcade receive almost as much sun as the plants on the south, simplifying planting choices.

Arcades can be formed from single garden arches, spaced at regular intervals along a straight or semi-circular path. Keep plants neatly tied to their supports, and clipped or pruned to maintain the effect of a curving garland of flowers.

THE TEMPLE OR PAVILION

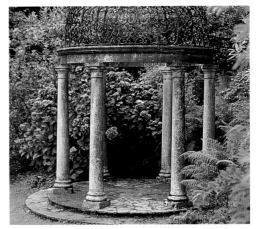

The roofed summerhouses, gazebos, or pavilions that drew walkers to the far corners of Victorian gardens for tea or a tête-a-tête often were replicated in the rose garden in wire, cast iron, or elaborate treillage. Little shelter from inclement weather, these "rose temples" were shade arbors gone berserk: domed or bell-topped structures more akin to elaborate birdcages or wedding cakes than to the simple sheltered seats that were their forebears. Indeed, the 1906 catalog listing for one octagonal Rose Temple boasted that it could be "readily adapted for an out-door aviary at moderate cost, by the addition of a zinc roof and finer mesh wirework." Frosted in creamy 'Félicité et Perpétue' roses, such frivolous structures must have been a stunning sight.

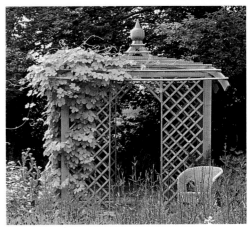

Today, these fussy pavilions have been replicated in simplified form, in delicate traceries of iron that will quickly be upstaged by any rose that climbs along their streamlined curves. A carpenter-built hexagonal or octagonal timber pavilion also recalls its Victorian-era predecessors, but without the fuss. Open to the air on the sides and roofed with roses or wisteria, it shades us as we share a Saturday lunch or read the Sunday paper and sip our tea or coffee. And if the roses rain petals as we sit there, so much the better. If we could, we'd linger in its leafy shelter till the last petal falls.

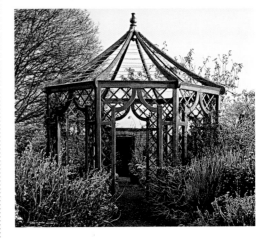

This classical garden temple has a metal filigree dome (top). A pavilion of painted latticework (center) beckons from a sunny corner. Even in winter, a pavilion lends structure to the landscape (above).

CHAPTER SEVEN PATHS AND WALKWAYS: *guides to the garden*

THE BEST PATHS MAKE THEMSELVES, OR SEEM TO. Animal tracks in the forest. Indian trails across streams and over mountains. The bare stretch of dirt between the swing set and the back door. All are habits made visible, scribed on the land. Once there, they lure other feet to follow.

Such paths persist because they lead directly to a destination, whether it's only a few yards from the path's beginning or thousands of miles away. After their initial blazing, they become guides to the nearest watering hole, to favored hunting grounds, to the fabled Oregon Country, or simply to a sunny bench set at the back of the garden. Even if we've never been to a place before, we don't need signs to find the way. Once on the path, we simply follow its lead.

In the garden, trailblazing takes place on a limited scale. Yet, just like pathfinders through the centuries, we must follow the logic of the land and mark out routes for paths that get us where we need to go in the best possible fashion. If the land is flat and without obstacles, our task is straightforward. If it challenges

A mulched path draws visitors into a flower-filled woodland (opposite). Worn stone steps evoke a jungle ruin (above).

us with slopes, bogs, streams, or pools, then we must give in to its demands and skirt its obstacles, or call on steps or bridges to ensure our forward progress.

DESTINATIONS

Some destinations clearly deserve a path or walkway. Most of us want to be able to get from the front yard to the back garden, to the front door from the street, and to the garage and the garbage cans. These routes are easy to plan into a garden from its inception. Other desirable destinations aren't so obvious on paper, but will reveal themselves as the garden develops. You may need stepping-stones through the flower beds to reach a birdbath that requires filling every other day. Or you may want to formalize the trail your kids are wearing to their hideaway beneath the weeping boughs of the willow.

A boardwalk (below) leads across uneven terrain to a hidden spot. A curve of bricks (center) easily skirts a birdbath. The goal of this cut-stone pathway (right) is a shaded garden bench.

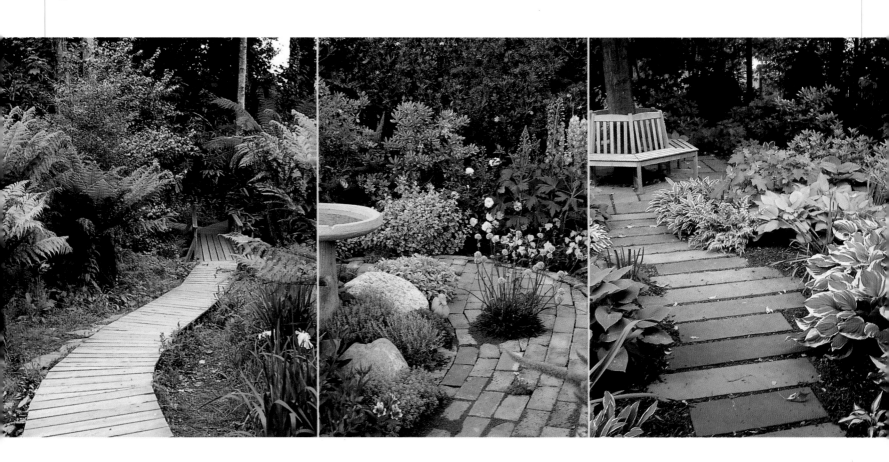

Even a garden that has established walkways, stepping-stones, or paths may need new or altered ones. If you traipse daily to the herb or vegetable beds to harvest 'Thumbelina' carrots or a handful of Italian parsley, a path to get you there and back is needed. If every morning finds you picking 'Just Joey' roses from the perennial beds, a path should take you there, too.

You also may want routes to less practical destinations: the woodland alcove that the trillium brightens every spring, the sunny corner where pine siskins feast on the native Hooker's primrose, or the rocky bed of alpines that can only be appreciated up close. These are the locations we want our paths to lure us to, even when the strawberries need mulching and the neglected weeding calls.

Likewise, these are the spots we want to share with family, neighbors, and friends. Consider how you show people through your garden. If you always end up tromping across the lawn or through the shrubberies to show off your favorite iris

"I will find a way, or make one."
—HANNIBAL

A path's endpoint should offer a suitable reward, such as a garden bench (left) or pavilion (center). There's no straying from this well-planted path (below).

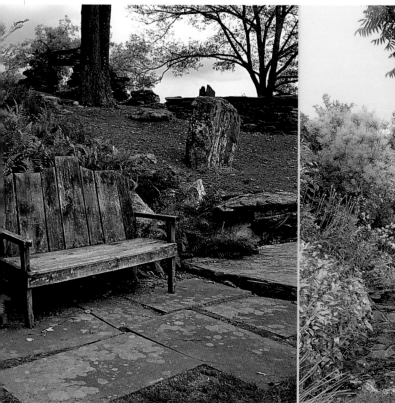

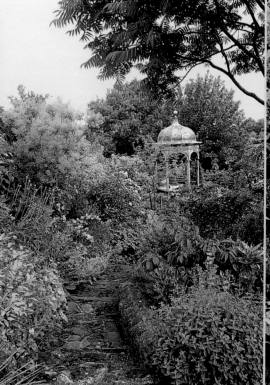

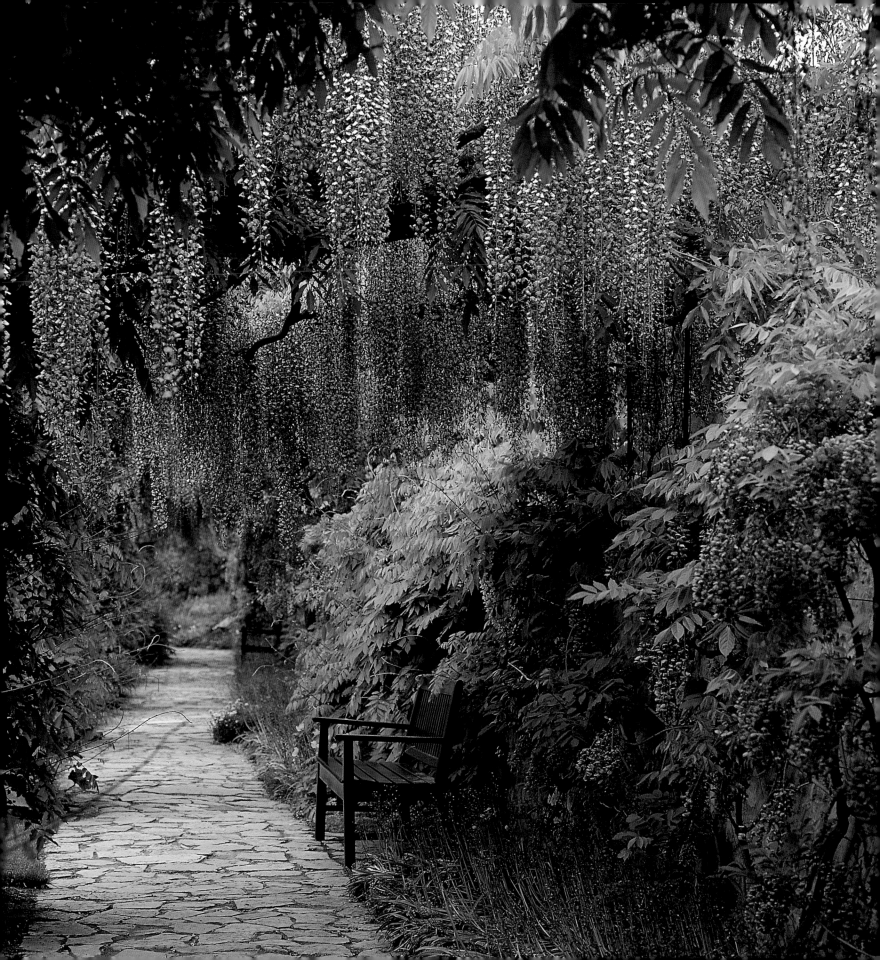

or to share a view of the distant hills, consider how a pathway might make such destinations more accessible. Even when you're inside putting the finishing touches on dinner, your visitors will submit gratefully to the path's guidance, trusting it will take them to the garden's choicest places.

PATH PLACEMENT

When a path is in the perfect spot, we take it for granted. Its course, and our desire, are one and the same. But if a path is poorly placed, we'll ignore its authority and strike out on our own. We'll make a beeline from the kitchen door to the compost pile instead of following the walkway that wends artfully past the roses. We'll take a shortcut from the patio to the bird feeder, rather than tread the path that divides the garden into perfect squares. We'll digress, diverge, or veer off, the pull of our destination stronger than the pathway's guidance.

That doesn't mean our garden pathways have to be ruler straight, taking the shortest possible distance between the back door and where we want to go. But to succeed, paths should bow to our natural shortcutting inclinations, in their careful placement, in the way their surroundings are planted, and in the manner in which they follow the natural terrain.

Take a look at the paths or walkways in your garden, observe the pattern of your movements, and notice your traveling inclinations. Are there awkward angles where you're tempted to cut corners? Are there curves where you're tempted to stray? These spots may need realignment, redesigning, or replanting.

PLANTING A PATH

Because paths divide the land, they *create* spaces in the garden, all of which provide opportunities for planting. A straight path begs for beds of annuals or

THE MOWN WAY

Sometimes all it takes to create a path is a lawn mower. Keep your lawn clipped to a healthy three or four inches, then mow a path through it with the mower at a lower setting. Or, push the mower through that grassy meadow beyond the garden's formal bounds. The resulting path—a smooth stroke across nature's rumpled canvas—will draw you out into the wilds and bring you safely back.

If you often need to traverse the route with your wheelbarrow, inset a single row of bricks—end to end with their bedding faces showing— down the center of the mown way. It will be wide enough to keep the barrow's lead wheel on course, but won't unduly civilize the nature of the path.

A broad flagstone path with gentle curves presents a peaceful prospect for a garden stroll (opposite).

perennials along its sides. A forked path demands a specimen tree or shrub where its arms diverge. A cruciform arrangement of paths calls out for balls of box in each of its corners, or neat beds of herbs to fill the quadrants it forms. Paths help us to organize the garden and make sense of its planting potential.

But there's another side to this equation. The plants near a path also determine how—and whether—the path is used. By careful planting, you can enhance a path's guidance, so that instead of saying, *You might want to walk here,* it says, *This is the best way to get where you want to go.*

For example, a path that proceeds straight out from the back door, then makes a right angle to reach a favorite bench, is not the most direct route and will probably tempt walkers to stray. Yet such a path provides more interest and planting possibilities in the garden than does its more direct alternative.

To ensure that the path does its job, provide obstacles that make sense of

Flowers and ornamental grasses billow along the margins of this boardwalk (below). Mounding perennials keep walkers on track (center). This turf path (right) defines the garden's main axis; side paths are blocked from view by hedges.

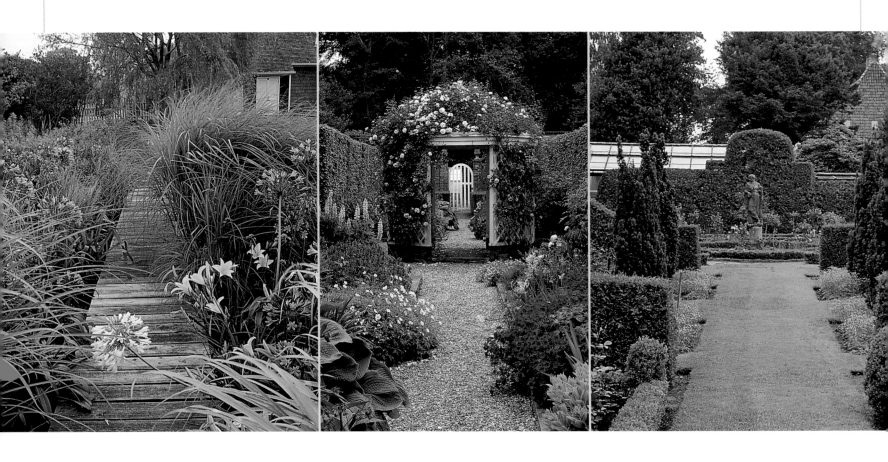

its indirect course. At the start of the path, shield the bench from view with a group of flowering shrubs. Give the first straight leg of the path a visual destination of its own, such as a birdbath or sundial. Plant a clump of small trees at the inside corner of the path, so that it seems you sited the path to go around them. Then add low planting beds alongside the final leg of the path to guide you to your destination.

Similar strategies will improve the pull of almost any path or walkway. A path that heads off across a lawn, for example, then ends abruptly at the back fence, hardly calls for exploration. Build a vine-clad arbor at the path's culmination, however, and it draws you along the path and into its leafy shade. (All paths and walkways ought to have a suitable destination.) You can further enhance a straight path's magnetism by adding a broad circle at its midpoint and installing a sundial or other garden ornament on a waist-high pillar, by planting pairs of shrubs at intervals along its length to emphasize a sense of passage, or by erecting a succession of

Flanking hedges outline the route around a stone sphere (left). Plantings conceal the edges of this cut-stone path (center) and funnel visitors toward a garden throne. A brick path changes width in the distance, increasing the sense of perspective (below).

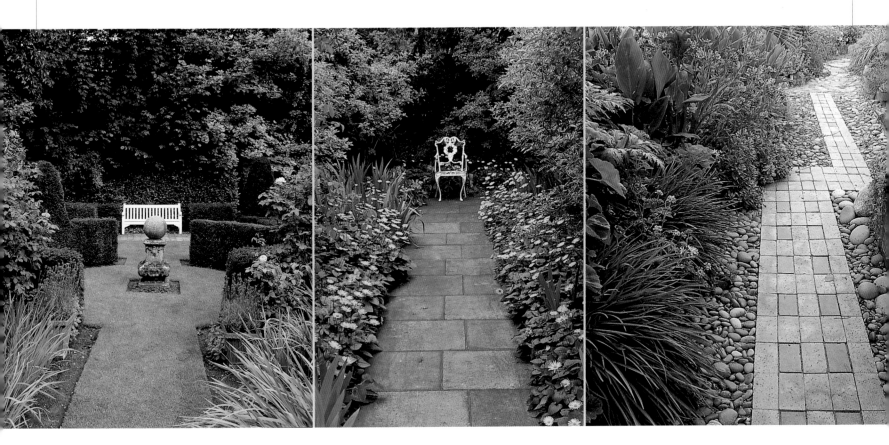

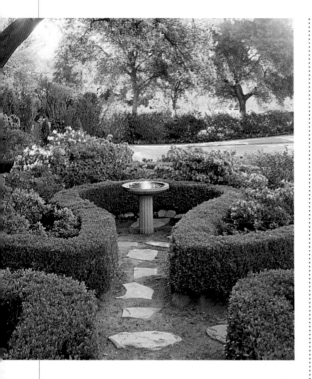

Boxwood hedges (top) insist that walkers stay on course. Curves shape the land much as nature does (above), while straight paths (opposite) counteract nature's way.

arches over it to form an inviting arcade.

Like a path with no destination, a path with too many curves is unappealing, no matter where it takes you. But if you fill in the curves with beds of herbs that you'll linger to pick, or roses you'll dally to savor, the pace of the curves will seem just right. Or take advantage of the planting pockets created by the curves and set out flowering shrubs and trees that will arch over the pathway or obscure the path's end point. If you can't see your destination, the curves of the paths will intrigue rather than annoy.

SETTING THE STYLE

Paths provide the underpinnings for the garden's style. They can be formal and grand, like the geometric gravel walks that dominated 17th-century royal gardens. They can be subtle and naturalistic, like the serpentine paths that wove their way through the landscape gardens of the 18th century. They can be primarily utilitarian, like the simple walks that crisscrossed many kitchen gardens of the 19th century, there primarily to get the gardener to the plants. Each type of path gives rise to a different sort of garden.

Placement. Part of the garden's style comes from the paths' placement on the land. A cruciform pattern of paths, for instance, divides the garden into neat quadrants, while a gently curving pathway divides the garden into two unequal parts. The layout of the paths alone has already formed each garden's fledgling character: one neat, orderly, and formal; the other, more casual and uncontrived.

Materials. The materials from which the paths are made also affect the garden's style. A curving walk of mortared brick has a less formal feeling than a straight brick path, but is far more formal in nature than a curved course of step-

THE GRASSY PATH

It is nothing more than a wide strip of lawn, neatly edged and mown. Yet a path of turf has become a hallmark of the English garden, emblematic of its fecundity and symbolic of its careful cultivation. Such a walk conjures up a time when a lawn was a thing of luxury, kept trimmed by an army of men with scythes, edging spades, and rollers, as well as with special rakes for beheading the daisies that dared besmirch the greensward.

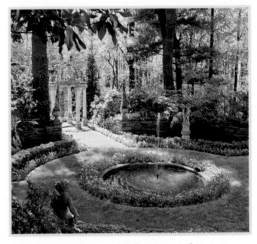

Masonry paths would dominate this setting, but grass lets the plantings shine.

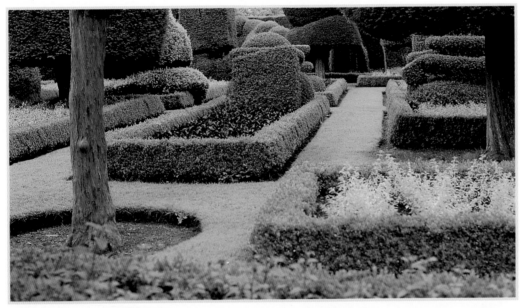

Lush turf in a formal garden forms inviting walks as straight and long as bowling lanes. The borders of such walks are carefully manicured with an edging spade.

Lawn mowers, invented in the 1830s, changed all that. By the late 1800s, turf paths had become both a pleasing and practical choice for average gardens rather than an extravagance reserved for the gentry.

"Grass walks . . . are the pleasantest of all ways of getting about the country garden or pleasure ground," wrote William Robinson in *The English Flower Garden,* first published in 1883. "There is much saving of labour in their formation, because . . . we have little to do except mark out and keep the walks regularly mown. When this work is compared with . . . the knowledge and annual care which are necessary to form and keep hard walks in order, the gain in favour of the grass walk is enormous."

Today, grass walks retain their allure, whether in a cottage garden in Surrey or in a suburban plot near Seattle. They flow like green rivers between beds of roses and catmint. Their neatly shorn surfaces provide a contrast to the billowing artemisia and spiky crocosmia, yet also lend continuity, since the grass is as much alive as the shrubs and flowers. They excel at linking small areas of lawn without interruption, like woodland rills that spill

from pool to pool, and impart serenity to even the busiest plantings.

Best of all, grass paths are inexpensive and can readily be formed in any shape or dimension. You can broadcast seed or lay turf on a well-prepared swath of soil,

whether it's a broad rectangle between perennial borders, a squiggle through the herb garden, or an alley between lilacs that's one hundred feet in length. Or, simply cut a large lawn down to size, leaving only the path, then form planting beds where the bulk of the lawn once was.

There are a few caveats. Don't plan grass paths for areas that see a lot of foot traffic, such as the walkway through an entry gate, or for routes that must bear the brunt of a cart's or wheelbarrow's wheels. Likewise, steer clear 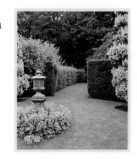 of planting grass paths in poorly drained spots that will become mud pits with only a few passings.

Most importantly, don't plant grass paths in climates with excessive summer heat or drought. Even Robinson warned that heat would "destroy the herbage. It is perhaps only in our country that the climate enables us to have the privilege of these verdant walks," he wrote, "which are impossible in warmer lands. . . ."

Other plants may better suit your site because of a particular soil type, excess of shade, lack of water, or your own taste. In Victorian England, for instance, paths of moss, heath, mown heather, and even thyme were common. In America, low-growing alternatives to traditional grasses include *Ajuga reptans, Chamaemelum nobile* (chamomile), *Cotula squalida,*

Hippocrepis comosa, Mazus reptans, Phyla nodiflora, Thymus types such as caraway-scented thyme, creeping thyme, or woolly thyme, *Sagina subulata* (Scotch or Irish moss), *Zoysia tenuifolia,* or any other low ground cover that can be kept in bounds with a simple edging. Most ground covers won't take much traffic, so set stepping-stones among the greenery and make sure there aren't raised roots, vines, or drip tubing to trip you up as you meander.

If you live in an area of extreme summer heat and drought, forgo the planting altogether and choose gravel, mulch, or decomposed granite. Such paths won't have the emerald allure of a grass walk. But they'll tie your garden to its spot on the earth just as firmly as ribbons of grass tether English gardens to their temperate home.

"We should make good use of what our climate aids us so much in doing," wrote Robinson to his English readers more than a century ago. No matter where we live, his advice is still germane.

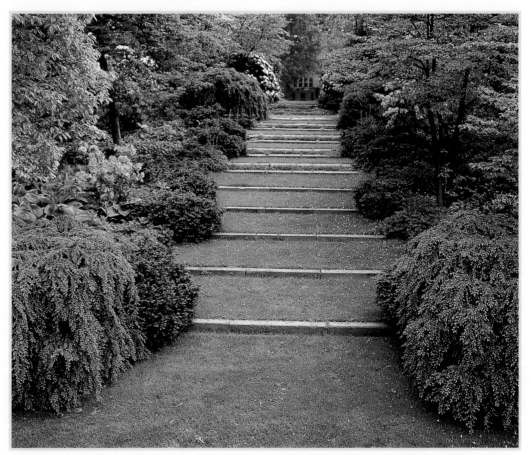

Low risers of cut stone hold back the slope and transform this grassy path into an elegant stairway. Such designs take careful maintenance and skill with the lawnmower.

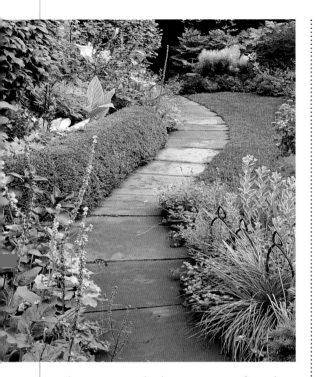

The curving path above suits an informal, modern dwelling, while the grand brick walk at right belongs to a more elegant abode.

ping-stones or a path carpeted in pine needles that wends its way through the trees. A straight walkway of cut and mortared stone has an elegant air compared to a rough path of flagstones, where sweet alyssum and Johnny-jump-ups have self-seeded among the cracks. And a path of decomposed granite sets a spare, arid tone compared to a lush path of emerald green turf.

Existing architecture. Like walls or fences, primary paths and walkways near the house should complement the dominant character of the building. In general, pair formal, traditional houses with symmetrically placed walkways and materials such as brick or cut stone, laid in classic patterns. Less formal dwellings may be better suited by gently curving walks of flagstones, sand-laid bricks, or even concrete. Such walks are stable underfoot, easy to maintain, and sturdy enough to take constant foot traffic.

Proximity. As the paths get farther from the house and are less frequently traveled, they can shift in demeanor. Out in the garden, materials such as shredded

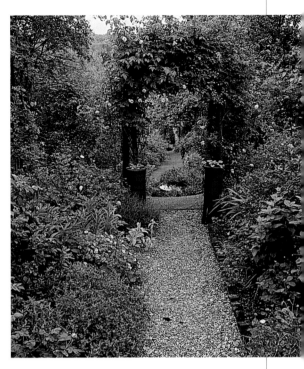

bark, gravel, turf, or pine needles are quite at home, as are stepping-stones, packed dirt paths, or grass.

Don't be afraid to go against type. You can also use the layout and material of your pathways to dress up—or dress down—a house or garden that's too formal or too relaxed for your taste.

Pine-needle paths and gravel walks (left and above) suit outlying areas such as the vegetable garden or a secluded garden room.

PLAYING WITH PATHS

The layout or materials of your paths and walks can influence other things besides the garden's style. Through them you can affect whether you wander through your plantings alone or with company, how large or small the garden seems, as well as the speed at which you move among the asters and geraniums.

Social standings. The width of a path determines whether it's used alone or in tandem. A broad and well-paved way, for instance, invites social meanderings, while a course of stepping-stones calls for solo explorations. Central gar-

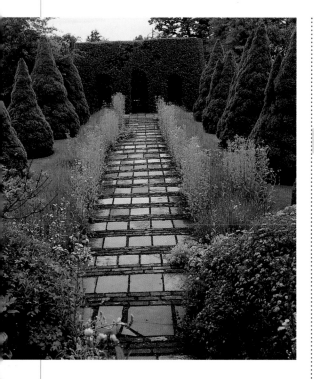

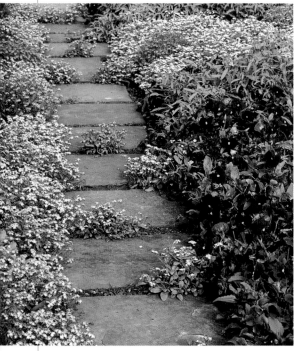

A broad walk enhances an expansive garden (top) but narrow paths work better for small, detailed spaces (above). A pine-needle path adds unstudied charm (opposite).

den walks should be wide enough for two people to stroll on them side by side, a minimum of four feet. Increase the perceived width of a path by planting low groundcovers at the path's edge and keeping taller plants at a distance.

Illusions of grandeur.

Whether you want your palatial garden to seem more intimate, or your postage-stamp plot to feel more expansive, paths can help you in your quest. First, make sure your paths are sized appropriately for the dimensions of your garden. Larger properties require broader paths; walks that are too narrow will seem stingy and serve to overemphasize the garden's ample proportions. In smaller gardens, however, large paths gobble up too much space. To make the most of the room you have, employ two-person pathways only where absolutely necessary, then install stepping-stones for other routes. When the garden takes longer to walk through, its perceived size will increase.

Keep the same effects in mind when choosing paving materials and patterns. Busy effects, such as paths of random-set flagstones or bricks set in a herringbone or basket-weave pattern, work best in small gardens, whereas larger gardens call for simpler surfaces such as gravel, cut stone, bricks in a running bond pattern, turf, or decomposed granite.

You also can trick visitors into believing a straight path is longer or shorter than it is by manipulating its perspective. In a small garden, narrow the path as it recedes, exaggerating the natural perspective. In a large garden, fight the natural effect by making the path wider at its far end than at its beginning. This ploy works best for paths of easily manipulated materials, such as gravel, turf, bark, or decomposed granite, and in gardens that are more apt to be looked at from a fixed point than thoroughly explored.

Speed limits.

Paths and walks are like roads and highways. Some are designed for safe travel at high speeds; others are meant for Sunday drives at a

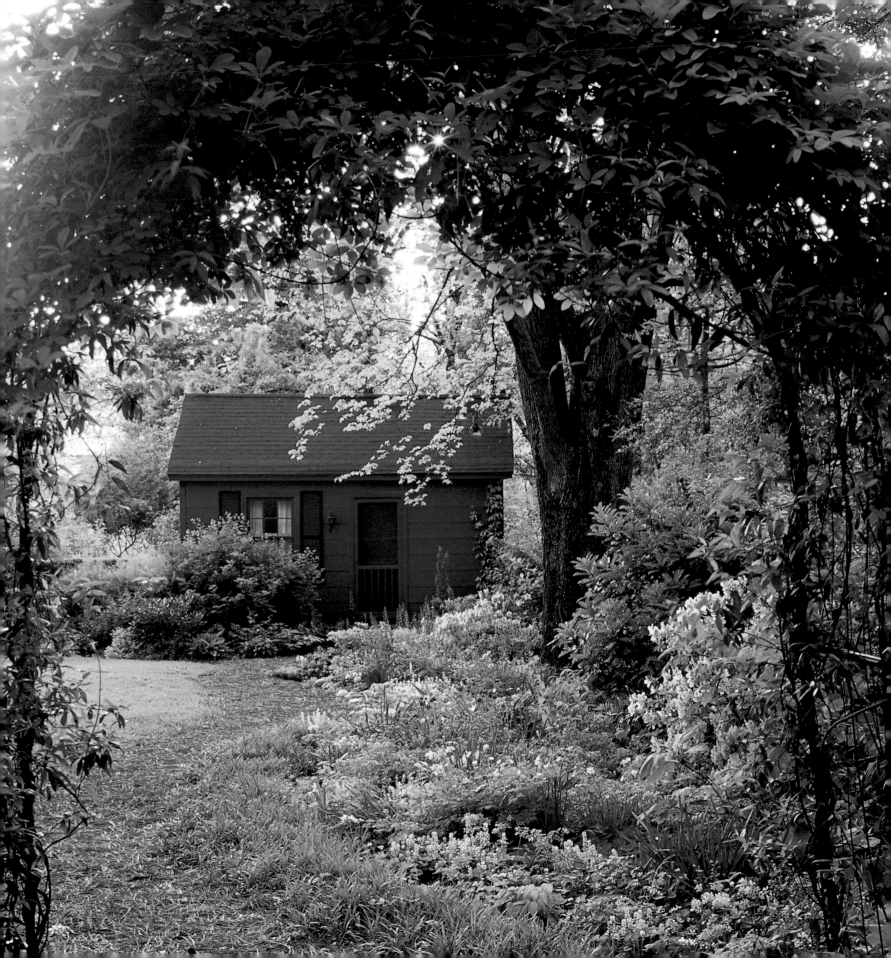

snail's pace. Their form, their width, and the materials they're made from all affect the velocity of their use.

The straighter, wider, and smoother the walkway, the faster you or your visitors will move from one end to the other. That's good if you're hauling in groceries from the garage, wheeling a load of compost from one bed to another, or welcoming a crowd of guests. The best materials for such hardworking walks include brick, large cut-stone pavers, ceramic pavers, concrete, and decomposed granite. All masonry materials should be mortared for stability, or well tamped in a bed of sand, so that you feel safe navigating these routes without ever glancing at your feet. You can also increase the speed at which the eye travels through the garden by setting bricks or oblong pavers parallel to the direction of the path.

If you'd rather have guests slow down and savor the hydrangeas or drink in the scent of the *Daphne odora,* then reverse your tactics. Lay out paths with gentle

Stepping-stones encourage the savoring of the garden's details (below) and set a contemplative mood (center). They also lengthen the life of well-traveled turf paths (right).

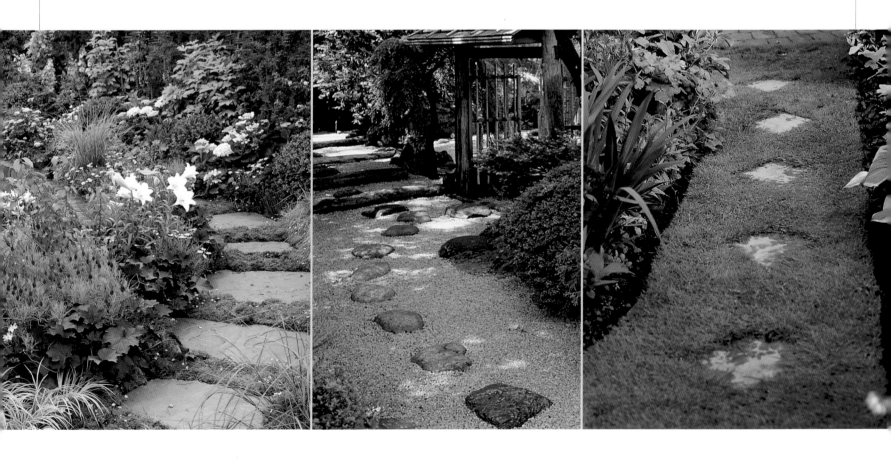

curves. Choose randomly set flagstones, or bricks set perpendicular to the path direction or in a herringbone pattern. Cobblestones, mosaic pebbles, or a mix of paving materials also tend to slow a walker's progress, as do pine needles, mulch, gravel, or any other loose material.

To slow speed to a crawl as a path curves through a fern-filled grotto, alongside a pond, or any place with small-scale plantings, resort to stepping-stones. Anytime people have to watch their step, they'll be more apt to savor the plants at their feet.

PAVING THE WAY

The walkways of old gardens seem to be natural extensions of the dwellings from which they radiate. The brick of the walk is identical to the brick of the chimney. The gravel that crunches underfoot has the same tones as the stone front steps. The fieldstones that form the garden's path are the same ones that rise up in the walls of the house. Built from one palette, all blend into a pleasing whole.

Such harmony used to happen without much forethought. The local brick-yard molded bricks from only one type of clay, and the rock and gravel came from the same quarry, an easy wagon ride from the garden. The fieldstones of both house and garden were unearthed in the back forty. Paths had a regional character well suited to their surroundings.

Today, however, you can have a walkway of Pennsylvania bluestone even if you live in Utah or Oregon, or a path of Arizona sandstone if you live in Florida— if you're willing to pay for them. But the best garden paths still blend with their native surroundings, and their materials should be chosen with that goal in mind.

Stone. Locally quarried stone appears to have arisen from the earth in which the garden grows, and generally will cost less than stone shipped in from afar. Check with stone dealers or quarries to see what types are quarried nearby. Stone

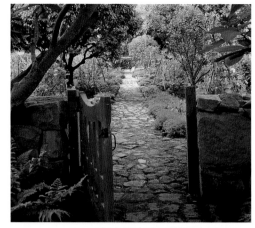

Rough fieldstones (top), pebbles laid in intricate mosaics (center), and cut-stone blocks (above) all have this in common: they reflect the landscape from which they originated.

CROSSING OVER: STEPS, BRIDGES, AND RAMPS

As much as the paths they connect, steps and bridges lead us through the garden. They take us by the hand and pull us onward, across gullies or streams, up slopes, or safely down precipices, easing our passage from one garden section to the next. These vital garden links help us get from where we are to where we know we want to go, but they also coax us into unexplored territory. Without them, much of the garden would be beyond our reach.

Nearby plants ramble across these steps, blending them into the garden.

SITING. As you're planning or rebuilding your garden, look for places that would benefit from the transition and structural interest a bridge or set of steps provides. Spots where there's an abrupt change of elevation or a natural watercourse are obvious choices, but there are other possibilities. Slightly sloping gardens will gain stature from a low retaining wall navigated by a mere step or two. A shallow dip in the land, planted with ornamental grasses, will grow more alluring when surmounted by a simple board bridge. A woodland path up a gentle hill will increase in appeal when crossed by log treads, partially embedded in the dirt and held in place with stakes.

Just make sure there's a functional reason that the bridge or flight of steps is

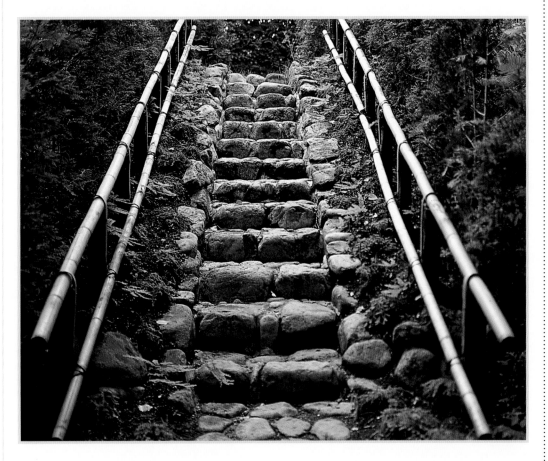

These weighty steps, which employ natural, rounded stones rather than the usual cut and dressed variety, transform a garden into an exotic paradise.

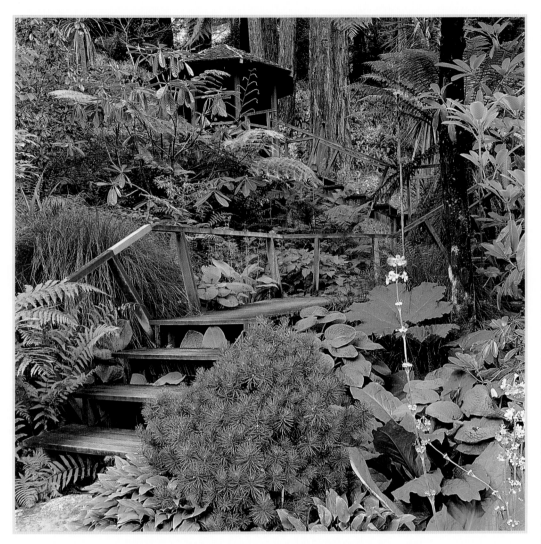

Ferns, hostas, and other lush growers lend a tropical air to this hillside pavilion, and practically engulf the simple staircase that leads to it.

there; few things look more contrived than a fancy bridge where there is nothing to cross, or steps that lead up a slope only to dead-end into a fence or wall.

STYLE. Like other structures, well-designed steps and bridges strengthen the sense of formality, informality, or even whimsy that's prevalent in the garden.

Come upon a long flight of brick steps or cross a bridge of cut stone, and it's hard not to think of the past, with its grand formal gardens and expansive pleasure grounds. Hike up heavy fieldstone treads embedded in a slope, or walk the rough plank that spans a moss-edged rivulet, and simple country plots come to mind. Sway on a rope bridge across a fern-filled chasm, or foolishly climb steps that lead to a trompe l'oeil door, and a garden of humor, adventure, or both is all that can be imagined.

In general, steps or bridges near the house should blend with its architecture, while structures in far-flung areas of the garden can stray into a more eclectic realm. These are prominent design elements, however, so don't fight your garden's prevailing character. A Chinese arched bridge or a flight of stairs worthy of Winterthur or Old Westbury will look sorely out of place if your garden lacks the appropriate setting, plantings, drama, or scale.

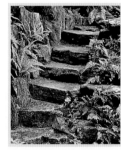

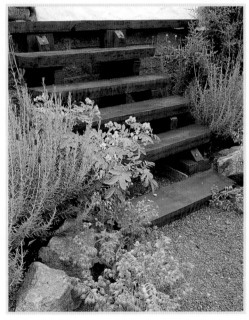

A coat of cobalt blue paint distinguishes this short flight of wood steps.

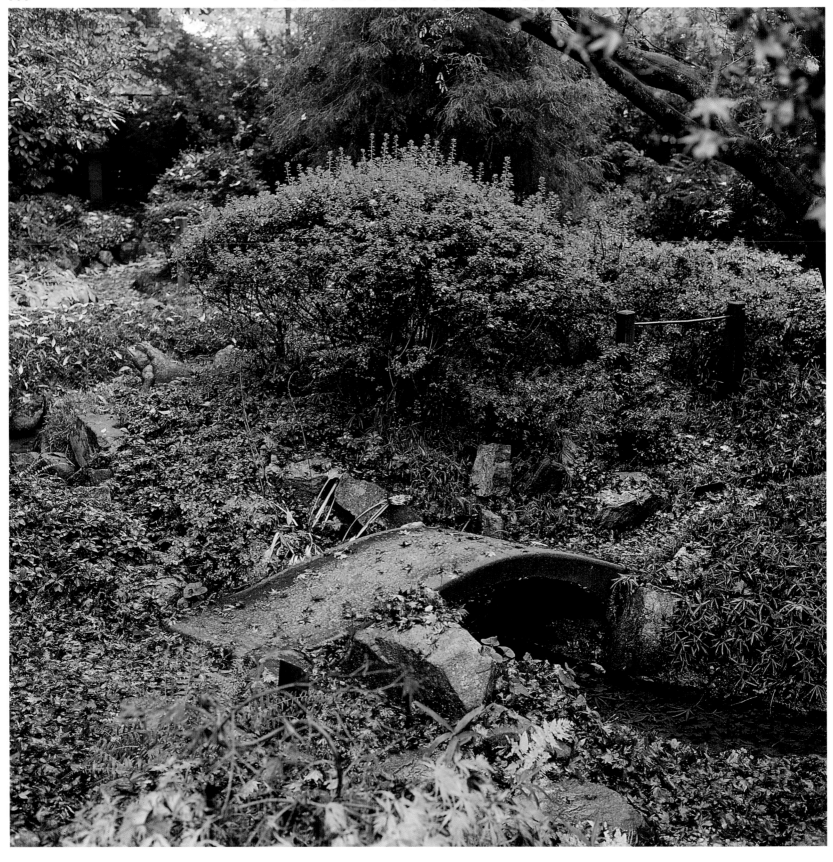

DESTINATIONS. Stairs and bridges are most enticing when they clearly link distinct sections of the garden. Who could resist climbing steps that rise from a carpet of lawn through a jungle of plantings to a slightly hidden pavilion that hugs a hill? Or crossing a rustic bridge that links a sunny spot to a path that disappears into the bluebell-carpeted woods? Even work-aday steps and

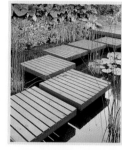

bridges benefit from having a visible destination, such as a shaded arbor off in the distance or a sundial that visitors will want to see up close. In the case of bridges, make certain that there's also a view from the bridge itself, whether of the water lilies that cluster near the bridge pilings or of a weeping cherry tree that can only be appreciated from midstream.

PLANTINGS. The right plants make steps and bridges seem an organic part of the garden, whether it's the baby's tears that creep unbidden to soften a flight of stone steps or the wisteria that drapes Monet's famed green bridge at Giverny in a veil of violet. Steps in

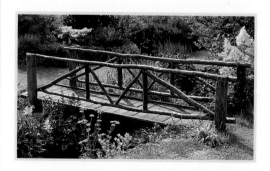

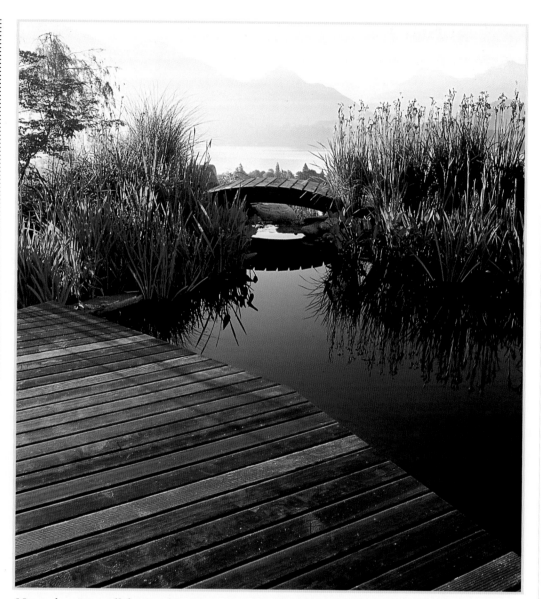

Natural settings call for simple structures, such as the wood bridge (above) or the concrete bridge (opposite). Both add subtle beauty to their surroundings.

particular cry out for thoughtful plantings along their flanks, since we tend to slow down and look to our feet as we ascend or descend. Here is the spot to put tiny rock garden plants, miniature roses, or any plants with small-scale leaves and flowers that would be lost in the garden at large.

Likewise, floating beauties such as the lotus or water snowflake are more apt to be savored when growing alongside a footbridge, whether it's a zigzag of planks across a pond (thought by the Chinese to discourage evil spirits) or a simple granite slab across a water channel.

paving is an excellent choice for walks near the house, where smooth passage and longevity are looked for. Cut stone (generally thin slabs of sandstone, limestone, or bluestone that are cut into squares or rectangles) makes the smoothest, most formal walks. Flagstones, which have irregular edges, give paths a more informal feeling and a slightly rougher surface. Small cobblestones also can be mortared into walkways, but tend to have an irregular surface ill-suited to frequently used routes. Slate becomes slippery when wet, so it isn't a good choice for underfoot.

Individual flagstones or large slabs of cut stone also make excellent stepping-stones, the former perfect for cottage gardens, the latter for more formal or modern settings.

Brick. Brick comes in a multitude of textures and colors that can be matched to almost any structure, old or new. Though manufactured in mass quantities, its earthen

Gaps between blocks of bricks create a pattern of their own (below), drawing the eye toward a garden pillar and urn. Bricks set in a herringbone pattern work well for informal as well as formal walkways (center and right).

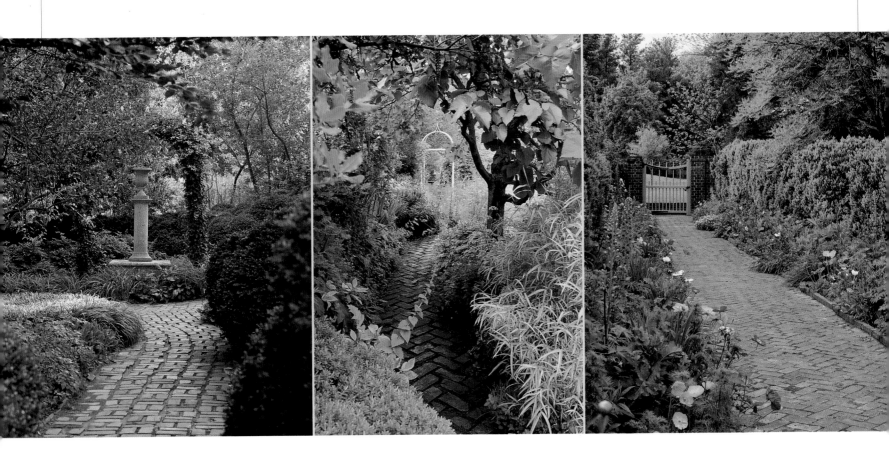

hues set off the blooms of the penstemon, catmint, and other cottage favorites much the way stone does. Yet, depending on the type of brick and the pattern in which it is laid, this classic material can also look elegant and formal or starkly modern.

Bricks are as smooth and stable as stone, a plus for paths near the house. Brick that has a severe weather (SW) rating will hold up best, particularly in frigid areas, but softer brick types, or used bricks, will seem more at home in the garden.

Concrete. Concrete walks are less expensive than either brick or stone, provide a smooth, durable surface, and are easily designed to suit almost any garden's character. They're plain enough to form a foil to busy plantings, and star in utility areas of the garden, where durability and ease of maintenance are more important than atmosphere. To lessen its gray monotony, concrete can be tinted in warm earth tones, inlaid with shells, topped with mosaic patterns of pebbles or broken

Concrete stepping-stones blend well with both plants and pebbles (left and center). This waterside walk looks like wood (below), yet is far more durable; only the designer knows whether it's cut stone or artful concrete.

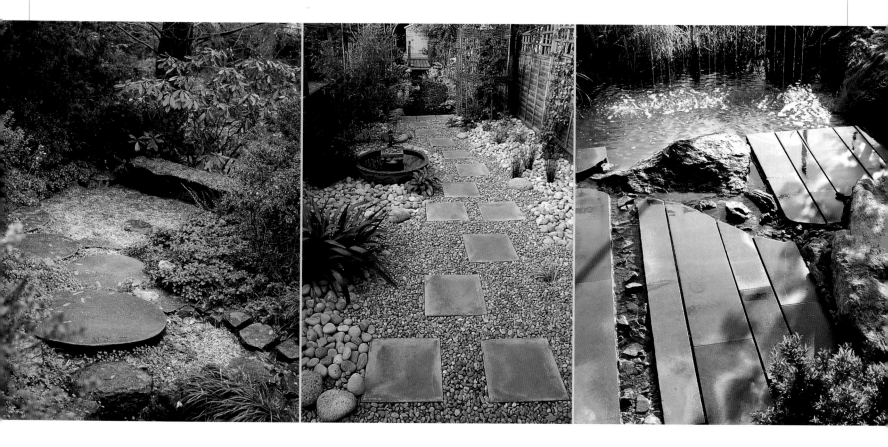

STEPPING OUT

Stepping-stones are miniature floors sized for our feet: they keep our clogs out of the spring mud and set a leisurely pace in the garden.

If natural flagstones aren't available, make your own stepping-stones from concrete or hypertufa: a mix long used to form faux-stone troughs for coddling alpine plants.

Step One: Stroll through the area where the stepping-stones will go. With each step, mark a point just inside the arch

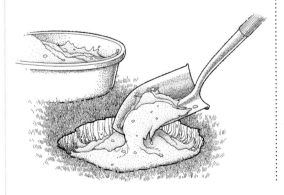

of your foot. These points will become the approximate center of each stone you make.

Step Two: Excavate the forms for the stones right in the soil. Using a trowel, shovel, or spade, dig down at least three

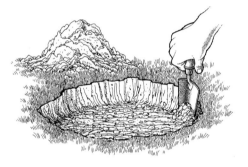

inches, keeping the sides straight up and down. Make the forms approximately 12 to 18 inches in each direction. Don't try for perfect rounds; nature rarely produces them. Instead, create elongated or blocky shapes with odd curves and angles. Make the stones at both the beginning and end of the path larger than the others. (See sidebar, page 175.)

Step Three: Don rubber gloves and a dust mask for mixing the concrete or hypertufa.

For concrete stones, mix *ready-mix concrete* with *water* until thoroughly moistened but stiff, then shovel it into the form. Smooth the top of each stone, then shape its edges with your hands or a mason's trowel. If desired, press in pebbles, shells, or other objects such as ferns or leaves.

Cover with *plastic* and let cure for four days.

For hypertufa stepping-stones, which will blend naturally with the garden as time passes, mix one part *#20 sand (medium grit),* one part *Portland cement,* and one part dry *peat moss.* Slowly add water and mix until the hypertufa sticks together but isn't soggy. Press into place in the hole you've excavated, then cover with plastic for one to four days.

Step Four: After the hypertufa stepping-stones have hardened to the touch but can still be scratched, distress their exposed surfaces with a chisel or wire brush. Let the stones cure for four to six weeks. If possible, shelter them from direct sunlight during the curing time.

Note: If you garden in a region that's prone to cycles of freezing and thawing, reinforce the hypertufa by mixing *Fibermesh* in with the dry ingredients. Fibermesh is a reinforcing fiber that's available from concrete suppliers and some home centers and building supply stores. You'll need to use about two cups of Fibermesh per gallon of dry hypertufa mix. Once the reinforced stepping-stone is fully cured, quickly burn off the fibers that stick up from the stone with a propane torch.

Both dry concrete and hypertufa mix may be tinted with *concrete colorant,* available at home centers and building supply stores. A little goes a long way.

pottery, brushed for texture, or stained or waxed.

Concrete stepping-stones are widely available in rounds or squares, or can be poured in place right in the garden. While they can look a bit stark on their own, and certainly don't resemble stone, they perform brilliantly when combined with other path materials. Square concrete pavers, for instance, take on a sophisticated stance when laid out in the middle of a gravel or pebble pathway that's edged with two-by-fours or benderboard, particularly when the pavers are angled into eye-catching diamond shapes. They form islands of stability in the loose gravel but still have a compatible feel.

Concrete also can mimic close-laid flagstones when scored after pouring or formed with the help of a multipart mold. While no one will believe these paths originated at the quarry, they're right at home with some 1920s and '30s cottages.

Wood.

Boardwalks excel at keeping feet clean while crossing muddy, boggy, or sandy terrain. Commonly constructed from rot-resistant lumber types such as cedar, redwood, or cypress, boardwalks can be made in sections, then moved into place in the garden. As a result, they're much easier than other path materials to shift as the shrubberies grow. Short lengths of boardwalk are particularly effective at bridging soggy spots in woodland paths that are surfaced with bark mulch, leaves, or pine needles. They seem most suited to outlying areas of woodland, meadow, or seaside gardens.

Wood stepping-stones, sliced from tree trunks, are also compatible with little-cultivated spots. You can buy them at some landscaping supply yards and nurseries. Alternatively, keep an eye out for trees that have been felled by storms and are being cut up by work crews. You may be able to wangle some fresh-cut rounds.

Or, consider wood blocks for pathway paving; lay them in sand in a similar manner to brick, with the end-grain revealed.

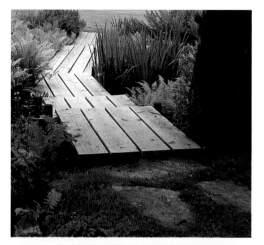

Wood is often overlooked as a material for paths, but stars in several forms: as boardwalks or duckboards (top), as stepping-stones (center), or as paving blocks (above).

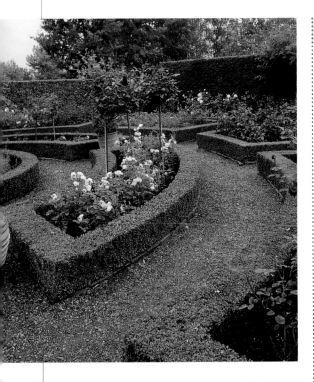

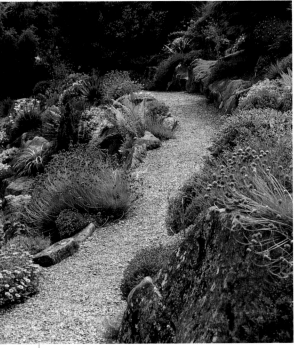

Gravel varies in color depending on its region of origin. Red lava rock (or crushed brick) sets off green edges of box (top); gray gravel complements pink hues (above).

Gravel. Victorian gardeners prided themselves on a well-packed gravel pathway. Today's gravel paths are less stable underfoot than those of the 19th century, but they have similar advantages. They're inexpensive in comparison to stone and brick, suit their natural surroundings when made with locally quarried material, and provide a simple foil for the most complex and colorful of plantings. In addition, they need little expertise to lay and have a satisfying crunch that will alert you to another's approach while you're checking the drippers or harvesting the lima beans. Gravel pathways shouldn't be used for the primary walks near the house, since the stones invariably get lodged in shoe treads and are tracked inside.

Decomposed granite. Pathways of decomposed granite have an earthy feel that blends in with the nature's handiwork, yet are a big step up from hard-packed dirt. They're formed from thin layers of crushed granite that is moistened, then packed into place with a heavy roller or compactor, often between two-by-four or benderboard edgings. These simple paths hold up well under kids' feet or wheelbarrow wheels, let water soak through to the roots of plants and trees, and are relatively inexpensive in areas where granite is plentiful. Decomposed granite often is gold or gray in tone, but colors may vary from region to region. Like gravel, decomposed granite will get tracked into the house if nearby, so it's best deployed in the garden's outer reaches.

Turf. Grass paths are like rivers of green that flow between the garden's beds: fresh, cool, and inviting. They require more maintenance than most path types (particularly when it comes to keeping their edges well manicured), need a great deal of water, and won't tolerate a ton of foot traffic. But each smooth swath of green sets off the flowers it borders like the perfect frame (see pages 156–157). To lessen trimming chores, add mortared brick or cut-stone mowing borders on turf paths to give the mower's wheels a stable track to ride on. (See page 151.)

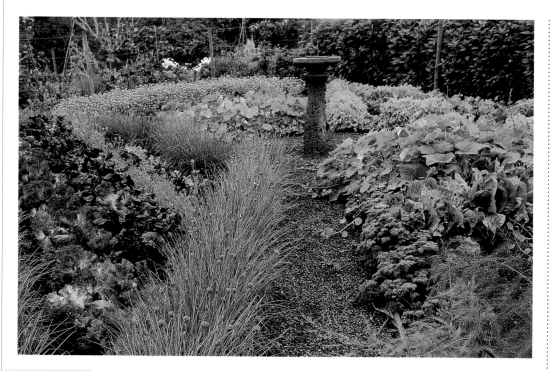

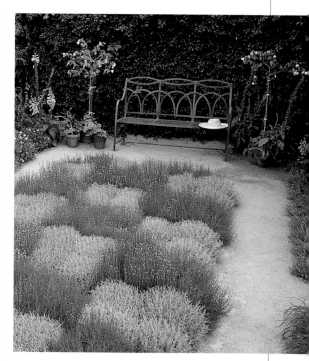

Mulch. Woodland or shaded paths benefit from soft materials that might naturally be found in the forest, such as pine needles, leaves, or shredded bark. These mulches help suppress weeds and lessen mud, while providing a surface that muffles the sound of your footsteps so you can savor the rustling birds or the whisper of wind in the trees.

Interlocking pavers. Manufacturers offer numerous types of cast-stone pavers that interlock to form a hard, stable surface suitable for walks, patios, or even driveways. While extremely durable, many seem to carry the stamp of the large-scale applications—shopping malls, public squares, housing tracts—in which they are most seen.

Mix and match. You can combine many path materials to enhance a design, cut costs, or meet the needs of a particular garden site. Achieve beautiful textural effects, for instance, by combining cut stone with fieldstone, or flagstones with cobbles or river rock. Lower the cost of a brick walkway, or dress up a con-

Gravel matches the demeanor of an herb garden (left). Decomposed granite frames a santolina checkerboard (top). Stone and brick (above) are an elegant pairing.

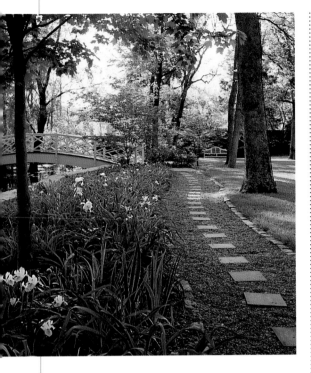

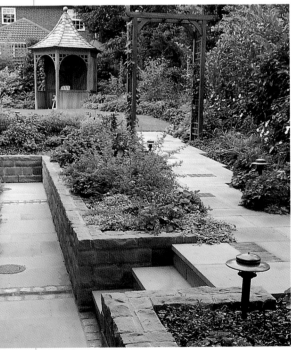

Stepping-stones provide both pattern and secure footing in a loose gravel path (top). Bricks and cut stones dress up a tinted concrete path (above).

crete one, by pouring rectangles of concrete in frames of brick. Stone and brick also make great companions. Or, lay a brick walk in a lattice pattern and fill the spaces with gravel, turf, or pebble mosaics.

PROCURING A PATH

Landscape architects are well qualified to design garden walks and paths and oversee their installation by qualified tradesmen, particularly when complicated sites, difficult drainages, or many changes in level are involved. But many paths and walkways, even stone and brick ones, can be built by the gardener who's blessed with patience, an eye for detail, a bit of brawn, and a penchant for craftsmanship.

Along with boardwalks, stepping-stones, and turf, materials such as gravel, decomposed granite, mulch, random-set flagstones, and brick or stone set in sand are the easiest path types to work with.

Begin by marking out the course of your path or walkway through the garden with stakes and string, rope, or garden hoses, or by drawing it in the dirt or sketching it out with landscape spray paint. Walk the route and observe it from different points in the garden, as well as from the windows of the house. Once you're satisfied that your path is in its proper place, get your spade or pick and shovel.

For most path types, excavate the route to a depth of two to seven inches (depending on whether there's turf and on the thickness or desired depth of your path material). Your goal is to have the finished surface of a paved path just slightly raised from the surrounding landscape so that water drains off, not into it. Paths of loose materials should be even with the surrounding ground level.

• For mulch paths or simple gravel paths on well-drained soil, the edge with brick, stone, or wood, and then fill the excavated area. Use landscape fabric underneath for weed control if desired.

• For durable brick or stone paths, excavate an area that's as wide as the

desired path plus its edgings. Fill the excavation with a 3-inch layer of base material (also called base rock, aggregate base, gravel subbase, or crushed rock). Compress the base with a vibrating plate compactor (available at retail centers), then add brick, stone, 2-by-4, or benderboard edgings and stake into place. (When installing both edgings and paving, stretch a string between stakes to mark the desired level and pitch of the path.) Top the base between edgings with a 1- to 1½-inch layer of coarse-grit sand. Level sand with the edge of a 2-by-6 board notched to fit over the edging. Tamp sand, add more sand, and level again. Lay the brick or stone, leaving it slightly proud of the desired level, then tamp it into place (a wide piece of board laid over the paving will help keep the area level). Brush fine sand into the joints.

For random-set pavers, lay the edge stones first, then fill in the middle. For cut stone or brick, start at one end of the path and work your way to the other.

• For decomposed granite paths, add wood edging (check for desired level with string and stakes), then spread a layer of decomposed granite that's one to one and a half inches thick. Wet it and let stand overnight, then roll with a roller or compress with a vibrating plate compactor (both can be rented). Repeat until the path is approximately three inches deep.

• For stepping-stones, excavate only the spot where you wish the stone to go. Add a layer of sand, then jiggle the stone into place.

Once your project is complete, take a break from your labors, then set your feet upon the path you have devised.

Let it pull you into the garden's farthest reaches. Let it lead you to the herb garden, the apple tree, the fountain, or the birdbath. Let it tug you past the roses, under the maple tree, and around by the garden shed. Feel its lure and acknowledge its power.

Then, when you've admired every brick or approved of every flagstone, let your handiwork guide you safely toward home.

THE RIGHT PACE

When placing stepping-stones of irregular shapes, or when casting concrete stepping-stones, group the stones loosely in pairs or triads. Vary their sizes, and locate the largest stones at the beginning and end of the path. Or substitute two stones, side by side, for these jumping-off and ending points. For long paths, include a broad stone at a central spot as a sort of resting place.

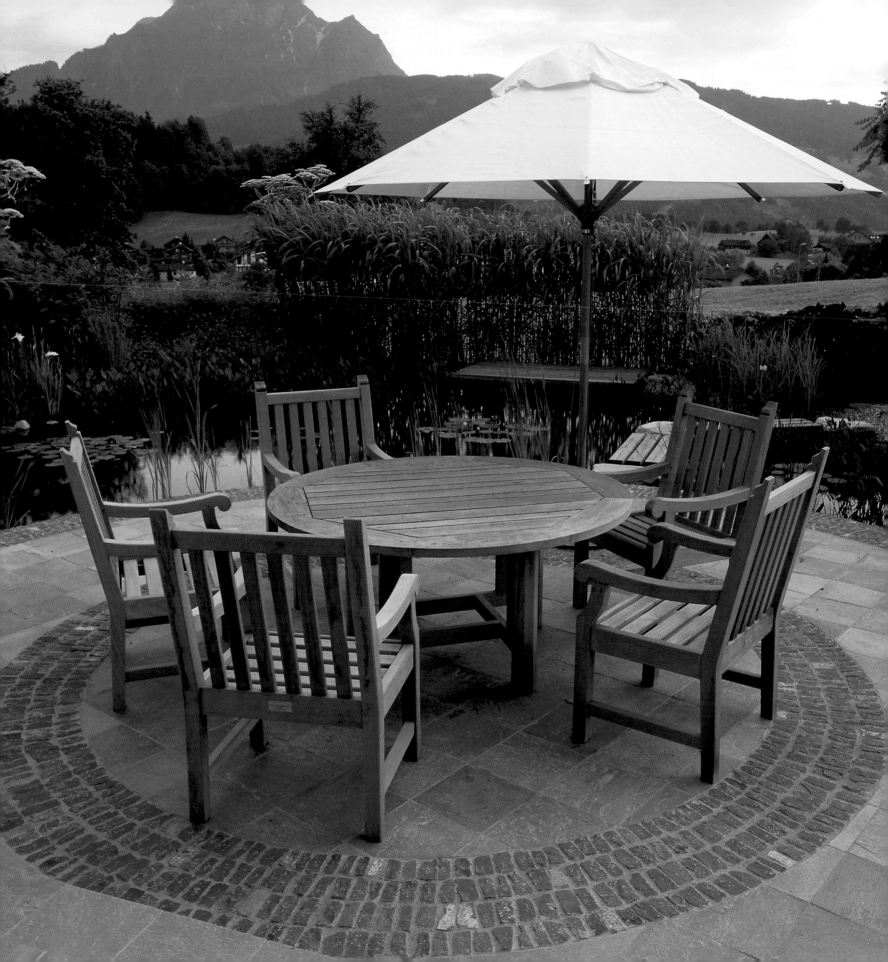

CHAPTER EIGHT PATIOS, DECKS, AND TERRACES:

the middle ground

LET OTHER PARTS OF THE GARDEN cater to the plants: the needs of the alchemilla or the desires of the dogwood. Patios, decks, and terraces are meant for people.

On them, in the dappled shade, sun, or light of the full moon, we catch our breath from the frantic pace beyond the garden's borders. We read, eat, nap, and watch the birds. We reminisce, shell peas, or dance under the stars. We grill salmon fillets, or vegetables fresh from the garden. We stare off into the trees, gaze across the fields, and admire the abundance of our flower beds. And sometimes we even work, tapping out memos or e-mail on the laptop, inspired by the peace of the plants, the music of a fountain, or the breeze from mountains or ocean.

Built to fill our needs, these open-air living rooms are the point where the house and the garden intersect: the realm where domesticity and nature join forces and become the best of friends.

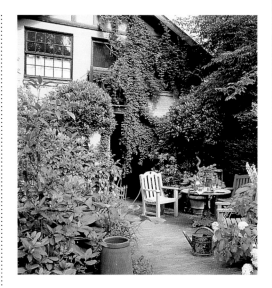

The stone in this patio (opposite) echoes craggy peaks in the distance. Even small gardens have room for a patio (above).

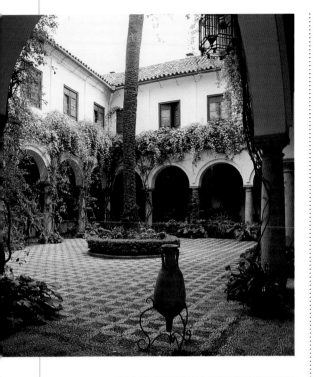

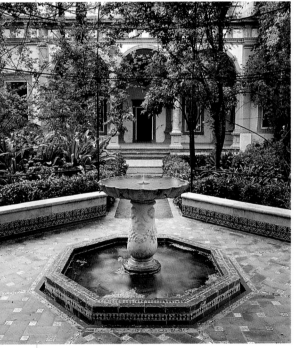

Spacious interior patios have long been a mainstay in sunny lands, where they provide privacy and a shaded outdoor living space at all but midday.

PAST PERFORMANCES

Such hospitable structures have been part of the garden for more than two thousand years. They arose in temperate climes as sheltered inner courtyards, surrounded on all sides by the walls of the dwelling yet open to the sun and sky. Well-to-do residents of Pompeii enjoyed the pleasures of such private courts, where trickling fountains masked the noise from the bustling streets. These roofless rooms soon evolved into patios, accessible to the garden on one or more sides, and have coddled their owners in Italy, Spain, and other sunny lands ever since that ancient time.

In northern lands during the Middle Ages, nobility escaped from dank, gloomy castles to walled outdoor living areas where they could read, drink wine, socialize, court, strum their lutes, play chess or backgammon, dine, or even dance. These sunny havens weren't paved with stone or brick, but had floors of grass (often spangled with strawberries or periwinkle), earth benches topped with turf on which the ladies and gentlemen could lounge or nap, refreshing founts or wells, and a wealth of sweet-scented flowers and trees. They must have seemed like heaven.

Garden living areas broke out of their walled confines during the Renaissance, when the open terrace rose to favor. Renaissance terraces were an artful solution to Italy's steep terrain, with forerunners in the terraced gardens of ancient Mesopotamia and Egypt, as well as in the more practical grading of hilly land to allow the cultivation of crops. Bordered by balustrades of gleaming marble and connected by long flights of steps, they became the garden ideal that designers in following centuries, and in far-flung locations, would strive to emulate.

By the 17th century, the raised terrace was a must-have adjunct to palaces or mansions throughout Europe and the British Isles, even where the land was flat. An artificially elevated terrace provided a grand stage on which noblemen and their ladies could stroll while surveying the vistas and ornate parterres of their formal grounds. While not as sheltered as a courtyard or walled garden, the terrace's views were much

improved. And there was plenty of elbowroom for lavish entertainments; Louis XIV reportedly once hosted three thousand guests on the terrace at Versailles.

After a brief fall from grace during the 18th century, particularly in England, terraces were revived by the status-conscious Victorians. When built in the Italianate style their suburban villas always included terraces, which according to American landscape designer Andrew J. Downing were "universally admired" as an object of taste. When villas were built in the Tudor or Gothic style, they often included verandas, porches, and balconies, which functioned as terraces but on a diminished scale.

New forms weren't far behind. As middle-class houses grew smaller and leisure time greater, paved outdoor areas expanded the usable living space. Called both patios and terraces, these were at ground level and usually backed onto a wall of the house or were tucked between its wings.

*"*H*e hath no leisure who uses it not."*

—GEORGE HERBERT

A traditional terrace is bounded by a weighty balustrade (left). This walled courtyard (center) has medieval roots. Elegant terraces such as this one (below) were designed to provide a view over an entire estate.

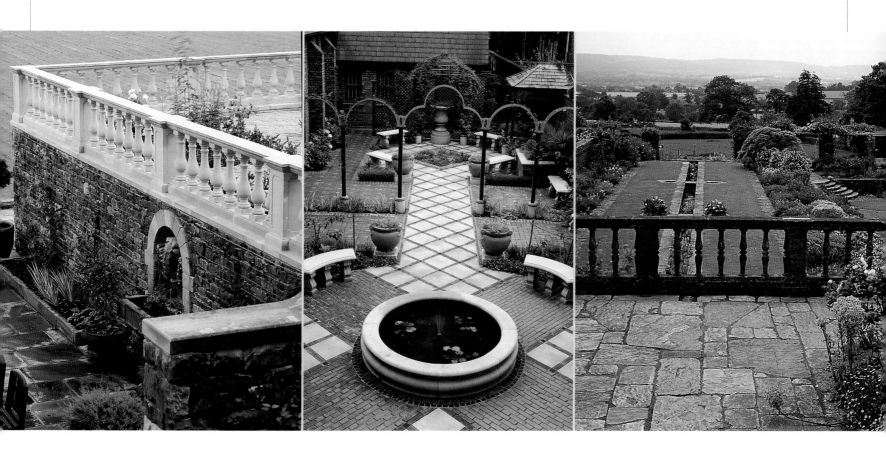

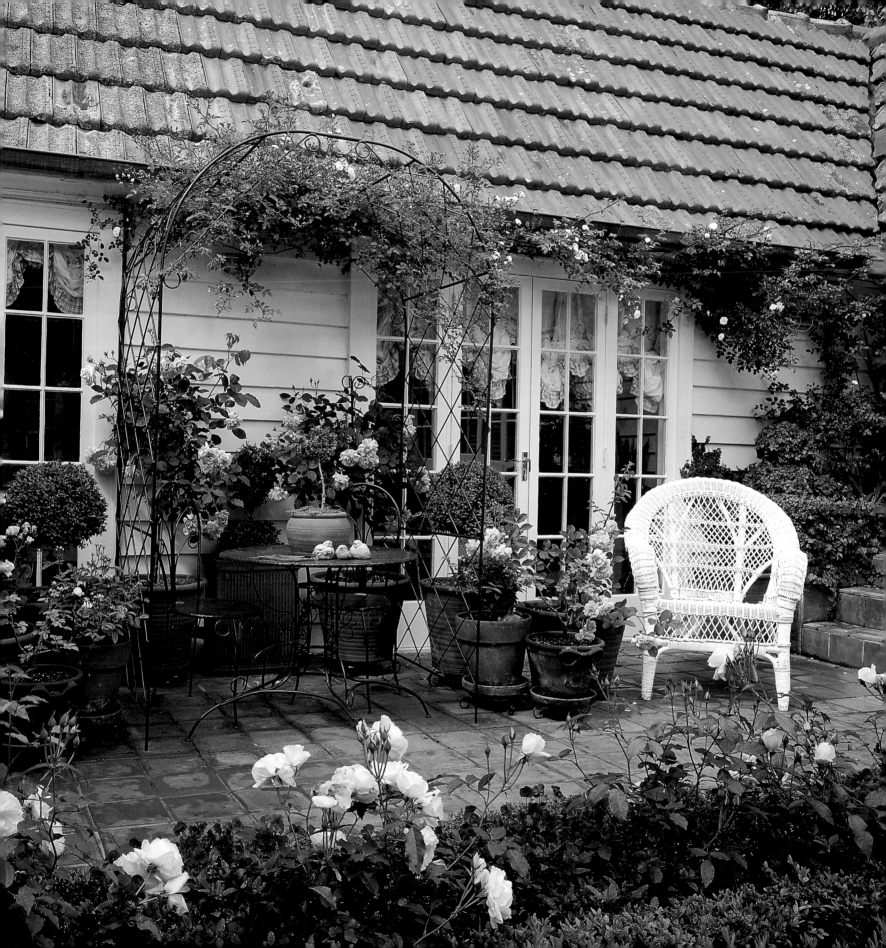

By the mid 20th century, the design and function of the raised terrace and the construction methods employed in wood verandas and porches had merged, and the deck was born. Chatting with the neighbors from the front porch was exchanged for barbecuing with friends on the back deck. Espoused by influential California landscape architect Thomas Church, decks came to fill a niche that patios and raised terraces could not, allowing outdoor living space to be built without disturbing mature trees or when houses were on steep slopes. Even in less demanding settings, decks starred, thanks to their flexibility and ease of construction.

CHOOSING A STYLE

The origins of patios, terraces, and decks give us guideposts to their uses in our own gardens. Elevated stone terraces with fat stone or concrete balusters, for instance, should be saved for Italianate villas or grand Georgian houses, not forced onto the backsides of stucco cottages or shingled bungalows. "Terraces are not permissible anywhere but around the mansion," wrote the author of *Johnson's Gardener's Dictionary,* first published in 1846, and that opinion largely still holds sway.

Less formal terraces, however, bordered by low stone walls, iron railings, latticed balustrades of brick, or no railing at all, might suit a wide range of homes and could be the ideal solution if your house sits on a rise above the main level of the garden. But keep in mind that terraces emphasize the view. If your yard is small and the only vista is of the neighbor's peeling clapboards, you'll be better off relaxing down at ground level, where you'll gaze at the wonders of your own garden.

Wood decks—neat constructions of redwood, cedar, or Douglas fir—generally should be saved for 20th-century houses of modern design, where they amplify the linear nature of the architecture, not bolted to upright Victorian farm-

French doors promise ease of access to this tile-paved patio (opposite). A wisteria-clad pergola shades a patio (top), while a sleek arbor does the same for a deck (above).

houses or brick Tudor two-stories. But again, exceptions do occur. Victorian verandas can be extended into appropriate decks that allow for sunning or entertaining, yet are styled and painted to match the trim of the house. A turn-of-the century shingle-style house might benefit from a deck with a shingled façade. And since they're inconspicuous in character, ground-skimming decks that function as patios can be designed to complement many building styles.

In similar fashion, ground-level patios tend to suit a variety of house styles, and to merge pleasingly with the garden. And because the weight of the paving is not an issue (as it would be in surfacing a deck), choosing materials that complement the structure of the house is a simple task.

A brick and cobblestone patio, for example, might set off a Craftsman bungalow with a clinker brick and river-rock chimney, while a flagstone patio would do the same for a stucco house of 1930s or modern design. A tiled patio would

A brick patio at the garden's fringes (below) belongs with a simple farmhouse; a geometric deck (center) suits a modern dwelling; while a cobblestone patio (right) blends with a wide range of architectural styles.

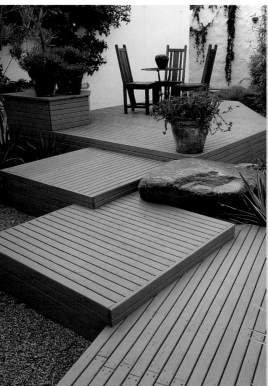
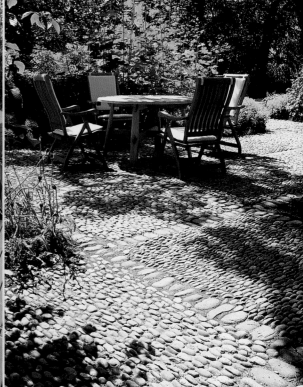

bring life to a 1920s or current-day Spanish Colonial home, while a concrete patio with an exposed aggregate finish might suit a 1950s ranch. And a patio laid with rectangles of bluestone might be equally at ease adjoining a steel-and-glass dwelling from the late 20th century or a saltbox built in Revolutionary times.

A broad terrace escapes pretension thanks to its gravel surface, low stone-and-brick balustrade, and ornaments of simple pottery urns.

SITING

Begin planning your outdoor living space by doing a little dreaming. Where would you most enjoy lounging in the garden on a sunny morning? How

PAVING PARTICULARS

Patio pavings, like squares of a patchwork quilt, may be pieced together in a variety of fashions, and stitched together with other materials in countless ways. Time-tested standards include the following:

A pebble mosaic, segmented like the shell of a chambered nautilus, uncurls in this sheltered patio. Such detailed stonework adds interest to cramped quarters.

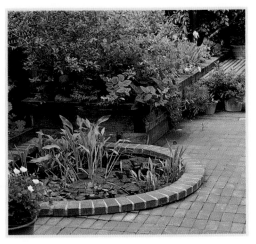

Brick set in a jack-on-jack pattern makes for an uncomplicated, soothing surface.

BRICK. These versatile blocks of fired clay can be set in sand, in dry mortar mix, or in wet mortar, and are easy for almost anyone to handle. In addition, most bricks are simple to cut and provide excellent traction if kept free of moss.

To shake bricks up a bit, try combining them with colorful tiles, wood timbers, bands or borders of low-lying ground covers, patches of pebbles, or wide bands of concrete with the aggregate exposed.

FLAGSTONE. Flagstones that are dressed into uniform rectangles will enhance your garden's formal side, while irregular flags will play up its romantic character. Both types can be laid on sand or on a mortar bed, and seem as indigenous to the garden as the plants themselves.

Consider mixing flagstones with patches of broken brick or insets of cobbles. Or fill in the irregular spaces between the flagstones with bright bits of broken tile, china, or even marbles, mortared into place.

TILES. Terra-cotta tiles conjure up the sun-drenched Southwest. Because they're thinner than bricks or flagstones, lay tiles in mortar on a concrete base.

Don't overlook the variety of natural stone tiles that are increasingly available. Particularly evocative are "antique" stone tiles that have been tumbled to mimic the wear of centuries. Combine them in subtle checkerboard patterns or insert them like archaeological relics into other pavings.

CONCRETE. Concrete's adaptability and low cost makes it one of the most versatile patio pavings around. You can pour concrete into any shape patio you can dream of, tint it to soften its appearance, or choose from a variety of surface finishes. For an artistic touch, inlay shells, pebbles, tiles, potsherds, broken bits of china, or insert traditional materials such as brick, stone, or wood. Or, lay interlocking concrete pavers, available in many shapes and colors.

many friends might you like to invite to your annual badminton tournament and barbecue? Where could you locate the hot tub for a better view of the stars? Where is there room to tuck a rustic table for summer banquets as the sun goes down?

Then get down to practical matters.

Sun. Most of us seek the sun, no matter where we live. At some point in the cycle of the seasons, its warmth becomes a balm that heals both the body and the soul. Track the sun's course through the year and determine where it lingers. Then decide when you'd value its soothing touch the most.

If you're housebound through frigid winters, and the summers are hot and humid, you might savor a terrace, patio, or deck that catches the sun in spring and fall. If your winters are mild, and the remainder of the year calls for cranking up the air conditioner, a spot that captures the sun at New Year's would be ideal. If your clime is coastal and the summers cool, then a deck or patio sited to welcome the sun at its zenith makes the most sense.

Don't worry if the sunniest spot is away from the house; sun-seekers will gladly trek to a far corner of the garden to catch an hour's glorious rays.

Shade. The ideal terrace, patio, or deck has shade as well as sun, so that your temperature can be adjusted simply by switching seats. Site a patio, for instance, so it's shaded by trees at midday but garners both the morning and evening sun. Or provide a deck with a shade structure, made of lath or cloaked with a grapevine, that provides some relief from the noonday heat. If space is too tight for both sun and shade, consider building two separate patios or decks: one for days when the temperature soars and another for when the air is cool but the sun bright.

Shelter. If you're apt to use your deck or patio mostly in warm weather, breezes may be welcome. But most outdoor living is best done out of the wind,

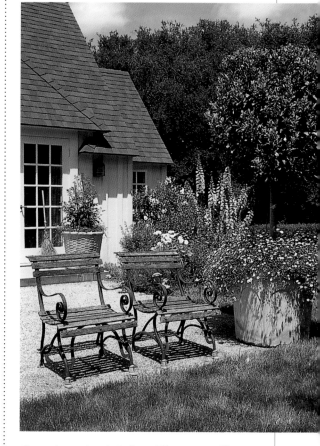

Sometimes simple is best. This patio off a bedroom is nothing more than a square of well-packed gravel, level with the lawn, yet it's an ideal spot for morning coffee.

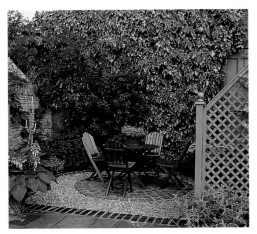

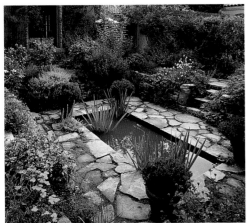

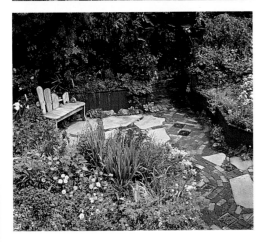

High walls create a private patio nook (top). Paving at poolside (center) provides room to pull up a chair and feed the carp. An outlying patio is just big enough for a quirky garden bench (above).

which can fray the nerves and coat the grill with dust. An inside corner where two walls of the house meet is an ideal site, as is an area directly in the lee of a privacy fence or wall. (Fences with a top baffle that slants out and into the wind give the most wind protection.) If your patio, deck, or terrace is exposed, carefully situated shrubs, wood screens, or even glass or acrylic panel fences will help keep much of the wind at bay.

Privacy. None of us want the neighbors peering, uninvited, into our living rooms; our outdoor living spaces should be equally inviolate. Existing privacy fences or walls will go a long way toward shielding your patio or deck from the street or the neighbor's view, or can be built solely for that purpose. If local fence-height restrictions leave you feeling a bit exposed, plant close-set trees, or extend the effective height of your fence or wall with wire trellises and perennial vines.

If neighbors peer down on your deck from higher up a hill, well-sited trees or tall shrubs will provide ample camouflage, allowing you to lounge in the sun unobserved. Even a patio in a city garden, visible from all the surrounding buildings, can be protected from view with an overhead lath or lattice. The arbor will cut down on your sun exposure (a desirable thing on steamy urban days), but your privacy will be ensured.

Proximity. Consider what you'd like to be near. When you're grilling for a crowd, you won't want to carry wineglasses or pans of marinated shish kebab through the laundry room, down the stairs, and across the garden. A patio or deck with direct access to the kitchen or dining room would be ideal. If your garden has a pond, situate a small patio near its borders so you can observe the resident aquatic life close-up. If your lot is blessed with a great view of neighboring fields, far-off hills, or the lake or sea, make sure some part of your deck or terrace takes advantage of the vistas.

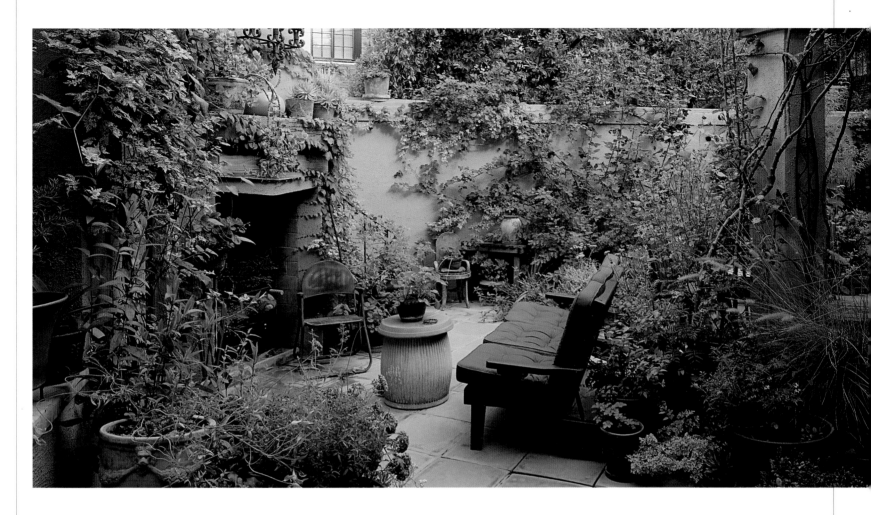

Reconstruction. Sometimes, siting the perfect patio, terrace, or deck may mean making changes in the structure of your house as well as your garden. You might want a small patio to catch the morning sun outside your bedroom, but the only way to get there is down the hall, through the kitchen, out the back door, and around the side of the house. Adding a pair of French doors in the bedroom will provide a direct route from bed to the sun-struck breakfast table and bring a bit of the garden's glory indoors (let someone else trek to the kitchen and make the coffee). Likewise, French doors or sliding doors from the living room, family room, or dining room to an adjoining patio or deck can make the difference between indoor and outdoor rooms that seldom see activity and ones around which your daily life revolves.

Tile pavers and high stucco walls frame an outdoor room in a city backyard. An eclectic mix of furniture and ornament give the space added personality.

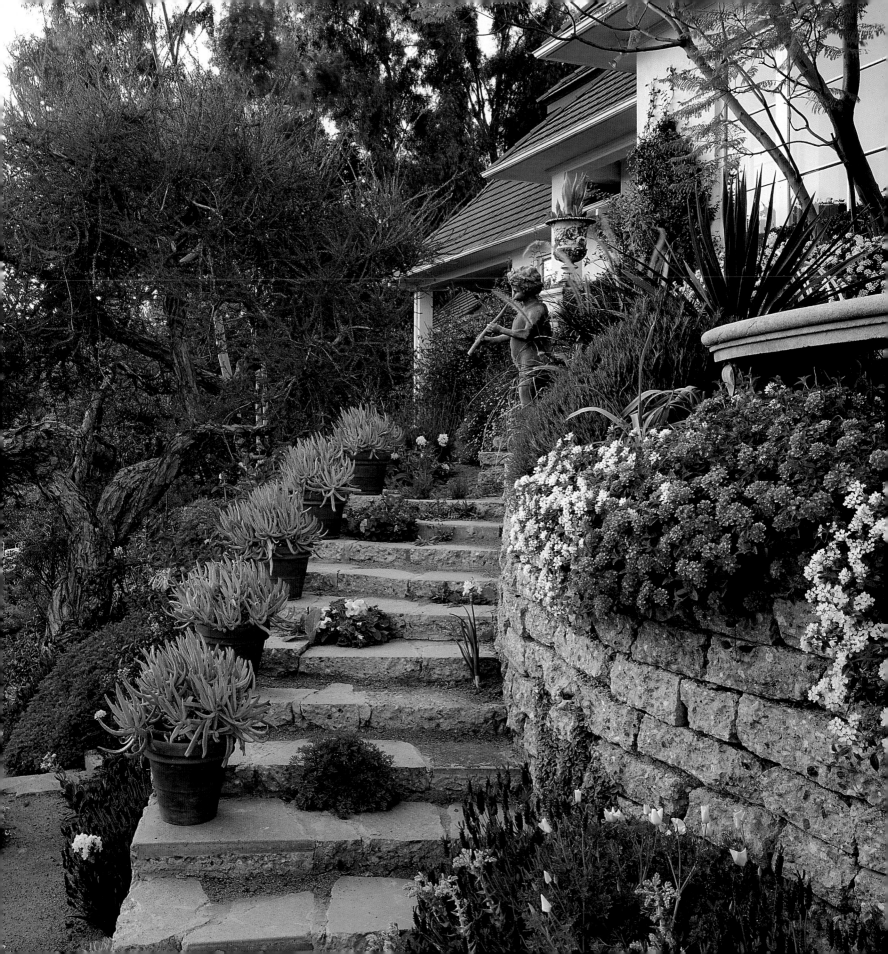

THE TERRACE

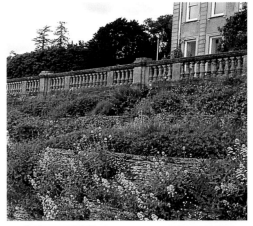

The classic terrace runs along the rear of the house and is raised above the surrounding garden. It may be only a step above the mallow and the poppies, a barely noticeable shift in stature. Or it may be elevated 5 or 10 feet or more, commanding a privileged view over the rose garden or apple orchard and out to the wood, meadows, or lake beyond. Your house, and the character of the terrain on which it sits, will largely determine which type of terrace you build.

Terraces merge three types of garden structures into one. The first is a suitable retaining wall, to hold back the earth upon which the terrace surface will sit and to transform a sloping piece of land into two distinct levels. The second is the terrace floor, which is no different from that of a ground-level patio. The third is a low wall or edging, traditionally in the form of a stone or cast-stone balustrade, that defines the edge of the terrace and keeps visitors from tumbling into the perennial beds below.

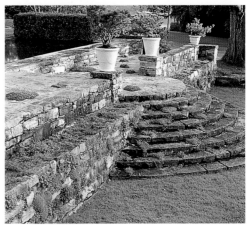

Retaining walls. As with other garden walls, terrace retaining walls should complement the character of adjacent architecture, both in material and level of formality. Classic materials for terrace retaining walls include dressed stone and brick, but ledger stones, river rock, poured concrete, and railroad ties (placed horizontally or vertically) also suit homes of a more informal nature.

Concrete-block retaining walls for terraces can be faced with brick, stucco, cast stone, or cut stone, or camouflaged by tall hedges or trellis-grown perennial vines. Retaining-wall blocks that are designed to interlock also may need an artful cover-up; they tend to look overly busy in tall applications.

Retaining walls for terraces are best built by professionals and require the evaluation of an engineer except when they're less than two feet high and are located more than six feet from the house or other buildings. Such walls not only

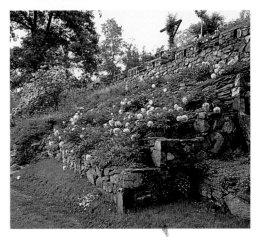

Steps and a retaining wall of recycled concrete lead up to a house-level terrace (opposite). Old terrace retaining walls like those above were often were fashioned with built-in planting beds or semicircular steps.

have to hold back the weight and pressure of a mountain of earth, but also must bear part of the weight of the house and contain the forces of expansion when the soil is saturated during rainy months. All retaining walls (except low drystone walls) should have drainage holes along their lower courses and may require additional means of draining off excess water.

Terrace flooring.

The floor of a terrace is simply an elevated patio and shares the same paving possibilities. Brick and dressed flagstones are both hard-wearing and shrug off the weather, and have a timeless character well suited to terraces of traditional formal design. Irregular flagstones have a more unstudied demeanor; if set in sand, they can be planted with self-seeders such as California poppies, Johnny-jump-ups, or linaria. Concrete pavers, Mexican terra-cotta pavers, granite cobblestones, even poured concrete (tinted a soft stone color) will all perform well underfoot.

This low terrace boasts a built-in lily pond (below). A brick forecourt terrace (center) blends with the house it adjoins. Rows of potted flowers direct visitors up onto this sheltered terrace (right).

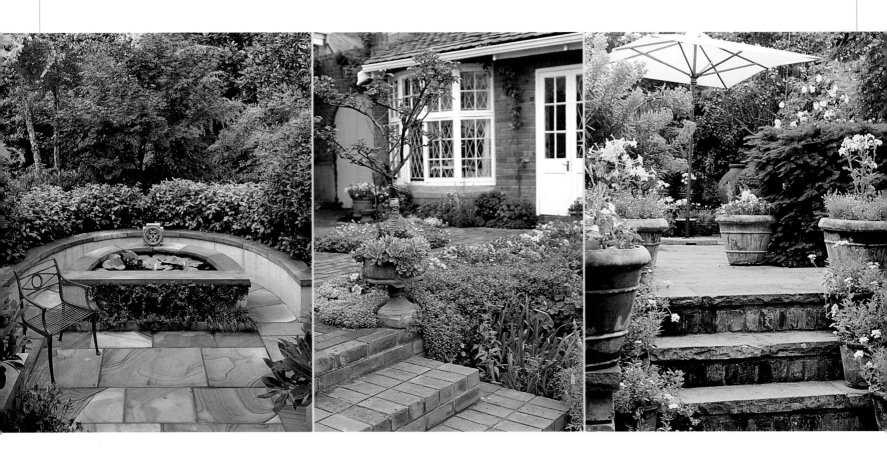

Whether the paving is set in sand or mortared into place, be sure it slopes slightly away from the house so that rain and snowmelt don't pool around the foundation.

Balustrades and railings.

Shapely balusters of stone bordered the terraces of Italian Renaissance and Baroque gardens, merging them with the architecture of the grand houses they adjoined. These low openwork walls were punctuated by stone piers that made perfect pedestals for classical marble statuary, stone spheres, or carved stone urns. In later centuries, ornate railings of wrought iron, set between masonry piers, sometimes stood in for the stone balusters, bestowing a lighter look. Today, traditional balustrades and railings still grace elegant terraces and provide display spots for garden ornaments, from cast-iron vases and antique urns to simple terra-cotta pots brimming with pansies or paper whites.

Surfaces such as gravel or decomposed granite make for an informal terrace (left). An iron balustrade dresses up a cliffside terrace (center). This terrace (below) is almost at ground level.

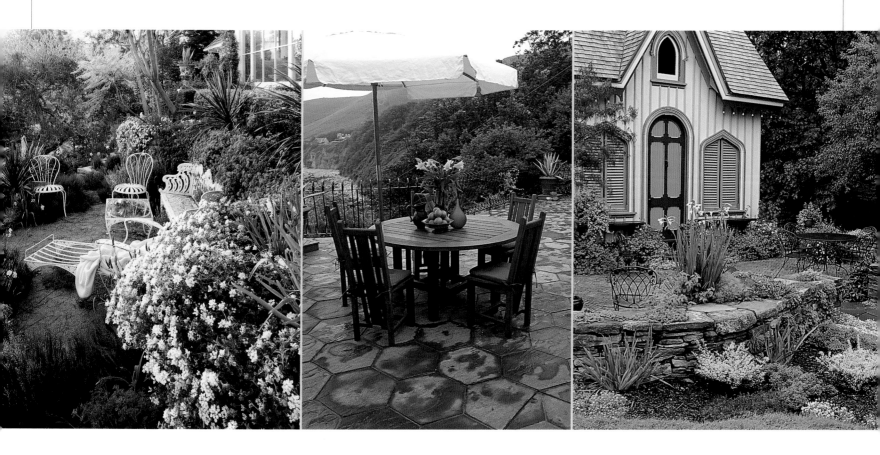

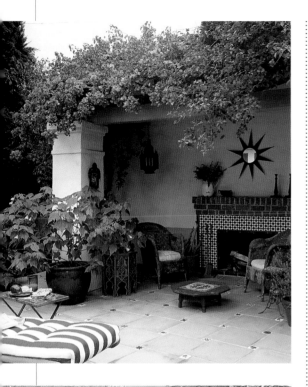

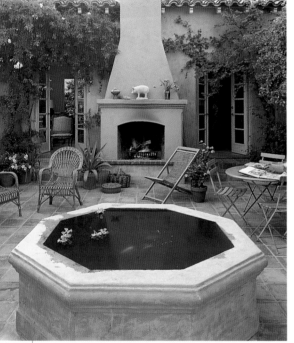

Fireplaces that back onto the house (top) or free-standing patio fireplaces, (above) extend summer evenings spent on the patio far into the night.

Unless you have a bona fide mansion and a passion for Italianate architecture —and a garden to go with them—a traditional balustrade can border on the overdone and overbearing, particularly when copied directly from historical examples.

Instead, consider an edging of more simple demeanor, such as an airy parapet of concave tiles, a border of bricks laid in a honeycomb bond to admit the garden's breezes, or a low wall of stone, coped on top to form a narrow seat. A low terrace may not need a balustrade or railing at all; just a single continuous step along its perimeter that invites us down and into the garden.

THE PATIO

A small rectangle of flagstones between the cucumber trellis and the herb garden hosts a pair of 1940s lawn chairs, from which we toast our horticultural successes as the sun goes down. A circle of bricks hides beneath the oak tree and supports a broad teak bench, from which we watch the acrobatics of the squirrels and feed peanuts to the blue jays. A kidney-shaped pad of concrete embedded with seashells sits at pondside, just big enough for a lounge chair from which we watch the hovering dragonflies.

These outlying patios add to the pleasures of any garden. But it is back at the house that patios play their most important role. With a patio in place outside the back door, a small house becomes one room larger, at least for the warm-weather season, and a large house grows infinitely more hospitable. With hardly a change in level we can step into an outdoor living room, complete with table, chairs, and fireplace (in the guise of barbecue, gas grill, firepit, or bonafide hearth), and plenty of room to relax with family or mingle with friends. The house seems to melt into the garden, with no clear distinction between the two.

All this is accomplished by means of a simple floor: a layer of paving that keeps our feet out of the mud and the legs of our chairs and tables on an even keel. But

PAVING PATTERNS

The bond patterns that keep a masonry wall from toppling aren't needed for horizontal pavings. Instead, choose paving patterns for their visual effects and the way they fit the chosen space.

BRICK:

• *Basket weave.* All the variations of the basket-weave pattern have a solid, traditional feeling and fit nicely within a square or rectangular border. They're nondirectional in nature and tend to make small areas seem larger.

• *Running bond.* With its staggered rows of bricks, running bond has a strong directional effect. When the rows follow the line of sight, they draw the eye forward and out into the garden. When they cross the line of sight, they direct the eye to the sides and make the paved area feel broader. You'll need to cut half-bricks to fill in along the edges. You can also cut half-bricks to fit between each whole brick for a flat version of Flemish bond or to fit between the rows of bricks for a paved version of English bond.

• *Spanish bond.* Like basket-weave patterns, Spanish bond is nondirectional and has ample interest for even small areas of paving. For still more impact, replace each half-brick with a square tile or with a half-brick of a lighter or darker color.

• *Stack bond or jack on jack.* Nonstaggered rows of bricks have a modern look, and a similar visual effect to running bond. Jack on jack can seem monotonous when used to pave a large area. It fits easily in a square or rectangular space.

• *Herringbone.* Bricks set in a herringbone pattern slow the movement of the eye and make small areas seem larger. Diagonal herringbone works well to fill in patios with curved edges, but you'll need to cut small triangles of brick or trim corners from whole bricks to fill in all the gaps.

STONE:

• *Dressed.* The regular shapes of cut stone have a calm, linear feel, yet can be trimmed to fit a rectangular or curved area. The stones should be proportioned to fit the size of the patio; oversized stones can make a small patio seem stingy. Depending on the shape of the paved area, the stones can be laid to emphasize either its depth (the long pieces all running parallel to the line of sight) or its width (the long pieces all running crosswise) or can be laid in a random, nondirectional pattern.

• *Irregular.* Irregular flagstones, sometimes called crazy paving, are nondirectional, and work well for areas of any shape. The smaller the stones, the busier the effect. Try for a balance between large stones and small ones, and pair some stones together to avoid a spotty look.

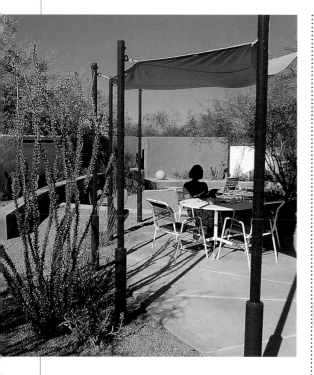

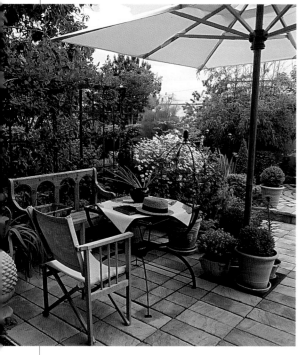

An unconventional awning shades a desert patio table (top) while a traditional umbrella does the same for a more verdant spot (above).

no single type of paving is appropriate for every patio. Along with the style of your house and garden, be sure to consider the following when choosing patio paving:

Texture. Different paving materials have different degrees of roughness and smoothness. Slate flagstones and smooth pebbles or cobbles, for instance, generally are slippery underfoot when wet, as are most tiles. The best choices for primary patio areas include materials with some surface roughness for traction, such as brick, sandstone, adobe pavers, or tinted concrete, but not so much texture that the patio is difficult to sweep.

Color. In general, light paving materials work best in shaded areas; dark materials such as red brick and bluestone may seem gloomy in shaded spots. The opposite is true for sunny expanses, where light materials such as concrete reflect too much light but brick and mottled stone look right at home.

Remember, too, that the color of the paving will affect the look of plants around it, whether in patios or pathways. Dark or middle-toned materials blend into the greenery and don't stand out from the rest of the garden, while light materials will set off the rugosa roses or coral bells in a dramatic fashion. If the predominant plants have silver or light foliage, the opposite effect will occur.

Glare. Glare can be a problem with any light-colored paving material, but some flagstone types have a surface sheen that reflects sun like a mirror. Avoid these types for patios that will receive direct sun.

Stability. Patio surfaces should be as smooth and level as possible, except for a slight slope for proper drainage. Avoid materials such as cobbles set in mortar for parts of the patio where you plan to place garden furniture; chairs and tables will always feel wobbly on such rocky foundations.

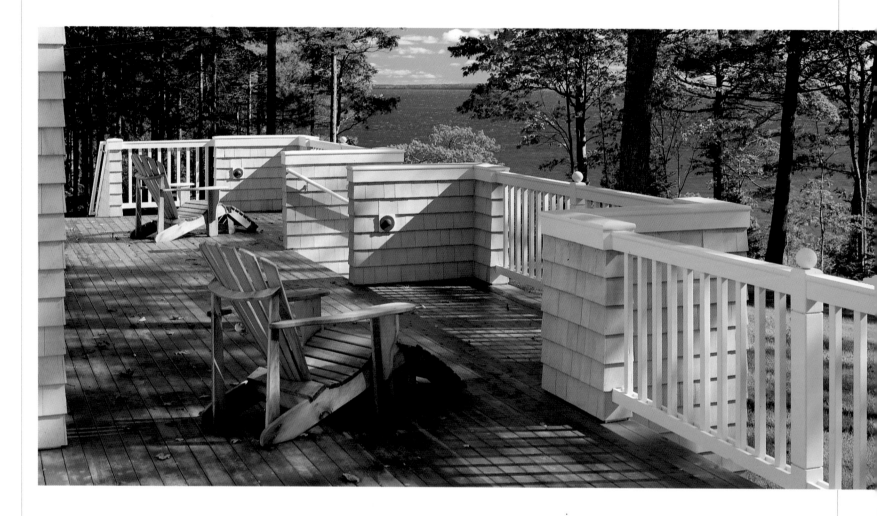

THE DECK

Decks are accomplished actors able to take on countless garden roles. They shine in bit parts where room is tight and readily act as supporting players to established patios, porches, or terraces. But they also know how to star: as expansive outdoor living rooms that can adapt to almost any site.

Decks can hug the ground in a single flat sweep of flooring or step up a gentle slope. They can jut out over precipitous hillsides, snuggle up to pools or hot tubs, or curve around established plantings. They can stick close to the house, expanding its activities into the garden, or venture far afield, providing getaways amid the vegetables or retreats amid the flowers.

Shingled half-walls tie this deck's architecture to the house it adjoins, and keep the railing from becoming monotonous. Centrally placed ball finials form decorative punctuation points.

From left to right: Because of their light weight, decks allow city rooftops to double as gardens. Where possible, decks should be oriented to the best garden views. Decks readily encompass mature trees and conquer slopes. A simple square of decking turns a garden into an outdoor living room.

Most decks are built predominately from wood: either redwood, cedar, or fir. But an increasing number are now being built in large part from decay-proof composite lumber, made from waste wood fiber and recycled plastic—an environmentally sound alternative to pressure-treated wood.

If you're as comfortable with a saw and hammer as with a spade and trowel, you can easily build a low-level deck over stable soil. For elevated decks, decks on steep slopes, or decks on unstable soil, it's best to hire professionals—from contractors to soils engineers—to do the job. And always check codes and obtain proper permits before beginning to build.

When designing your deck, keep the following factors in mind so that the finished project suits both the nature of your garden, the design of your home, and the character of your leisure time.

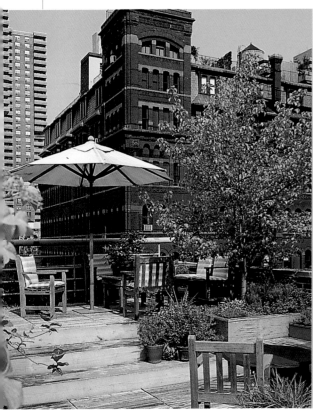

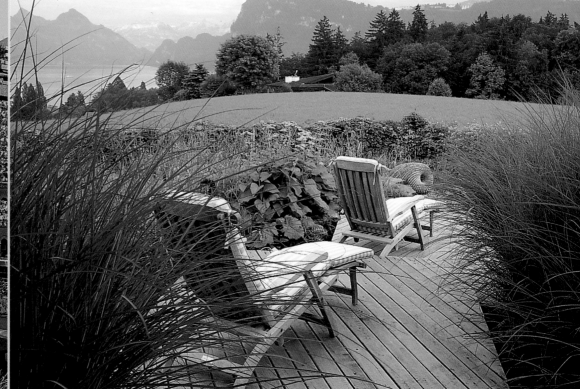

Style. Though decks are a product of the 20th century and seem most in tune with modern houses, they are readily dressed in a range of costumes. A deck's railings, in particular, affect its style. Railings with simple Chinese lattice patterns, painted pristine white, make a deck suitable for a Colonial-style or neoclassical house. Railings that feature cased posts topped with ball finials work well with both Victorian and Colonial architecture. Railings of heavy timbers with exposed bolts have a modern, utilitarian feel, as do railings of galvanized pipe.

Shape. Squares and rectangles are only a starting point. Decks seem most a part of the garden when they're shaped in less predictable ways. Build a series of overlapping platforms that cascade down to garden level. Construct an octagonal outcropping to embrace an established oak. Angle the deck to jut out over a garden pool, so you can dip your toes on scorching summer days. Cut out a corner of

■HOW-TO CONCRETE CAMOUFLAGE

Transform an existing concrete patio by topping it with bricks set in mortar.

Frame in the slab with a wood or brick edging that rises to the desired finished level of the bricks. Butter the bedding face of each brick with a half-inch of mortar, then set the brick in the desired pattern on the moistened slab. Or apply mortar to small sections of the moistened slab with a notched trowel, then set the bricks. Be sure to include an expansion joint between the bricks wherever there is an expansion joint in the underlying slab. When the mortar has cured for 24 hours, brush a dry mortar mix (1 part cement to 4 parts sand) into the joints between the bricks and tamp it into place with the side of a thin board. Dampen repeatedly with a fine mist for the next few hours, then let cure.

BETWEEN THE CRACKS

Over time, escapees from the garden's beds may find a foothold among the cracks of a flagstone patio or path, adding a poppy's grace or a viola's charm to the rockwork. Or you can plant the crevices yourself, hastening the transformation from barren masonry to a garden underfoot.

Flagstones set in sand or soil are ideal for encouraging self-sowing plants.

Thymus herba-barona (caraway scented thyme)
Thymus praecox arctius (creeping thyme)
Viola cornuta (horned violet)
Viola hederacea (australian violet)
Viola labradorica
Viola tricolor (Johnny-jump-up)

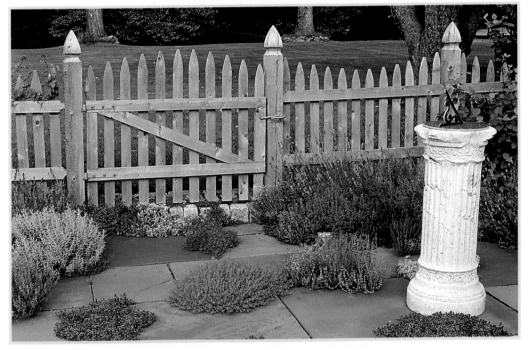

Even the tight cracks between cut-stone pavers will support a colony of plants and turn a paved dooryard into a garden.

Along with many others, the following plants thrive in the tight spaces between flagstones or in the gap left behind by a lifted brick:

Alchemilla mollis (lady's mantle)
Arabis (rock cress)
Arenaria montana (sandwort)
Aubrieta deltoidea (common aubrieta)
Erodium chamaedryoides (cranesbill)
Eschscholzia californica (California poppy)
Laurentia fluviatilis (blue-star creeper)
Linaria marocanna (toadflax)
Lobularia maritima (sweet alyssum)
Meconopsis cambrica (Welsh poppy)
Mentha requienii (Corsican mint)
Soleirolia soleirolii (baby's tears)
Thymus pseudolanuginosus (woolly thyme)

Thyme takes readily to patio pavings, enjoying the heat of the stone surface.

the deck to accommodate a boulder. Though more work in the construction stages, such shapings are compatible with nature and keep the garden close.

Pattern. You can lay the flooring of a deck in a variety of patterns, all of which affect the deck's character. Broad expanses of decking, with all the wood running in the same direction, may seem monotonous or calming, depending on the deck's surroundings. Boards laid on the diagonal set a modern tone, while two-by-fours set with their narrow edges revealed have an almost Oriental character. Even the way the boards are joined when they meet at right angles alters their demeanor. Deck boards that are mitered at the joint have a strictly modern feel, while boards that butt together take on the comforting pattern of a log-cabin quilt.

Structure. While the site of the deck and the weight of the wood decking will largely determine the design of the deck's foundation and substructure, be aware that different decking patterns may require different underlying patterns of support posts and joists.

Extras. While your deck is still in the planning stages, don't forget to design in all the comforts of home: bench seats, custom lighting, an electrical outlet for the laptop, windscreens of wood or glass, shade-casting arbors or awnings, and storage for barbecue or gardening gear, along with built-in planters from which you can pluck ripe strawberries for your morning cereal or clip rosemary for whatever's on the grill.

After all, we want to be able to live in *comfort* in the garden's embrace, whether on the deck, patio, or terrace. To read the Sunday paper while we inhale the scents of the heliotrope and datura. To share mealtime with the titmice or rufous-sided towhees. To pluck ripe grapes or kiwis from the arbor over our table. And to drink in the view, unhampered by windows or walls, in the rejuvenating middle ground where home and garden meet.

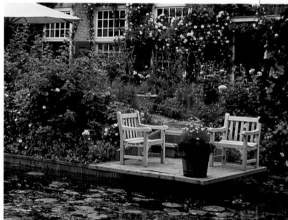

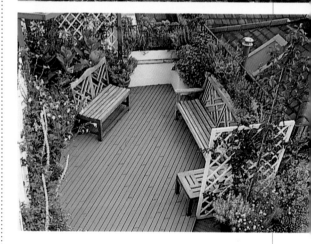

Cool blues and greens lower a deck's temperature on sweltering days (top). This half-pint deck (center) is cantilevered over the water. Roof decks may need the shelter of artificial lattice screens (above).

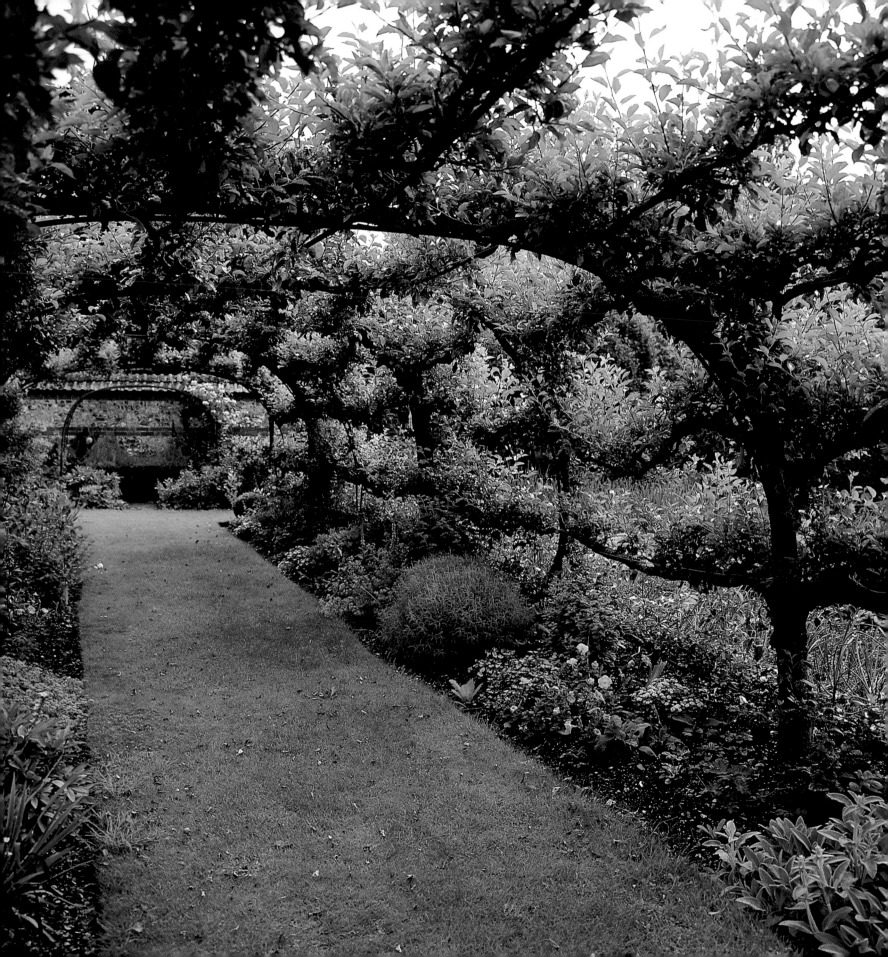

CHAPTER NINE HEDGES
AND ESPALIER:

growing
the bones

WE RELY ON THE LUMBERYARD, THE STONEYARD, and the brickyard in building our garden structures, but often overlook the architectural potential of our plants. Yet, positioned wisely and guided with a firm hand, they are willing partners in our work.

Set at the garden's boundary, transplants of barberry or burning bush weave tangled branches into fences of year-round beauty and keep passersby at bay. Spaced along the walk, espaliered apples or pears stretch out their knobby arms to form fruit-full screens for the vegetable beds. Kept at a discreet distance, pairs of cypress or arborvitae clasp hands overhead to frame a path or shade a seat, growing evergreen arches, arbors, or bowers from the ground skyward.

Such living structures give the garden bones that provide shape and order throughout the seasons. Yet they blend into the garden because they *are* the garden, subject to the same cycles and needs as the other shrubs and trees. As they mature, they bestow upon us the gift of every leaf, twig, fruit, and flower, but they also exact a price.

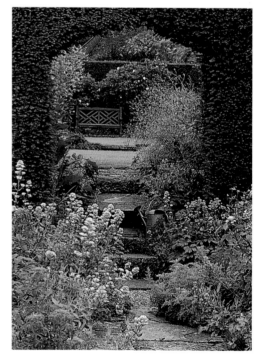

Espaliered fruit trees arc gracefully over a turf path (opposite). A pleached hedge (above) forms a perfect arch.

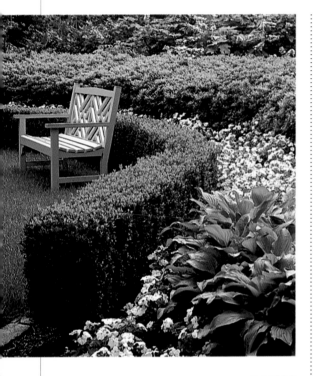

A formal hedge of clipped box is backed by a less manicured barrier (top). Hedges of hydrangeas segment a rural landscape (above).

A wood fence can be erected in a weekend or two, and a purchased wood arch or arbor put up in an afternoon. The gratification is immediate. In contrast, a hedge, a living arch, or an espaliered fence can take years from the date of planting to grow to perfection. Such living structures require vision and extended supervision. The pruning shears, hedge clippers, and our arms and shoulders get a regular workout.

But there's satisfaction in both the work and the waiting. And as the branches fill in, and the desired forms emerge, we know the pleasure of collaborating with nature herself, and of patience rewarded.

THE HEDGE

When Englishman William Cobbett roamed the American countryside in the early 1800s, few hedges set off garden from farmland or road from field. Plentiful lumber had ensured that the country's first barriers were primarily fences, from stockades of sharpened palings and barriers of wattle to meandering posts and rails. Yet Cobbett recommended that Americans change their lumber-profligate ways, get rid of "these steril-looking and cheerless enclosures," and plant living fences of white thorn (hawthorn—*Crataegus monogyna*), even if the seeds had to come all the way from England.

"Of the beauty of such a hedge it is impossible for any one, who has not seen it, to form an idea," Cobbett wrote in his 1821 volume *The American Gardener*. "[C]ontrasted with a wooden, or even a brick, fence it is like the land of Canaan compared with the deserts of Arabia."

Such thick, thorny hedges had been a gardening mainstay in England and Europe for centuries, and they excelled at providing shelter for tender plants in chill weather, shade for others in summer's heat, and protection from intruders—the same jobs a fence or wall was expected to perform.

NATIVE DEFENSE: THE OSAGE ORANGE

In the spring of 1804, Captain Meriwether Lewis sent Thomas Jefferson the first of many plant specimens he'd been instructed to collect on his expedition to the Pacific. Lewis called them "Osage apples," since the cuttings came from trees that bore curious round green fruit and were originally procured from an Osage Indian village to the west of St. Louis.

"So much do the savages esteem the wood of this tree for the purpose of making their bows," Lewis wrote, "that they travel many hundred miles in quest of it." But it wasn't bows that the distinctive tree became famous for, though it's still cherished for bowmaking to this day. Instead, *Maclura pomifera* became an essential ally to settlers on wood-scarce prairies who found the thorny Osage orange (as it came to be called) invaluable for growing hedgerows. Properly planted and maintained, such prickly barriers were strong enough to "turn stock," meaning that horses, cattle, and even pigs couldn't force their way through them into the farmers' fields.

"The beautiful osage orange . . . has been subdued with great success, and is likely to prove the most valuable of live fencing in the Middle and Western States," wrote Frank J. Scott in 1886. Scott's stamp of approval was a bit belated; it is estimated that by 1869 there were already some 60,000 miles of Osage orange hedges across the Midwest.

As barbed-wire fencing began to sup-

Chartreuse fruits dangle like ornaments from the branches of an Osage orange tree.

plement and then supplant hedges during the 1870s and '80s, the Osage orange became widely sought for a new purpose. Barbed wire had to be strung on fence posts, and posts of Osage orange were hard, dense, and almost completely impervious to decay. It was even recommended that double rows of the trees be planted along railroads to supply rot-proof railroad ties right on the spot.

In the 20th century, as with England's hedgerows, surviving bands of Osage oranges in many rural areas suffered from new farming methods, which valued boundless acreage over smaller fields. Many were destroyed, resulting in the loss of vital wildlife habit and the disappearance of soil-preserving windbreaks.

But the trees still garner interest today, from nostalgic grown-ups who remember lobbing the strange green fruit in mock battles against their siblings, and from others seeking sturdy hedge plants prickly enough to rebuff any intruder.

While the bumpy chartreuse fruits borne by the female plants can't be eaten by humans, the seeds are relished by squirrels and other animals. And the green globes are sought by florists and decorators, as well as by folk who plop them around their foundations, in their basements, or on the shelves of their linen closets and swear they repel insect pests.

You can grow Osage orange trees or hedge plants from seed or cuttings, or purchase them from some nurseries and mail-order sources. Osage oranges grown as trees can reach 60 feet, but most are in the 20-to-30 foot range. Hedge plants can be kept pruned to six or eight feet in height. Check with a local nursery professional to determine whether these plants are suitable for your climate and situation.

Maclura pomifera is also called hedge apple, horse apple, wild orange, and yellowwood (because of the yellow/orange hue of the wood). Perhaps the most romantic and venerable of its appellations, however, is *bois d'arc,* French for "wood of the bow."

"Everything comes if a man will only wait."
—Benjamin Disraeli

This hedge is askew (below), but adds a jaunty air to a garden gateway. Hedges with colored foliage (center) set off more conventional greenery. Hedges excel at dividing gardens into rooms (right).

But hawthorn hedges also surrounded the garden with tender spring green, filled it with the fragrance of their May-blooming white flowers, and decorated it in fall with bright red haws and fiery leaves. Early in the season, wild primroses and violets peeped from beneath the hedges' protective skirts, and thrushes nested safely in their branches. Later in the year, the thrushes, along with waxwings and blackbirds, devoured the haws in droves. And, unlike fences built from lumber, which were bound to tumble inside of 20 years, hedges of hawthorn were nearly everlasting.

Cobbett wasn't alone in his promotion of hedges. At the same time Cobbett was preparing *The American Gardener,* Mr. Maine of the District of Columbia was cultivating native hedge plants (either hawthorn or osage orange), of which some 50,000 were purchased by a Virginia planter for the purpose of hedging. Isaac Pierce of Baltimore was offering "thorn quicks" of "the American hedging and

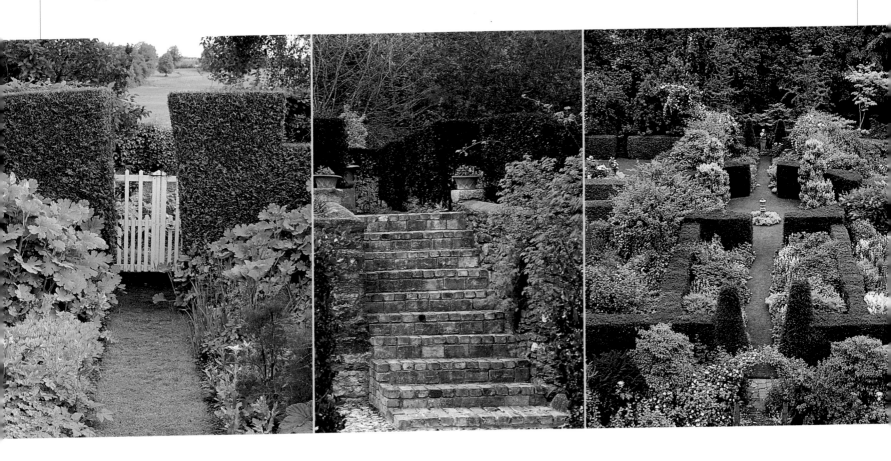

pyricantha" for sale through the *American Farmer's Magazine.* And the use of close-clipped privet, adopted for hedging in Philadelphia during the mid-1700s due to a local dearth of fence wood, was on the rise.

Though boundary hedges still were rare, low herb or boxwood edgings and close-cropped ornamental hedges were already in place inside the most progressive American gardens and soon would become a mainstay. Yew, favored in the British Isles for its velvety surface after close shearing, was rarely as successful here, so Americans made do with interior hedges of well-clipped privet, cypress, hemlock, or holly.

Today, hedges retain all the attributes that so enchanted Cobbett. As boundary and privacy fences, they can rise to heights that would be prohibitive in cost if duplicated in wood, brick, or stone. They dissipate the wind, keeping turbulence to a whisper. They soak up sound, buffering the garden from alley or roadway. When dense or thorny, they provide a safe haven for nesting birds and are far more challenging than fences or walls for intruders to climb. And somehow, their green or flowering faces seem friendlier than fences, sharing a hint of the garden's beauty even with those whose entrance they deny.

Hedges also perform admirably as interior screens: camouflaging the plant nursery or the compost bin so they can't be seen from the terrace or a favorite seat. They excel at dividing the garden into distinct rooms, a function for which tall walls or fences would be overbearing. And in wintertime their evergreen or twiggy ramparts catch even the slightest dustings of snow, highlighting the stark beauty of the season.

CHOOSING AND PLANTING A HEDGE

Before rushing to the nursery to buy dozens of uniform privets or cotoneasters, consider the character of your home and garden. Like walls or fences,

Winter brings color to hedgerow plants Rosa canina *(top) and* Ilex verticillata *(above), as well as to* Skimmia japonica *(center).*

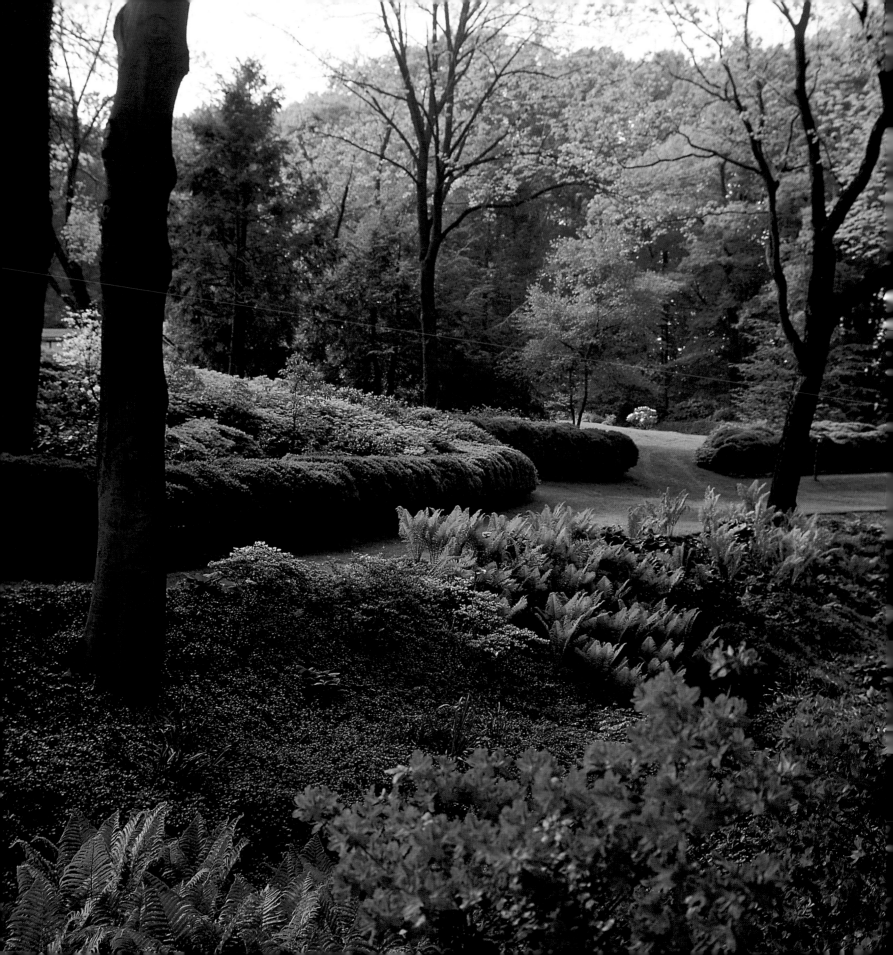

hedges are prominent features that impart a strong sense of style and should be chosen to complement—or form a foil to—the nearby architecture or plantings. This is another time when wandering the neighborhoods around you will bear dividends; you'll come to know which hedges thrive, and look their best, in your area. Don't limit yourself to just those choices, however. Your neighbors may not have considered the purple glory of an 'Atropurpurea' Japanese barberry, the fall fireworks of a 'Flame' Amur maple, or the grace of a row of deutzias in bloom.

Formal or informal.

Closely clipped hedges often mimic walls and have a decidedly formal bent, while unclipped hedges give the garden a slightly wild, informal air. Different plants generally are required for each type of hedge, though some plants are well suited to both forms.

Formal hedges call for plants with dense stiff growth and small needles or leaves that can withstand shearing, such as arborvitae, cypress, or hornbeam. Many formal hedges are formed from plants with single trunks that would grow to tree size over time if left to their own devices. If possible, choose slow-growing plants for hedges that will be closely clipped, so a once- or twice-a-year grooming will be sufficient.

Informal hedges are more apt to be made up of deciduous plants with multiple trunks that grow to full size in the hedge, and that have an interesting branch structure and colorful leaves, fruit, and flowers. English shrub roses, for instance, will form a beautiful loose hedge, as will mountain laurel or viburnum.

Evergreen or deciduous.

Whether they lose their leaves or not, hedges will continue to give shape to the garden through the winter. But if privacy is a concern, an evergreen hedge may be your best choice. Pines, yews, cypress, and hemlocks aren't your only options; hollies, barberries, pyracantha, and arborvitae

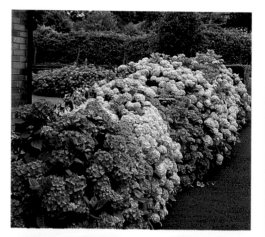

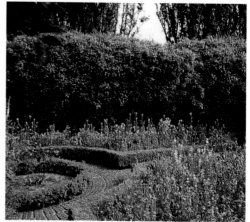

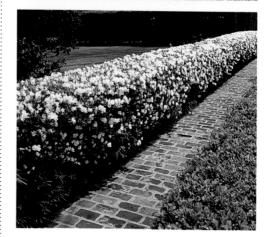

Informal hedges (opposite) are clipped lightly if at all. Hydrangeas (top), ceanothus (center), and oleander (above) all make colorful informal hedges when their season of bloom arrives.

HEDGEROWS:
BOUNDARIES OF ABUNDANCE

"Two things made us buy this land," wrote Clare Leighton in 1935 of her garden in Oxfordshire's Chiltern Hills. "We could not withstand the appealing beauty of the clumps of cowslips nor resist the hawthorn hedges that bounded the grassland."

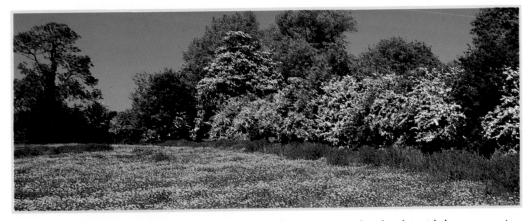

In May, this hedgerow of blooming hawthorne borders a hay meadow bright with buttercups; in the fall, the white blossoms transform into shiny red haws beloved by birds.

The type of hedgerow that Clare and her husband Noel fell in love with have bordered fields in the British Isles and much of Europe for centuries. Many hedgerows, in fact, have survived since their initial planting in the Middle Ages or even earlier, carefully tended and renewed by generations of husbandmen.

These impenetrable barriers of tangled hawthorn, ash, blackthorn, elm, hazel, and other trees, shrubs, and vines were a valued part of agrarian life. They kept livestock out of the fields—their primary purpose. They broke the force of the wind and drank up excess damp from the soil. They provided sheltered nesting spots and sustenance for countless birds, who in turn gobbled insects that threatened crops. Foxes and hedgehogs called them home; wild carrot, wallflowers, and cow parsley grew happily in their shaded fringes; and wild roses, honeysuckle, and woodbine clambered over their ramparts.

Yet they were not wild. They were planted by skilled husbandmen, as well as by birds and beasts who brought seeds in their droppings. Their owners pruned them back every few years to keep them in bounds. They freed them from invasive interlopers such as old-man's beard (*Clematis vitalba*), which threatened to smother them and ruin their health. And every 15 years or so, when the hedgerows' lower growth grew sparse, their owners "laid" or "plashed" them.

Readers of *Johnson's Gardeners' Dictionary,* first published in 1846, got a concise definition of the time-honored technique: "Plashing is a mode of repairing or modifying a hedge by bending down a portion of the shoots, cutting them half through near the ground to render them more pliable, and twisting them among the upright stems, so as to render the whole more effective as a fence, and, at the same time, preserve all the branches alive." The shoots or branches that had been laid down threw up new vertical shoots that soon restored the barrier's impregnable density.

But what was woven through a millennium began to unravel in the 20th century. Hedgerows increasingly came under attack as being time-consuming to maintain, incompatible with mechanized farming, and home to vermin. Their image wasn't helped by the horrors of World War II, when troops in France had to do battle with well-concealed enemies at each and every hedgerow in their

path, while at the same time facing surprise attack from behind the hedgerows on their flanks. Even tanks sometimes couldn't break through the dense bands of growth, which were often bordered by deep ditches.

As postwar farmers sought to expand their fields, combining one with the next to allow for more efficient cultivation, the ancient hedgerows—seeming barriers to progress—were destroyed and the very structure of the countryside began to change. Other hedges were neglected by owners who couldn't bother with the old, labor-intensive renewal methods, and quickly began to deteriorate.

Today, however, the environmental costs of such practices are becoming clearer. Groups such as the Council for the Protection of Rural England are campaigning to reverse the destructive trend, which threatens wildlife, soil health, and even tourism. Slowly, new hedgerows are being planted and old ones restored, though others continue to disappear at an alarming rate.

There are lessons to be learned, especially for the gardener. We may not need a bona fide hedgerow to keep cattle or hogs out of our fields or orchards, but we would all benefit from an increase in the numbers of songbirds and beneficial insects in our gardens, as well as the sheltering embrace and rambling structure

that a hedgerow provides.

To gain some of a hedgerow's traditional blessings, plant mixed belts of native shrubs, rambling roses, berries, and small trees at the fringes of your property. Let time tangle their stems and branches, weaving sheltered pockets for nesting thrushes or jays and casting shade for violets and even clumps of cuckoopint (wild arum).

Keep the hedgerows in bounds, but err on nature's side. As in the rest of the garden, shun synthetic pesticides and herbicides. Then let the vines ramble, the leaves pile up, and the seedlings and suckers grow.

"The bounding hedges live their own life," wrote Clare Leighton in her oft-reprinted book.

It's a life abundant in birdsong and berries, fruits and flowers, and seeds and saplings, as well as in the rustle of the unseen, comfortably at home in the shaded depths.

PLANT LIST:

Plants that are suitable for modified American hedgerows include the following, all of which attract birds and many of which are natives. Check with a local nursery professional as to the suitability of specific plants for your climate zone and situation.

Abelia (*Abelia grandiflora*)
American holly (*Ilex opaca*)
American Elderberry (*Sambucas canadensis*)
American Plum (*Prunus americana*)

American Mountain Ash (*Sorbus americana*)
Arrowwood Viburnum (*Viburnum dentatum*)
Black cherry (*Prunus serotina*)
Brambles (*Rubus spp.*)
Buffaloberry (*Shepherdia argentea*)
California lilac (*Ceanothus spp.*)
Cockspur hawthorn (*Crataegus crus-galli*)
Common chokecherry (*Prunus virginiana*)
Common Spicebush (*Lindera benzoin*)
Coralberry (*Symphoricarpos orbiculatus*)
Cotoneaster (*Cotoneaster spp.*)
European Red Elder (*Sambucus racemosa*)
Firethorn (*Pyracantha spp.*)
Flowering dogwood (*Cornus florida*)
Flowering Currant (*Ribes sanguineum*)
Golden Currant (*Ribes aureum*)
Hawthorn (*Crataegus flabellata*)
Honeysuckle (*Lonicera periclymemum*)
Inkberry (*Ilex glabra*)
Mahonia (*Mahonia pinnata*)
Mountain dogwood (*Cornus nuttallii*)
Nannyberry (*Viburnum lentago*)
Northern bayberry (*Myrica pensylvanica*)
Oregon Grape Holly (*Mahonia aquifolium*)
Osage orange (*Maclura pomifera*)
Possum haw (*Ilex decidua*)
Red mulberry (*Morus rubra*)
Red buckeye (*Aesculus pavia*)
Sargent crabapple (*Malus sargentii*)
Sitka mountain ash (*Sorbus sitchensis*)
Staghorn sumac (*Rhus typhina*)
Sugar bush (*Rhus ovata*)
Toyon (*Heteromeles arbutifolia*)
Wax myrtle (*Myrica cerifera*)
Weigela (*Weigela florida*)
Western thimbleberry (*Rubus parviflorus*)
Wild rose (*Rosa virginiana*)

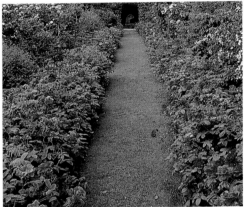

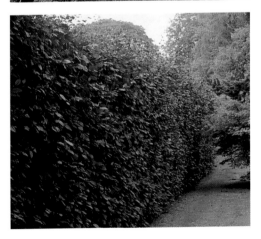

An informal hedge of Berberis thunbergii *'Rose Glow' seems to have an inner light (top). Low hedges of* Rosa gallica *line a path with pink (center). Hedges of purple beech (*Fagus sylvatica *'Atropurpurea') stand out amid green surroundings (above).*

all retain their leaves in winter. The leaves of hedges grown from European beech also stay on during the winter, but turn a dusty brown.

Though other deciduous hedges strip to the buff once winter arrives, the show they put on in fall may be worth the leaf loss. Larch, rugosa roses, viburnum, European hornbeam, and many other hedge plants all wear some of their showiest attire just before their foliage heads south.

Height.

As with fences and walls, the optimal height of a hedge is determined by the job you'd like it to perform. Privacy hedges that bound a garden should be six feet or higher, and call for plants that provide dense foliage from the ground up. (You may need to build a temporary fence that will last the five or so years the hedge will need to reach its full height and density.) Hedges that serve as screens in the garden may be between three to six feet or more in height, depending on what they're hiding from view. Hedges three feet in height and lower work well to funnel visitors around corners or along walks, or to dramatize an entrance. And diminutive hedges, kept clipped to less than a foot in height, excel at edging garden beds or emphasizing the geometry of a walk, herb bed, or patio.

Whatever height hedge you need, be sure to pick hedge plants that naturally have the desired short, mid-range, or tall growth habits.

Planting a hedge.

Gardeners and husbandmen from the Middle Ages to the 19th century called their thorny green barriers *quick-set hedges*, but they were hardly that. "It ought rather to be called an *Everlasting Hedge*," wrote Cobbett; "for it is not, as will be seen by-and-by, *so very quickly set*; or, at least, so very quickly raised." Though some plants shoot up more quickly than hawthorn, all hedges take time to properly plan and prepare for.

Apply the same practices to the planting of hedges as you do to other garden shrubs and trees. Purchase uniform plants from a reputable nursery, either bare

root, potted, boxed, or balled. Evergreens should be well branched at the bottom, while deciduous shrubs and trees may be more open in form. Severe pruning later on will help them branch out just above their ankles.

Dig a broad trench where the hedge is to grow and prepare the soil, if needed, with well-rotted manure, compost, or other organic matter. If planting a perimeter hedge, plan to set the hedge plants back from the boundary line so they won't extend beyond it once they've matured to their final form. Plant in spring or early summer in cold-winter areas, and in fall in areas with mild, rainy winters. The shorter the hedge, and the more formal its desired appearance, the closer together you should set the plants. Boxwood edging plants, for instance, should be set six to eighteen inches apart; plants for taller hedges may be set four or five feet apart, depending on their species and the hedge type you're aiming for. Water plants well; then mulch.

Almost all newly situated hedge plants require immediate cutting back by about a third in order to encourage low, dense growth. Species vary in their needs, however. Consult a certified nursery professional where you purchased your plants, a qualified landscape gardener, or a reference work dedicated solely to hedges and their culture to determine the proper procedures for your type of hedge.

The actual shaping and training of a formal hedge should begin a year after planting. Some multibranched, suckering plants will need to be cut back to within a foot of ground level. Others will need only minimal pruning and shaping.

If patience *isn't* your strong suit, or you need a *truly* quick-set hedge, consider the screening potential of annuals. Border your front yard with a picket fence of sunflowers. Filter your view of the kids' sandbox with a rampart of hollyhocks. Grow a wall of sweet corn between the roses and the herb garden. None will last through the winter, but all will bring the beauty of living structure to the garden.

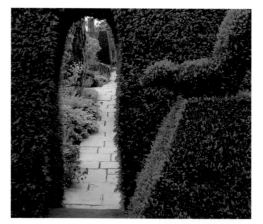

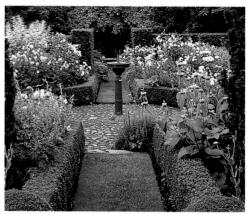

A doorway in a hedge allows a topiary squirrel to see a slice of the garden beyond (top). Low hedges provide the same guidance as their taller relatives (center). Sunflowers sprout into a fast-growing though short-lived hedge (above).

ESPALIER

Few garden structures are as glorious as a freestanding fence or screen of espaliered apples or pears, on which shapely fruit seductively dangle. Because the two-dimensional form of these trees takes such care to achieve, they seem the very essence of husbandry and bestow a sense of abundance on even the smallest spaces.

In the spot where one full-size apple tree might grow, overwhelming you with bushels of one variety of fruit, espalier makes it possible to try out Jonathans, Galas, and Granny Smiths, along with Red and Golden Delicious apples. Though the crop of each tree is small, espaliered trees often produce superior fruits because they receive optimal sun and air circulation, keeping disease problems to a minimum.

These trees (below and center) are both espaliered in a classic upright cordon pattern. A fruit tree (right) sports a more innovative and romantic design, the result of years of training.

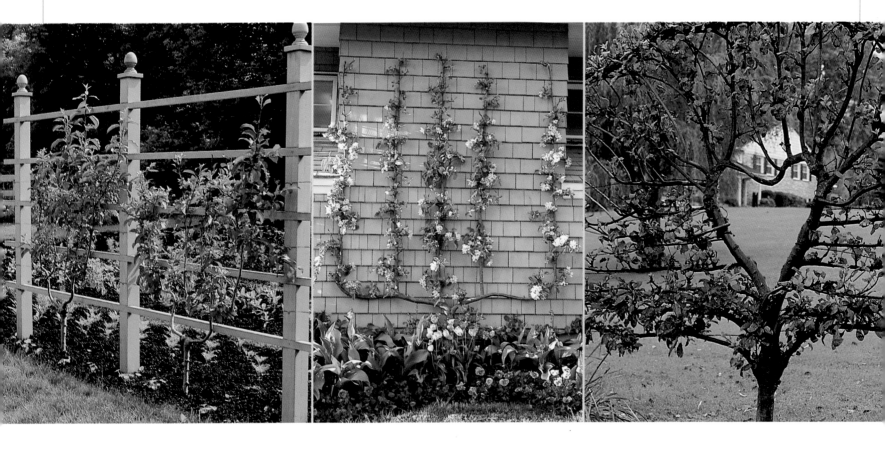

Espalier patterns. Trained in time-honored patterns on wood, metal, or wire trellises, trees can be shaped into low fences, high screens, arches, or even tunnels.

For a low fence, one of the best espalier patterns is the double horizontal cordon. This pattern forms a tree that has two pairs of horizontal branches (cordons) emerging from a short central trunk. If you train a row of dwarf trees in this pattern until their horizontal arms meet, they will form a low barrier that resembles a leafy post-and-rail fence.

For a taller fence or garden screen, the Belgian fence design excels. Each tree is pruned and trained into a V-shape atop a short trunk, using a wire and stake framework. As the two arms of each "V" grow taller, they overlap the branches of the adjacent espaliered trees, forming an eye-catching lattice pattern over successive seasons.

This espaliered tree (left) is tied to a trellis-like training frame, and stands out like ornament against weather-worn clapboards. Even espaliered trees set a heavy crop (below).

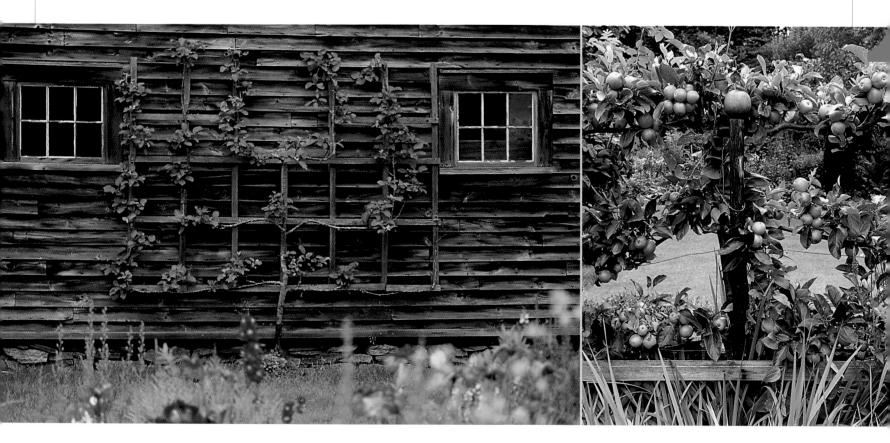

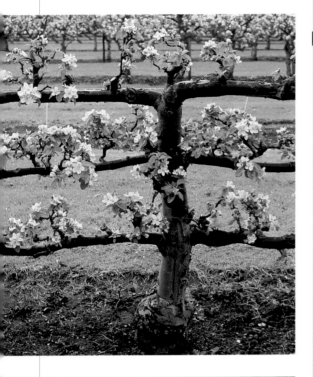

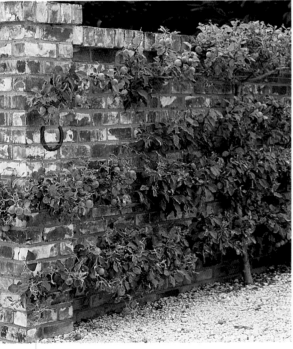

Both trees above are espaliered in the horizontal cordon pattern. One forms a fence with three tiers, the other a wall screen with four levels.

■HOW-TO A FRUITFUL FENCE

The sun-warmed walls and walks of grand English kitchen gardens once boasted enough espaliered trees, disciplined by an army of gardeners, to keep the master and mistress well supplied with Lord Napier nectarines, Hale's Early peaches, or delectable Cox's Orange pippins for a lengthy season. But such training regimens for trees were hardly needed in America. Here, the climate across much of the land was warm enough to ripen fruits without the shelter of a wall, so most trees were grown full size in the open orchard or at the back of the garden.

Today, however, a fascination with espalier has taken root, spurred on by smaller garden spaces, a revival of traditional gardening ways, and the recognition of espalier's many benefits and pleasures.

One of the most rewarding types of espalier for novices is the low fence, formed from rows of espaliered apple or pear trees trained in the double horizontal cordon pattern. To get one growing, follow these seasonal steps:

FALL, BEFORE PLANTING

• Prepare soil along the fenceline, digging in lots of well-rotted manure or other organic matter.

• Construct a temporary support structure: a two-rail fence or a low trellis with two horizontal wires. The horizontal supports should be 12 to 18 inches above ground level and 18 inches apart. Place stakes or fence posts four feet apart.

WINTER, BEFORE PLANTING

• Order one-year-old bare-root whips (trees that have a slender trunk but no side branches) of varieties that are suited to your climate. Be sure that the apples or pears are on true dwarfing root stock and are spur-bearing varieties. Let the nursery personnel know you plan to espalier them, and ask about necessary pollinators.

SPRING, FIRST YEAR:

• In early spring, as soon as the ground can be worked, plant bare-root whips along the fence or trellis adjacent to the posts or stakes. (In temperate climes, this step can be done in late fall and the trees pruned in winter.)

• Prune each whip back to a bud just above the lowest horizontal

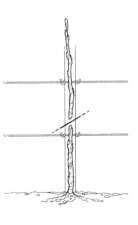

support. Be sure to leave at least three viable buds. The shoot that emerges just above the support will become the central leader and two other strong lateral shoots just below the support will become the horizontal cordons, or branches. Remove any other shoots.

SUMMER, FIRST YEAR:

• With jute twine, tie the middle shoot (the central leader) to the fence post or a vertical stake. Secure the two lateral shoots to stakes or poles tied to the support framework at a 45-degree angle from the central leader.

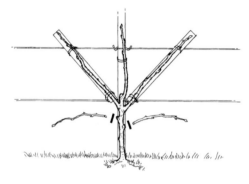

LATE SUMMER, FIRST YEAR

• Over a few weeks' time, gradually lower the laterals to a horizontal position and tie them into place on the support.

WINTER, SECOND YEAR:

• Prune the central leader back to just below the uppermost support.

SUMMER, SECOND YEAR:

• Once lateral shoots grow, choose the best two of those growing just below the upper support; cut back any others. Again, secure the two laterals to stakes set at a 45-degree angle.

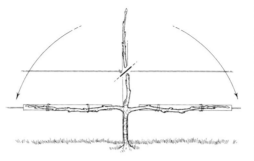

LATE SUMMER, SECOND YEAR

• Gradually lower the two uppermost laterals into opposing horizontal positions and tie them to the upper support.

ONGOING:

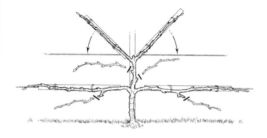

• When each set of horizontal cordons grows long enough to overlap those of the neighboring trees, hold them at that point by tip pruning each cordon back to a lateral shoot.

• In summer, cut back all side shoots that sprout from the central leader or horizontal cordons to three or four leaves above the lowest cluster of leaves. If new growth appears before winter, cut it back to mature wood.

• Cut back any secondary shoots that sprout from side shoots to one leaf above the lowest cluster of leaves.

• Over time, the zigzag spur systems that develop will become crowded and should be thinned out at winter pruning time.

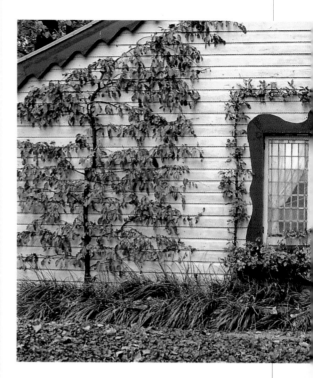

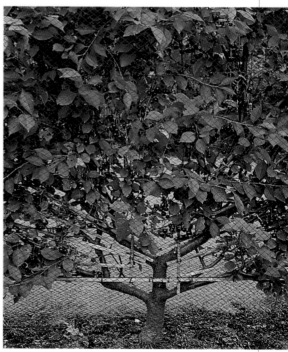

Espaliered trees decorate a wall and frame a window (top). Due to their growth habits, cherry trees and other stone fruits often are espaliered in a fan pattern (above).

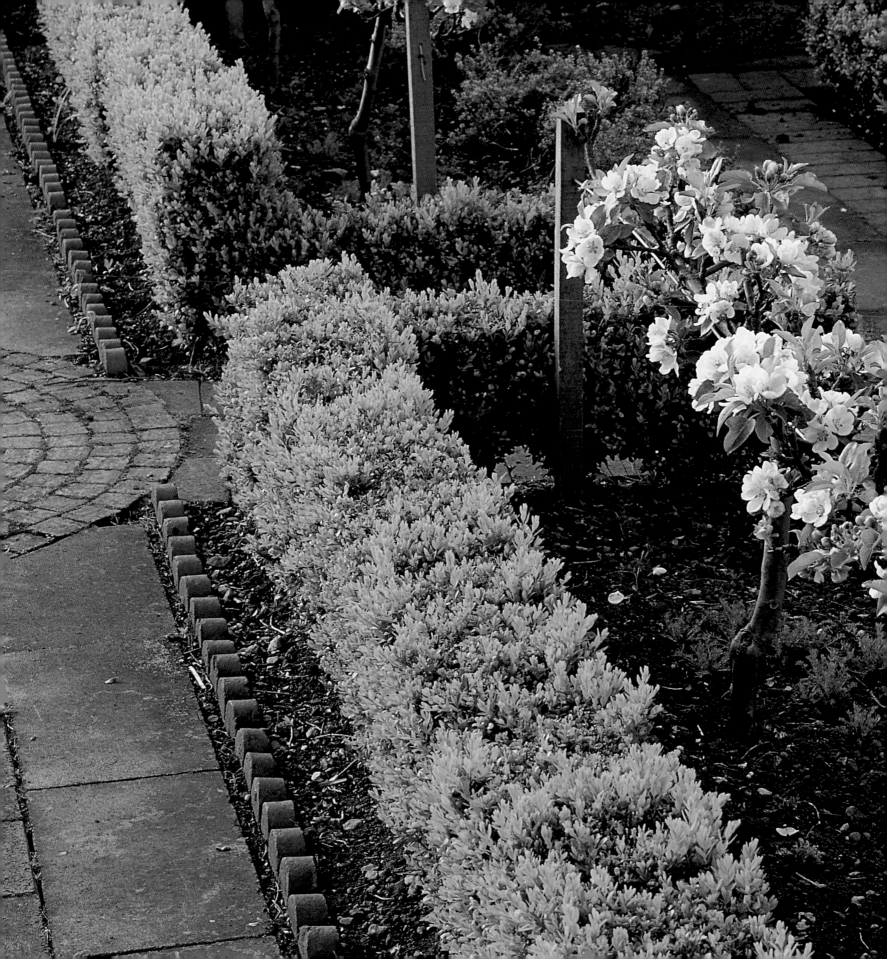

To form an arch or even a tunnel, pairs of trees are trained in single, upright cordons, and tied to an arched framework until they eventually meet at the top. Purchased steel garden arches make excellent trainers.

Apple and pear trees are the best fruit types for training into formally patterned fences, screens, and arches. Because most apples and pears grow fruiting spurs on old wood, they will produce fruit from the same branches for more than half a century. As the trees mature, the training framework can be removed, leaving only the trees and their fruit to ornament the garden.

Other choices. Fruit trees aren't the only plants that will form living structures—some formally patterned, others more free-form—under the gardener's firm guidance. Espaliered pyracantha makes a stunning fence that is aflame with orange-red berries in the fall; berry-feasting birds provide further ornament. Other choices include *Photinia fraseri, Laburnum watereri,* pineapple guava (*Feijoa sellowiana*), and sumac (*Rhus integrifolia*), as well as sweet olive (*Osmanthus fragrans*), known for the powerful scent of its inconspicuous blossoms. These cooperative growers, as well as traditional fruit trees, also can be espaliered against a solid wall or fence to bring added color and texture to the garden. Wall-grown plants, however, may get too hot in areas with high summer temperatures.

Nineteenth-century gardeners knew almost without thinking just where and when to prune and trim their espaliered trees, but to espalier novices the regimen may seem daunting. Keep a written set of directions with your gardening gear or in your garden notebook, and mark each step with the year and season in which it must be done. Then follow the time line faithfully. If attention to detail is one of your traits, and patience one of your virtues, you'll be amply rewarded.

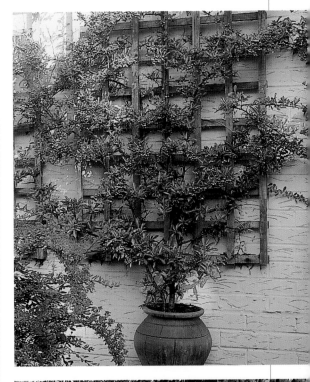

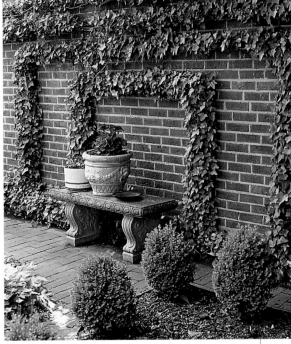

Espaliered trees in bloom (opposite) are just as decorative as those ready for the harvest. The wall-trained pyracantha and ivy above add interest to brick.

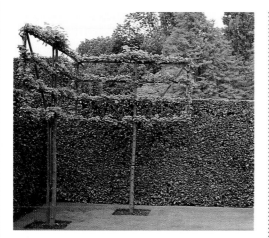

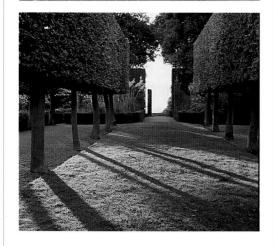

Pleached trees will soon extend the screening effect of a hedge (top). Trees and shrubs with columnar growth form a stilt hedge with little effort (center). A classic stilt hedge flanks a turf path (above).

PLEACHING

In pleaching, the branches of trees or shrubs are woven or tied together to form one unbroken swath, canopy, or arch of greenery, which can be trimmed close like a hedge, shaped into simple geometric forms, or left to run a little wild. In essence, it's a form of hedging: somewhere between the neat clipping of a plain hedge and the elaborate shaping of figural topiary or espalier.

The verdant tunnels of medieval and Renaissance gardens often were made by careful pleaching, as were the arched green galleries, windowed hedges, and tunnels that were elevated to an art form by the 17th century Dutch. Formal French and English gardens of the 18th century also sported elaborate conceits made from pleached trees, trimmed to mimic walls with stone arches, columns, and arched stone openings, some complete with well-sheared keystones.

Stilt hedges. The most recognizable form of pleaching today is the pole hedge, or stilt hedge, in which branches are cleared from the lower part of the trunks of adjacent plants and the upper branches are interwoven and trimmed like a hedge. The result is a hedge with legs, which can be as tall as the treetops (perfect for screening out an unwanted view) or low enough to border a garden path, depending on the growth habits of the pleached plant. This sort of pleaching calls for trees or plants with sturdy, attractive trunks.

Arches. These living structures seem to spring from the same lineage as natural stone arches, sculpted by wind and water from desert canyon or ocean cliff. But they're formed by a gardener's careful pleaching and clipping; nature simply supplies the raw materials. Often grown from hemlock, yew, elm, or hawthorn, they have ancestors in Spain, were frequent features of topiary gardens during the 17th century, and were a hallmark of Victorian flower gardens.

"There are many species of evergreens which may be planted on each side of the gateways of ordinary foot-walks so as to be made into charming arches over the entrance," author Frank J. Scott pointed out in 1886. "With patience and annual care, these can be perfected within about ten years, but they will also afford pleasing labor from the beginning." The illustration in Scott's book showed a pair of hemlocks woven together over a walk and trimmed into an exotic pagoda form.

Most single-trunked hedge plants that are suitable for shearing may be pleached into arches, using a metal garden arch as a training frame and following methods used by gardeners almost a hundred years in the past. Favorite arch plants of that time included privet, beech, slippery elm, willow, and the tall-growing dogwoods, along with American hornbeam, blue beech, and redbud.

Traditionally, pleaching was done in early spring. First some of the longest branches of the plant were secured to the pleaching framework with raffia. Then other branches were woven or braided together and tied into place, "not very tightly, else their tips will be choked," warned Grace Tabor in 1911. Growth that ventured outside the desired form was trimmed off, followed by another trimming later in the summer and in subsequent years. Frequent shearing made for the thickest growth.

Such living arches still stand at the entry to many a garden planted early in the 20th century, bearing witness to a long-ago gardener's patience and skill, and welcoming visitors long after wood or wire arches installed only decades ago have rusted or decayed.

Arbors and pavilions.

Pleaching also lends itself to the fashioning of living arbors and pavilions: leafy tents or canopies of green that cast shade as refreshing as a woodland pool. Rarely seen today, and a luxury even in earlier years, these elaborate structures had foliage all the way to ground level or, more like leafy gazebos, had columns formed by a circle of trunks and a thick roof formed from interwoven branches.

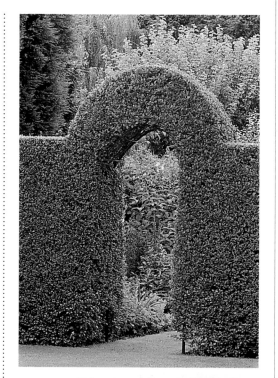

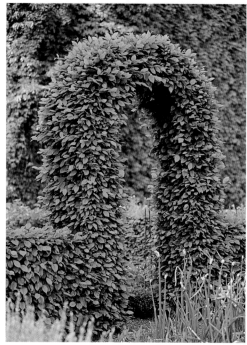

Hedge plants form pleached arches of greatly different character. Yew or cypress has a just-shorn look (top); hornbeam or beech has a leafier air (above).

GEOMETRIC TOPIARY

The illusions of the magician aren't limited to the stage. Gardeners perform magic tricks every time they shear a shrub of boxwood into a stonelike cube, shape a cypress into a bricklike pilaster, or trim an arborvitae into an obelisk that mimics marble, limestone, or wood. It's a sleight of hand that was employed in Roman times and has been practiced by canny gardeners ever since.

These structural stand-ins lend a sense of organization and order to the garden just as their conventional counterparts do, yet serve to mesh the unfettered shapes of nature with the restraints of the built world. Well-sheared obelisks or domes of holly beckon us to traverse a garden walkway, but welcome the birds when nesting season arrives. Boxwood, trimmed in a stair-step pattern to echo the risers of a nearby walk, adds to the sense of movement in the garden but softens

Lollipop-like standards flank the path to a pleached arch (below). Topiary pyramids rise up like grand monuments (center) and aren't for novice clippers. Balls of box mark the position of low steps and define an otherwise unbounded pathway (right).

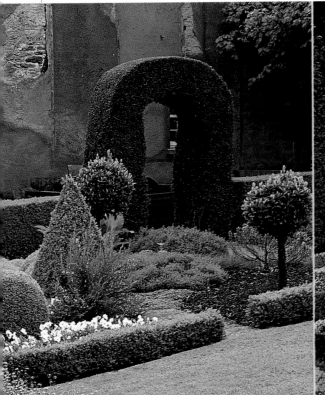

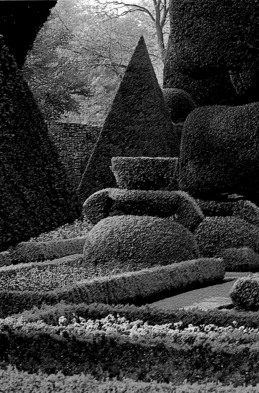

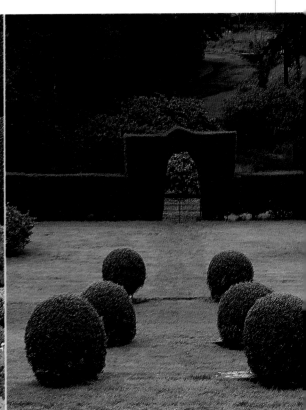

the boundary between garden and brick. Trimmed yews or arborvitae form neat piers that frame an entry just as effectively as stacks of stone or brick, yet soak up the sun and rain and sigh in the wind. The garden itself becomes architecture but retains nature's distinctive stamp.

These simple topiary forms, inherited from Roman gardeners, are most effective when planted in pairs that flank a gate or walk, frame a favorite ornament, or draw our eyes to a distant vista. Rounded forms such as spheres or domes are easiest to achieve and keep well groomed; forms with right angles call for precise shearing, and may require stake-and-string guides to keep the hedge shears on a suitably straight path.

THE ALLÉE

Like geometric topiaries, allées organize the garden, whether outlining the approach to the house or emphasizing the garden's central axes. These straight, parallel rows of trees, tall shrubs, or hedges have the power of a magnet; we can hardly help traversing their lengths, whether they culminate in a grand vista, a modest summerhouse, or only a simple garden seat.

Such geometric walks or avenues grew out of the gardens of the Renaissance, when the theory of perspective transformed the design of palatial grounds. During the peak of the French garden style, grand allées radiated out across royal land as far as the eye could see, symbolizing the power of man over nature.

Today's allées rarely span the 48-foot width or half-mile length of many at Versailles, but still draw the eye and urge the feet to follow. If your garden has the room, consider an allée or alley through the back meadow of semidwarf pear trees, a lilac walk through the garden's heart, or a miniature allée through the front garden of rose trees or clipped standards of bay. Though they won't have the grandeur of towering lindens, elms, oaks, or cypress, all will lend a hint of Renaissance brilliance—and the vitality of nature—to your garden's structural form.

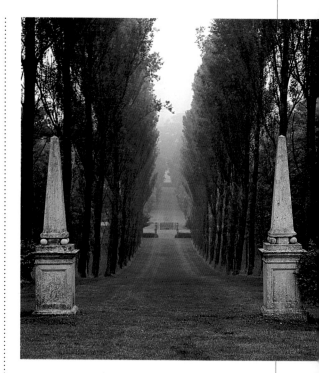

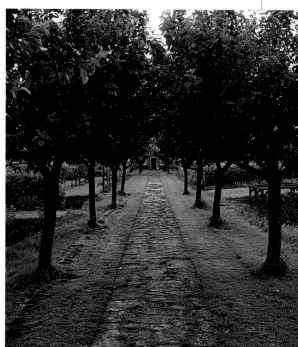

A grand allée of tall trees leads to a destination shrouded in mist (top). An allée of shrubs or fruit trees (above) is more suited to most contemporary gardens.

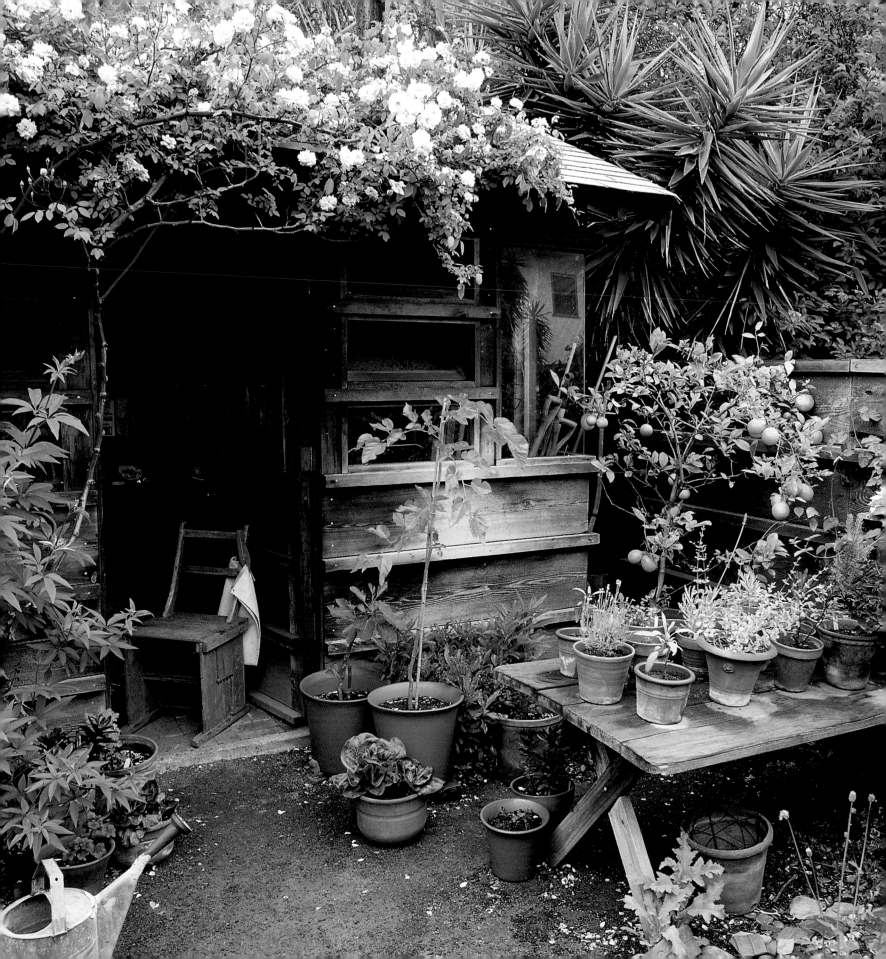

CHAPTER TEN POTTING SHEDS AND GREENHOUSES: *new beginnings*

To ensure our garden's future, we need places to nurture our plants. A protected spot where we can coax tomatoes from the confines of their seeds and convince our cuttings of mahonia or myrtle to take root. A place where we can coddle tender sprouts of cosmos, pot up the transplants of nicotiana, nemesia, and phlox, and overwinter the rosemary or lime. A work space where everything that's needed to care for our charges—both in infancy and in maturity—is at our beck and call.

For some of us, a corner of the garage and a sunny window are enough. There we can store our spade and trowel, or pot up seedlings of eggplant and broccoli and raise them to transplant size. For others of us, only a potting shed and greenhouse will do, allowing us to tend pint-size fields of lettuce while the land is locked in ice, ensure the long-term survival of the kumquat and bromeliad,

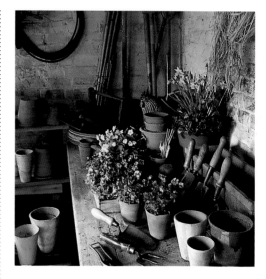

This potting shed (opposite) supports a gardener in every task. A sturdy bench (above) gets hard use when it's time to pot.

"Of a good beginning cometh a good end.

—THOMAS HEYWOOD

A lattice front screens an open shed (below). This shed has a prime position at the rear of the vegetable garden (center). Wall-trained peaches can be plucked by the door of this old shed (right).

and orchestrate the growth of our garden's plants during every season of the year.

Depending on our tastes and circumstances, we cobble together these structures from old lumber and salvaged windows, order them ready-made from catalogs, or hire architects, carpenters, or masons to give shape to our imaginings. One gardener's potting shed might be a stone cottage, complete with woodstove or fireplace; another's a no-nonsense lean-to of wood and tar paper. Greenhouses likewise will vary, from glass and iron-frilled concoctions of Victorian design to plastic-covered A-frames and marvels of technology with automated heat, irrigation, and air conditioning.

No matter how different, all share common ground, for both potting sheds and greenhouses have one overriding job that dictates their design. Though made of inanimate wood, brick, stone, or glass, they are midwives to the garden's birth, giving us welcome aid in our labors to bring forth life.

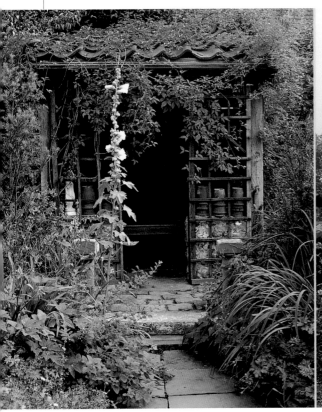

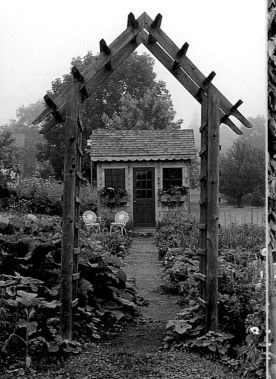

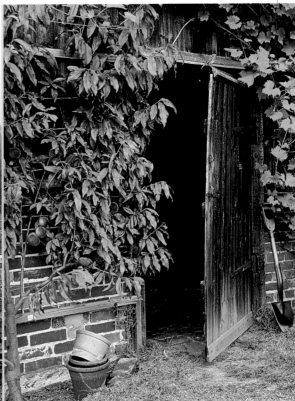

THE POTTING SHED

This is the structure where the garden's growth begins. It is here that we watch in wonder as the first sprouts of the violas try the air, their cotyledons like emeralds scattered in the flats. This is where we prepare our cuttings of cotoneaster or kerria, prick out our seedlings of 'Big Jim' peppers, divide our iris and hostas, and get our bulbs of amaryllis or paper whites off to a rousing start. And it is here that we plot out our rows of carrots and beets, determine how to rotate our crops, and order our seeds when yet another growing season beckons.

Similar garden work and storage sheds were depicted as early as the 1600s in garden books, and probably were in use even earlier. It wasn't until the 19th century, however, that *potting* sheds, as places to start seeds and pot on plants, became a must-have item, particularly for gardeners on large estates.

Vines and potted plants engulf a well-used shed (left). A stone potting shed (center) is many a gardener's dream. In this shed (below) hoes and spades are only a step from where they're needed.

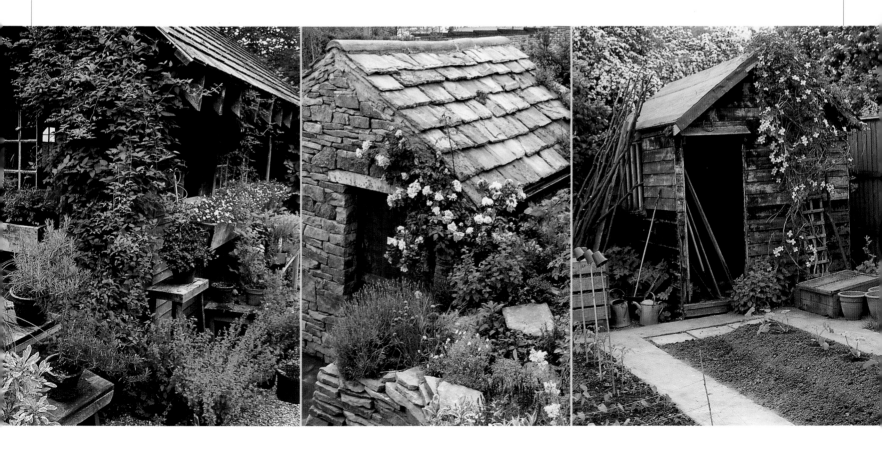

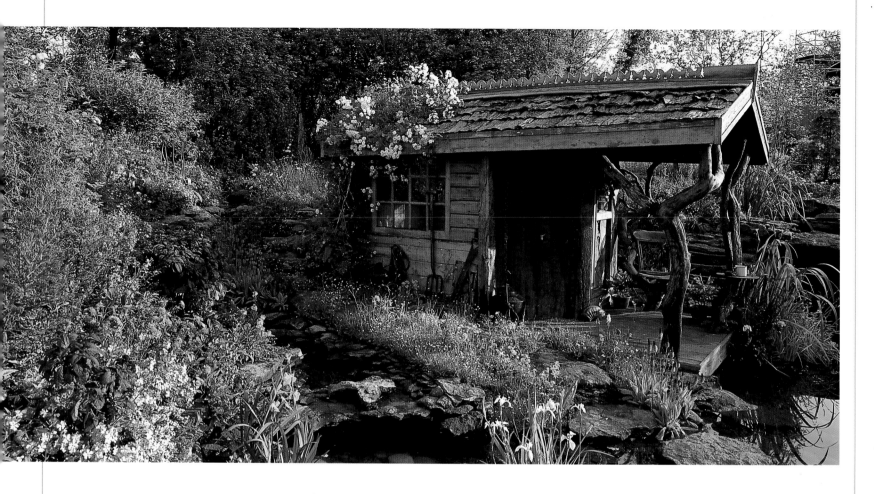

This alluring one-room cottage at pondside is part potting shed, part secluded gardener's retreat.

Until that time, most gardeners started seeds or rooted cuttings out-of-doors, saving tender plants to start as soon as the land was safe from frost. But with an increase in greenhouse and hotbed culture, potting sheds came of age.

Gardeners needed a place to pot up all those greenhouse plants and to carry out chores such as as making wattle hurdles or scribing lead plant labels. The potting sheds they worked in were as long as 40 feet, and supplemented an array of fruit rooms, mushroom sheds, and manure sheds, all of which enabled gardeners to provide delicacies for their well-to-do employers.

Writing early in the 19th century, John Claudius Loudon described sheds more suitable for average garden plots: "In small gardens, where there are no hothouses, one small building is generally devoted to all the purposes for which the office, seed, tool, and fruit rooms, and working sheds are used. This should be fit-

ted up with some degree of attention to the various uses for which it is designed, and a fireplace never omitted."

Potting sheds remained a garden mainstay on both sides of the Atlantic until after World War I, when they gradually fell out of favor in America. Small lots and large lawns required little of the laborious potting, planting, and greenhouse culture of the previous century, and the mainstays of the traditional kitchen garden were readily available at the corner grocery. Sheds remained an English hallmark, however, in gardens large and small. And as Americans rediscovered gardening's glories late in the 20th century, a passion for potting sheds wasn't far behind.

PROCURING A POTTING SHED

Gardeners travel many paths in pursuit of a place to pot. Some of us climb right to the pinnacle and build palatial sheds with all the features any gardener could desire: hot and cold running water, a built-in refrigerator for chilling bulbs and lemonade, a woodstove or heater—and skylights— for work on somber winter days. Some of us take a welcome shortcut and buy a ready-made shed, perhaps with a built-in greenhouse window, from a garden catalog or local supplier. Others of us take a more gradual route and build or buy only the shed's most essential element: a sturdy potting bench. Placed just inside the garage or under an overhanging eave, it gives us all the potting room we need for the moment. Still others of us go trailblazing and take over existing garden sheds, too-small garages, or old chicken coops: building a sturdy bench along one wall, adding a window for light and air, nailing up shelves for storage and securing hooks for hanging tools.

No matter the route we choose, most of us have an ideal in mind, a vision of a proper potting shed that would cater to every garden task. While not everyone's dream arises from the same blueprint, the following features have suited gardeners—and their plants—for centuries.

In this vegetable garden (top) potting shed and greenhouse are only a short stroll apart. A blooming amaryllis brightens this shed (above), where every tool has its proper home when the day is done.

THE CLASSIC POTTING BENCH

This sturdy, spacious bench will carry you through years of gardening's most elemental tasks, from blending potting mixes and pricking out basil seedlings to starting cuttings and potting up paper whites. You can build it from pine, but cedar or redwood will last longer and weather to a pleasing gray.

This bench is large and heavy, measuring eight feet in length and almost a yard deep. Adjust measurements as desired and to fit the space you have available. Predrill all screw holes, use two-and-a-half-inch galvanized screws or deck screws, and assemble the bench near the spot you'll be using it.

LUMBER LIST:
Eleven 8-foot 2-by-4s
Three 8-foot 1-by-12s or 2-by-12s
One 8-foot 1-by-12 plus 3
 foot length of 1-by-12
Seven 8-foot 1-by-2s

Legs: Make each leg from a 36-inch length of 2-by-4 and a 32½-inch length of 2-by-4, screwed together.
Top Frame: The top frame measures 8 feet by 30 inches. Assemble it from two 8-foot 2-by-4s and three 27-inch lengths of 2-by-4.

Bottom Frame: The bottom frame measures 8 feet by 27 inches. Assemble it from two 8-foot 2-by-4s and four 24-inch lengths of 2-by-4.

FRAME ASSEMBLY: Lay the front two legs about 7½ feet apart, shorter pieces facing up. Position the bottom frame over them four inches from their lower ends. The frame sides should be even with the outer sides of the legs. Check for square, then screw the frame to the legs. Attach frame to rear legs in the same way.

Set the frame upright. Lower the top frame into the notches in the legs and screw in place. Cut a 7-foot 5-inch piece of 2-by-4 and fit it into the gap between the rear legs, even with the upper frame. Screw into place.

Space seven 1-by-2s evenly across the bottom frame, then screw into place.

TOP ASSEMBLY: Set three 8-foot 2-by-12s (or 1-by-12s) in place and screw them to the base frame along their outer edges. The back of the rear 2-by-12 should be flush with the backs of the rear legs; the front 2-by-12 will extend ¾ inch beyond the front legs.

For the rear backsplash, position an 8-foot length of 1-by-12 along the rear of the bench top and screw it to the back of the bench. For the side backsplash, position a 33¾-inch length of 1-by-12 along the left side of the bench, overlapping the rear backsplash at the corner. Screw to the bench, then to the rear backsplash at the corner.

Or, install a top and backsplash fabricated from plywood or particle board, surfaced with plastic laminate or galvanized sheet metal.

The shed. The more like a miniature house the actual shed structure is, the better. Though some gardeners get by with a 4-by-6-foot work space, a well-built structure that is a minimum of 8 by 10 feet will give you—and your flats and pots—more room to spread out. Choose a sturdy roof to fend off the elements, and floor materials that can withstand dirt, moisture, and lots of sweeping up. Tradition calls for brick, stone, or tile on the floor, but painted concrete, painted wood, asphalt tile, linoleum, or resilient flooring all will work. The walls may be insulated and finished, but many gardeners prefer to leave the studs exposed. Consider a Dutch door, so you can swing the top wide open on sunny mornings.

The potting bench. The ideal bench is 24 to 36 inches deep and as wide as space allows, and is built of sturdy lumber to withstand the weight of dozens of pots and mounds of damp potting mix. Design your bench with a solid backsplash 6 to 12 inches in height to keep potting soils from falling off the back edge. If possible, extend the backsplash along one side of the bench, so you can easily corral potting soils in one corner while you're mixing them.

The bench top should be at a comfortable working height, approximately 36 inches from the floor, but higher if you're tall and lower if you're short.

Don't let the area beneath the bench top go to waste. Wide shelves there can be used for storing pots and potting supplies, or for housing plastic bins with snap-on covers for storing peat moss, perlite, and other potting ingredients. Some gardeners prefer drawers and cupboards down below; others opt for tilt-out storage bins like those in old Hoosier cabinets.

Storage. "Have a place for everything, and everything in its place," wrote Mr. Barnes of England's Bicton Gardens in the mid-19th century, a commandment that still serves gardeners well today. In addition to storage below the potting

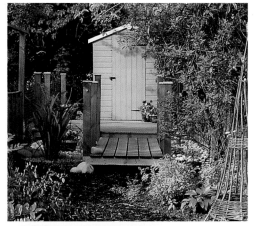

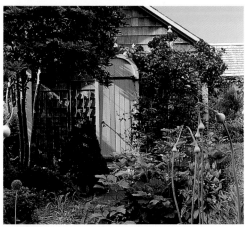

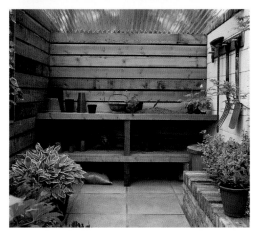

Some sheds are garden wallflowers, others stand out (top). An arched yellow door distinguishes this simple shed (center). An open-sided potting space with sturdy bench gets its light from overhead (above).

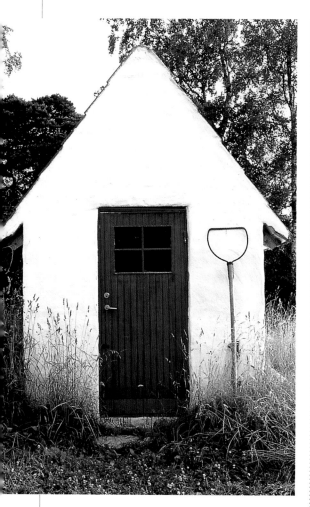

Pristine as new snow, this upright shed promises a neat and well-organized interior. The bright blue door stands out amid the green surroundings.

bench, be sure to supply a specific resting spot for every spade, fork, trowel, pot, sprayer, and pair of garden gloves. (Avoid resting shovels and spades on the floor, which can dull their blades.)

Peruse the hardware store for sturdy shelf brackets, hooks, and special holders that will firmly grasp the shafts of shovels and brooms. Add closed cupboards for concealing bags of bonemeal, bottles of insecticidal soap, and boxes of amendments, as well as slatted shelves for stacking pots or mud-caked boots. Hang up baskets by the door in which to nest garden gloves, plant tags, or pruning shears. Drawers work well for securing smaller items such as grafting knives, boxes of plant staples, or rolls of jute twine; keep a mug handy on the bench top for stashing pencils and pens. And don't forget shelves for lining up your dog-eared garden reference works and notebooks.

Your storage solutions may be fancy (the latest in cabinetry from a custom builder), nostalgic (an antique cupboard you discovered at a yard sale), or decidedly makeshift (nails pounded into the studs from which to hang your trowel or cultivator). Some gardeners plan for storage from the beginning, sketching everything out on paper; others add it as they go, putting up a shelf here and a hook there. Just remember—when it comes to storage for your gardening gear, you can never have too much.

Light. Light is the gardener's friend, nurturing our plants, brightening our work, and lifting our spirits on even the grayest winter days. So be sure to include windows in your shed, facing east for morning warmth and north for gentle, all-day illumination. Casement windows that open out onto the garden will let in the breezes when days grow warm and the shed provides an escape from the beating sun. If you plan to raise seedlings to transplant size inside the shed, a south-facing greenhouse window will be an asset. Provide shades or blinds for any south-facing windows so you can moderate the direct sunlight (a greenhouse window may require shade cloth on the outside to moderate the heat).

In addition to natural light, provide electric fixtures to brighten specific spots, such as the bench top where you prick out delicate seedlings from flats to pots, the chair where you consult your favorite authors, or the table where you sketch out planting plans or update garden notebooks. If you don't have a greenhouse, you may also want to mount fluorescent fixtures over a bench or table to nurture seedlings through their early stages. Hang the lights so you can adjust their height; most seedlings grow best when the lights are only a few inches away. (If your shed gets too cold at night, you'll be better off mounting your lights and raising your transplants in the basement or a spare bedroom.)

If abundant windows aren't feasible, and your only light fixture is a bare bulb in the middle of the ceiling, boost the brightness of your shed by giving the interior a fresh coat of white paint or whitewash.

Water. Hot and cold running water in the shed is many a gardener's dream, but if you do a lot of gardening it's hardly a luxury. On cold spring days, outdoor spigots may still be out of commission, and hauling water from the house for scouring pots or dampening seed mixes can be a daunting task. Far better to plumb in a broad, shallow sink adjacent to the potting bench with at least a cold-water faucet, though your hands will thank you if you also install an instant-acting water heater.

Heat. Early in the 19th century, when John Claudius Loudon wrote that every garden shed should have a fireplace, he was only being practical. He knew far more work would get done in sheds where fires crackled during the fall, winter, and spring months than in unheated sheds. For that very reason, sheds on large estates often were built behind the hothouses to share heat from their boilers.

Though most modern sheds lack a hearth, and woodstoves are shed rarities, a portable heater will transform even the coldest work space into a welcoming retreat on an icy March morning. Seeds started in the potting shed also will need

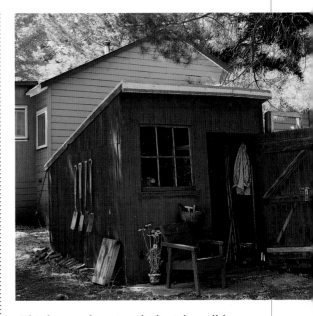

This barn-red potting shed might well have begun life as a chicken coop; now it invites a gardener to roost.

"*The part of these sheds more particularly set apart for working . . . ought to be made perfectly light, and well aired by having numerous windows, and along these a range of benches or tables, for potting cuttings or bulbs, sowing seeds, preparing cuttings, numbering tallies, painting and naming them, preparing props for plants, hooks for layers, lists for wall-trees, making baskets, wattled hurdles, and a great variety of other operations performed in winter, or severe weather, when little or nothing can be done in the open air.*"

—J. C. LOUDON, *An Encyclopaedia of Gardening*, 1835

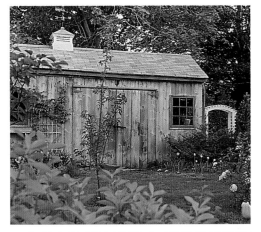

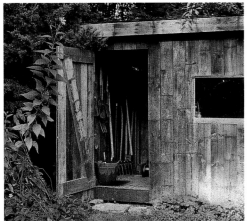

Sheds should be sized to match a gardener's needs, from one with ample parking space for a riding mower (top), to one just wide enough for a potting bench (center), to one no bigger than a closet (above).

warmth to germinate; special heating mats or coils are available from many garden catalogs for this purpose.

Miscellany. A potting shed that sees a lot of use changes over time, growing more comfortable and better suited to its owner's character. Certain elements help make it that way, and set one shed apart from another. Back in the 1930s, Anna Gilman Hill hung brightly painted baskets from the rafters of her stone potting shed; she used the baskets to send plants home with friends, and their vivid colors reminded the borrowers to bring them back. Your potting shed might have a hot plate and pair of handmade stoneware mugs, for sharing tea with friends who drop by, or a chintz-covered chair, too worn for the house but perfect for perusing the Thompson and Morgan seed catalog or your tattered copy of *The Fragrant Path*. As much a part of the shed as the potting bench or spade and fork, these are the things that make the shed a gardener's home.

PLACING THE POTTING SHED

Estate-sized Victorian potting sheds almost always were kept out of view, considered too unsightly for the neatly cultivated kitchen garden. Because of their out-of-the-way position on the back side of the garden wall, they were even called one of the "back sheds." In contrast, today's potting sheds are not only presentable but perhaps also the garden's focal point: neatly trimmed and painted, roofed with cedar shingles, and engulfed in a wave of daylilies at the garden's heart.

Potting sheds are best placed where they will welcome the sun in spring and fall, but be shaded during summer's torrid peak. Carefully sited deciduous trees will provide needed relief from the heat but allow the sun to warm the shed at colder times of year. If possible, locate the shed so it's nearest the part of the garden where the most work occurs, so you won't have far to tote the watering can or sprayer, or carry your transplants of basil or melons.

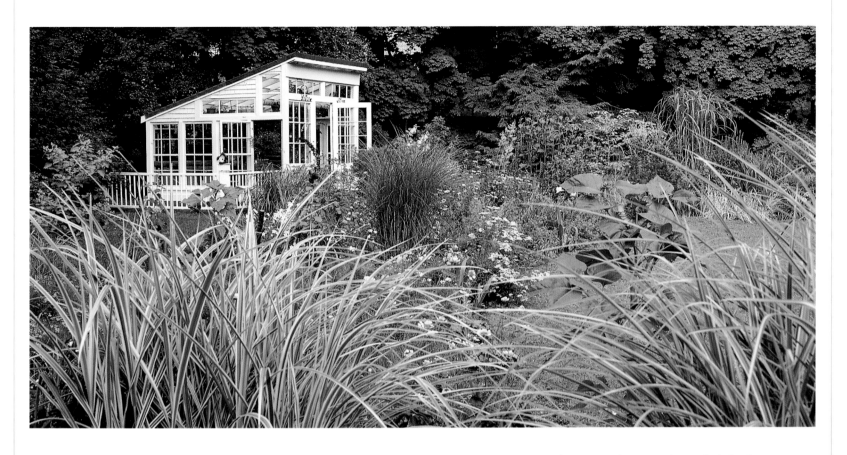

THE GREENHOUSE

Greenhouses are time machines that harness the sun, allowing us to leapfrog through the seasons and relish succulent tomatoes, tart lemons, or passion-flowers while winter rages, or to start the outdoor garden growing long before the frost dates will allow. To enter one on a grim day in February is to be transported to another time and place, where the air is filled with the scents and sights of a tropical summer.

The ancient Romans knew the benefits of protecting plants from harsh weather, but it wasn't until the 16th century that wintering tender plants indoors became a standard part of horticultural practice. At that time, wealthy plant collectors began erecting orangeries on their large estates: narrow stone or brick rooms, heated with stoves and boasting small panes of glass on their south walls,

A greenhouse at the garden's farthest margin becomes a steamy refuge when temperatures plummet and tender plants are moved indoors. Such a retreat can be built from conventional windows and French doors.

where tender potted plants were kept alive through the worst of winter. Foremost among these coddled treasures were exotic orange trees, grown in boxes that could be wheeled out of doors when the weather grew warm.

Such orangeries, according to one 16th century writer, were "magnificent sumptuosities in which the mildness of spring and summer always reigns." But in truth they were ill suited to the growing of plants.

By the late 1600s and early 1700s, royal hothouses with increased amounts of glazing were producing hampers of out-of-season fruits and vegetables such as strawberries and salad greens. Called both conservatories (a conserve for tender plants) and greenhouses (a house for tender greens), these structures also protected rare foreign specimens such as lemons, myrtle, pomegranates, figs, bay, olives, and aloe, and allowed the forcing of treats such as bananas, mangoes, pineapples, and melons. However, it wasn't until the 19th century that green-

Greenhouses in English kitchen gardens often leaned against heated walls for added warmth (below). Grapes crowd the ceiling of this glass house (right), helping them to fruit in less than optimal climes.

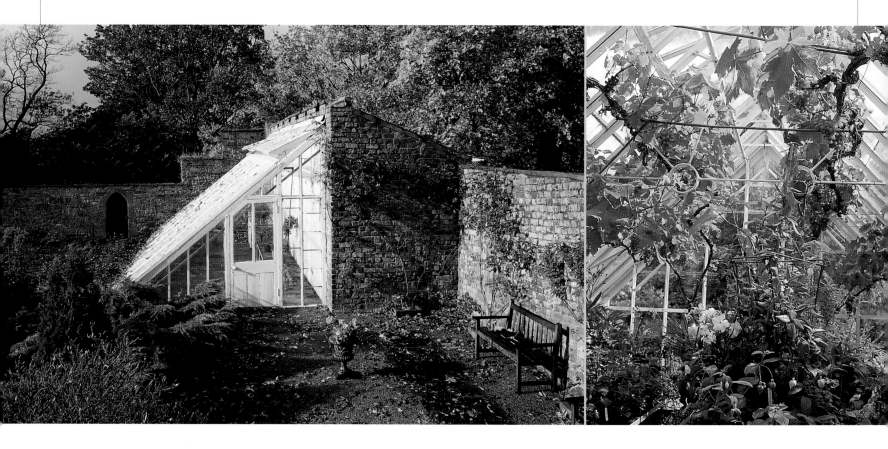

houses became a must-have item in every large garden.

Greenhouse designs and heating methods had improved by then. But it was a change in the manufacturing of glass (allowing for larger, better-quality panes) and a repeal of repressive English glass taxes (making the structures more afford-able) that ensured the greenhouse's widespread success. Gardening under glass became an art form practiced by a skilled class of professional gardeners, particu-larly in England where the growing season was short and relatively cool.

Many a heated glasshouse in the walled kitchen gardens of large estates turned out grapes, melons, cucumbers, and peaches for the master's table. Others elsewhere in the garden supplied thousands of plants for bedding out: the latest rage in gardening (as many as 50,000 bedding plants were grown in the green-houses on some estates). With the greenhouses filled with fruits and flowers, there was little room for full-grown specimen plants. These became the province of the

Out-of-season vegetables (left) enjoy the heat of a greenhouse as much as do forced daffodils and freesias (center). The glories of this lean-to greenhouse (below) are easily reached from inside the house.

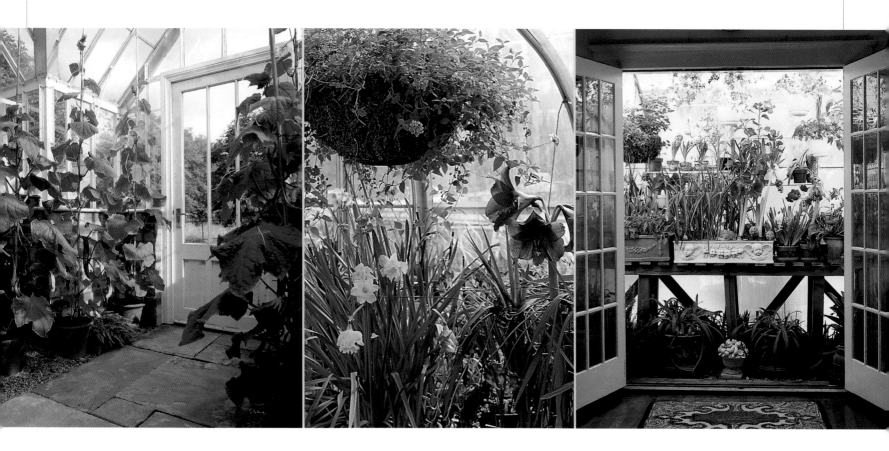

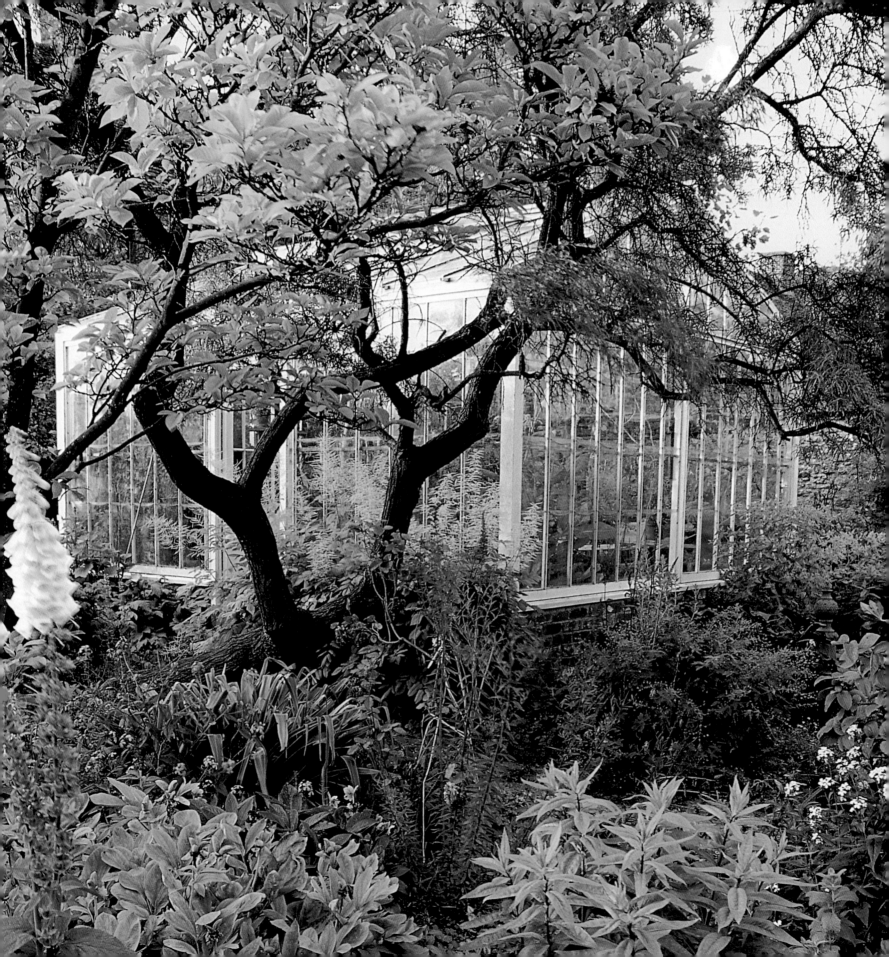

conservatory, which soared to fantasy proportions with the help of iron framing and housed ever-increasing collections of tender tropical specimens—from orchids to Amazon water lilies—collected by daring plant hunters abroad.

Despite lower glass prices and better heating technology, greenhouse culture was both expensive and labor-intensive. And as the 19th century rolled into the 20th, a decided chill descended on once-grand gardens in both England and America, and the golden age of the Victorian glasshouse slowly came to an end. Labor prices rose, and artificial bedding schemes of tender plants fell out of favor. Improved shipping methods brought exotic fruits year-round to the grocer's. And skill levels plummeted as the Great War stole away a generation of expert gardeners. Slowly, the greenhouses and conservatories of the large estates fell into disrepair and soon were cheaper to demolish than restore.

Today, while commercial greenhouse operations are booming, churning out hothouse tomatoes, cucumbers, and innumerable flowers and nursery plants, privately owned greenhouses of Victorian dimensions remain a rarity. Smaller greenhouses have taken their place, tended by avid home gardeners with a passion for gardening all the year round. The heating, ventilation, and watering chores that used to take an army of gardeners and garden boys to accomplish now can be completely automated, allowing us to concentrate all our time on the pleasures of propagation and the undeniable joys of the harvest.

GETTING A GREENHOUSE

Greenhouses suited to the home garden are more widely available than ever before and boast increasingly sophisticated designs and amenities. The range of structures is extensive, so it's important to determine what your needs and expectations are before you begin to build or shop.

Many simple greenhouse designs can be built at home from plans in books devoted to greenhouse construction or from instructions found on some garden-

> *"How much better, during a long and dreary winter, for daughters, and even sons, to assist, or attend, their mother, in a green-house, than to be seated with her at cards, or in the blubberings over a stupid novel, or at any other amusement that can possibly be conceived!"*
>
> —WILLIAM COBBETT, *The English Gardener*, 1833

A spacious greenhouse rises up like a temple dedicated to nature's fecundity (opposite). Side windows open to vent this greenhouse (above), affording the gardener a pleasing view.

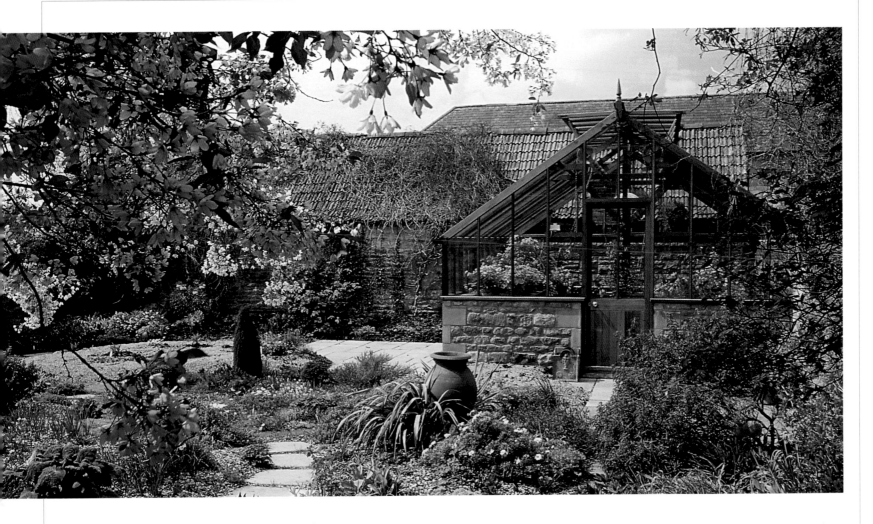

Stone half-walls tie this greenhouse to its surroundings. Many greenhouse designs feature half-walls of brick or wood, which give added protection to plants in winter without blocking too much sunshine.

ing Web sites. You can also order greenhouse kits from many catalogs. Some kits require purchasing additional materials from lumberyards or home centers; others come with everything included. Alternatively, you can order ready-made greenhouses from catalogs or directly from manufacturers, or have a greenhouse custom built to meet your specific demands.

Greenhouse types. The simplest greenhouse type (called a tunnel greenhouse) is shaped like a Quonset hut, consists of ribs covered with plastic sheeting, and can cost as little as $100 to build—if you are willing to tackle the work. Most home greenhouses, however, have aluminum, redwood, or red cedar frames in the form of a peaked-roof house, A-frame, or lean-to, and are glazed with

either plastic, glass, or double-walled polycarbonate. Greenhouses of these types typically cost anywhere from $500 to $5,000 or more, depending on their size and amenities.

Glazing.

The glazing, which captures the sun's warmth and light, is the greenhouse's most vital feature. Some gardeners prefer plastic or polycarbonate glazing, both of which have the advantage of light weight, superior safety, and low cost in comparison to glass, but may deteriorate or yellow over time from ultraviolet exposure. Other gardeners swear by glass, which has served greenhouse owners and their tender plants well for more than 200 years. Your glazing choice may depend on both your pocketbook and your climate. Plastic, for instance, provides less insulation than glass, while double-walled polycarbonate is as efficient as double-glazing.

Foundations and floors.

Though some tunnel greenhouses can be erected directly on a bare patch of garden soil, most greenhouses require a sturdy foundation of four-by-fours, concrete block, or poured concrete. Plans, kits, and ready-made greenhouses usually come with instructions for appropriate foundations; check to see if local building codes apply before you begin to build.

If your greenhouse type calls for a perimeter foundation rather than a concrete slab, you can form a suitable floor and central walkway by laying down landscape fabric over the soil and topping it with two inches of gravel. Frame in a walkway down the center of the structure with cedar, redwood, or composite two-by-fours, then fill in the space with stone, brick, or concrete pavers set in sand. Or build a redwood or cedar boardwalk to keep your feet up off the ground.

Whatever greenhouse type you choose, buy or construct the biggest one you can afford. There's hardly a greenhouse owner around who doesn't wish for more room once the melon vines begin to climb and the cymbidiums to flower.

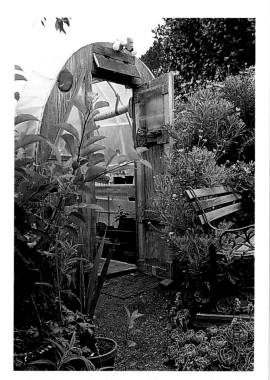

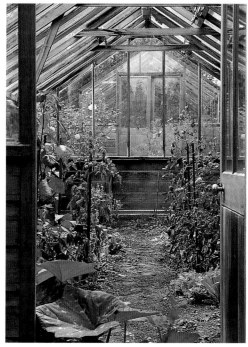

A tunnel greenhouse (top) can be built with inexpensive materials. This greenhouse has no flooring, so tomatoes can be grown right in the earth (above).

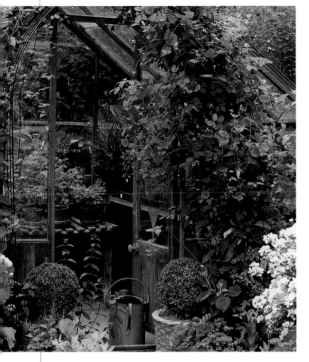

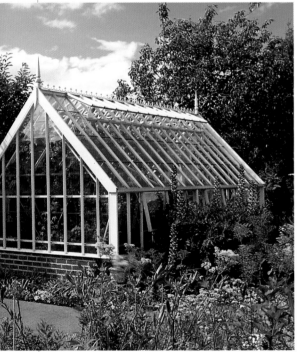

Slatted benches provide growing space with good drainage in this greenhouse (top). Roof vents open (above) when temperatures in this greenhouse rise too high.

THE COMFORTS OF HOME

Ever since orangeries first sheltered rare citrus trees, greenhouse gardeners have struggled with ways to meet the needs of the resident plants. Today, the following elements are considered essential to successful greenhouse culture:

Furniture. Most greenhouses are fitted with traylike growing benches or slatted display shelves to provide maximum growing space for seedlings, cuttings, and potted plants. You can build many types of slatted shelves and benches at home from rot-resistant lumber, marine plywood, and galvanized pipe, or even put purchased folding tables or plastic shelving to good use. Many excellent bench and shelving options also are available through greenhouse supply companies and catalogs.

Heat. Greenhouses are categorized by their nighttime interior heat levels. A "cold" greenhouse, for instance, which is suited to overwintering many plants, requires a nighttime temperature of only 35 to 40 degrees Fahrenheit. In some climates, this temperature can be maintained with solar gain and double-glazing alone; other climates will require heaters to keep the temperature continually above freezing. At the other end of the spectrum is the "warm" greenhouse, which requires a consistent nighttime temperature of 65 to 70 degrees. In such cozy surroundings, even lemons, bananas, eggplant, and tomatoes will thrive. Substantial heaters are a necessity for this greenhouse type no matter where you live.

Greenhouse heaters come in a wide variety of models, powered by electricity, propane, gas, or oil. They should be controlled by a thermostat so you needn't worry about capricious weather. Greenhouses also can be designed using solar heating technology, so that daytime heat is stored and released at night; these types also will need a backup heat source.

Ventilation and circulation.

Ventilation is essential in order to keep the greenhouse from overheating on warm days and is normally accomplished with a combination of vents, fans, and shutters. In the simplest of greenhouses, gardeners simply open the door to keep the heat from cooking their gloxinias or gardenias.

Air must also circulate within the greenhouse itself in order for the plants to thrive. Still air promotes diseases and keeps adequate carbon dioxide from reaching the plants, and the warmest air will stay trapped near the ceiling without a fan to bring it down to plant level. If possible, all vents and fans should be automated and controlled by thermostats so that a day's oversight doesn't destroy months or years of growth. Many vent and fan types are available, including vents that are opened by solar power and that close when the temperature drops.

Shade.

In addition to causing heat buildup, too much direct sunlight can sunburn plants, so some form of summer shading is a must for most greenhouses. Early greenhouse operators once shaded their plants with reed mats, straw, or shutters, or painted the glass for the summer season. Now aluminum, fiberglass, and knitted plastic roll-up shades are common, as are fixed shades of polypropylene. Greenhouse paint (called shading emulsion) remains available for use on glass, but must be scrubbed off at the end of the warm season. Well-placed vines also will filter the sun and help blend the greenhouse into the rest of the garden.

Most shade materials block out a certain percentage of light; a mid-range shade cloth rated at 50 to 60 percent density is a good all-purpose choice for all but the hottest zones. To prevent overheating, shade materials should be installed on the exterior of the greenhouse, and should cover its roof and the upper section of its southernmost side. Western exposures also may need some shade late in the afternoon and evening. Elevate shade cloth above the surface of the greenhouse to allow for air circulation underneath, and to allow vents to open and close.

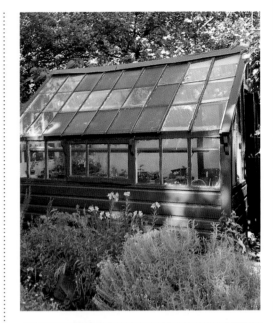

This green-painted hothouse blends in with its surroundings (top). A small greenhouse (above) is quickly filled to capacity with heat-loving plants.

HALFWAY HOUSES: COLD FRAMES AND HOTBEDS

For gardeners raised on the convenience of nursery-bought plants and grocery store produce, cold frames or hotbeds may seem a quaint anachronism. But for those of us who want to grow heirloom 'Purple Cherokee' tomatoes, harden off hordes of seedlings, root cuttings of our neighbor's myrtle, or harvest radicchio and chard through the worst of winter, these protective frames are invaluable helpmates in the garden.

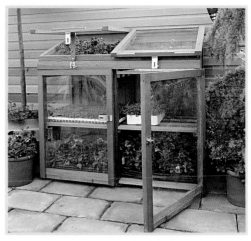

This purchased cold frame and mini-greenhouse fits in the smallest garden.

A brick cold frame attached to a greenhouse simplifies the chore of hardening off succulent seedlings or cuttings and preparing them for life in the open garden.

Cold frames and hotbeds are incubators for plants: smaller, cheaper, and easier to care for than a greenhouse. Simple cold frames, heated by the sun, suffice for almost all garden tasks. But hotbeds can be used earlier in the season, will provide bottom heat that's perfect for starting most seeds or rooting cuttings, and can be converted to a cold frame once the weather starts to moderate. Today, most hotbeds are heated by electrical cables buried under a bed of sand and controlled by a thermostat. But they also may be heated by hot-water pipes or even by rotting manure—a standard practice from the 1600s on that was pioneered by the ancient Romans.

WHAT'S IN A FRAME

Most cold frames and hotbeds are bottomless wooden boxes that slant up from front to back at a slight angle and are topped by glazed covers, from old storm-window sash to the same double-walled polycarbonate used in many greenhouses. Some frames are portable and can be moved to any spot in the garden as the season demands, so plants can be grown right in the soil. Others are permanent structures, with foundations of stone, brick, or concrete block.

Many permanent frames are excavated into the ground as much as two feet, adding to their protective abilities and making them suitable for sheltering larger potted plants throughout the winter months.

GETTING A FRAME

You can build cold frames and hotbeds from scrap lumber and old window sash, construct them like a fine piece of furni-

ture out of the best redwood, or buy them ready-made from garden suppliers. A century ago, standard frames measured 6 by 12 feet, with four 3-by-4-foot glazed covers. But a frame that measures approximately 3 feet deep by 4 feet wide is ample for many gardeners, and more frames—or bigger ones—are easily added if your passion for winter spinach or 'Brune d'Hiver' lettuce grows.

To site your frame, choose a spot in your garden that faces south, or southeast or southwest; receives sun most of the day; and is on level, well-drained ground or ground that slopes slightly to the south. An ideal site is one that's protected

directly on the north by your house, potting shed, or greenhouse, or by a wall, hedge, or fence. It should be close to a water source, and to electricity if you plan to heat it. Mostly, however, it should be close to you, so that you can easily tend to the plants or harvest winter delicacies as desired.

Once the frame is in place, you'll need to become familiar with its temperature fluctuations through the seasons. Place a thermometer inside, out of the direct sun, and note temperatures and weather conditions throughout the day and into the evening. Traditionally, gardeners have propped open the covers of their frames with notched sticks whenever the sun promised high interior temperatures, which

could quickly cook plants, then lowered them as soon as the day began to cool. Today, many gardeners rely in part on solar-powered automatic openers, which will open the frame covers whenever the inside temperature gets uncomfortably steamy. These indispensable devices are available from many mail-order sources, and work best with lightweight covers made of Plexiglas, fiberglass, or polycarbonate.

The Frame's Year

Even if you only put your frame to work initially hardening off your seedlings of eggplant or peppers, it will be well worth having. And soon you'll be a master, filling it with an assortment of seedlings, cuttings, or ready-to-harvest plants throughout the year.

Here's a brief sampling of frame activities (timing may vary according to your climate):

Late Winter, Early Spring:

- Germinate and grow salad crops, from radishes to arugula.
- Germinate seeds and grow seedlings of cool-season plants such as broccoli, peas, pansies, or stock.

Spring:

- Germinate and grow in hot beds seedlings of plants that take a long time to mature or enjoy heat, such as melons, cucumbers, tomatoes, peppers, and eggplants.
- Harden off seedlings of annuals, perennials, and vegetables in the cold frame, and gradually expose them to sun and air.

Insulate the frame at night with straw, leaves, or old blankets if a late cold snap threatens.

- Germinate seeds and grow seedlings of tender annual plants.

Summer, Late Summer:

- Germinate and grow transplants of cool-season fall and winter crops, such as carrots, scallions, arugula, lettuce, and Swiss chard.
- Root semiripe cuttings in sand in the frame; paint the cover with greenhouse emulsion or cover with shade cloth.

Fall, Winter:

- Protect full-grown winter vegetables and greens.
- Hold over perennials or biennials or cuttings started the previous summer for planting in the spring.
- Protect perennials and herbs that succumb to hard frosts.
- Force hardy spring bulbs.
- Root hardwood cuttings.

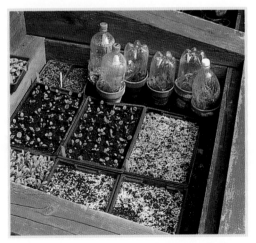

Flats of seedlings and potted cuttings find a comfy though temporary home.

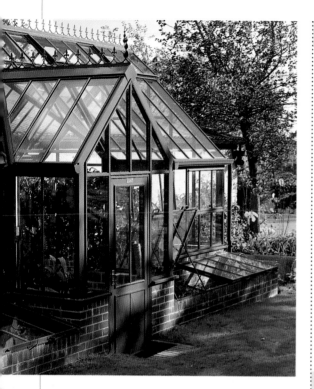

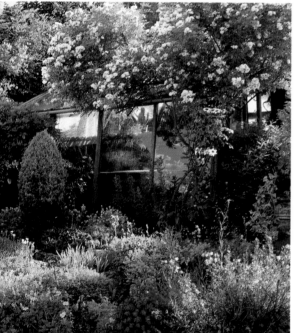

Elaborate greenhouses worthy of a Victorian garden (top) can still be purchased today. Climbing roses shade this greenhouse from excessive summer sun (above).

Humidity. All that air movement and sunshine can suck moisture out of the plants and air in the greenhouse, dropping humidity levels well below the 50 to 70 percent level that's desirable for healthy growth. A variety of misting systems are capable of transforming the desert back into the tropics, and will lower excessively high temperatures at the same time. Mist systems are a particular boon if you'll be doing lots of plant propagation from cuttings, which must have high humidity levels to survive until they root.

Because the humidity rises naturally at night as temperatures drop, misters should be run only during the day to avoid fungus and disease problems, and should be turned off an hour or two before sundown. Like heat and ventilation systems, misters perform best when automated.

Cooling. Greenhouses in some climates may need more summer cooling than ventilation and a mist system can provide. Evaporative coolers often are used for this purpose.

Light. Though greenhouses are constructed to bring a maximum of natural light to plants, sometimes the available sunshine isn't enough. Plants such as ferns, orchids, palms, and philodendrons will thrive at low light levels, but plants such as tomatoes and eggplants may need an extra dose of light in the morning and evening if they're going to produce during short winter days. Fluorescent lights hung a few inches over seedlings or cuttings will create stocky growth, but plants that you expect to fruit or flower in the greenhouse may need high intensity discharge lights, such as high-pressure sodium or metal halide lights. (Put lights on a timer, and remember to check your lighting schedule with the neighbors if your greenhouse happens to be close to their property.) And don't forget to install a simple incandescent or fluorescent fixture to shed light on your work when the sky is gray.

Water. While it's possible to drag the hose in from outside to water your plants in warm-weather months, hose bibs inside the greenhouse are far more convenient. (Consult a plumbing contractor on how to adequately protect pipes in cold winter areas.) Choose from an array of handy hoses, watering wands, and misters, and consider installing an automatic watering system that will allow you to go traveling without hiring a plant sitter. If you don't have an adjoining potting shed, you may also want to install a broad, shallow sink in the greenhouse for soaking flats or pots or for rinsing off your winter harvest of hothouse cukes or peppers.

SITING THE GREENHOUSE

Greenhouses without sun are like gardeners without soil; neither can do their job. Try to position your greenhouse where it will receive the greatest amount of winter sun your garden allows—at least six hours a day. If space permits, orient the greenhouse so its longest dimension runs from east to west for maximum southern exposure, and pick a spot that's sheltered from the wind.

Like the potting shed, your greenhouse should be adjacent to the busiest part of the garden to save on travel time, or near or connected to the house or potting shed so you can slip into it in a moment on even the frostiest mornings. Some greenhouses, however, aren't particularly eye-catching, so a bit of artful camouflage with shrubs, small trees, or lattice screens may be in order (they'll also help break the wind). Just be sure you don't block the slanting rays of the winter sun in the process.

Low in the sky as they are, those feeble rays are what will coax the 'Sungold' tomatoes to bear trusses of succulent fruit, and urge the mandevilla vine to flower in the middle of January. They will turn the greenhouse air to a soothing balm, soft and moist as a kiss. And they will warm both our bodies and our hearts as we labor on frigid March days, nurturing the life of the garden yet to come.

> "*This is the transcendent merit of a greenhouse,—the sense of mastery over the forces of nature. It is an oasis in one's life as well as in the winter. One has dominion.*"
>
> —LIBERTY HYDE BAILEY,
> *The Garden Lover*

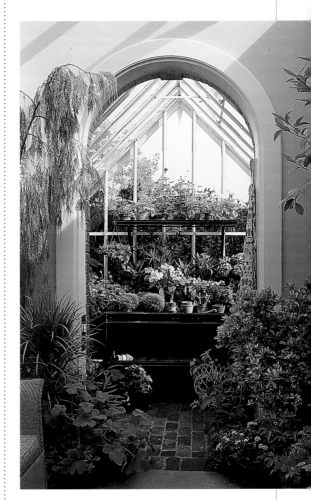

A brief greenhouse addition reached through an arched doorway offers up summer's tender glories even in the midst of winter.

PHOTO CREDITS

PHOTO RESEARCH AND EDITING: ALEXANDRA TRUITT & JERRY MARSHALL, www.pictureresearching.com

Front Cover © Jerry Harpur; Inside Front Cover © Susan A. Roth; Back Cover Left © Jerry Howard/Positive Images; Back Cover Center © Karen Bussolini; Back Cover Oval © Derek Fell; Back Cover Right © Hugh Palmer [l: left; r: right; c: center; t: top; b: bottom]

Introduction Page x Ping Amranand; Page 1 Ron Sutherland/ Garden Picture Library; 2l Elizabeth Whiting Assocs; 2c Nils Reinhard; 2r Kathlene Persoff; 3l Karen Bussolini; 3r Tim Street-Porter; 4l Nils Reinhard; 4r Hugh Palmer; 5l Karen Bussolini; 5tr Ron Sutherland/Garden Picture Library; 5br Elizabeth Whiting Assocs; 6t Andrew Lawson; 6c Andrew Lawson (Designer: George Carter); 6b Ron Sutherland/Garden Picture Library; 7 Eric Crichton/Garden Picture Library

Gates and Doorways Page 8 Derek Fell; 9 Susan A. Roth (Designer: Candy Cleveland); 10l Andrew Lawson; 10c Susan A. Roth; 10r Photos Horticultural; 11l Jerry Pavia; 11r Ian Adams/gardenIMAGE; 12 Clive Nichols/Vale End, Surrey; 13 Tim Street-Porter; 14l Susan A. Roth; 14c Kathleen Norris Cook; 14r Zara McCalmont/Garden Picture Library; 15l Derek Fell; 15r Curtice Taylor; 16l Garden Matters; 16c John Peden; 16r Derek Fell; 17l Vincent Motte; 17c Reinhard-Tierfoto; 17r Kieth Scott Morton; 18 Mick Hales; 19 Charles Mann; 20 Kathlene Persoff; 21l Linda Joan Smith; 21c Derek Fell; 21r Lynn Karlin; 22t Clive Nichols/Johny Woodford; 22b Ken Druse; 23l Garden Matters; 23c Andrew Lawson; 23r Ron Sutherland/Garden Picture Library; 25 Reinhard-Tierfoto; 26 Kathlene Persoff; 27t Hugh Palmer; 27b Garden Matters; 28l Jerry Pavia; 28c Lynn Karlin; 28r Garden Matters; 29l Jerry Pavia; 29c Lynn Karlin; 29r Garden Matters

Fences Page 30 Karen Bussolini; 31 Ken Druse; 32t Kathlene Persoff; 32b Ken Druse; 33l Susan A. Roth; 33c Susan A. Roth; 33r Curtice Taylor; 34 Kathlene Persoff; 35l Kathlene Persoff; 35c Steven Wooster/ Garden Picture Library; 35r Lamontage/Garden Picture Library; 37 Curtice Taylor; 38l Vincent Motte; 38r John Glover; 39 Clive Nichols (Designer: Randle Siddeley); 40 Curtice Taylor; 41t Harry Smith Horticultural Photographic Collection; 41c Lynn Karlin; 41b Harry Smith Horticultural Photographic Collection; 42t Bill Goule/Bruce Coleman, Inc. - New York; 42b Tom Hollyman/Photo Researchers, Inc.; 43 Derek Fell; 44t Ken Druse; 44b Linda Joan Smith; 45 Susan A. Roth; 46 Photos Horticultural; 47t Karen Bussolini; 47b Curtice Taylor; 48l Susan A. Roth; 48tr Lynn Karlin; 48br Ron Sutherland/ Garden Picture Library; 49tl Garden Matters; 49bl Derek Fell; 49r Vincent Motte; 50tl Lynn Karlin; 50bl Eric Crichton/ Garden Picture Library; 50r Charles Mann; 51l Vincent Motte; 51r Lamontagne/ Garden Picture Library; 52l Susan A. Roth; 52tr Julie Sprott/ gardenIMAGE; 52cr Tim Spence/ Garden Picture Library; 52br Garden Picture Library; 53t Tim Street-Porter; 53c Lynn Karlin; 53b Derek Fell; 54l Hugh Palmer; 54c Hugh Palmer; 54r Jerry Pavia; 55l Linda Joan Smith; 55r Jerry Harpur; 57t Susan A. Roth; 57c Linda Joan Smith; 57b Linda Joan Smith

Walls Page 58 Hugh Palmer; 59 Hugh Palmer; 60t Kathlene Persoff; 60b Kathlene Persoff; 61l Ken Druse (Designer: Jonathan Plant); 61tr Ping Amranand; 61br Tim Street-Porter; 62l John Glover; 62c Carol Simowitz; 62r Pam Spaulding/Positive Images; 63l Hugh Palmer; 63r Lynn Karlin; 64l Marianne Majerus/Garden Picture Library; 64tr Hugh Palmer; 64br Curtice Taylor; 65l Jerry Pavia; 65r Peter Stiles Photography; 66 JS Sira/Garden Picture Library; 67l Derek Fell; 67tr Tim Street-Porter; 67br Tim Street-Porter; 68l Reinhard-Tierfoto; 68c Margaret Hensel/Positive Images; 68r Hugh Palmer; 69t Linda Joan Smith; 69c Linda Joan Smith; 69b Linda Joan Smith; 70t Photos Horticultural; 70b Susan A. Roth; 71t Jerry Harpur (Designer: Jan Martinez); 71b Susan A. Roth; 72l Curtice Taylor; 72r Curtice Taylor; 73l Hugh Palmer; 73r Jerry Howard/Positive Images; 74t Susan A. Roth; 74b Curtice Taylor; 75l Nils Reinhard; 75r Linda Joan Smith; 76Mick Hales; 77t Tim Street-Porter; 77b Jerry Howard/Positive Images; 78t Jerry Pavia; 78b Alan & Linda Detrick (Designer: Marylin Coombe Stewart); 79t Peter Stiles Photography; 79b Hugh Palmer; 80t Linda Joan Smith; 80b Jerry Pavia; 81l Andrew Drake/ gardenIMAGE; 81tr Ron Sutherland/ Garden Picture Library; 81br Kathlene Persoff; 82t Jerry Pavia; 82b Kathlene Persoff; 83t Kathlene Persoff; 83c Photos Horticultural; 83b Photos Horticultural; 84l Derek Fell; 84r Susan A. Roth

Edgings Page 86 Susan A. Roth; 87 Photos Horticultural; 88l Andrew Lawson; 88r Kathlene Persoff; 90l Terry Wild Studio; 90c Eric Crichton/ Garden Picture Library; 90r Karen Bussolini; 91l Derek Fell; 91r Lynn Karlin; 93l Hugh Palmer; 93tr Andrew Lawson; 93cr Photos Horticultural; 93br Andrew Lawson; 94t Photos Horticultural; 94c Linda Joan Smith; 94b Peter Stiles Photography; 95l Derek Fell; 95tr Margaret Hensel/Positive Images; 95br Derek Fell; 96 Linda Joan Smith; 97l Clive Nichols; 97tr Gary Rogers/Garden Picture Library; 97br John Glover; 98t Derek Fell; 98b Marijke Heuff/Garden Picture Library; 99l Photos Horticultural; 99c Georgia Glynn-Smith/Garden Picture Library; 99r Brian Carter/Garden Picture Library

Trellises Page 100 Ron Schramm/ gardenIMAGE; 101 Harry Haralambou/ Positive Images; 102 Photos Horticultural; 103 Photos Horticultural; 104 Lynn Karlin; 105t Alan & Linda Detrick; 105b Hugh Palmer; 106 Karen Bussolini; 107l Elizabeth Whiting Assocs; 107tr Derek Fell; 107br Kathlene Persoff; 108l Andrew Lawson; 108c Andrew Lawson; 108r Kathlene Persoff; 109l John Glover; 109r Hugh Palmer; 110 Mick Hales; 111t Derek Fell; 111b Sunniva Harte/Garden Picture Library; 112l Andrew Lawson; 112c Hugh Palmer; 112tr Derek Fell; 112br Ken Druse; 113t Peter Stiles Photography; 113b Howard Rice/Garden Picture Library; 114l Susan A. Roth; 114c Garden Matters; 114r Phots Horticultural; 115l Lynn Karlin; 115r Pam Spaulding/Positive Images; 117t Linda Joan Smith; 117b Linda Joan Smith; 118l Jerry Harpur; 118bl Harry Smith Horticultural Photographic Collection; 118r Steven Wooster/Garden Picture Library; 119 Charles Mann; 120t Jerry Harpur; 120b Karen Bussolini

Arbors, Pergolas, and Arches Page 122 Susan A. Roth; 123 Margaret Hensel/ Positive Images; 124t Garden Matters; 124b Vincent Motte; 125 Mick Hales; 126l Ping Amranand; 126c Clive Nichols/ Clive & Jane Nichols; 126r Ken Druse; 127l Ping Amranand; 127c Carol Simowitz; 127r Kathleen Norris Cook; 128l Ron Sutherland/ Garden Picture Library; 128tr Howard Rice/Garden Picture Library; 128br Peter Stiles Photography; 129l Lee Anne White/Positive Images; 129r Clay Perry /Garden Picture Library; 130 Derek Fell; 131l Motte or Karlin; 131tc Derek Fell; 131bc Margaret Hensel/Positive Images; 131r Christopher Gallagher/Garden Picture Library; 132l Lynn Karlin; 132c Lynn Karllin; 132r Garden Matters; 133l Ken Druse; 133c Vincent Motte; 133r John Peden; 134 Clive Nichols/Wollerton Old Hall, Shropshire; 135t Tim Street-Porter; 135b Saxon Holt; 136t Hugh Palmer; 136b Vincent Motte; 137t Lynn Karlin; 137c Andrew Lawson/ gardenIMAGE; 137b John Peden; 138 Ping Amranand; 139t JS Sira/ Garden Picture Library; 139c Steven Wooster/Garden Picture Library; 139b Hugh Palmer; 140l Lynn Karlin; 140c Alan & Linda Detrick; 140r Curtice Taylor; 141l Ken Druse; 141c Steeie Shields/Garden Matters; 141r Ping Amranand; 142t Neil Campbell Sharp; 142b Keith Scott Morton; 143l Derek Fell; 143c Steven Wooster/ Garden Picture Library; 143r Juliette Wade/ Garden Picture Library; 144t Derek Fell; 144c Linda Joan Smith; 144b Hugh Palmer; 145t Brian Carter/Garden Picture Library; 145c Ron Sutherland/ Garden Picture Library; 145b Clive Nichols/Wollerton Old Hall, Shropshire

Paths and Walkways Page 146 Kathy Mansfield/Positive Images; 147 Russell Illig/gardenIMAGE; 148l Peter Stiles Photography; 148c Kathlene Persoff; 148r Ivan Massar/Positive Images; 149l Curtice Taylor; 149c Garden Picture Library; 149r Hugh Palmer; 150 Reinhard-Tierfoto; 152l Susan A. Roth (Designer: Kristin Horn); 152c Jerry Harpur; 152r Curtice Taylor; 153l Curtice Taylor; 153c Howard Rice/Garden Picture Library; 153r Jerry Pavia; 154t Kathlene Persoff; 154b Hugh Palmer; 155 Hugh Palmer; 156l Derek Fell; 156tr Derek Fell; 156b Reinhard-Tierfoto; 157l Curtice Taylor; 157r Curtice Taylor; 158l Ian Adams/gardenIMAGE; 158r Peter Stiles Photography; 159l Ken Druse; 159r Eric Crichton/ Garden Picture Library; 160t Curtice Taylor; 160b Reinhard-Tierfoto; 161 Susan A. Roth; 162l Reinhard-Tierfoto; 162c Curtice Taylor; 162r Reinhard-Tierfoto; 163t Saxon Holt; 163c Kathlene Persoff; 163b Photos Horticultural; 164l Ken Druse; 164tr Hugh Palmer; 164br John Peden; 165l Steven Wooster/Garden Picture Library; 165tr Derek Fell; 165br Ron Sutherland/Garden Picture Library; 166 Derek Fell; 167tl Steven Wooster/Garden Picture Library; 167bl Eric Crichton/

Garden Picture Library; 167r Ron Sutherland/Garden Picture Library; 168l Hugh Palmer; 168c Hugh Palmer; 168r Ping Amranand; 169l Derek Fell; 169c John Glover; 169r Clive Nichols (Designer: David Stevens, Chelsea '98); 171t Curtice Taylor; 171c John Glover; 171b Reinhard-Tierfoto; 172t Reinhard-Tierfoto; 172b Reinhard-Tierfoto; 173l Neil Campbell-Sharp; 173tr Kathlene Persoff; 173br Jerry Harpur; 174t Curtice Taylor; 174b John Glover

Patios, Decks, and Terraces Page 176 Ron Sutherland/Garden Picture Library; 177 Steven Wooster/Garden Picture Library; 178t Hugh Palmer; 178b Hugh Palmer; 179l Hugh Palmer; 179c Hugh Palmer; 179r Curtice Taylor; 180 Steven Wooster/Garden Picture Library; 181t Tim Street-Porter; 181b Gary Rogers/Garden Picture Library; 182l Lynn Karlin; 182c Ron Sutherland; 182r Ron Sutherland/Garden Picture Library; 183 Kathlene Persoff; 184l Jacqui Hurst/Garden Picture Library; 184r Kathlene Persoff; 185 Linda Joan Smith; 186t John Glover; 186c Kathlene Persoff; 186b Clive Nichols (Designer: Keeyla Meadows); 187 Kathlene Persoff; 188 Kathlene Persoff; 189t Curtice Taylor; 189c Andrew Lawson; 189b Curtice Taylor; 190l Ping Amranand; 190c Derek Fell; 190r Hugh Palmer; 191l Kathlene Persoff; 191c Ron Sutherland/Garden Picture Library; 192t Tim Street-Porter; 192b Kathlene Persoff; 194t Charles Mann; 194b Brigitte Thomas/Garden Picture Library; 195 Brian Vanden Brink (John Morris Architect); 196l Jerry Harpur; 196r Ron Sutherland/Garden Picture Library; 197l Brian Vanden Brink (Winton Scott Architects); 197r Susan A. Roth; 198l Karen Bussolini/Positive Images; 198tr Susan A. Roth (Designer: Conni Cross); 198br Mick Hales; 199t Michael Paul/Garden Picture Library; 199c Curtice Taylor; 199b John Glover

Hedges and Espalier Page 200 Reinhard-Tierfoto; 201 John Glover/Garden Picture Library; 202t Curtice Taylor; 202b Francois Gohier/Photo Researchers, Inc.; 203 Derek Fell; 204l Mayer/Le Scanf/Garden Picture Library; 204c Andrew Lawson; 204r Curtice Taylor; 205t Matt Bain/NHPA; 205c Andrew Lawson; 205b Pam Spaulding/Positive Images; 206 Derek Fell; 207t Photos Horticultural; 207c Andrew Lawson; 207b Garden Matters; 208l E. A. James/NHPA; 208r Roger Wilmshurst/Photo Researchers, Inc.; 209l J. & M. Bain/NHPA; 209r William Patton/NHPA; 210t Andrew Lawson; 210c Andrew Lawson (Kiftsgate Court, Gloucestershire); 210b Photos Horticultural; 211t Hugh Palmer; 211c Curtice Taylor; 211b Harry Haralambou/Positive Images; 212l Karen Bussolini; 212c Lynn Karlin; 212r Derek Fell; 213l Lynn Karlin; 213r Curtice Taylor; 214t Anne Hyde/ Country Life Picture Library; 214b Reinhard-Tierfoto; 215t Derek Fell; 215b John Glover; 216 Andrew Lawson; 217t John Glover/Garden Picture Library; 217b Harry Haralambou/ Positive Images; 218t Curtice Taylor; 218c Lynn Karlin; 218b Hugh Palmer; 219t Clive Nichols/Swinton Lane, Worcs.; 219b Reinhard-Tierfoto; 220l Hugh Palmer; 220l Andrew Lawson/ gardenIMAGE; 220l Hugh Palmer; 221t Hugh Palmer; 221b Hugh Palmer

Potting Sheds & Greenhouses Page 222 Kathlene Persoff; 223 John Glover; 224l Lynne Brotchie/Garden Picture Library; 224c Curtice Taylor; 224r Stephen Dalton/NHPA; 225l Pam Spaulding/Positive Images; 225c Photos Horticultural; 225r John Phipps/Garden Matters; 226 JS Sira/Garden Picture Library; 227t Keith Scott Morton; 227b Linda Burgess/Garden Picture Library; 229t John Glover; 229c Carole Ottensen/gardenIMAGE; 229b Photos Horticultural; 230 I. Snitt/Stock Image Production; 231 Hugh Palmer; 232t Harry Haralambou/Positive Images; 232c Karen Bussolini/ Positive Images; 232b Andrew Lawson (Designer: Penelope Hobhouse); 233 Karen Bussolini; 234l Hugh Palmer; 234r John Glover; 235l Curtice Taylor; 235c Jerry Howard/Positive Images; 235r Jerry Howard/Positive Images; 236 Julitte Wade/Garden Picture Library; 237 Vincent Motte; 238 John Glover; 239t Linda Joan Smith; 239b Vincent Motte; 240t Juliette Wade/Garden Picture Library; 240b John Glover; 241t John Miller/Garden Picture Library; 241b Hugh Palmer; 242l Michael Howes/Garden Picture Library; 242tr Hugh Palmer; 242br Photos Horticultural; 243l Peter Stiles Photography; 243r John Glover/Garden Picture Library; 244t John Glover; 244b Marie O'Hara/Garden Picture Library; 245 John Glover